MODERN ISLAMIC ART

MODERN

University Press of Florida
Gainesville
Tallahassee
Tampa
Boca Raton
Pensacola
Orlando
Miami
Jacksonville

ISLAMIC ART

Development and Continuity

Wijdan Ali

With love to Ali, Nafa'a, Rajwa, Basma, and Abbas.

02 01 00 99 98 97 6 5 4 3 2 1

Every attempt has been made to locate and identify the
proper copyright holders; please report any errors or
omissions to the publisher.

LIBRARY OF CONGRESS CATALOGING-IN-PUBLICATION DATA
Ali, Wijdan.
Modern Islamic art: development and continuity / Wijdan Ali.
p. cm.
Includes bibliographical references and index.
ISBN 0-8130-1526-x (alk. paper)
1. Art, Islamic. 2. Art, Modern—20th century—Islamic countries.
I. Title.
N7265.A43 1997
709'.17'6710904—dc21 97-24325

The University Press of Florida is the scholarly publishing agency
for the State University System of Florida, comprised of Florida
A & M University, Florida Atlantic University, Florida International
University, Florida State University, University of Central Florida,
University of Florida, University of North Florida, University of
South Florida, and University of West Florida

University Press of Florida
15 Northwest 15th Street
Gainesville, FL 32611
http://nersp.nerdc.ufl.edu/~upf

CONTENTS

ILLUSTRATIONS

COLOR PLATES FOLLOWING PAGE 84

WHEN I JOINED the School of Oriental and African Studies at the University of London in 1989, I inherited from Professor Geza Fehervari a number of doctoral candidates, all of whom proved to be both distinguished and distinctive. Among them was Wijdan Ali, who, in contrast to my other students pursuing the arts of Islam past, had decided to embark on a thesis with a far different emphasis, looking at the nature of Islamic art in the present and at its roots. This volume is the fruit of that doctoral dissertation.

One of the immediately obvious problems was the lack of references for such a study. Very little had been written on the recent art of the Islamic world, and this lack of literature underlined the neglect that had befallen the subject. Rather than exploring recent Islamic art, studies have emphasized the classical traditions of the past, from Umayyad and Abbasid painting through Baghdad and Mosul, to the Mongols, Timurids, Safavids, and Ottomans.

The hiatus between past and present paintings that Ali's work identifies has its counterpart in the cultural history of the Islamic world. The decline of classical Islamic art is part of the broader period of decline in the Islamic world that took place before Napoleon's invasion of Egypt, which brought about disjuncture with the past. In this period, painting simply stagnated in the Islamic countries, lacking either court patronage or the context of individualism that marked European painting in the nineteenth century. Ali traces the roots of the revival in the somewhat unexpected milieu of Turkish military painting, followed by the growing vigor of cultural rediscovery and renaissance in the Arab countries and the Islamic world that has occurred in the present century.

Although the continuity of Islamic art may have suffered a hiatus, the framework whence it arose did not dissolve. Yet it would be equally wrong to focus on the art of Islam as relating solely to the past. Within the internationalization and globalization of art during the twentieth century, there remain clear differentiations that go far beyond mere dialects within modernism and postmodernism. The regeneration of art in the Islamic world takes on its own unique characteristics, and it is this issue that runs as a core through Ali's discussion. At the heart of Ali's investigation is

the area where continuity is most to be expected: the quintessentially Islamic art of calligraphy. No other subject matter is as central to Islam as the script of the Holy Qur'an and the language of revelation. It is inevitable that the same script is a central part of Islamic art's revival, not as a matter of antiquarianism but as innovation and rejuvenation. Rightly recognizing this point, Wijdan Ali has laid the foundation for studies of Islamic calligraphic art in the modern period.

GEOFFREY KING
University of London

PREFACE

MODERN ISLAMIC ART is an enigma that carries ambiguous connotations, in both its name and its nature. On the one hand, the term *modern* conjures up a progressive, up-to-date condition. On the other hand, the word *Islamic* has overtones of tradition and religion, more relevant to the past than the present. Finally, the word *art* can mean anything from high monumental architecture to cartoon drawings. As a contemporary Islamic artist, my identity is constantly being questioned, both in the Islamic world and in the West. This issue of identity and the tentative position of modern Islamic art were the main reasons for choosing the subject of this book.

Part I of the book is an analytical study of contemporary modern art in the Islamic countries of Turkey, Egypt, Lebanon, Iraq, Algeria, Tunisia, Morocco, Iran, Syria, Jordan, Palestine, Sudan, and the states of the Arabian Peninsula. They are examined in chronological order according to the point at which Western painting began to develop in each country. The early starters—Turkey, Egypt, and Lebanon—brought about modern art in the Islamic world. They are placed in concentric rings of cultural sophistication, moving outward to those countries that were encompassed last by modern art movements.

The reason I did not include Pakistan and Bangladesh in my survey is their very short history as independent Islamic countries: Pakistan was created in 1947 and Bangladesh in 1971. Both were previously part of India, and they thus share most of the history of the modern art movement there. As for Malaysia and Indonesia, as well as Burkina Faso, Nigeria, and Senegal, none of them was subject to any of the major Islamic dynasties (Umayyad, Abbasid, Mamluk, and the like) that established artistic traditions within Islamic civilization.

The discussion starts with Turkey because the Ottoman Empire ruled over the largest part of the Islamic world—including all Arab countries save for Morocco—and was thus extremely influential. Furthermore, it was mainly through the Ottoman Empire that Western aesthetics infiltrated the Islamic Near and Middle East. The chapters on individual countries include brief historical backgrounds, and they probe into each country's artistic traditions, the inception of Western

aesthetics, and the evolution of its art in the modern period, including the different periods and stages of development. Among the specific topics of each chapter are noteworthy artistic trends, artistic societies, programs of art education, art patronage, and a concise critical account of modern Islamic artists who have been instrumental in each country's art movement.

The little that has been written on modern Islamic art focuses mainly on its development in chronological terms, without analyzing the factors that have brought it about. Even these few sources are often contradictory, inadequate, exaggerated, or too general to have any academic value. I have used such few books as I could find on the history of modern art in the countries of the Middle East as well as information from exhibition catalogs, periodicals, and the archives of the Jordan National Gallery of Fine Arts. Whenever possible, I have interviewed artists, art historians, and critics. Thereafter, I have verified what I found dubious by cross-checking with other sources. Sources on countries such as Sudan, for example, are so scarce and so general in nature that I found it necessary to visit the country myself to gather information firsthand. Even then, meetings with some of the artists I wanted to interview were impossible because of a deteriorating political situation and the breakdown of internal communications. Some of the people I met were afraid to talk freely, while others gave me inaccurate facts instead of admitting their ignorance. In the end, I traveled to London to interview Sudanese artists living there.

Part II of this book analyzes the three stages that many contemporary Islamic artists have undergone, regardless of the time period when their respective countries adopted Western aesthetics. It also addresses the artistic identity crisis that modern Islamic artists have experienced in the quest for an original modern Islamic art. In this quest, various art movements have interacted in the development of the contemporary

Calligraphic School of art. Part II also investigates the origins and discusses the main branches of the modern Calligraphic School, including in-depth analysis of each style and its adherents. The question of placing the Calligraphic School within the scope of international art is also addressed.

The book ends by establishing a continuity between traditional Islamic art and the contemporary Calligraphic School of the Islamic world. It attempts to close the gap between the artistic past and present in countries of the Middle East and North Africa, between classical and modern Islamic art.

The goal of this book is thus twofold: to trace the development of Western aesthetics and modern painting in the Islamic world and to establish the continuity of Islamic art in the twentieth century through the contemporary Calligraphic School of art.

The Appendix is made up of summary biographies of the artists discussed, with brief critiques of their work. The names of Arabic and Iranian artists are reproduced here in the way their owners spell them, and all Turkish names are spelled using the modern Turkish alphabet. The names of cities and towns are spelled in the way they are most commonly written among the references cited. All transliteration of Arabic words is based on the *Encyclopedia of Islam* (new edition, 1993). Because of the scarcity of written sources on contemporary Islamic art, only the following two references (both periodicals) are cited in abbreviated form: *Art and the Islamic World* = AIW; *Al-ḥawlīyāt al-atharīyah al-ʿarabīyah al-surīya* (The annual Arab Syrian archaeological and historical revue) = HAAS.

I would like to thank all those who have been of assistance to me in writing this book, who are too numerous to list. Special thanks go to the artists and critics whom I interviewed and to the staff of the Jordan National Gallery of Fine Arts, whose cooperation was of great help; in particular, Ms. Luna Khirfan of the gallery was of invaluable assistance with the illustrations. To all of them I am most grateful.

INTRODUCTION

By the mid-sixteenth century, there were two broad centers of Islamic civilization: the Ottoman Empire, which included the whole of the Middle East, North Africa, and Eastern Europe; and the Safavid Dynasty in Iran. However, there was a clear disparity in the cultural and artistic development of the different parts of the Islamic world. As Lebanon, Syria, Egypt, and Tunisia fell within the cultural sphere of Istanbul, whatever originated in the Ottoman capital was soon emulated in Beirut, Jerusalem, Damascus, Cairo, and Tunis, be it in the field of architecture or the applied arts. In Iran, Islamic art maintained its vigor and innovation throughout the Safavid and the early Qajar periods. On the other hand, geography kept Iraq, Jordan, Sudan, Algeria, and the Arabian Peninsula far removed from the Ottoman sphere of influence. These areas, the backwaters of the Ottoman Empire, contributed very little to the progress of Islamic art at the time. Despite the annual pilgrimage to Mecca that gave the Hijaz an important position in the world of Islam, it nevertheless contributed nothing to the art of the great metropolitan centers of the Islamic world.

By the late eighteenth century, some European art was manufactured specifically for the Middle Eastern market, and the local elites began to visit Europe more frequently. They admired what they encountered and returned home to emulate the West. The infiltration of European culture and artwork into the Islamic world intensified in keeping with the development of trade relations with Europe; the opening of missionary schools and convents, particularly in Lebanon; and Napoleon's invasion of Egypt in 1798. By the 1850s, the fashion of Orientalism was reaching its peak in Europe, encouraging hundreds of adventurers, explorers, poets, artists, writers, and mere tourists to visit the East.

Meanwhile, in sharp contrast to the West's energetic discovery of the Islamic East, the Islamic world was at its lowest ebb by the end of the nineteenth century, a feeble recipient of what came from the powerful West. Politically, this process expressed itself in the Western colonization of Islamic lands, mainly by the French and the British. Their culture superimposed itself on the much-weakened indigenous Islamic art and cultural traditions.

By the beginning of the twentieth century, Europe had revolutionized itself industrially, politically, and socially, while the Islamic East was only beginning its race to catch up with the West. The Muslim world spared no effort in pushing aside all that was perceived to hinder the replacement of human beings with machines, and the rejects included the applied Islamic arts and indigenous handicrafts. Eventually, both formal and informal patrons of Islamic art—the state, the ruling classes, and the gentry—ceased their support. Gradually, the production of crafts tapered off to match the demand of foreign tourists, rather than being collected by the local elite. In the economic reality of the turn of the century, the younger generation was working in well-paying factory jobs instead of apprenticing in the ateliers of its elders. Quantity overtook quality as communities were transformed into consumer societies. Imitation and repetition replaced innovation, apprenticeship, and creativity, leading to careless workmanship and the debasement of art.

In general, the more quickly a country became industrialized, the faster its traditional Islamic arts declined. Even in countries that lagged behind in their race to industrialize, where craftsmen continued to work in a traditional manner, the innovation, ingenuity, and quality of Islamic arts greatly suffered. Whatever was produced simply repeated the old forms and styles, bypassing meticulous workmanship. The bourgeoisie and nouveau riche who replaced the old aristocracy and elite acquired expensive items expressly to flaunt their wealth. For them, Limoges porcelain, Murano crystal, and English silver were far more valuable than Iznik ceramics, Çesme Bulbul glass, or Iranian metalwork. In poor countries such as Morocco, work in pure silver was eventually discontinued, replaced by silver-plated metal.

Music was one of the few arts that remained unaffected by the West. In its classical Arabic, Persian, Turkish, and Urdu variations, the music of Islam has maintained its original characteristics. Although it is not as popular as modern Western music, it has managed to safeguard its purity against foreign influence.

In a similar manner, Arabic calligraphy is the only visual art form to have been rescued from degeneration. Because of its intimate relationship with the copying of the Qur'an, it has kept its original dignity, whereas the other arts of the book—miniature painting, bookbinding, and illumination—have rapidly deteriorated, almost to their complete demise.

The decline of the Islamic arts was accompanied by the weakening of the political institutions, the decadence of the governing bodies, and the deterioration of the regional economy of the entire Islamic world. These phenomena were interrelated, and as the aesthetic and creative fiber of Islamic art weakened, it succumbed to the Western art forms and styles that invaded the Islamic world under the banner of the West's political, economic, scientific, and military superiority. Above all, improvements in the means of communications between Europe and the Islamic countries exposed the Islamic world to the West to an overwhelming degree.

However, the political, economic, and social environment that undermined traditional art in the Islamic world also paved the way for a modern Islamic art that encompasses Western aesthetics. From the mid-nineteenth century, an "artistic renaissance" in the Middle East and North Africa took place in the evolution of visual arts, especially painting. By the mid-twentieth century, nearly all of the countries in the Middle East and North Africa had modern art movements, which reflected their cultural and artistic growth through their art institutions, artistic activities, the growing number of artists, and the level of their work.

The chapters that follow survey Islamic countries and their evolution in painting, from first exposure to the West in the nineteenth century through the late twentieth century. They prepare the ground for the chapters in Part II, which trace the revitalization of contemporary Islamic art, in the form of the modern School of Calligraphy.

I ~ THE COUNTRIES

1 TURKEY

AS EARLY AS the seventeenth century, Ottoman artists and architects began borrowing isolated Western stylistic features— such as profile technique in miniatures (derived from the Western artistic traditions of portraiture) and linear three-dimensional features in topographical paintings. They did so within the framework of an Ottoman aesthetic that was dominant until the reign of Sultan Selim III (1789–1809). Istanbul, the center of political power in one of the greatest empires on earth, was also its most important cultural metropolis. Artistic and architectural trends emanated from it and immediately spread throughout the empire via a powerful guild system, organized under the strongly centralized regime of that time.

Many European artists visited the Ottoman court. Among the first were the Italians Constanzo da Ferrara and Gentile Bellini. Bellini, who painted a portrait of Sultan Mehmet II (1451–1481), was followed by the Danish painter Melchior Lorck during the reign of Sultan Süleyman the Magnificent (1520–1566). Another Danish painter, Johannes Lewenklaü, came to the court during the reign of Sultan Murat III (1574–1595). However, none of these artists left behind, among his local peers, a Western tradition in the practice of oil painting. Nor were Turkish miniature painters and other artists acquainted with the great contemporary masters of the West.

By the early nineteenth century, following the Napoleonic wars and improved trade relations between Europe and Turkey, European tastes had pervaded Istanbul. The palace circle, which in more than one way had always been in the vanguard, was inundated with Western fashions in architecture, clothing, bric-a-brac, jewelry, and painting. Sultan Abdülmecit (1839–1861) had built a large European-style pavilion-kiosk at Topkapi before moving to his new rococo creation, the Dolmabahçe palace. The British artist Sir David Wilkie painted Sultan Abdülmecit's portrait in 1840.

When Sultan Abdülaziz (1861–1876) visited Europe in 1867, he became the first Ottoman ruler to cross his empire's borders for a purpose other than war. During his visit, he acquired first-hand knowledge of European art. Upon his return, Western-inspired institutions began to replace traditional ones. For example, after the conquest of Constantinople in 1453 by Sultan

Mehmet II, all crafts were organized into a comprehensive guild system in Istanbul, under the Imperial Architect's Lodge (Hassa Mimarlar Oçaği), which had previously regulated construction throughout the empire. Included in its membership were architects and artisans of various ranks, such as mason-architects, minaret masters, marble and stone workers, stucco masters, carpenters, and ornamentors (carvers and tracers), as well as plasterers, drainage experts, and artists working in metal, glass, and lead. In the mid-nineteenth century, the lodge was replaced by a Royal Administrative Bureau (Ebniye-i Hassa Müdürlüğü). It was followed by Western-style schools of architecture and fine arts. They effectively superseded the ancient guild system and palace schools, which had made the first selection of talented artists for all the major crafts, thereby securing the best artisans for the imperial workshops.

During the second half of the nineteenth century, European architects, artists, and craftsmen were imported to teach their local counterparts. Sultan Abdülaziz invited European artists such as Antoine Guillemet, Amadeo Preziosi, Chlebowski, and Stanislas von Aivazowski to his court. The sultan encouraged Guillemet to open an art academy, which he did in 1874 in Pera in Istanbul. It was a futile venture, however, because its small group of students were mostly non-Muslim residents of the city.

Sultan Abdülaziz also acquired a collection of paintings by nineteenth century Orientalists including Jean-Léon Gérôme, Louis Boulanger, and Eugène Fromentin, as well as several sculptures, to be displayed in the Dolmabahçe Palace. What was probably the first painting exhibition in the Islamic world took place in the Ottoman capital in 1874 under the patronage of the sultan.[1]

MURAL PAINTING

In spite of the infusion of Western features into Turkish miniature painting, the shift to Western styles did not occur suddenly. It was difficult for the Turks to accept a foreign concept of art derived through political and economic relations. Adaptation began during a transitional period in the eighteenth and nineteenth centuries and was first apparent in wall paintings of landscapes and still lifes saturated with European elements. Yet it was not until the second half of the nineteenth century that easel painting was introduced.

With the introduction of the printing press in Istanbul in 1729, the demand for hand-written books sharply diminished, thus decreasing the production of miniatures. At this stage, it was only natural for a new genre of painting to develop, and a novel form of mural painting began to replace miniatures. In the second half of the eighteenth century, baroque and rococo styles that had been popular in European architecture during the seventeenth and eighteenth centuries began to pervade Turkey, and with these new influences on Ottoman architecture, mural painting was introduced into Turkey.

The new paintings were not executed in the Western fresco technique but were a type of *fresco a secco*, produced by the application of pigments of root dyes mixed with gum or water over dry plaster. While this same technique was used in traditional Ottoman wall decoration known as *kalem işi* (painted brushwork tracery), the new genre had a different language. The stylized floral and geometric decorative motifs of traditional Ottoman wall paintings were replaced by Western baroque and rococo ornamental patterns that included both landscapes and still lifes of flowers, fruit pots, and baskets. Unlike their Western archetypes, Turkish murals were totally devoid of human figures. Thus, this new form of painting was adapted to local interpretations. Turkish artists started including human figuration in their mural compositions only in the late nineteenth century. However, wall decorations consisting mainly of scenic murals played a significant role in the development of Turkish pictorial art.

The earliest mural paintings in the rococo style appeared in the harem section of Topkapi Palace during the Tulip Period, in the first quarter of the eighteenth century. The murals were narrow friezes filled with rows of flower bouquets and fruit bowls, either painted or carved on walls. They later included pictures of kiosks and other architectural elements as well as trees and fountains. Gradually such friezes expanded in size and developed into panoramic views of Istanbul. They were placed within niches or on the

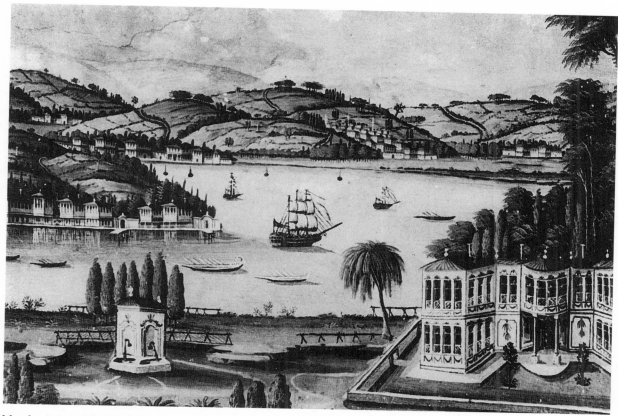

Mural painting of the Bosphorus from Sadullah Paşa Yalisi, first quarter of 20th century.

upper portions of walls and were surrounded by various types of decorative frames.

The careful depiction of buildings added some documentary value to these paintings. The application of color, however, was not realistic. For the first time, Western-style perspective, though primitively achieved, was introduced, as artists had begun experimenting with light and shade. In spite of these new conventions, the detail-oriented tradition of miniatures continued to prevail in all mural paintings.

This new genre of painting soon spread outside the palace walls to private mansions and buildings in Istanbul. The same stylistic features were imitated, a sign that there was a community of mural painters practicing outside the palace. Standardized models helped artists adopt Western painting techniques. Most of the murals resembled one another, repeating the same visual vocabulary—red-roofed and windowed houses, fountains, bridges, pale trees, and pink skies. They are thus proof of stereotyped motifs. Specifically Western elements such as perspective and light and shade, indirectly introduced to Turkish art, were applied to landscape murals mostly by copying.

In the second half of the nineteenth century, oil painting was introduced into Turkey and artists began applying it to pictorial murals. Although the most popular subject matter continued to be Istanbul and its various quarters, certain new themes were introduced: country scenes incorporating towers and castles similar to those in European postcard illustrations; hunting representations; exotic views with palm trees; and monuments from the Arab provinces. Vases and baskets filled with flowers, fruit cups, and watermelons pierced with knives, executed in Western fashion, were featured in many buildings.

The Turkish art historian Günsel Renda believes that it was possible for European masters such as Aivazowski, Preziosi, and Chlebowski, who had been invited to Istanbul by Sultan Abdülaziz in the second half of the nineteenth century, to have worked on murals of this period. She speculates that mural paintings of purely European nature would have been executed first by a foreign artist, creating the prototype to be copied and adopted by local painters. Renda thinks that the visits of foreign artists account both for the presence of European-style buildings in Ottoman mu-

Still life from the ceiling of Başmabeyinci Konağ, last quarter of 19th century.

ral painting and for the type of Islamic architecture popular among European Orientalist painters of the nineteenth century. Had this been the case, one might expect at least some of the original murals still to exist. They would have been signed by the artists, making them easy to identify. It seems unlikely that all of the originals were destroyed, especially if they were painted on palace walls. Furthermore, murals copied from European models by Turkish painters would be expected to show a better interpretation of light and shade and a more accurate adherence to rules of perspective and anatomy, if indeed they were as dependent on Western models as Renda suggests.

During the nineteenth century, mural painting spread from Istanbul to other parts of Turkey, including Anatolia and Rumelia, and wall paintings reached the distant provinces of the Ottoman Empire. Houses in Aleppo, Damascus, Baghdad, and Cairo as well as in Bulgaria and Albania still retain examples of European-influenced Turkish mural painting, as do some mosques. The themes changed according to the region, although topographic representations of Istanbul and views of Mecca, Medina, and Jerusalem were popular throughout the Ottoman Empire.

At a different level, the influence of lithography and printing made itself felt. Two French brothers, Jacques and Henri Caillol, who traveled to Istanbul in 1831 at the invitation of Mehmet Hüsrev Paşa, founded the first lithography workshop there. Using materials and equipment brought from France, their establishment printed countless educational and administrative books filled with pictures and drawings. In 1836 the shop was closed down after Hüsrev Paşa fell from office, but Caillol Brothers opened a private lithographic workshop, and others followed their example in the ensuing years. The technique of lithography was first put to use in books and pamphlets printed for the army, illustrating troops, weapons, maps, and charts. Later, lithography was used to print popular books with pictures.[2]

COFFEEHOUSE PICTURES

In later decades, prints known as "coffeehouse pictures" became popular. They were colored lithographs that displayed a variety of subjects, depending on the interest of the public at the time: religious themes, sultans, national and folk heroes, warships, and important events such as the opening of the Suez Canal

(1869), the Balkan Wars (1912–13), and the Turkish War of Independence (1919–22). After the Republic of Turkey was established in 1923, there were various portrayals of Kemal Atatürk made by painters attached to printing houses.

The size of the prints varied between 35 x 50 cm and 57 x 82 cm, depending on the size of the stone or zinc plate. They were generally made by obscure craftsmen or folk artists to hang as decoration, alongside printed calligraphic works, in coffeehouses, workplaces, and private homes. It was a long-established custom to decorate coffeehouses with mural paintings, but after the introduction of lithography, hanging pictures on the wall supplanted the older custom, continuing into the 1950s. The low cost of printing such reproductions doubtless had the effect of popularizing coffeehouse pictures.[3]

SOLDIER-PAINTERS

In the eighteenth century, a new pictorial art emerged in Turkey. Bypassing the figurative representation familiar in Turkish miniatures, it manifested itself first in mural painting, painted cupboard doors, and later in free-standing easel paintings. This new pictorial art adhered to the trends of baroque architecture and eventually led to landscape painting. The first easel painters were trained in the military and naval engineering schools of the Ottoman army such as Darüşşafaka, where drawing and perspective courses were part of the topography curriculum. The Ottoman government believed that to restore the former power of the empire, army officers had to be trained according to Western methods and procedures.

The first military training institution was the Imperial Land Engineering School (Muhendishane-i Berri-i Humayun), founded in 1793 by Sultan Selim III. It was followed by the Imperial School of Military Sciences (Mekteb-i Ulumu Harbiye-i Şahane) in 1834. Both schools taught painting to enable young cadets to illustrate landscapes, buildings, roads, and bridges in topographic layouts and technical drawings, used to clarify battle plans or to report results of military actions. Their art training included the techniques of mapping, engraving, and carving. Thus, the teaching of art started in military schools, not civilian institutions, and the resulting phenomenon of soldier-painters is probably unique in the history of painting.

The topographical and technical training of the soldier-painters maintained an interest in nature, emphasized the outdoors, and assigned a special importance

Anonymous, *Hamidiye Mosque in Yildiz Palace*, ca. 1890s. Oil on canvas, 64 x 80 cm. Courtesy of the Ankara Museum of Painting and Sculpture.

to perspective. Linear representation (*resim-i hatti*) or scenic views (*menazir*) emphasized the study of nature and topography and excluded the human figure from the composition. It might even be argued that the soldier-painters, linked to each other in a hierarchy, replaced the old court miniature painters. Those with talent and interest continued to paint after military school and formed the nucleus of Turkey's early, Western-trained artists. Some were sent to Europe by the sultan to further their education and art training, and upon return they were attached to the Ottoman court. However, there was no difference in the work of soldier-painters trained abroad and those schooled in Turkey. All demonstrated the same unsophisticated view of the world, as well as a shy and respectful approach to art, and their early works emphasized detailed workmanship. Those who remained in Turkey were classified by Turkish writers as primitives. Their works resembled the mural paintings of the same period. A number of soldier-painters served as field officers, though most worked as painting instructors at the various levels of military schools. Others became aides-de-camp to the sultan or designers in the Yildiz Palace tile and porcelain workshops.[4]

PHOTOGRAPHY

In 1867 Sultan Abdülaziz appointed a photographer to his court, and photography soon gained popularity. In military schools and Daruşşafaka, lessons were based on painting from prints and photographs. Considering the basic level of photographic technology at the time and the quality of the photographs, the clarity, transparency, and sensitivity of the colors depicted in nineteenth-century Turkish paintings were the products of the artist's skill, talent, and training rather than photographic aid. The primitive painters wanted to copy nature down to the last detail, whether through direct observation or from photographs. Coupled with the painters' very disciplined training, such copying made all their works resemble each other.

The first Ottoman photographers were Christians who chose models from their own communities. The earliest were Armenians and Greeks, who introduced photography into Turkey and the Levant. Muslims and Jews living in the Ottoman Empire opposed the introduction of photography. To them, photography was the exact reproduction of the human image, which they considered against the teachings of their respective religions. Through the encouragement of the sultans, this attitude gradually changed. Sultan Abdülhamit II, himself a photographer, had photographs taken of every major event and site in the empire, including all the naval ships, military installations, and state buildings such as schools, police stations, mosques, and archaeological sites, as well as ethnographic and natural scenes. The albums were deposited in the Yildiz Palace library. Sultan Abdülmecit was the first ruler to present decorations to photographers. In 1910 Rahmizade Bahaeddin became one of the first Muslims to open a photographic studio in Istanbul.[5]

EARLY WESTERN-ORIENTED PAINTERS

A Turkish school of Western-style painting originated with Ferik Ibrahim Paşa (1815–1889), Ferik Tevfik Paşa (1819–1866), and Hüsnü Yusuf Bey (1817–1861), who were among the first soldier-painters. Because none of their works has survived, it is difficult to evaluate their art. Unfortunately, many of the early works that have reached us are unsigned and impossible to identify.

The first generation of Western-oriented painters included Osman Nuri, Salih Molla Aşki, Hüseyn Giritli, Ahmet Bedri, Servili Ahmet Emin, Ahmet Ragip, Çemal Gedipaşali, and Çemal Kasimpaşali. No records exist for this group of artists, who are known only by their signatures. They painted behind the walls of the Ottoman palaces, thus avoiding the disapproval of reactionaries. Their subject matter was restricted to the palaces: well-kept flower beds, decorated kiosks, quiet ponds, and gushing fountains. In spite of the use of large canvases and oils, the thoroughness of miniature painting tradition was still evident in their work, and their cultural and artistic heritage persisted in spite of their Western orientation.

Among the first soldier-painters to go abroad were Ahmet Ali Efendi, who was assistant instructor of painting in the military medical high school, and Süleyman Seyyit, stationed in the military academy. Sultan Abdülaziz sent them to the Académie des Beaux

Çemal Gedipaşali, *The Tile Kiosk*, ca. 1889. Oil on canvas, 76 x 100 cm. Courtesy of the Museum of Painting and Sculpture, Istanbul.

Arts in Paris, to be trained as educators for the military schools upon their return.

Ahmet Ali, known as Şeker Ahmet Paşa (1841–1906), was the most prominent artist among the second generation. After returning from his art studies in Paris, he laid the foundation for Western-style Turkish painting with his semimuted canvases of forests, animals, and still lifes. Though not a military man, Şeker Ahmet Paşa was shortly promoted to the rank of general and became master of ceremonies, *teşrifat naziri,* at the Imperial Court, where his duty was to acquire paintings for the palace. By the time of his death in 1906, he was occupying the high post of intendant of the palace, *saray naziri.* In 1873 (or 1874, according to Renda) and 1875, he organized what were probably the first two group exhibitions in the Islamic world. Süleyman Seyyit (1842–1913), after his return from Paris, was the first art instructor to take his students outdoors to draw from nature.

Though born two decades later, Hüseyin Zakâi Paşa (1860–1919) has always been treated and evaluated along with Şeker Ahmet and Süleyman Seyyit. While he was a student at the military academy, one of his paintings was presented to Sultan Abdülhamit II (1842–1918), who was impressed by it. Subsequently,

the sultan promoted Zakâi to the rank of lieutenant and appointed him aide-de-camp. He was one of the few soldier-painters who served as a field officer.

The most famous Ottoman artist was Osman Hamdi Bey (1842–1910). Artist, archaeologist, architect, poet, writer, musician, and curator, he was a remarkable multifaceted person with great stamina and dedication. After returning to Istanbul from his twenty-year sojourn in Paris, he founded the Imperial Ottoman Museum in 1881 and was its first director. Hamdi also drew up the founding regulations for the School of Fine Arts (Sanayi-i Nefis Mektebi), which opened under his directorship in 1883 and became the Academy of Fine Arts (Guzel Sanatlar Akademisi) after 1928. Unlike Şeker Ahmet Paşa, Süleyman Seyyit (who kept his female portraits hidden in his studio), and Zakâi Paşa, Osman Hamdi gained his reputation as the first Turkish artist to include human figures in his compositions.

Halife Abdülmecit Efendi (1868–1944), the last caliph of Islam and Ottoman ruler (1922–1924), was an exceptionally talented painter of his time as well as a calligrapher and art patron. He trained with his protégé Avni Lifij and painted portraits, landscapes, and scenes of the palace environment. While he was still a

Above: Hüseyin Zakâi Paşa, *View of Yildiz Palace Garden,* ca. 1900. Oil on canvas, 95 x 130 cm. Courtesy of the Museum of Painting and Sculpture, Istanbul.

Right: Osman Hamdi Bey, *A Teacher Conversing in the Courtyard of a Mosque,* ca. 1908–10. Oil on canvas, 140 x 105 cm. Courtesy of the Museum of Painting and Sculpture, Istanbul.

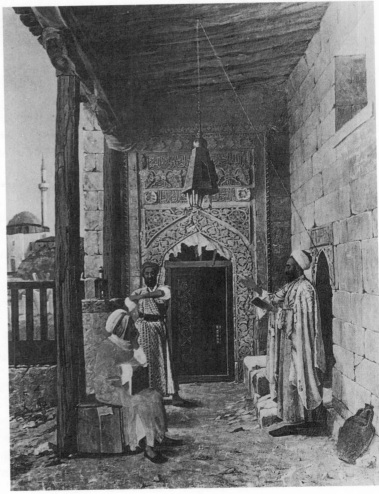

crown prince, few of his paintings were exhibited in "salons" in Paris (ca. 1922). A highly cultured person, Abdülmecit Efendi held a literary salon in Dolmabahçe and invited all foreign visiting artists to the palace. Among his foreign artist-friends was Aivazowski. In 1909, he founded the Ottoman Painters Society and was in close contact with members of the 1914-Generation group, whom he invited to the palace quite often. After the declaration of the republic, Abdülmecit went into exile in France, where he continued to paint and exhibit at the Paris salons. One of his works, a self-portrait, is in the permanent collection of the Museé Massena in Nice.[6]

THE TEACHING OF ART

Until 1883 the main venues for teaching easel painting in Turkey were the military and naval schools, as noted previously. Since its inauguration in that year, the Academy of Fine Arts has become Turkey's most important center for teaching painting and sculpture, where the concepts of the Renaissance and its classical foundations were first encountered. It institutionalized art on a professional level.

The academy had two departments: painting and sculpture. The former has sustained the only active visual art form in the Western-oriented artistic life of Turkey since the early nineteenth century; the focus of the sculpture department has shifted from architectural decoration to the field of fine arts. Osman Hamdi modeled the academy on the École des Beaux Arts in Paris and brought in foreign academic instructors. He believed that the Turkish painters who had trained in the military schools, even if they had studied abroad, did not approach or understand art in a manner that would suit the new institution. Only after 1910 did the academy begin to graduate artists who were qualified to teach in its classrooms and studios.

The Turkish Academy of Fine Arts first emulated the European art academies that had flourished from the seventeenth to the nineteenth centuries. Its academic approach emphasized the rigid conservative rules of drawing and painting, based on the styles and principles of Greek and Roman antiquity. The pro-

gram also adhered to the concept of classical rationality, which appeared devoid of emotion in the figurative style of copying nature. However, during the late nineteenth century, art academies in Europe became the bastions of opposition to all new ideas in art. The term "academic" became a synonym for dullness and conservatism, as a cleavage opened between official bodies and the majority of artists outside the academic fold.

Since its founding in 1883, Istanbul's Academy of Fine Arts has had no rival institution, though it has engendered many provincial academies and institutes, the most important being the Gazi Institute, established in Ankara in 1930.

The teaching of Western-style drawing was introduced into the curricula of teachers' training schools in the first part of the nineteenth century, before the inauguration of the Academy of Fine Arts. It was part of Tanzimat policy (the Reform Edict of 1839) to prepare teachers for a new education system. By the time the Turkish Academy opened, a generation of young men had already been exposed to Western art forms as part of their regular secondary education. They became the foundation for the active art training that has continued through the teachers' training schools such as the Gazi Institute of Education in Ankara, which has produced some of Turkey's leading painters.

In 1914 the Ottoman government opened the Academy of Fine Arts for Women (Inas Sanayi-i Nefis Mektebi). It was offered as a solution to parents who would not send their daughters to the Academy of Fine Arts because, at the time, mixed education was unheard of in Turkey. The new academy had a dynamic woman artist as its director: Mihri Müşfik Hanim (1887–?), who had studied in Paris and Rome. She was known for her still lifes and portraits from the world of veiled Istanbul ladies, using soft lines and strong colors. As director of the Women's Art Academy, she was determined to offer her female students the same opportunities available to their male counterparts. In 1926 the Women's Academy merged with the Academy of Fine Arts, becoming coeducational two years later. In 1950, Mihri Müşfik Hanim emigrated to the United States.[7]

WOMEN ARTISTS

Other early women artists in Turkey included Müfide
Kadri (1890–1912), who won a medal at a very young
age for a painting she exhibited in a Munich gallery
in 1911. Harika Sirel (b. 1896), sister of Turkish sculp-
tor Najat Sirel and wife of painter Avni Lifij, drew sen-
sitive impressionistic landscapes from nature. Güzin
Duran (b. 1898) was trained by her well-known hus-
band, Feyhaman Duran. Sabiha Bozçali (b. 1903) stud-
ied art with private tutors even before girls were sent
to schools. She went on to Rome to make copies at the
Vatican Art Gallery. After World War I, she joined the
Haiman studio in Berlin, then went to the Munich
Academy for three years. In 1931 Bozçali left for Paris
and worked with the noted Paul Signac, developing a
close friendship with him. Between 1947 and 1949 she
worked with the Italian metaphysical painter Giorgio
de Chirico. In Turkey, Bozçali participated in the exhi-
bitions of the Association of Independent Painters and
Sculptors. Fahrelnissa Zeid, her sister Aliye Berger,
and Hale Asaf were also accomplished early Turkish
women painters.[8]

EARLY MODERN TRENDS IN PAINTING:
THE 1914-GENERATION

Between 1910 and 1920, graduates of the Academy of
Fine Arts, especially those who continued their train-
ing in the West, came to represent a modern outlook.
They denied all artistic traditions and styles of the
past and assumed a revolutionary attitude. Under the
banner of "new" art, they took over the administra-
tion of the Academy of Fine Arts. They welcomed
the spread of Impressionism, which had already been
replaced in Europe by even more modern develop-
ments. The most effective Turkish painters emerging
in the second decade of the twentieth century were
referred to as the 1914-Generation. As instructors in
the Academy of Fine Arts, they controlled the educa-
tion system, thus dominating the whole art scene. In
1914 Ibrahim Çalli (1882–1960) became the first Turk-
ish artist to be appointed to the academy. He played
such a vital role in the development of the art move-
ment that the 1914-Generation group was also referred
to as the Çalli Group.

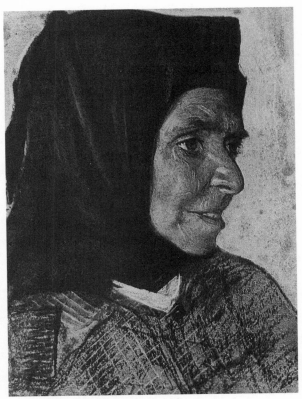

Mihri Müşfik Hanim, *Old Lady*, undated. Oil on canvas, 30 x
40 cm. Courtesy of the Museum of Painting and Sculpture,
Istanbul.

Through his highly personalized style, Çalli closed
the door on the academic realism of the previous gen-
eration. An enthusiastic pedagogue and a flexible art-
ist, he opened new vistas for Turkish painting, always
welcoming novel and unconventional ideas, such as
Cubism. The Çalli Group trained the next generation
of painters, who went to Europe in the 1920s. In 1909,
with the backing of Crown Prince Abdülmecit, the
group formed Turkey's first art association, the Otto-
man Painters Society (Osmanli Ressamlar Çemiyeti).
Its members were both military and civilian artists.
The main activity of this association, which continued
to influence the art scene until the mid-1920s, was
an annual group exhibition. After the creation of the
Turkish Republic, it was renamed the Association of
Turkish Painters (Türk Ressamlar Birliği). The group
also published the first periodical of art news and cri-
ticism, *Naşir-i Efkâr* (Promoter of ideas). It was finan-

cially supported by the painter-calligrapher Crown Prince Abdülmecit.

At the Academy of Fine Arts, Çalli's appointment was followed by those of Hikmet Onat (1882–1977) in 1915, Nazmi Ziya Güran (1881–1937) in 1918, and Feyhaman Duran (1886–1970) in 1919. The teaching of art thus passed into the hands of the generation of the constitutional monarchy (Meşrutiyet). Namik Ismail (1890–1935) joined these artists upon his return from Germany, and Avni Lifij (1889–1927), an eminent member of this generation, became an instructor in the Department of Decorative Arts in 1923. Other prominent artists of the 1914-Generation included Ruhi Arel, Hikmet Onat, Major Sami Yetik, Avni Lifij, Namik Ismail, Feyhaman Duran, and Nazmi Ziya Güran.

By introducing Impressionism into Turkish modern art, these artists became the defenders of a new color concept and art style based on free, agile brush strokes. The old dark color schemes were supplanted by fresh pinks, yellows, greens, and purples, applied with a careless energy and in thick layers. The earlier placid landscapes of Istanbul and the Bosphorus were

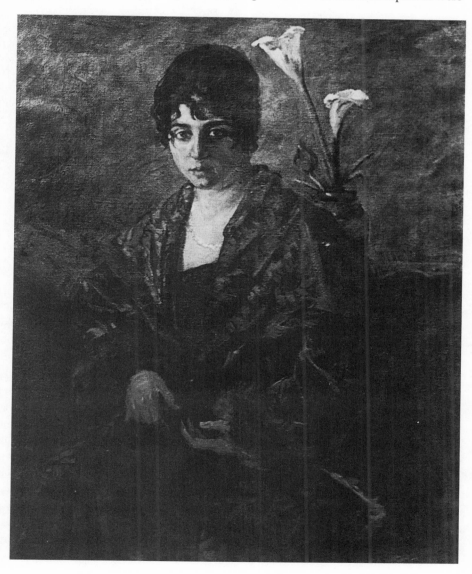

Ibrahim Çalli, *Portrait of Lütfiye Izzet* (unfinished), ca. 1929. Oil on canvas, 100 x 80 cm. Özel Collection, Istanbul.

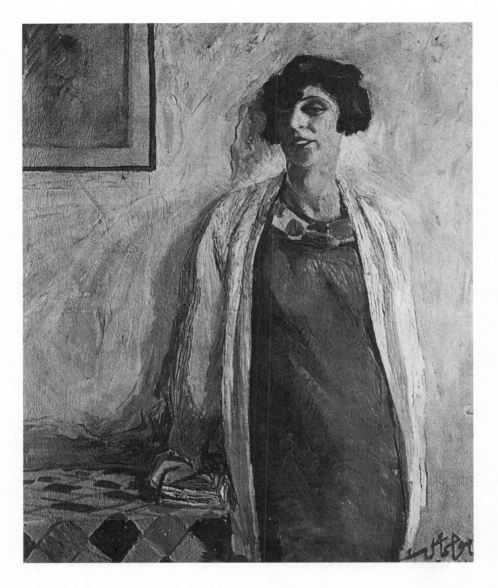

Namik Ismail, *Portrait of a Standing Woman,* 1927. Oil on canvas, 98 x 84 cm. Courtesy of the Museum of Painting and Sculpture, Istanbul.

replaced by reclining female nudes and multifigured narrative compositions. The public quickly accepted this novelty in Turkish painting. Unlike Europeans, people in Turkey were unacquainted with the concept of *peinture classique* and its prejudice against new styles.

The Ministry of War gave the artists of the 1914-Generation a large workshop filled with cannons, rifles, other military equipment, and uniformed models and asked them to produce compositions glorifying the battles of the Turkish army at Çanakkale (Gallipoli). The ministry arranged for journalists, literary figures, and artists (including Çalli and his peers) to visit the military front during World War I so that they could translate their first-hand experiences in writing and onto canvas. The paintings that came out of these

episodes were exhibited in Vienna and Berlin. After the declaration of the Turkish Republic, the same artists portrayed the war of independence in their paintings.

Meanwhile, a significant development in portraiture took place at the behest of Istanbul's enlightened and wealthy circles, who wanted to have their likenesses painted. Many statesmen, starting with Kemal Atatürk, commissioned their portraits. The image of Atatürk eventually took on an official character and became a symbol of modern Turkey. It was the first personality cult to develop in the modern art of the Middle East. Numerous paintings and statues of Atatürk, in all sizes and various poses, were made by established as well as obscure artists. They were distributed in government offices, airports, schools, uni-

versities, and official buildings throughout Turkey. They are still seen in almost every public space.

During the period of the constitutional monarchy after World War I, the Committee of Union and Progress sent talented artists and other young men abroad to give them first-hand experience of European culture. This program was a continuation of efforts in the eighteenth century to renovate the Otto-man State. However, in the early years of the twentieth century, Ottoman intellectuals and ideologues of the Committee of Union and Progress believed that civic modernization should be balanced with cultural nationalism (the expression of national identity through local culture), a dualism that continued under the republic and remained potent until well beyond the 1950s.[9]

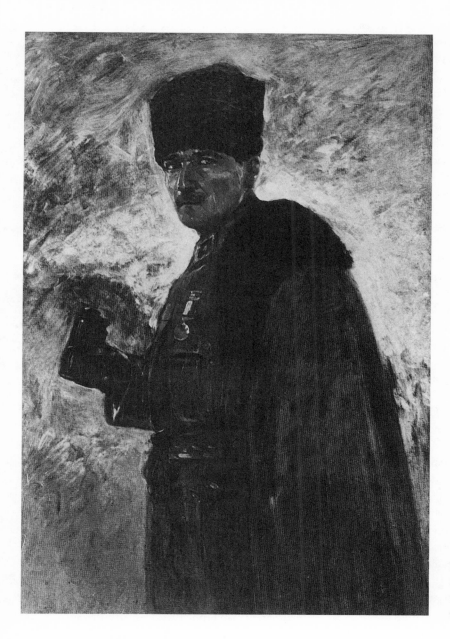

Nazmi Ziya Güran, *Portrait of Mustafa Kemal Atatürk,* ca. 1925. Oil on canvas, 131 x 91 cm. Courtesy of the Museum of Painting and Sculpture, Istanbul.

THE SECOND GENERATION AND BEYOND

As evidenced with the 1914-Generation, local ideologies and government policies in Turkey have influenced the emergence of art groups. The first reaction to the 1914-Generation and the Association of Turkish Painters, which influenced modern Turkish art for a long period of time, was the formation in 1923 of the New Painting Society. The members of this group, who considered themselves the true representatives of the "Republican Generation," held their first exhibition in 1924. Deriving their enthusiasm and faith from their new state, they rejected the ideals of Çalli's older generation, which they claimed had monopolized Turkey's art world. The group was made up of young graduates of the Academy of Fine Arts who had been sent to France, Germany, and Italy. Their claim to innovation, however, did not go beyond their choice of local subject matter.

During 1928–29 a new group was founded, calling itself the Association of Independent Painters and Sculptors. The members (who had been active in the short-lived New Painting Society) were mostly young artists who worked as art instructors or as civil servants. All were passionate art lovers and hoped to benefit by belonging to an established group. They published a manifesto in 1929, in which their declared aim was to aid the rebirth of Turkish painting and to help the national fine arts attain a high standard. The Independents considered older artists, including their own teachers, to be representatives of "official" art. The core of the Independents, whose membership continually grew, included Ali Avni Çelebi, Hale Asaf, Muhittin Sebati, Zeki Koçamemi, Çevat Dereli, Refik Epikman, Mahmut Çuda, Şeref Akdik, and Nurullah Berk. One of this group of intellectuals, Burhan Toprak, later became director of the Academy of Fine Arts. The critics' reaction to the Independents was that they were too Europeanized in their style and choice of subject matter. Evidently, the question of local and national awareness regarding artistic identity was being raised among Turkish intellectuals as early as the 1930s.

The Independents' intellectual style was opposed to the naturalistic and spontaneous painting of the 1914-Generation, which was based on Impressionism. The two leading figures of the group, Zeki Koçamemi (1901–1959) and Ali Çelebi (b. 1904), attended Munich's Fine Arts Academy from 1923 until 1927, studying with Hans Hofmann and taking up his Constructivism. When the two exhibited their work in 1927–28, they stirred up interest among intellectuals. In contrast to previously exhibited work, Koçamemi and Çelebi's post-Cubist and Constructivist paintings emphasized the affinity between their deformed, fragmented figures and space, while disregarding the values of color and light. Çelebi's Expressionistic style eventually reached a vigorous form of semiabstraction. Koçamemi represented his subject matter through architectural constructions divided into various planes. Another member of the Independents was Refik Epikman (1902–1974).

In their works, the Independents severed all ties with the formal academic training and styles of the 1914-Generation. In both style and subject matter, they focused on internationalism rather than regionalism and showed their preference for post-Impressionist Western schools.

In 1933 the D-Group was formed by five painters—Nurullah Berk, Elif Naci, Abidin Dino, Zeki Faik Izer, and Çemal Tollu—and the sculptor Zühtü Müridoğlu. The letter D, the fourth in the Turkish alphabet, was chosen to indicate that the group was the fourth artistic organization to be established in Turkey. Membership was closely regulated. In time Eşref Üren, Turgut Zaim, Fahrelnissa Zeid, Bedri Rahmi Eyüboğlu, and his wife, Eren Eyüboğlu, joined the group.

The members collectively rejected the Turkish Impressionism adopted by the Çalli Group and their teachers at the Academy of Fine Arts. They tried to intellectualize art and bring contemporary European artistic trends to Turkey as quickly as possible, to keep up with the changes brought about by the new republic. They paid tribute to both traditional Western art and the Italian Renaissance masters as well as to contemporary European trends. Most of the members gained first-hand knowledge of leading art movements when they trained with well-known European artists such as Gromaire, Léger, Lhôte, Friesz, Despiau, and Gimond in Paris.

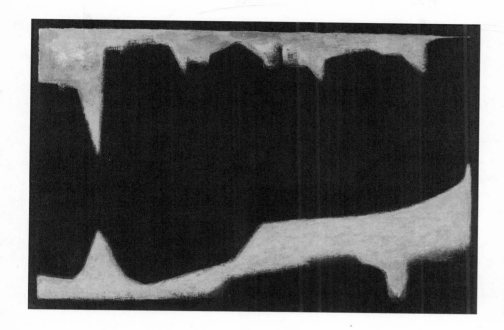

Abidin Dino, untitled, undated. Oil on canvas, 25 x 40 cm. Courtesy of the Jordan National Gallery of Fine Arts, Amman.

The most outstanding member of the D-Group was Nurullah Berk (1906–1982). He was instrumental in modernizing Turkish painting through his participation in both the D-Group and the Independent Painters Association. Berk also cofounded the Turkish branch of the International Art Critics Association. Through his books and lectures, he was able to draw the attention of European critics to Turkish art, and he organized international exhibitions for Turkish artists abroad. Nurullah Berk and the other members of the D-Group introduced Cubism, Constructivism, and Expressionism to Turkey on a large scale. Through the Independents and the D-Group, Turkish artists adopted European post-Impressionist models and became totally modernized.[10]

OFFICIAL PATRONAGE

The Ottoman sultans had always been patrons of the arts. Custom dictated that each sultan was trained in a wide range of traditional arts, from the composition of poetry and music to miniature painting, jewelry and cabinetmaking, gardening, and calligraphy. The first sultan to show an active interest in Western art was Mahmud II (1808–1839), a highly cultivated man who introduced many European innovations into his capital. During his reign, Western music, the piano, popu-

lar bands, orchestras, and theater—all based on the European model—first made their appearance in Turkey. He was also the first sultan to display his portrait publicly, a custom totally alien to earlier Ottoman traditions. During the reign of his son, Sultan Abdül-mecit (1839–1861), official portraiture became more widespread and exhibitions were held in the palace. Sultan Abdülmecit was also interested in Western music. In 1847 Franz Liszt gave a recital for him, and the sultan presented Liszt with an imperial decoration. Royal patronage continued until the demise of the empire.

After the founding of the Turkish Republic, state-sponsored activities in art increased. The number of art scholarships to Europe multiplied, and government art schools and galleries opened in both Ankara and Istanbul. The development of Turkish modern art appears to have taken place in alternating phases of localization and internationalization, mainly evident in the subject matter depicted. From 1937 to 1944, the republic sponsored annual trips for artists to travel throughout Turkey and paint the Anatolian steppes, providing them with all the materials they needed. These tours lasted over eight years, included fifty-three artists, and covered sixty-three of Turkey's sixty-seven provinces. They were instrumental in mobiliz-

ing national trends by incorporating Anatolian motifs and subject matter in Turkish art throughout the ensuing decades.[11]

FROM THE 1940s onward, Turkish art has consistently moved along a dual track. In both style and subject matter, it has incorporated Western schools of art along with local trends. The only omission in Turkey's modern art is the use of calligraphy. Atatürk's "language reform" in 1928 and the substitution of the Roman alphabet for Arabic severed all ties with the linguistic and aesthetic heritage of Ottoman Turkey. Thus, the integration of calligraphy into modern art forms, as is the case in other Islamic countries, is totally absent in Turkey. Only since the 1960s have a few artists, such as Bedri Rahmi Eyüboglu, Elif Naci, Adnan Turani, Erol Akyavaş, and Burhan Doğançay, included Arabic characters in their abstract works. However, the practice of classical calligraphy has continued, though on a smaller scale than during the Ottoman period.

As the first Islamic country to experiment with the European approach to modern art, Turkey developed certain traits that are distinctive. Its artists had first-hand exposure to Western training in the nineteenth century. Many early artists studied with their European contemporaries. The first group, the soldier-painters, trained with masters such as Louis and Gustave Boulanger, Jean-Léon Gérôme, and Eugène Fromentin. During the second decade of the twentieth century, a number of artists went to France and Germany, either on scholarships or on their own. They were exposed to vibrant artistic communities and either visited or worked with the trend setters of modern Western art. Numerous Turkish painters joined the workshop of Fernand Cormon in Paris. Other young artists were able to learn from Paul Signac, who worked in Istanbul. The Germans Hans Hofmann, Louis Corinth, and Max Liebermann, and France's Marcel Bachet, Paul-Albert Laurens, André Lhôte, Fernand Léger, Marcel Gromaire, and Charles Despiau were not merely signatures on reproductions seen in books or on paintings hanging in galleries. They were teachers who distilled their techniques and ideas for young Turkish artists, who returned to their country and were instrumental in introducing Impressionism, Cubism, Constructivism, and other styles into the mainstream of contemporary Turkish art. Rarely have the artists of an Islamic society been exposed in such numbers to Western teachers of such caliber.

The first group of Turkish artists went to Europe at a time when European painters had started to reject academic teaching and embrace Impressionism. However, Turkish artists were unaffected by the revolution in Western painting. They consciously conformed to academic principles for, unlike the Europeans, the Turks had no classical tradition against which to revolt. Their classical artistic heritage in painting was the two-dimensional Islamic miniature, which bore no relationship to the academic approach they were learning from Europe. In a way, their orientation to the concepts and aesthetics of Western art was in itself a revolt against their own artistic traditions. Not until the second decade of the twentieth century and the arrival of the 1914-Generation did Turkish artists adopt Impressionism.

While it was rare for women artists to gain recognition in the Islamic world, this was very much a phenomenon in the early stages of development of modern art in Turkey. It started during the Ottoman period, when women were still behind veils. Even prior to Atatürk's revolution, which championed the cause of women's equality, women were given an opportunity in art. The trend has continued under the republic, and today Turkey has four generations of recognized women artists.

Since the nineteenth century, art associations have played a lively role in the Turkish modern art movement. From the soldier-painters to the 1914-Generation and the D-Group, every art group has, in one way or another, contributed to the growth and evolution of modern Turkish art. Every group rejected what was current at the time, rebelling against conventional norms as the innovators in modernizing Turkish art. It was thus that old trends faded and new ones began.

Ever since the golden age of the Ottoman Empire, the state, as embodied in the sultans, has sponsored all the arts. The rulers and their high officials patronized local artists and supported the introduction of Western culture into Turkey. In the nineteenth century, the

palace was instrumental in shifting local artistic trends toward a European aesthetic. This kind of sponsorship continued under the constitutional monarchy. At the founding of the Turkish Republic, Atatürk declared that his greatest ambition was to elevate national culture by emphasizing the development of all the arts. The government launched an intensive program to increase the number of art scholarships abroad, open art museums and institutes, direct artists toward nationalistic subjects, and help them materially. In fact, the state utilized art and culture to arouse and strengthen nationalist sentiments among the population, thereby helping to accelerate the development of contemporary Turkish art.

Although Turkish modern art had a rather late beginning compared with European art, yet it has caught up with the latest postmodern artistic schools in the West in a relatively short span of time. Through experiment, debate, group support, and exposure to international art, Turkish artists have moved to the forefront in their creative concepts and their work.

2 EGYPT

EGYPT WAS THE first Arab country where Western art was formally embraced, in the form of a Cairo school founded in 1908. It educated the country's pioneers in modern art. Egypt had been abruptly exposed to Western civilization a little more than a hundred years earlier, when Napoleon Bonaparte's armies invaded Egypt in 1798, bringing with them the influence of European aesthetics.

Cultural exchange was a two-way street. Egypt's ancient history captivated the 150 savants who accompanied Napoleon's Egyptian campaign, including historians and painters such as Rigoult, as well as geologists, botanists, geographers, archaeologists, and writers, some of them members of the Académie Française. When the military campaign ended, a number of French scientists and artists stayed on to study and record the monuments and to paint native scenes. They adopted local dress and integrated themselves into society, and some were responsible for introducing Western painting into Egypt.

THE WESTERNIZATION PROCESS

After the French withdrawal, Muhammad Ali Pasha gained power as effective ruler of Egypt. He became *wālī* in 1805 and soon made clear that he intended to build Egypt into a modern country. He displayed interest in the arts as well as sciences and military skills, and he sent several missions to Europe to learn the arts of engraving, painting, and sculpture, among other subjects. Those travelers taught at technical craft schools once they returned.

The palaces and public parks built during Muhammad Ali's reign were designed and decorated by foreign architects and artists, who filled them with statues and paintings. In this manner, a taste for the baroque and rococo was introduced into Ottoman Egypt. Meanwhile, a number of foreign artists visited Egypt, among them the Orientalists David Roberts, Eugène Fromentin, Théodore Frère, Adrien Dauzats, John Varley, Émile LecomteVernet, Marc-Gabriel-Charles Gleyre, and William Holman Hunt. Others, such as John Frederick Lewis, Jean-Léon Gérôme, and Leopold Karl Müller, settled in Cairo for months, sometimes years.

Under the Khedive Isma'il (1862–1879), Egypt became virtually independent of the Ottoman Empire. The attempt to establish modern institutions, initiated by Muhammad Ali, continued. The opening of the Suez Canal in 1869 was an occasion that accelerated exposure to Western culture. Isma'il used the opportunity to present his country as part of the "civilized" European world rather than "backward" Africa. The khedive invited the Emperor of Austria; Empress Eugénie of France; the Crown Prince of Prussia; writers and artists such as Théophile Gautier, Émile Zola, Henrik Ibsen, and Eugène Fromentin, as well as a number of famous scientists and musicians, to the opening ceremony. Cairo's Opera House was inaugurated with a cantata in honor of Isma'il and a performance of Verdi's *Rigoletto*.

Eventually, Western artistic influences came to pervade Egyptian upper-class society. Alfred Jacquemart made statues of Muhammad Ali and Sulayman Basha that were erected in Cairo. He also created sculptures of four lions that were mounted two at each end of the Qasr al-Nil Bridge. Cordier designed a statue of Ibrahim Basha to be placed in the Opera Square. Similar public sculptures were unveiled in Alexandria. Until the beginning of the twentieth century, the rendering of such public sculptures was confined to European artists. They were commissioned by the rulers, princes, and elite as a manifestation of their desire to emulate the West in decorating their urban and rural palaces with paintings and architectural ornamentation. They imported craftsmen from Greece, Armenia, and France to train local decorators in trompe l'oeil.

The Islamic trend in Egyptian art was thus replaced by the latest European currents. A community of resident French artists settled on Kharanfash street, which became a diminutive Montparnasse. Yet, despite their numbers, European artists were popular among only a minority of upper-class Egyptians. The majority of the people remained indifferent to their work.

In 1891 the Orientalist painters living in Egypt held an exhibit at the Opera House—Egypt's first. It was attended by the khedive and a number of dignitaries, who followed his example and bought works to please him rather than out of pure appreciation.

Among the exhibiting artists were Ralli, Rasengy, Bogdanof, and an Egyptian painter named Ya'qub Sanu', who gave painting lessons to the children of the wealthy. Following their success, the French painters made improvements on their street and changed its name to Art Street (*Shāri' al-fann*). They began organizing European concerts for affluent Egyptians in the courtyard of one of the houses on Art Street. In 1902 a second exhibition, *Cercle Artistique,* took place in an antique shop. It included the works of Bebi Martin and Bonello and was inaugurated by the khedive, who suggested that the unsold works be auctioned off. Thus, the first art auction took place in Cairo almost accidentally.

By the beginning of the twentieth century, the modern concept of nationalism was embraced by a number of intellectuals led by Mustafa Kamil Basha, the founder of the Egyptian National Party. They advocated independence through peaceful means by educating and mobilizing masses of people in progressive action programs. One of the intellectuals in this group was Prince Yusuf Kamal, an enthusiastic patron of the arts who took upon himself his people's "education of taste." The idea of an art school was contemplated alongside that of a university. The British opposed the establishment of a university at first, while some popular and religious factions considered an art school to be antithetical to the principles of Islam.

The latter debate was settled when the mufti of Egypt, Sheikh Muhammad 'Abdu, a great reformer and an enlightened Islamic scholar, came out in favor of art education and the restoration and preservation of antiquities. In 1908 Prince Yusuf Kamal opened the School of Fine Arts in Cairo. It was the first institution in the Arab world to teach Western art. For twenty years, the privately owned school provided free tuition and training for talented Egyptian youth, requiring no prerequisite other than the wish to study art. Because of the lack of Egyptian artists accomplished in Western styles, the school employed foreigners to teach painting, decoration, and sculpture.

The school proved to be an immediate success, and students from Cairo as well as the countryside enrolled in it. Its first art students comprised the nucleus

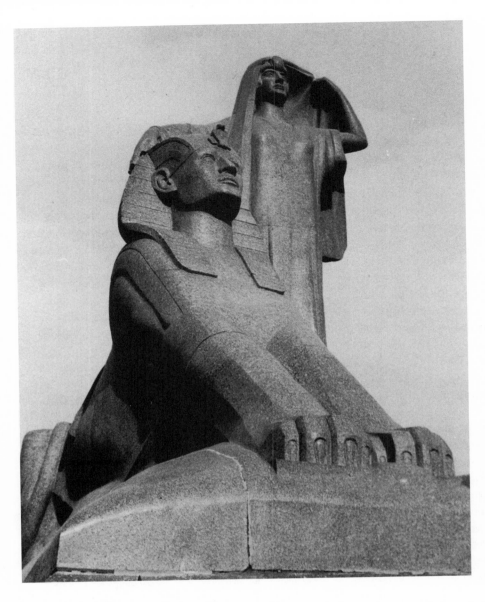

Mahmoud Mukhtar,
Egyptian Awakening, 1919–
28. Pink granite, Cairo
University Gate, Cairo.

of the pioneer generation of modern Egyptian artists. They were Mahmoud Mukhtar, Muhammad Nagy, Mahmoud Said, Raghib Ayyad, and Habib Gorgi.[1]

THE PIONEERS

The group of pioneer Egyptian artists laid down the basic concepts of their country's modern art movement. They tried to combine their ancient artistic traditions with contemporary techniques and teachings, reshaping them within a distinct Egyptian individuality that emerged out of the country's pharaonic-Mediterranean past. No artist considered reverting to Egypt's Arab-Islamic traditions at that time. Although popular in the Levant, pan-Arabism was alien to Egyptians during the first two decades of the twentieth century, while Islamic culture was regarded as

only a phase in their historic development. The first graduates of the School of Fine Arts expressed a nationalistic trait based on Egypt's pharaonic past, which reflected the general atmosphere of the time.

The Egyptian Mahmoud Mukhtar (1891–1934) was the first artist to go abroad to study; his benefactor, Prince Yusuf Kamal, sent the peasant boy to the École des Beaux Arts in Paris to continue his art training. Mukhtar came to be considered the father of modern Arab sculpture, interpreting his people's struggle against foreign domination and exalting Egypt's national heroes. Mukhtar's forms took up what was later referred to as the neopharaonic style. He used ancient hieroglyphic symbolism and borrowed a classical structural style for his figures, always keeping a thematic quality in the work.

By drawing on pharaonic stylization and adapting Western techniques and training to his cultural artistic heritage, Mukhtar gave Egyptian art a new identity, a look of nationalism without xenophobia. He was the first Egyptian artist to exhibit his works abroad and to win an international award. Mukhtar was important in Egypt's modern art movement, for both sculptors and painters, as the first artist to exemplify a national artistic identity.

In painting, Mahmoud Said (1897–1964), a lawyer by profession, was the first to draw on local subjects by depicting genre scenes and portraits of both simple folk and society figures, in an individual, lush, and sensual style. Raghib Ayyad (1892–1982) revealed a freedom from the academic style and was one of Egypt's first painters to draw on his pharaonic cultural background. He painted peasants with their animals, market scenes,

and popular celebrations in an expressionistic, symbolic manner. For a long period, he specialized in depicting Coptic church icons and paintings. Ahmad Sabri's (1889–1955) sensitive, Impressionistic portraits of Egyptian personalities and landscapes formed the nucleus of Impressionism in his country.

Other pioneer artists of the Egyptian modern art movement were Youssef Kamel, Seif Wanli, Ramsis Younan, Hussein Bikar, Muhammad Hassan, Hussein Fawzi, Sabri Ragheb, Marghuerite Nakhla, Abdel Kader Rizk, and Salah Taher. Most of them graduated from Cairo's School of Fine Arts, and some continued their training in Paris and Rome, acquiring valuable firsthand exposure to post-Impressionist styles in Europe. Most of the works of this generation were thematic and depicted local customs and landscapes from the Egyptian countryside. However, the artists

Raghib Ayyad, *In the Field*, 1960. Oil on canvas, 60 x 70 cm. Courtesy of the Jordan National Gallery of Fine Arts, Amman.

recorded what they saw according to well-known European styles. Their local subject matter was their sole expression of artistic identity.[2]

FOREIGN ARTISTS LIVING IN EGYPT

For the first half of the twentieth century, Egypt's Greek and Italian communities lived mainly in Alexandria. Apart from the Orientalist painters of the nineteenth century, many artists from these communities were instrumental in training local talent and introducing Western art into the country. Among these artists were the Greeks Constantin Zoghrafos, Litsas, and Madame Kravia, and the Italians Arturo Zanieri, Cevilini, Gelvani, Giacomo Scaliti, Aturino Bechi, Angelo Polo, Enrico Brandani, Antonio Zanin, and Emelia Casanato. All gave lessons in their own studios and played the role of an art institute in the education of Alexandrian artists.

It should be stressed that Alexandria's art movement developed independently from that of Cairo. Under the tutelage of the foreign resident artists, pioneers like Mahmoud Said, Seif and Adham Wanli, Muhammad Nagy, and Kamil Moustafa were able to flourish and contribute to their country's artistic development.[3]

WOMEN ARTISTS

Unlike other Arab countries, Egypt produced a number of early women artists who began painting even before the School of Fine Arts was established. Among this group were the sculptor Princess Samiha Husayn, the daughter of Sultan Husayn Kamil (1914–17) (he ruled after Khedive Abbas Hilmi and before King Ahmad Fuad); the famous women's rights activist Huda Sha'rawi; Sharifa Riyadh, the wife of the art patron Wissa Wassef; Mrs. Hussein Sirri; Mrs. Mahmud Sirri; and Nafisa Ahmad 'Abdin. When drawing and painting lessons were introduced into the curricula by the Ministry of Education, girls' schools were included. The art teachers and inspectors were all British, and art lessons consisted of copying and enlarging pictures.

Inji Iflatoun, *Farmers' Roofs,* 1984. Oil on canvas, 60 x 75 cm. Courtesy of the Jordan National Gallery of Fine Arts, Amman.

'Afifa Tawfiq was the first female student to be sent on an art scholarship when she went to England in 1924. In 1925 Zainab 'Abdu, Iskandara Gabriel, and 'Ismat Kamal followed her on scholarships in chemistry, biology, and physical fitness. At the end of their first year, their scholarships were changed to painting. They returned to Egypt after four years to work as art instructors at girls' schools. Following in their footsteps, Alice Tadros, 'Adalat Sidki, In'am Sa'id, and Kawkab Yusuf went to England to study art. Upon their return, they introduced modern teaching methods that used psychology in art education.[4]

Egypt has since bred a number of prominent women artists, including Marghuerite Nakhla, Effat Nagui, Nazli Madkour, Gazbia Sirri, Inji Iflatoun, I'tidal Hassan, Minhatallah Hilmi, and Rabab Nimr, among others.

THE TEACHING OF ART

Egypt was the first Arab country to formalize art education by establishing state-run institutes and schools for both applied and fine arts. Opened by the government in 1835, the School of Arts and Decoration was the first to train craftsmen formally in Islamic design, decorative metalwork, textiles, woodcarving, and carpentry. It later became the College of Applied Arts, which graduated a number of pioneer designers and artists, such as Said Sadr (1908–1985), Ahmed Osman (1907–1965), Mansour Faraj (b. 1907), and Abdul Aziz Fahim (b. 1908).

In 1899 the Khedive Teachers' Training School was founded; it was later renamed the Sultaniyya Teachers' School and finally denominated the Higher Institute for Teachers. Some of its graduates—Hussein Youssef Amin (b. 1906), Hamid Said (b. 1892), and Shafik Rizk (b. 1908), for example—were among the leaders of the modern art movement and helped form several artistic groups.

The forerunner of the College of Applied Arts was founded in 1868 as a training institute for skilled workers such as mechanics and electricians. When the division of Arts and Decorative Industries was added in 1909, it had three sections: textiles, weaving, and dyeing; carving, engraving, and carpentry; and decorative metalwork. In 1918–19 the Department of Deco-

rative Industries became an independent school under the directorship of an Englishman, William Stuart. In 1928–29 it became the School of Applied Arts and launched new divisions in stained glass, ceramics, photography, and wrought iron (others were added later). Its first Egyptian director was appointed in 1934.

In 1941 the institution became the Higher School of Applied Arts, then in 1950 the Royal School of Applied Arts, and in 1953 it was elevated to College of Applied Arts. In 1957 it became a coeducational institution. In 1968–69 the college began accepting postgraduate students for M.A. and Ph.D. degrees. When Hulwan University was created in 1975, the College of Applied Arts became part of it.

The Leonardo da Vinci School of Arts was founded by the Italian Society of Dante Alighieri in 1898 to train assistants for architects. It later expanded into a department for painting and decoration. At its inception, most of the students were foreigners, though the ratio of Egyptians eventually increased to 90 percent. The majority of the students who enrolled at the Leonardo da Vinci School had been rejected by the College of Fine Arts for one reason or another. A number of students from Egypt and the Arab world who later became established artists were among the rejected group. In 1976 the cultural agreement between Italy and Egypt was terminated and the school closed down.

When Prince Yusuf Kamal inaugurated the School of Fine Arts in 1908, its instructors were all foreigners. Guillaume Laplagne was its director and sculpture teacher; Fourschella, Juan Antes, and Bonot taught painting; Colonne taught decoration; and Peron was the architecture teacher. Under their tutelage, young Egyptians were instructed in the principles and application of Western art. In 1909 the prince created a trust fund for a new building and scholarships for outstanding students to study abroad.

The first exhibition of Egyptian artists took place in 1911 at the School of Fine Arts. It displayed the architectural designs, paintings, and sculptures of students at the school. Among the exhibiting artists were Youssef Kamel, Raghib Ayyad, and Ali Hassan. By 1928 all its faculty members were local artists. In 1941 the insti-

tution became the Higher School of Fine Arts and in 1950 the Royal College of Fine Arts. In 1952, the year of Egypt's Revolution, it was renamed the College of Fine Arts. In 1961 it became the responsibility of the Ministry of Education and was incorporated into Hulwan University in 1975.

The Atelier of Fine Arts was created by the Ministry of Education in 1941 for the outstanding graduates of the Higher School of Fine Arts. The school nominated exceptional students to join the atelier for two years, receiving a monthly stipend of 12 Egyptian pounds to continue with their research in art unrestricted. At the end of the two-year period, each student would present academic papers and artwork, which would be displayed in a special exhibition. In winter the artists worked in a studio in Luxor, amid the pharaonic monuments; in summer they returned to a studio situated in an Islamic house in the heart of old Cairo. The atelier was Egypt's first attempt at creating postgraduate studies in art. Unfortunately, the government did not raise the monthly stipend, and by 1967 only one student was left at the atelier. It had to close down soon thereafter.

The art program at government schools was unbalanced at first. It concentrated on the elements of drawing rather than providing students with a well-rounded art education. However, a few dedicated teachers introduced basic pedagogical theories into their classes. As the number of trained artists appointed as teachers in the Ministry of Education increased, the standard of the art classes improved. The Ministry of Education began to hold annual exhibitions for students in Cairo and the various *muhafadat* (governorates) throughout the country. The most important exhibition, held in the capital on the anniversary of the 1952 Revolution, incorporates students from all over Egypt.

The Higher Institute of Fine Arts for Female Teachers was the first art academy for young women. It was established by the government in 1939 under the directorship of the painter Zainab 'Abdu (b. 1906). In 1947 it became the coeducational Higher Institute for Art Teachers, and in 1970 the College of Art Education. In the early 1950s, Hamid Said established the

School for Artistic Studies. He persuaded young art graduates, who were interested in studying nature and analytically recording monuments and other subjects, to teach at his college.

In 1957 a new, full-fledged College of Fine Arts, with departments in painting, sculpture, decoration, graphics, and architecture, was established in Alexandria. Its dean, the sculptor Ahmed Osman, employed many prominent local artists, such as Seif and Adham Wanli and Hamid Nada, as faculty members. In the 1980s, the government founded new art training institutions in areas outside Cairo and Alexandria, and in 1982 the Ministry of Higher Education established an art college in Minia, a provincial city south of the capital.

The first student to be sent abroad on scholarship was Mahmoud Mukhtar in 1911, as noted; he attended the École des Beaux Arts in Paris. In 1912 the painter Ali Ahwani traveled to Paris on his own, while Youssef Kamel and Raghib Ayyad made their way to Rome. The Egyptian government has been regularly sending artists to train at Western academies since 1917. Many were sent to study at art institutions in the former Eastern Bloc as well as the West, following the 1952 Revolution. Upon their return, the graduates were absorbed as teachers into Egypt's various art colleges and institutes.[5]

ART SOCIETIES

Art societies have played a crucial role in the advancement of Egyptian modern art. The Society of Fine Arts was the first art association established in Egypt (1918). Mahmoud Mukhtar, Raghib Ayyad, Youssef Kamel, Mahmoud Said, Ahmad Sabri, and Muhammad Nagy were some of its members, as were a few resident foreign artists. They held an exhibition of works by native and foreign artists in 1919. A year later, their second and last exhibition included five Egyptian women artists among the fifty-five participants.

In 1920 Fuad Abdul Malik, an important and active patron, created the House of Arts and Crafts in Cairo to promote the fine arts. Its secretary was Raghib Ay-

yad. It held its first exhibition in 1922 under the title *Salon du Caire,* in which twenty-seven local and fifteen foreign artists participated. The Salon du Caire has since become a yearly event.

In 1923 Abdul Malik founded the Society of Art Lovers with the express goal of promoting painting, sculpture, drawing, architecture, and crafts. This group also sought to cultivate, through lectures and exhibitions, artistic taste among the public. Prince Yusuf Kamal presided over its body of more than twenty Egyptian and foreign art patrons, as well as a committee of women artists, headed by the painter-sculptor Princess Samiha Husayn. In 1923 the Society of Art Lovers held the second Salon du Caire, which included ninety-three painters and sculptors. In 1925 the government allocated an annual budget to buy works of art as well as a yearly subsidy for the society.

In 1927 the Society of Art Lovers rented a mansion for its annual exhibitions, which by then had become the most important artistic event in Egypt. By 1938 a total of 122 local artists participated in the salon, while the number of foreign participants remained relatively constant. Besides holding the ongoing Salon du Caire, the Society of Art Lovers has organized countless group and one-person exhibitions of photography and applied and fine arts by local and foreign artists, as well as exhibitions of books and children's exhibitions. The society has also assisted artists in participating in international exhibitions such as *Egypt-France* at the Louvre in 1949. It has also been instrumental in raising art awareness among the public through its program of lectures, publications, scholarships, and prizes for talented artists in all fields.

In 1927 a new group was established by a number of pioneer artists from Mahmoud Mukhtar's circle. La Chimère's members included Mahmoud Said, Raghib Ayyad, and Muhammad Nagy, and it held its first exhibition in 1928. The group's aim was to break free from blindly copying nature and to be innovative in terms of individual interpretation in a work of art. When Mukhtar left to prepare for his Paris exhibition in 1930, the group members, most of whom were studying abroad, dispersed, meeting again at the Salon du Caire.

A new group consisting of graduates of the Teachers Training School was founded in 1928: the Society of Artistic Propaganda, headed by the pedagogue-painter Habib Gorgi (1892–1965). Its professed aims were to paint directly from nature, to spread art awareness among the public, and to rid the Egyptian art movement of foreign influences. One of the important accomplishments of the group was the publication of the book *Ghāyat al-rassām al-ʿaṣrī* (The aim of the modern artist) by Ramsis Younan in 1937. It contained the theoretical underpinning of the goals of the Society of Artistic Propaganda.

Several of the artistic groups founded in the 1930s failed to survive for lack of funds. Among these was the Egyptian Academy of Fine Arts (1933), started by Muhammad Sidki Gabakhangi, which held the first exhibition of native Egyptian artists. Other short-lived groups included the Essaistes (1934), which published an art journal in French, *Un Effort;* the Association of Egyptian Artists (1936); the New Orientalists (1937); and the Palette Group (1940).

Egyptian artists went through a turbulent period between 1935 and 1945. They were caught between the events of World War II and internal political breakdown at home. The new avant-garde groups that were formed rejected the teachings of the Society of the Friends of Art, labeling them sterile and academic. One such group was Art for Freedom, led by George Hunein. Its foundation was a reaction against Fascist attitudes toward Western artists—such as Paul Klee, Max Ernst, and Oscar Kokoschka—and the closure of the Bauhaus School by the Nazis. Its members published a manifesto, *For a Revolutionary Independent Art,* in which the thirty-seven signatories condemned the oppressive Nazi measures taken against freedom of expression. The manifesto also emphasized the necessity of individual creativity as a great revolutionary force. Among the artists who participated in the *Art and Freedom* exhibition of 1940 were Mahmoud Said and Ramsis Younan.

Through the group's exhibitions, which lasted from 1939 until 1945, new artistic trends such as Surrealism, Cubism, and abstraction were introduced into Egypt.

They were met with opposition and even sarcasm from the public. However, the members of Art for Freedom were able to emphasize the importance of individuality in artistic styles and to usher in a new period of artistic experimentation. When the group dispersed in 1947, its main figures, Ramsis Younan and Kamil Tilmissani, left Egypt, while Fouad Kamil founded a new group known as Automatic Art.

In 1944 Hussein Youssef Amin (b. 1906) founded the Group of Contemporary Art. Amin was a caring teacher who followed the progress of his students from secondary school through college. He concentrated on young people outside the cultural mainstream and encouraged them to create instinctive works, far from Eastern or Western aesthetic dictates. Amin believed that the artistic output of a nation gave it its character, provided it was executed by simple folk from modest backgrounds, who were "restricted" only by their own "backwardness." Their work could transmit a revolutionary aesthetic and carry a message with deep social undertones. When an exhibition of Amin's students opened the same year, it engendered a cultural and political reaction, both negative and positive.

Artists such as Kamil Tilmissani (1917–1970), Kamal Mallakh (1919–1986), Samir Rafii (b. 1924), Maher Raif (b. 1924), Hamid Nada (1924–1990), and Abdul Hadi Gazzar (1925–1965) were members of the Group of Contemporary Art. Like their mentor, they embarked on a search for Egyptian traditions and applied folk signs mixed with popular philosophy in order to counter Orientalist and imported Western trends. The group became the symbol of a rejectionist movement against the prevailing superficiality and shallow romanticism in art. It continued as a rejectionist movement up to the 1952 Revolution.

In 1946 a new group called Art and Life, led by Hamid Said and his students, was formed at the Teachers Training Institute. It refuted Western academic teachings as well as modern European art, and it adopted instead a philosophy based on contemplation of natural law and respect for ancient national artistic traditions. Art and Life tried to foster a collective artistic style instead of individualistic expressions, believing that ancient Egyptian art was itself a collective effort.

Art and Life held seven exhibitions in London and Egypt and took part in the 1956 Venice Biennial. It was acclaimed by the critic Herbert Read for its unity of purpose and sincerity of expression.

The Atelier Group was formed in Alexandria in 1932 by Muhammad Nagy and three foreign artists (Thorn, Sebati, and Richard). It had a branch in Cairo and held several exhibitions, including the Alexandria Salon, the Swiss and Belgian art exhibitions, and a number of one-person shows. The Atelier Group's hall has become one of the most important art venues in Alexandria.

The Revolution of 1952 produced fundamental changes in the social structure of Egypt. It put an end to the monarchy and the old affluent segment of society that had patronized art throughout the first half of the twentieth century. The new regime consisted of army officers who lacked any artistic interests. They nationalized all private enterprise and companies, limited land ownership, and confiscated the property of the rich, leaving some families destitute overnight. The budget that had been allocated by the government since 1925 to purchase works of art was cut off in 1954–55. When funds were once again resumed after the new regime realized the importance of artistic development in the country, the budget was greatly reduced.

After the Revolution, all political parties were dissolved, and a law was promulgated that allowed the authorities to arrest any gathering of more than five people. Art groups disintegrated and no others were created in the 1950s. The only group that survived was Art and Life because it refrained from sponsoring exhibitions and other activities. It was a closed society whose members worked on their own; some left to work abroad, and Art and Life stopped functioning. A law allowing the formation of associations and unions was eventually passed. It encouraged artists to regroup under the supervision of the Ministry of Culture.

A number of closed societies were founded in the 1960s but did not last long. Most of their members were young artists who wanted to establish themselves by working within groups of limited membership. Among them were the Group of Five Artists

(1962); the Group of Experimentalists, which was formed in the mid-1960s; and the Group of Art and Man. The latter two were based in Alexandria and had only three members each.

In 1981 a number of Alexandrian artists formed the Axis Group. Its aim was to work collectively while each member maintained his or her individuality of expression. Having been founded at a time when artists were working in isolation from each other because of the political situation in the country, the Axis Group was open to new members, in hopes that contact among them would breed intellectual and artistic exchange. Other art societies were the National Society of Fine Arts and the Association of Arts and Crafts. The largest and most active association of artists continues to be the Union of Egyptian Plastic Artists, which was founded in 1978. Its membership is open to all Egyptian painters and sculptors. Its most outstanding accomplishment was obtaining an income tax exemption for all the members in 1980. A similar Union of Designers of Applied Arts was formed in the same year.[6]

OFFICIAL PATRONAGE

Since the 1920s, the state has played an important role in developing the modern art movement in Egypt. In 1924 the Exhibition of Contemporary Art was opened under the patronage of King Fuad, giving the movement a fresh incentive. Muhammad Mahmoud Khalil, president of the Society of Art Lovers, started collecting works from the Salon du Caire on behalf of the Ministry of Education in 1925. Later acquisitions extended to purchases from Parisian exhibitions. In 1927–28, the Ministry of Education paid almost one thousand Egyptian pounds, an astronomical figure at the time, to acquire works of art from Egypt and abroad.

The Egyptian Parliament in the 1920s legislated to guarantee artists their freedom of expression and bestow on the arts official protection. One bill recommended special attention for the visual arts, and in 1927 Parliament passed a law approving the establishment of the Museum of Modern Art, which opened in 1931. A committee was formed to acquire a collection of paintings and sculptures by Egyptian and modern

European artists. The foreign works in the collection, mainly Impressionist and post-Impressionist, included paintings by Monet, Manet, and Rodin. In 1935 the museum published its first catalog, a volume of 224 pages.

In 1963 the museum was closed down, then demolished so that a hotel could be built on the site. Contemporary Egyptian works from the collection were temporarily removed to a private villa, while the works of Italian, French, Dutch, and English artists were housed in the Gezira Museum. Most of this artwork has since been either misplaced or lost, drastically reducing the breadth of the collection. Some works were hung in the offices of high-level officials in the Ministry of Culture, the headquarters of the Arab Socialist Union (the official ruling party at the time), and the Parliament. Most of this art disappeared without a trace.

The theft of a painting by Rubens from the Gezira Museum in 1967 finally forced the authorities to acknowledge the value of the nineteenth-century European masterpieces they owned. Gamal Abdul Nassir reacted by ordering the construction of a seven-story Palace of Arts on the grounds of Muhammad Mahmoud Khalil's museum. The Palace of Arts would house, among other facilities, several permanent exhibitions and ateliers in a proper arts complex. However, only three stories were completed by the time Abdul Nassir died in 1970; Anwar Sadat took over the project and converted it into a presidential palace.

Between 1962 and 1967, Muhammad Mahmoud Khalil's collection had been reduced from 304 international paintings and sculptures to 233 pieces. After his widow died in 1962, the Ministry of Culture had taken over his house and opened it to the public. His collection consisted of works by Rodin, Van Gogh, Toulouse-Lautrec, Sisley, Renoir, Pissaro, Monet, Manet, Ingres, Gauguin, Delacroix, Degas, Daumier, and Corot, among others. In 1971 it was transferred to the confiscated former palace of Prince 'Amr Ibrahim.

When the only work by Van Gogh, *The Poppy Flower*, was stolen in 1977, the authorities finally became aware of the importance of Khalil's collection. After the work was recovered following an intensive media campaign, the collection was insured and properly

displayed. In 1984 the authorities put the collection in the care of the National Center for the Arts. A 2.5-million-pound museum has been inaugurated at the National Center for the Arts (the new opera complex) to house the entire Egyptian contemporary collection.

Approximately thirty private and government-owned museums operate in Egypt today, mainly in Cairo and Alexandria. The Municipal Museum of Alexandria hosts the Alexandria Biennial for Mediterranean countries. The National Center for the Arts, built by the Japanese government in the capital, hosts the newly created Cairo Biennial in its modern exhibition halls, as well as foreign and local exhibitions held on regular basis. Other venues for art shows include the Nile Exhibition Hall, the largest in the country; the Arts Centers of Zamalek and Gezira; and the Muhammad Mahmoud Khalil Museum. All the governorates in Egypt maintain exhibition halls in the state-built Palaces of People's Culture, where artists residing in the vicinity have an opportunity to display their work.[7]

THE PIONEERS OF modern Egyptian art, mostly graduates of the School of Fine Arts (1908), reflected in their work the national spirit of the time. Mahmoud Mukhtar and Raghib Ayyad represented the struggle of their nation against colonialism by drawing on ancient traditions in painting and sculpture and linking them to Western art styles. The two, along with Mahmoud Said, managed to free their work from the European academic school and to pave the way for a national Egyptian school of art. The art periodicals and reviews that began to appear early in the twentieth century provided a forum for debate among intellectuals on whether Egypt was pharaonic or Arab in nature, with champions of each group relying heavily on their cultural heritage. In 1937 Kamil Tilmissani published a statement entitled *Declaration of the Post-Orientalists*, which dealt with the state of the arts in Egypt, calling for a break with the influence of foreign artists. It emphasized the need to cultivate a unique Egyptian artistic identity. This declaration coincided with the end of the British Mandate in 1936 and the demand for free elections and an independent parliament. Between 1938 and 1946, Fouad Kamel (1919–1971), Ramsis You-

nan (1909–1967), and Tilmissani departed from the then-dominant figurative trend and embraced Surrealism, a style they maintained until 1955.[8]

When the Revolution took place in 1952, Egyptian artists found themselves living in a new political reality. They expressed their newly found freedom by espousing the slogans of the Revolution, which supported the same ideals that some had been trying to propagate earlier. A new group of artists that appeared portrayed Egyptian nationalism through symbolism. They hailed their country's independence from foreign rule and the end of nepotism and a privileged aristocratic class. Egyptian peasantry, a feature of modern Egyptian art, was glorified, along with manual laborers and other segments of the working classes. Popular ceremonies, marketplaces, and folk traditions among the poor were depicted in an effort to replace European aesthetics. These works were met with official and popular appreciation, which encouraged artists in their efforts to bestow on art a local character.

However, despite the numerous attempts to develop indigenous artistic trends, ideas about reviving cultural heritage remained vague until 1958. At that time, the issue of international art and modernization had just started to spread in the artistic milieu. The path that artists would follow became clearer after 1958. The nationalization of the Suez Canal by Gamal Abdul Nassir, followed by the Tripartite Aggression against Egypt, fortified feelings of nationalism among all Egyptians. The new trend was pan-Arabism, popularized by Abdul Nassir's attempts to unite the Arabs under his leadership.

The idea of combining heritage with modernity evolved in the form of a quest for an Arab national artistic identity, free of all kinds of imported artistic influences. One group of artists turned to Egyptian rural life, in which they found a continuity of religious and folk traditions. Among them were pioneer artists such as Mahmoud Said, Raghib Ayyad, and Said Sadr. In fact, this group continued what their forerunners had begun.

A second group of artists drew on ancient Egyptian artistic traditions to assert a national artistic identity. Once more the continuity between them and the pre-

vious generations was unmistakable. A third group of artists looked to their Islamic heritage and set out to revive the aesthetics of Islamic art. The outcome was geometric abstraction inspired by arabesque designs and calligraphic art based on classical Arabic calligraphy. A parallel trend that fostered internationalism of art and followed Western styles ranging from Impressionism to Expressionism, abstraction, and Pop Art flourished until the early 1970s. The most effective artists of this kind were the Alexandria Experimental Group, headed by Seif Wanli (1906–1979), a daring and prolific artist willing to pursue the latest trends in the West.

After Egypt's defeat in the 1967 Six-Day War with Israel, the country's art suffered a time of stagnation. This lasted until 1973, when a period of intense artistic activity began with Anwar Sadat's new open-door policy. The number of exhibition halls increased throughout Egypt and foreign cultural centers were reactivated. The Cairo Biennial was inaugurated in 1982, along the model of its Alexandrian sister, and the new National Center for the Arts, including an opera house, was opened.

Being the first Arab country exposed to European culture, Egypt was also the pioneer in Western aesthetics and artistic techniques, especially among the upper class and intellectuals. Consequently, it was also the first Arab country whose artists worked toward grounding their work in the local environment and creating an individual art style.

3 LEBANON

BY THE BEGINNING of the seventeenth century, Mīr Fakhr-al-dīn II, a local potentate, ruled the whole of Ottoman Lebanon, including the *sanjaqs* of Beirut, Sidon, and Tripoli, as well as Baalback, Biqaʿ, Safad, Tiberius, and Nazareth. In 1613 he visited the Medici court in Florence and was impressed by its Renaissance art and architecture. He brought back with him Italian architects and artisans to build a Venetian-style palace in Beirut. Upon his return to Lebanon, he decided to open his country to the mainstream of Western civilization by ruling according to contemporary Western methods and launching an open-door policy toward Europe. His rule marked the beginning of a new era, particularly along the Lebanese coast.

Lebanon under Ottoman rule was divided into administrative districts, of which Mount Lebanon was one. The district, which included an inaccessible range of snow-clad mountains, deep valleys, and rivers, overlooked the narrow coastal plain. This region retained a strong sense of individuality under its feudal and religious system. Early currents of Westernization penetrated the mountainous region of Lebanon at the hands of European missionaries. They opened convents and missionary schools and introduced the printing press into the region. Western painting and, to a lesser extent, sculpture were taught by these missionaries. They established the basis for a cultural, social, and political life that revolved around a religious axis and that led to an intellectual and artistic awakening.

Through the church, Gothic style became popular in eighteenth-century Lebanon, and a local Gothic school of religious painting eventually developed. It was an art of icons and simple religious scenes with a hierarchic flavor, distinguished by its realistic lines and lifelike colors. Works of art in this style filled the halls and corridors of numerous churches and convents in mountain towns and villages.

By the eighteenth century, imported art from Italy and Austria began to leave an impact on local talent. The many Orientalists who visited Beirut and the Lebanese coast during the second half of the nineteenth century included David Roberts, William Bartlett, Horace Vernet, Sir David Wilkie, Edward Lear, Carl

Haag, and Amadeo Preziosi. They recorded land-scapes, ruins, and monuments in minute detail and were fascinated by the local customs, especially people in national costumes participating in popular celebrations. As a result of this influx of Orientalist artists, a new school of art began in Beirut.

Lebanon had experienced a period of prosperity since the seventeenth century under an affluent merchant class that patronized the arts. The ports of Lebanon, Tripoli, Beirut, Tyre, and Sidon also became the gates to Syria and Palestine. For the first time, not only pilgrims but tourists started coming to the Levant in such numbers that they prompted the opening of the first hotel in the Middle East, Grand Hotel Bassoul, in Beirut. Trade with Europe continued to flourish, ushering in economic prosperity. By the early nineteenth century, many schools had been opened in the mountains and along the coastline by Catholic, Protestant, and Greek Orthodox missionaries from Europe and the United States. Among them was the first girls' school, founded in Beirut by the wife of an American missionary in 1834. During the same year the Americans established a printing press in Beirut; the Jesuits founded another in 1846.

The seeds for two institutions of higher education were sown by the Americans and the French. The Syrian Protestant College, later known as the American University of Beirut, opened in 1866. Jesuits who moved their seminary to Beirut in 1875 founded the University of St. Joseph. Secular education was simultaneously introduced into the region and began to compete with the old monastic system.[1]

THE DEVELOPMENT OF PAINTING

The earliest reference to painting in the Lebanese mountain region dates back to 1587. Built by Father Antone Gemayel, the Church of Mar 'Abda in Bekfayya contained murals by Ilias al-Hasrouni, a demonstration of the early impulse in Lebanon in iconographic mural painting. A later painting, credited to al-Shammas 'Abd Allah al-Zakher (1684–1748) of the Shuwairi order, is a self-portrait in Gothic style. Except for this scanty information on these two artists, no particulars have reached us on the art movement in

Lebanon during the sixteenth through the eighteenth centuries, presumably because very little was being done, and that was mainly confined to church circles.

The earliest Lebanese painters whose works are known date from the first half of the nineteenth century. The oldest of this group was Moussa Dib (d. 1826), who in 1777 became head of the Convent of Our Lady of the Fields (Deir Sayīdat al-Ḥaqla), succeeding his uncle Butros Dib. In 1816 internal clerical intrigue caused him to be dismissed from his post, which he recovered two years later and at which he remained until his death. Most of his work, found in churches and convents, consists of portraits of church patriarchs and religious scenes.

Kenaan Dib (d. 1873) was a nephew and pupil of Moussa Dib. Though he trained with his uncle, he was influenced most by the Italian artist Constantin Giusti, who came to Beirut with the Jesuits in 1831. Throughout his life, Giusti remained closely connected with the Jesuit order in Lebanon, Syria, and Palestine. Like his uncle, Kenaan was a prolific religious painter, whose works still decorate numerous churches, convents, and monasteries in Lebanon. Otherwise little is known about him. Youssef Estephan (ca. 1800), who may have been an artist, layman, or priest, is known only through his work at the convent of Mar Youhanna Hrach. Apart from this scattered information, little documentation exists for artists living in the first half of the nineteenth century. It is obvious that the earliest Lebanese painters were Christian artists. The aesthetic environment was confined to church circles, where the depiction of religious themes and portraits of the clergy constituted the main repertoire.[2]

THE MARINE SCHOOL

As subjects of the Ottoman Empire, a number of Arab and Lebanese youth went to Istanbul in the second half of the nineteenth century to pursue their studies in Turkish academies. Those who joined the military and naval academies adhered to the trends prevalent among Turkish soldier-painters, which influenced the Lebanese Marine School of painting. The influence was evident in the depiction of historical events and

Kenaan Dib, *Saint John and the Dragon*, ca. 1859. Oil on canvas, 111 x 77 cm. Mar Yacoub al-Muqatta'a Church, Dlibta, Lebanon.

sea battles in an exact and descriptive manner that crowded as many figures as possible into the compositions, thereby emphasizing the historical importance of the event represented. The inclusion of human figures in the landscape occurred in Lebanon earlier than in Turkey because of the former's religious pictorial tradition. The Marine School was distinguished by its scenes of the Lebanese coast with its beautiful setting, luminous atmosphere, and ships.

Ibrahim Sarabiyye, celebrated for his masterpiece commemorating the arrival of Emperor Wilhelm II of Germany in Beirut, was one of the well-known soldier-painters. Another was Ali Jamal al-Beiruti, a graduate naval officer of the War School in Istanbul, where he settled and taught painting in government schools. Others included Hassan Tannir; a young man

from the Dimashqya family whose first name is unknown; Muhammad Said Mire'i, who later emigrated to the United States; Najib Bekh'azi, who emigrated to Russia; Mirlay Ibrahim al-Najjar, a medical doctor with the Ottoman army and the most outstanding figure in this group; Najib Fayyad; and Salim Haddad, who later settled in Egypt where he became well established. Another early pioneer was Ibrahim Yaziji (1847–?), known for his improvements on the typography of the Arabic press. His importance for the arts lies in the exact drawings he made of his friends and relatives, in both color and charcoal, of which some were rescued and kept at the National Library in Beirut.

During this period, many families descended from the mountains to Beirut, seeking refuge from the conflicts raging between Druzes and Maronites that had started in 1843. This demographic shift benefited American missionaries, schools, institutes, and universities, especially those founded after 1834, which were desperately short of teachers with an excellent command of the Arabic language and its literature. Unfortunately, most works by artists of the second half of the nineteenth century have been lost. Those remaining indicate that these early pioneers were mostly amateurs, lacking academic training and technical skill. Only through raw talent, a keen sense of observation, and relentless dedication were they able to pursue a career in art. Rai'if Shdoudi, the only exception, followed the principles of art during his rather short career.[3]

PHOTOGRAPHY

By the mid-nineteenth century, photography had been introduced to Lebanon and even competed with topographical painting. One of the most famous photographic families in the Middle East was French: Felix Bonfils, his wife, Lydia, and their son, Adrien, who settled in Beirut in 1877. They were indefatigable photographers whose numerous pictures of Lebanon, Syria, Palestine, and Egypt provide a wealth of topographical, ethnic, religious, social, and incidental records of the area. Two Lebanese photographers—Sarrafian and Saboungi—also established themselves in Beirut. In the mountains, the Maronite Bishop Em-

manuel Phares el-Ferkh used his own photographs on fund-raising tours. Photography profoundly influenced the world of painting, and a photographic way of seeing the world began to appear in the works of Lebanese painters by the turn of the century. This influence is noticeable in the paintings of Daoud Corm, Khalil Saleeby, and others, be it in portraits or landscapes.[4]

THE FIRST GENERATION OF LEBANESE ARTISTS

The end of the nineteenth century ushered in an important era for Lebanese culture. Beirut was already an established bridge between East and West. It witnessed the birth of theater, a public library, commercial printing, and local newspapers, including an art journal. Furthermore, the establishment of universities brought an increase of Western influences to the cultural and artistic life of the city. The early pioneers of Lebanese modern art worked at the end of the nineteenth and the beginning of the twentieth centuries. Most of them traveled to European cities—Brussels, Rome, London, and Paris—to train in art and to gain

Daoud Corm, *Self-portrait,* ca. 1890. Oil on canvas, 55 x 40 cm. Private collection.

first-hand knowledge of classical and contemporary Western trends by visiting museums and the studios of individual artists. Daoud Corm, Habib Srour, Ni'matallah Maadi, Philippe Mourani, and Khalil Saleeby were among these artists.

Daoud Corm (1852–1930), who was known as a religious painter, freed Lebanese art of its previous narrow, amateurish tradition and led it to the wide perspectives of the great European classical masters, thus marking an important step in the history of modern art in Lebanon. Habib Srour (1860–1938) was a skilled pedagogue who trained many artists of the following generation. His realistic landscapes and still lifes, done in the Renaissance style, show an accomplished technique in the depiction of forms and use of color. In 1920, Khalil Saleeby (1870–1928) launched his own studio in Beirut, where many aspiring young artists were trained, including César Gemayel and Omar Onsi. Saleeby is considered to be the father of the Lebanese artistic renaissance. He was the only Lebanese painter of his time to rebel against popular genre and religious painting and fall under the influence of the Impressionists.

By contrast, most Lebanese artists, like their counterparts in Turkey at the end of the nineteenth century, were not affected by Impressionism, so popular in France. In spite of their training in Rome and Paris and their exposure to Western art, they continued to maintain an academic style in their own work and instructed their pupils accordingly. Again, not unlike Turkey, the absence of a strong and widespread Western painting tradition in Lebanon left artists without a basis for rejection or rebellion. Academic teaching in itself was new to them. Furthermore, art was mainly confined to places of worship and the limited circles of the ruling class, which gave artists a restricted public to satisfy.

SECOND GENERATION OF ARTISTS

Without a transitional period, a second generation of modern artists appeared in Lebanon at the turn of the century. They were Yousef Hoyeck, Youssef Ghassoub, and Khalil Gibran. Although these three artists were raised under various influences of Western art, they never suffered the loss of identity that was common

Habib Srour, *Bedouin Girl,* ca. 1900.
Oil on canvas, 41 x 31 cm. Collec-
tion of Ms. Nadia Klat.

among their contemporaries in other Arab countries. They managed to free themselves of the local genre of religious art and took advantage of the preceding generation's experience and Western training.

Youssef Hoyeck (1883–1962) spent twenty years learning drawing and sculpture in Rome and Paris, where he trained under Henri Bourdelle and shared a studio with Gibran. He was influenced by Renaissance sculpture and Rodin's tormented figures. In 1932 he returned to Beirut and devoted himself to sculpting and teaching. Hoyeck, considered the father of modern sculpture in Lebanon, was instrumental in training most artists of the following two generations. Gibran Khalil Gibran (1883–1931) is best known for his literary contributions in Arabic and English. A symbiotic relationship between Gibran's writing and paintings manifested itself through a highly personalized mystical symbolism, independent of current art trends. Gibran trained and worked in Paris and Boston and spent most of his life outside Lebanon; therefore his contribution to Lebanese modern painting was minimal.

Unlike his colleagues whose initial training in art was in the West, Youssef Ghassoub (1898–1967) first trained with the father of Arab sculpture, the Egyptian Mahmoud Mukhtar. He eventually went to Paris and Rome to sharpen his technique. He left a wealth of sculptures executed in a naturalistic style throughout Palestine, Syria, and Lebanon.[5]

THE PIONEERS OF MODERN ART

With the end of World War I, Ottoman rule over Lebanon ended. In 1919, the French Mandate was estab-

lished over the country, and in 1924 the mandate authorities made French and Arabic the official languages of Lebanon. In the same year, coeducation was officially introduced at the American University of Beirut.

During this period, a most important generation of Lebanese artists appeared. Its leaders were Moustapha Farroukh, César Gemayel, Omar Onsi, Saliba Douaihy, and Rachid Wehbi. They laid the foundation for modern art in Lebanon, and their impact continues until the present day. The work of these five pioneers manifested a spirit of freedom and originality, in both style and mode of expression, which had not materialized in the works of the two previous generations. From the very outset, their foundations were laid for them by their teachers, Corm, Srour, and Saleeby, who helped them gain self-confidence and establish their artistic roots within the intimate atmosphere of their own national culture. This saved them the agitation and commotion that Western artists were experiencing after the trauma of World War I.

Unlike their predecessors, who had trained in the West, the initial art training of the modern pioneers took place in Lebanon. Moustapha Farroukh (1902–

1957), Saliba Douaihy (b. 1912), and Rachid Wehbi (b. 1917) started their art lessons with Habib Srour, while Omar Onsi (1901–1969) and César Gemayel (1898–1958) trained with Khaleel Saleeby. Eventually, they all went to Rome and Paris. By then, religious subjects in the West had been replaced by genre paintings of national events and heroes. They were able to experience the new trends in art—Cubism, Dadaism, Fauvism—that were emerging in postwar Europe. Upon their return to Lebanon, they became instrumental in awakening a feeling of national pride in the recent history of their country and they translated the natural beauty of Lebanon from every angle. A wealth of carefully recorded documentation appeared in their detailed works of the coastline and mountain landscapes, which included architecture, nature, and people in their national costumes, practicing their local customs. The only one of the five artists to later develop his work into abstraction was Douaihy. Even so, he started with an indigenous form such as the *shalwār*, the local trousers worn by mountain people, and turned it into an abstract motif.

This group of artists found that art was a luxury enjoyed behind the doors of churches and palaces,

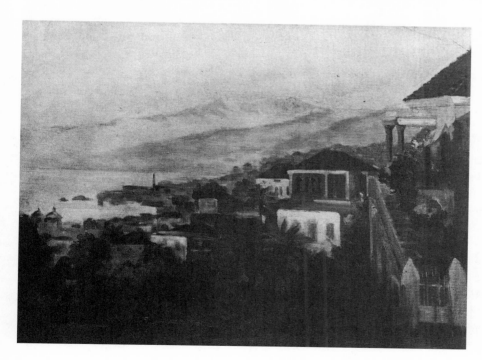

Moustapha Farroukh, *View of Beirut*, 1929. Oil on canvas, 49 x 67 cm. Collection of Mr. Camille Aboussouan.

Omar Onsi, *Landscape,* undated. Watercolor on paper, 34 x 50 cm. Collection of Princess Ghida Talal, Amman.

which only the clergy and the wealthy could afford. They came from modest backgrounds, and art was alien to their families. Faroukh's father was an illiterate man who repaired copper utensils, Wehbi's father was a poor schoolteacher, and Gemayel had to work on the construction of mountain roads to earn a living. Through the art classes they taught at schools such as La Sagesse (*al-Hikma*) and Maqasid (the first schools opened in Beirut by Islamic societies), they were able to transmit to their students both the training they had received at the studios of their predecessors and the new Western techniques and skills they had gained at European academies. Before their departure to the West, their training at the hands of the previous generation was instrumental in safeguarding their identity and maintaining their links with their culture and heritage. Simultaneously, they were able to improve their techniques and widen their horizons in the West. Through their dedication, hard work, and talent, they were able to inject Lebanese modern art into the contemporary mainstream and popularize it by making art classes accessible to the masses.

It was this third generation of artists that succeeded in laying the foundations of modern art and familiarizing the public with contemporary European modernistic trends. Through oils and watercolors, based on the Impressionist and Expressionist schools, and their choice of local subject matter, Farroukh, Douaihy, Wehbi, Onsi, and Gemayel formed a distinctive movement that might be called an early Lebanese style of art.

BEIRUT AS AN ART CENTER

In the 1930s Beirut was fast becoming a cultural and artistic center where artists and amateurs from Lebanon, France, and other countries worked. Encouraged by the French Mandate authorities, a series of exhibitions was held to stress the cultural aspects of French policy. Regardless of the ulterior motives, these exhibitions created lively artistic activities. An exhibition at the Arts and Crafts School was held in 1931, in which Rachid Wehbi and César Gemayel, just back from Paris, took part. In 1933, the French painter George Cyr settled in Beirut and profoundly influenced many

local painters, including Chafic Abboud, Elie Kanaan, Omar Onsi, and Farid Awad. In 1934 an exhibition was organized by the newspaper *La Syrie* at the Saint-George Hotel, in which Habib Srour, Philippe Mourani, Moustapha Farroukh, and Rachid Wehbi participated. In 1936 the Parliament building hosted yet another big exhibition. The Académie Libanaise des Beaux Arts opened in 1937. In 1939 Hoyeck and other Lebanese artists exhibited their works in the Lebanese Pavilion at the International World Fair in New York. In 1940 the Association of Artists, Painters, and Sculptors was founded. Thus, Beirut's reputation as an Arab, Francophile art center was established during the 1930s.[6]

ART EDUCATION

Training for early Lebanese artists had initially been acquired by joining a military school in Istanbul, and subsequently by studying under an established artist at home, or by traveling abroad (mainly to Rome and Paris), to enroll in a foreign art institution. With the exception of Gibran, few artists went to the United States for their art studies.

When Alexis Boutros founded the Académie Libanaise des Beaux Arts in Beirut in 1937, he employed French and Italian as well as Lebanese teachers, including César Gemayel. Through the academy specialization in art became accessible to those who wanted instruction within Lebanon, although many still preferred to go abroad for their training.

After World War II, the United States emerged as a popular superpower in the Arab world, and Arab youth looked up to America with its ideas of equality and democracy. American culture and art began to spread in those circles where French culture had once dominated.

In 1954 the American University of Beirut opened its Department of Fine Arts and two American artists were brought in. The most innovative contribution of this department was its art seminars, a program of public lectures and demonstrations that was open to the public. This method of teaching had a profound impact on the art scene. Most important, no artistic prerequisites were necessary to join the seminars. Furthermore, the department disproved the myth that

France alone had a monopoly on culture, thus exposing the students to more expansive artistic horizons. In 1965 the Fine Arts Institute was established at the Lebanese University; Beirut College for Women (later Lebanese American University), founded in 1926 as the American Junior College for Women, already had a Fine Arts Department. Although formal art training began relatively late in Lebanon, by the 1960s several art institutions in Beirut were providing Lebanese students with a high level of artistic education.[7]

FOURTH GENERATION OF ARTISTS

Since the beginning of the twentieth century, Lebanese society—which in fact is Beirut society—has experienced a strong pull toward all aspects of Western culture. As Lebanon gained its independence in 1944, a fourth generation of Lebanese artists began to emerge. They had not experienced deprivation and demoralization from the war, unlike their European counter-

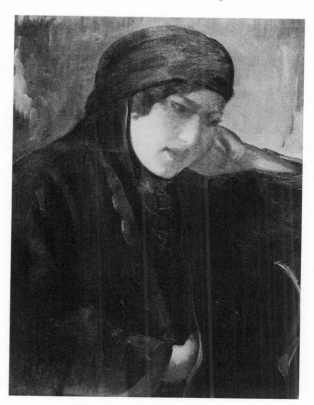

César Gemayel, *The Bedouin*, 1945. Oil on canvas, 58 x 45 cm. Museum César Gemayel.

parts. Nevertheless, because of the widespread communications between Europe and Lebanon, many artists tried to share the experience of their Western peers by following the art movements that were in vogue at the time. It was a sad experience that unfortunately met with failure. The world those artists were trying to penetrate was foreign to them: it had different problems, based on a view of reality they did not share, and for the first time they experienced a feeling of alienation between two worlds while belonging to none.

The deluge of Western culture that engulfed Beirut by the 1950s also contributed to this loss of identity. Most of the artists of the 1950s came from conservative mountain towns and villages. For decades, the only subjects taught in the mountains had been Arabic language, literature, and history, alongside religion and a smattering of science. When these young people came to Beirut, they were overwhelmed by Western philosophy, literature, science, culture, history, psychology, music, art, and theater. They encountered new social codes and values, much different from those that they had been brought up with in their sheltered mountains. This push and pull between the two cultures created in them a psychological and cultural dichotomy. Many university graduates were confronted with unemployment, causing resentment and disappointment. Some eventually took up art as an easy escape from their frustrations, but the poor quality of their work affected the general artistic standard of the country.

A number of these new artists embraced existentialism, which had become popular in France; they took in Cubism, Surrealism, or abstraction, copying the forms without knowing much about the components of these styles or their underlying philosophies. Their work inevitably reflected a superficiality devoid of meaning or message or even the basic principles of art. As a result of this cultural and psychological disorientation, some artists, such as Michel Murr (1930–1970), eventually committed suicide, although others were able to regain their self-assurance.

Not all artists of the fourth generation fall within this group. There were those who detached themselves and stayed out of their peers' turmoil, mainly due to the sound training they had received from the second and third generations of artists and at the Académie Libanaise. Study and research characterized this second group from the fourth generation of Lebanese artists, who were able to rediscover their identity and reaffirm their art by producing highly expressive and original works. Artists in Lebanon began to dig into the past for inspiration, out of a desire to confirm their artistic identity. Yet the works that they produced were free of imitation or repetition and were acclaimed both in their own country and abroad. These works were characterized by three elements: a solid technique, inspiration drawn from rich cultural sources, and arbitrary expression.

Paradoxically, the West was attracted by the East, driven by a tendency to adopt and incorporate trends from other cultures. The East with its strong light and colors, arabesque motifs, and elegant calligraphy was discovered in Europe by artists including Paul Klee and Paul Franck, and many Lebanese artists in turn, became conscious of their artistic heritage through the works of their European peers. Folk culture was the first source to which Lebanese artists such as Rafic Charaf reverted; it was followed by Arabic calligraphy. The five main artists in Lebanon who included calligraphy in their repertoire of subject matter were Wajih Nahle, Rafic Charaf, Etel Adnan, Hussein Madi, and Said Akl.[8]

BEIRUT AS AN ARAB ART CENTER

In 1954 Unesco opened its regional headquarters in Beirut, earmarking its Congress Hall for grand art exhibitions, according to the Unesco office in Amman, although Edouard Lahoud states that the first Unesco exhibition was held in 1949. In 1952 Nicholas I. Sursock, a descendant of an old Lebanese family, bequeathed his residence to the Beirut municipality and transformed it into an art museum. The Nicholas Sursock Museum for Contemporary Art has a collection of painting and sculpture by Lebanese artists, as well as a small collection of Western modern art.

The activities of the Musée Sursock included an annual salon of painting and sculpture that started in 1961, as well as international exhibitions from Lebanon and abroad. The first Baalbeck festival opened in

1955 and thereafter became a yearly international cultural event, inviting world-famous artists such as Margot Fonteyn and Rudolf Nureyev to perform with the London Ballet. During the same year Lebanese artists began to participate in the Alexandria Biennial. In 1957 a new Association of Lebanese Artists, Painters, and Sculptors was founded. In 1959, Lebanese artists exhibited their work in the Paris Biennial for the first time.

By the 1960s, Beirut had become the cultural center of the Arab world. Artists from other Arab countries flocked to the Lebanese capital, either to train, to exhibit their works, or to immerse themselves in the intellectual atmosphere of the city, with its Western undercurrents and freedom of expression (usually lacking in the artists' native countries). Lebanese artists expressed their individuality through their work regardless of popular taste. Cultural activities included exhibitions, lectures, seminars, and book launchings. A number of commercial galleries prospered. Apart from the Arabic, English, and French daily, weekly, and monthly periodicals, critics voiced their opinion through several art publications.

The art public was quite enlightened and showed considerable enthusiasm in collecting works, which led to a boom in the market and pushed artists to increase their output while maintaining high standards. They were encouraged by informed critics who were instrumental in educating the public. Even the existence of a pretentious group of Lebanese society helped the art boom with their buying power. Through exposure, many of the so-called Francophile upper class became interested in their country's artistic output. A healthy circle of dynamic interaction developed among artist, critic, the public, and the art dealer, in an atmosphere of complete intellectual freedom, without any interference either from the state or from pressure groups. The art movement in Lebanon eventually interacted with other international art movements and contributed to Arab art through audacious experiments carried out by seasoned artists.[9]

THE CIVIL WAR

The Lebanese civil war, which broke out in 1975, dealt a severe blow to one of the most flourishing modern art movements in the Arab and Islamic world. The disruption of all social, political, and moral values brought the development of the arts to a complete standstill. The artistic values that had taken artists decades to build were destroyed overnight, leaving behind an aftertaste of despair and a sense of banality. The humiliation of the Israeli invasion of South Lebanon in 1978 and of Beirut in 1982, the breakdown of the economic order, and the senseless, bloody internal sectarian and political strife created near-impossible living conditions throughout the country. The state of lawlessness gave rise to terrorism and militia rule under the creed "Might makes right"; only the fittest were able to survive.

Art patronage by the state, the affluent middle class, and the intelligentsia ceased. Cultural and artistic activity suffered. Foreign cultural centers and commercial galleries closed down. Unesco moved its headquarters to Amman, and universities held classes only sporadically, depending on the extent of the fighting and the violence.

A considerable number of recognized artists left Lebanon to live abroad, mostly in Europe and the United States. Among them were Saliba Douaihy and Chafic Abboud, who went to Paris. Those who remained behind had to choose between keeping their artistic standards and starving, or succumbing to the prevalent vulgar taste in order to sell their works and make a living.

Two trends subsequently developed on the Lebanese art scene. The first and most common was salable decorative works that copied Islamic motifs and the old naturalistic styles of Onsi, Farroukh, and Douaihy. These bland folkloric paintings, lacking any personal interpretation or innovation, almost completely replaced expressiveness and individuality in style. The second trend was carried on by individual artists, such as Amine Elbacha, Hussein Madi, Said Akl, Paul Guiragossian, and Rafic Charaf, who stayed in Beirut and continued to paint in isolation from the general public. Some drew on calligraphy and other traditional forms but presented them through a novel perspective with new aesthetics, adding modern values to their heritage. A number of artists had to travel to other capitals inside and outside the Arab world to

Paul Guiragossian, *Purity*, undated. Oil on canvas, 100 x 100 cm. Courtesy of the Jordan National Gallery of Fine Arts, Amman.

exhibit their work. On the whole, the Lebanese art movement suffered a major setback. Nevertheless, judgment should be withheld. The cruel living conditions under which artists had to survive during their country's internal strife might easily lead to creative impotence.

The Musée Sursock was one of the few institutions that maintained its activities despite the turmoil. The annual salons took place, albeit rather irregularly. Unable to carry on its activities inside Lebanon, the musée moved them abroad. In 1982 it organized an exhibition at Unesco headquarters in Paris entitled *Le Livre et le Liban*. In 1984 it took an exhibition of Lebanese architecture to Paris, and in 1986 it organized the exhibition *Romantic Lebanon* in Leighton House in London. In 1989 the British Lebanese Association held an important panoramic exhibition, *Lebanon—The artist's view: 200 years of Lebanese painting*, at the Barbican

Center in London. Only in 1991 did the Lebanese civil war come to an end. In the short period of time since, cultural and artistic life has begun to pick up.[10]

LEBANON WAS ONE of the first Arab countries to adopt Western aesthetics. Much like their early Turkish counterparts, Lebanese artists were directly exposed to European art styles through their training in European academies and at the studios of established Western artists. Unlike other Arab countries, this exposure took place outside the influence of the state. Although Lebanese art had its birth within church circles, it later developed in a purely secular milieu and made great progress toward a modern Arab art movement in an international context. Interrupted by the country's civil war, artists have resumed their activities since 1992.

4 IRAQ

MODERN WESTERN ART did not start to develop in Iraq until the end of the nineteenth century, after the bureaucratic reforms implemented by the Ottoman *wālī* Midhat Basha (1869–1872). These reforms included the founding of new cities for the settlement of Bedouin tribes; the erection of new buildings in Baghdad; the opening of the first modern school, printing press, newspaper, and hospital; and a horse-drawn railway built between Baghdad and Kadimiyya. Meanwhile, Islamic architecture and traditional crafts such as rug weaving, jewelry, metalwork, woodwork, ceramics, and tile work were still practiced by local artists and artisans.[1]

MURAL ART AND PAINTING IN THE NINETEENTH CENTURY

Mural decorations consisting of ceramic tiles and mural paintings, which were quite widespread in nineteenth-century Iraq, had a long history dating back to the Assyrians in the ninth century B.C. Ceramic tile decorations, introduced from Iran and consisting of geometric and floral arabesque designs, were used particularly in tombs and mosques. The painted murals found in coffeehouses, shops, and private homes of all social classes were an extension of Turkish wall painting (see chapter 1). They included images of birds perched on branches, ducks, and horses. Mural painters were considered craftsmen rather than artists, although generally we know little or nothing about specific individuals. 'Abbud the Jewish *Naqqāsh* (Decorator) is one of the very few known painters of the nineteenth century. The mural art form was practiced until the end of the last century and went out of fashion after photography became popular and easel painting was introduced.

Painting on glass was another pictorial art form popular in Iraq in the nineteenth century. It was probably introduced by the Ottomans, who picked it up after conquering Bohemia and the Balkan states. The subjects painted on glass were illustrations taken from folk tales and were executed in a naive style using bright primary colors.

The earliest Iraqi painter mentioned in the nineteenth century was Niazi Mawlawi Baghdadi. He was a calligrapher, painter, and decorator, of whom little is

Niazi Mawlawi Baghdadi, *Calligraphy,* undated. Ink on paper. National Archives, Baghdad.

known, although the works he left behind give an indication of his background. His refined drawings in miniature style, kept at the National Library in Baghdad, indicate Persian influences, while his use of three dimensions reveals a clearly Western aesthetic. In spite of the strict rules he followed in his calligraphic pieces, Baghdadi displayed modern graphic tendencies by utilizing the spatial and plastic qualities of Arabic letters, which might be considered one of the earliest experiments in Op Art. He was a *ṣūfī,* or Muslim mystic, of the Mawlawi order and an artist ahead of his time. His precise drawings demonstrate a great mastery of technique, and his calligraphic experiments indicate a bold vision that was achieved by other Iraqi and Arab artists only in the second half of the twentieth century.[2]

THE BEGINNING OF WESTERN ART

After the end of Ottoman rule in 1917, Iraq was controlled by the British, who had made it part of their mandate from the end of World War I until 1932. The Hashemite monarchy was established in 1921, while the country was still under British mandate. In this period, the British introduced several reforms in the country. In 1919 they opened eight secondary schools in the capital, and by 1920 there were twenty daily papers and six periodicals published in Baghdad. Subsequently, a cultural and political consciousness began to develop among the people, literature and music witnessed a revival, and traditional crafts thrived, albeit painting remained somewhat stagnant.

Easel painting in oils was begun in Iraq at the turn of the century by a group of officers who had received their training at military schools in Istanbul. They formed the nucleus for the development of Iraqi modern art. The most important figure among this group was 'Abd al-Qadir al-Rassam (1882–1952). Al-Rassam, who had trained at the Turkish military academy, painted in the same naive manner as the Turkish soldier-painters, executing numerous canvases of landscapes and military scenes and demonstrating a great sensitivity in his depiction of light and shade. He painted the first modern mural in a public building in Iraq—at the entrance of the Cinema Royal in Baghdad.

He offered painting lessons in his studio and urged young artists to continue their artistic training in Europe. Many artists who were later instrumental in the development of Iraqi modern art started their careers with al-Rassam. Later in life, he traveled in Italy, France, Germany, and England as well as other Arab countries, acquainting himself with European art movements and improving his own art education.

Contemporaries of al-Rassam were Hajj Muhammad Salim, Muhammad Saleh Zaki (1888–1974), and Assim Abdul Hafid (1886–?). Salim and Abdul Hafid were in the Ottoman army and trained at Turkish military colleges, while Zaki studied at the Academy of Fine Arts in Istanbul. Reflecting his training, Zaki's paintings had a freer and more naturalistic brush stroke than that of his peers. Abdul Hafid went to Paris on his own (1928–31) and continued his art training with Antoine Renault. He was later appointed an art teacher in government schools and wrote *durūs al-fann li'l-taṭbīq 'ala'l-ṭabī'a* (Painting lessons to apply to nature), the first art handbook to be published in Iraq. It was used in teaching secondary school students.

This group of early artists introduced Western painting into Iraq through their own works, through private lessons, and through teaching at secondary schools. However, they lived in a society in which only a few of the educated upper class appreciated the visual arts. To a certain extent they managed to free their paintings of the rigid style followed by the Ottoman soldier-painters and encouraged their students to paint from nature instead of copying from photographs, which was a common practice.

It is said that the first painting exhibition in Iraq was held in 1922, one year after the ascension of King Faisal I to the throne. Little information on this exhibition is available except in a reference concerning Gertrude Bell. In the 1920s and 1930s there was a small group of painters who considered themselves art teachers rather than artists. Among them was Abdul Karim Mahmoud (1906–1986), who was influenced by his relative Hajj Muhammad Salim and by 'Abd al-Qadir al-Rassam. Mahmoud taught Hafid Drubi, Jawad Salim, 'Issa Hannah, and Zeid Saleh, who all became established artists. Another early artist was

the painter and sculptor Muhammad Khidr, who taught Faik Hassan and who died at a young age in 1941. Unfortunately, none of Khidr's work has survived.

Hajj Suad Salim (b. 1918), the son of Hajj Muhammad Salim, was the first Iraqi cartoonist. He often published cartoons of social and political criticism in the daily papers. He also painted naturalistic landscapes in oils and watercolors. Other artists of the same period were 'Issa Hannah, 'Ata Sabri (b. 1913), and Akram Shukri (b. 1910). Shukri was the first Iraqi to receive a government scholarship to study in England. Sabri, who trained first at the Accademia di Belle Arte in Rome (1937), after World War II was sent to Goldsmith College in London, graduating in 1950. In 1932 the second group exhibition was held as part of the Industrial and Agricultural Fair in Baghdad.

During the 1930s, progress in the cultural field took off as the state encouraged art activities. In 1931 the government, at the instruction of King Faisal I, began

'Ata Sabri, *Italian Drink,* 1938. Oil on canvas, 55 x 45 cm. Courtesy of the Jordan National Gallery of Fine Arts, Amman.

allocating scholarships for art studies abroad; Ak-
ram Shukri, the first recipient, was followed by Faik
Hassan in 1933. In 1936 the Ministry of Education
founded the Music Institute under the directorship
of Sharif Muhyiddin Haidar, an accomplished musi-
cian and composer. The success of the Music Institute
prompted the government to open new departments
in drama, painting, and sculpture, and by 1941 the
Institute of Music had become the Institute of Fine
Arts.

The first group of fine arts students to graduate
from the institute totaled twelve and included Ismail
Sheikhly, Khalid Jadir, Naziha Salim, and Nizar Salim.
Faik Hassan chaired the Department of Painting and
Sculpture, which also employed 'Izra Hayya, who had
previously taught at the Académie Julian in Paris.
They were the only artists employed at the institute
until Jawad Salim returned from Paris and took over
the Department of Sculpture in 1941. Remarkably, no
foreign or other Arab instructors taught at the insti-
tute. The artists initially trained their pupils in draw-
ing, painting, and sculpture according to their own
acquired knowledge of Western rules of art and aes-
thetics. Even music classes adhered to the Western
model at the outset. It was not until 1937 that the insti-
tute began to teach Oriental music by offering 'ud les-
sons.

The preference for Western art derived from a
strong desire among Iraqi intellectuals to become ac-
quainted with all aspects of European thought and
culture, a tendency that grew stronger when World
War II broke out. Iraqis opened up to new ideas be-
cause of the increasing contact with the West, espe-
cially England, which had the largest presence in
the country. These ideas appeared advanced and un-
usual in comparison with the Ottoman thought under
which they were raised.

By the 1940s, fine art had become part of intellec-
tual life in Iraq and in 1941 the first art society was
formed—the Society of the Friends of Art. It was
founded by artists, architects, and art lovers among
whose founding members were 'Abd al-Qadir al-
Rassam, Hajj Muhammad Salim, Akram Shukri, Faik
Hassan, Jawad Salim, Hajj Suad Salim, 'Ata Sabri,

'Issa Hanna, and Hafid Drubi. In 1941, the society held
its first group show for professional and amateur art-
ists; it continued to mount regular exhibitions and
conduct other cultural activities (including lectures
and painting lessons) for several years.

During World War II a group of Polish officers came
to Baghdad with the Allied troops. Among them were
several painters, two of whom had studied with Pierre
Bonnard. The Polish painters got to know several Iraqi
artists and introduced them to the latest European
styles and the concept of painting from a personal
point of view rather than copying nature. Faik Hassan
admitted that only after meeting the Polish artists did
he notice that natural light in Baghdad was not crystal
clear, as he used to think, but full of dust. Jawad Salim
wrote in his diary that, after a discussion with the
Poles, he came to realize the importance of color and
its application, and only then was he able to under-
stand the works of Cézanne, Renoir, and Goya.

Although Iraqi art historians such as Shaker Hassan
Al Said dismiss the influence of the Polish artists on
their modern art, they seem to have played a signifi-
cant role in introducing Iraqi painters to modern con-
cepts of art in the 1940s. Al Said himself acknowledges
that Polish artists were responsible for breaking the
links with the academic style, and it was only at the
1943 annual show of the Society of the Friends of Art
that current European styles became apparent in some
of the works exhibited. Pointillism, which was intro-
duced by the Polish artists, appeared in the works of
Faik Hassan, Akram Shukri, and Jawad Salim, three
pioneers in Iraqi modern art. Thus the role of the Pol-
ish contribution is hard to ignore.

The British presence in Iraq during World War II
also encouraged artistic development. For example,
the 1943 exhibition of the Society of the Friends of Art
was held at the British Council in Baghdad. The open-
ing of the Institute of Fine Arts, providing art scholar-
ships for study abroad, the involvement of the Polish
artists with their local counterparts, and the activities
of the Society of Friends of Art all contributed to mov-
ing the Iraqi modern art movement from its limited
boundaries into a broader international scale of refer-
ence.[3]

THE MODERN PIONEERS

The most important figure in Iraqi modern art was Jawad Salim (1919–1961) (discussed in detail in chapter 14), who guided the Iraqi art movement toward internationalism. He was the first artist to seek an equation between traditional heritage and modernism, turning to the artistic legacy of ancient Mesopotamia and Islamic art and using both in terms of contemporary international artistic styles. As noted, Salim, who was trained in Paris, Rome, and London, was head of the Department of Sculpture at the Institute of Fine Arts in Baghdad. There he instilled in his students the necessity of drawing on their cultural heritage to create a distinctive Iraqi art.

Faik Hassan (1914–1992), like his friend Jawad Salim, sought to develop an indigenous approach that could express local and international art concepts. He believed that this could be achieved through the choice of subject matter rather than through a distinctive style. Hafid Drubi (1914–?) was a third Iraqi pioneer artist. In 1951 Drubi was appointed supervisor of the joint atelier of the Faculty of Arts and Sciences at Baghdad University. He was faced with the challenge of discovering new talent by encouraging students to take up art. His success at the atelier inspired other colleges to open their own studios. Drubi's chief significance lies in his teaching career, for as a pedagogue he introduced his students to post-Impressionism.[4]

ART GROUPS

As in Turkey and Egypt, art groups or societies were a major phenomenon in Iraq. It seems that in countries where early academies and a strong artistic movement flourished, art groups were the means by which different sets of artists united to become identified with a certain style or a set of ideas. Iraqi art groups started in the early 1950s with the formation of the Société

Faik Hassan, *The Tent*, 1956. Oil on wood, 60 x 90 cm. Courtesy of the Jordan National Gallery of Fine Arts, Amman.

Hafid Drubi, *The Market Place,* 1980. Oil on canvas, 79 x 95 cm. Courtesy of the Jordan National Gallery of Fine Arts, Amman.

Primitive by the French-educated Faik Hassan. The Société Primitive later changed its name to the Pioneers and continued its activities until the mid-1970s. Its members were a mixture of trained and self-taught artists, whose number grew with time. At its inception, the founding members were devoted to depicting scenes from nature as well as village and country life, and they painted on site. They held their first exhibition in 1950 and continued to hold private exhibitions until 1962, when their shows moved to the National Museum of Modern Art.

The second art group was formed by Jawad Salim in 1951 and named the Baghdad Group of Modern Art (further discussed in chapter 14). Members of this group were the first to call for a local art style that drew on the country's cultural heritage, a distinctive Iraqi style that would also benefit from international artistic schools.

In 1953 a third group of artists known as the Impressionists was formed by Hafid Drubi, who had also been a founder of the Society of Friends of Art. The group formed an Iraqi Impressionist school of painting that depicted local subjects; they directed Iraqi art toward a Western approach, away from academic figuration. Members of the Impressionists later experimented with various art trends, which led some of them to paint in a Cubist, Surrealist, or abstract manner.

The 1950s were active years for Iraqi artists. Apart from the formation of the three art groups that defined

the outline for the development of Iraqi art, other crucial events took place. Most important, the Artists Society was created, with King Faisal II as its honorary president. Its members were mainly established artists and architects who promoted the arts. The society established the first exhibition hall, in which it held a sequence of exhibitions linking the artists to the public.

Two other important art shows took place during the same period. The first was a comprehensive exhibition of Iraqi artists held by the Artists Society at al-Mansour Club in 1956. It included a great number of works that demonstrated the different trends and styles current at the time. The jury that selected the work to be displayed refused many of the submitted pieces for being of unacceptable standard. Artists whose works were turned down held a separate show, the *Rejected Exhibition,* along the same lines as the Paris *Salon des Refusés* of 1863. Both Iraqi exhibitions revealed the standard that Iraqi artists had attained and the degree of self-confidence they had reached in their effort to form a distinctive artistic identity. In the Artists Society's 1957 exhibition, the public was surprised to see a portrait in oil painted by King Faisal II. The king, an accomplished artist in his own right, had trained with one of Iraq's pioneer artists, 'Ata Sabri.[5]

THE POSTREVOLUTIONARY PERIOD

On June 14, 1958, a bloody coup by a group of military officers ended Iraq's constitutional monarchy. King Faisal II was murdered, along with his uncle the crown prince, his aunt, his grandmother, and many others, including Prime Minister Nuri El-Said. Thus came to an end a period characterized by cultural growth, when the visual arts, literature, and music flourished alongside social, educational, and economic development. Before the 1958 revolution, artists in all fields were integrated into the mainstream of development, enjoying public as well as private patronage. The military revolution jolted the art movement in Iraq. Artists were torn between succumbing to the new dictatorship as propaganda tools in order to succeed, or safeguarding their freedom of expression at the price of obscurity and recrimination. A few of

those who chose the latter course had to leave their country. The rest resigned themselves to the new regime in the hope that the political conditions would improve.

The unsettled internal political situation in Iraq during the early 1960s, with its numerous coups d'état, military dictatorships, state censorship, local uprisings, and mass executions, created an unhealthy atmosphere that stunted art development. Appointments of deans and professors at Baghdad University and the Academy of Fine Arts were dictated by political affiliations rather than academic or artistic qualifications. Most of the artists employed by the government were communists. The untimely death of Jawad Salim in 1961, at the age of forty-one, and the withdrawal of Faik Hassan from the Pioneer group in 1962 threw the art movement into further stagnation.

By the mid-1960s, young artists had begun to return to Iraq after completing their studies in Western Europe, the United States, the former Soviet Union, Poland, and China. During the monarchy, art students who were given scholarships were sent to Western Europe and the United States, whereas under the postrevolution communist regime all scholarships went for training in the former Soviet Union, the Eastern Bloc, and China. Some of these newcomers managed to inject the stagnating artistic movement with new blood. Jawad Salim's spirit and Faik Hassan's art classes had imbued Iraqi modern art with a continuing sense of discipline and a longing to break through domestic boundaries into the Arab world and toward internationalism. The two pioneers had advocated the necessity of artistic exchange. Modern communications led to more international artistic exchanges. However, artists of the 1960s generation remained faithful to the three pioneers: Jawad Salim, Faik Hassan, and Hafid Drubi, each with his own method and group of disciples.

In 1962 the National Museum of Modern Art was inaugurated. It was a project that had started under the monarchy and was funded by the Gulbenkian Foundation; it housed a collection of contemporary Iraqi art. Many cultural schemes that were completed in the 1960s had started under the monarchy, although when they were inaugurated the revolutionary gov-

ernment took credit for them. One such project was the sports stadium designed by Le Corbusier.

The Institute of Fine Arts, which became the Academy of Fine Arts in 1962, at present is the College of Fine Arts. Most of the academy's graduates became art teachers in government schools. A Polish couple, Roman and Sofia Artomosky, and a Yugoslav named Lazeski taught alongside Iraqi instructors. The three Eastern Europeans guided their students toward abstract art and helped pave the way for a strong modernist element in Iraqi art.

A number of artists from the 1960s generation began abiding by the teachings of Jawad Salim and including indigenous elements within the broader styles they followed. Among them were Mohammad Ghani Hikmat (b. 1929), who assisted Jawad Salim in creating his well-known public work *Monument of Freedom,* and Kadim Haidar (1932–1987), who was a highly educated artist. In 1965 Haidar had the first one-theme exhibition in Iraq, entitled *Karbalā'.* In this show, he introduced a concept that was rebellious in both form and content. He included poetry and figuration in his works, intellectualizing art as well as presenting the public with a thematic exhibition.[6]

NEW ART GROUPS

The formation of artistic groups continued through the 1960s. In 1965 the Innovationist group was formed by a number of young artists, most of them graduates of the Institute of Fine Arts; it lasted for four years. Innovation in the execution of artworks was their major concern. In addition to canvas, oils, and watercolors, they experimented with new media such as printer's ink, monotype, aluminum, and collage. Their first exhibition was held at the National Museum of Modern Art.

Al-Zawiyah was another artistic group. Headed by Faik Hassan, it included among its members Mohammad Ghani and artists from the 1950s generation. These artists advocated the implementation of art to serve national causes, a movement that developed after the 1967 Arab-Israeli war. The group held only one exhibition, which was the first to include works of political and nationalistic themes.

The New Vision (*al-ru'yā al-jadīda*) was formed in 1969 by Dia Azzawi, Rafa al-Nasiri, Saleh al-Jumaie, and other young artists. Their declaration called for freedom and revolution and proclaimed that "revolution and art [were] linked to the development of humanity." They opposed the revival of cultural heritage, stating that "as long as we act freely toward it, our [artistic legacy] will not become a dictatorial force that imprisons us. We consider it our duty to use [our heritage] to conquer the world. We will speak a new language with symbols, that belongs to a new life and a new man." The New Vision held several exhibitions under numerical titles signifying the number of participating artists. The group's exaggerated, sweeping, and emotional statements can be considered a reflection of the official climate in Iraq after the revolution. They introduced a new art trend that drew on mythology, calligraphy, and religious iconography, in abstract and expressionistic canvases, and appeared to be an extension of the Baghdad Group of Modern Art.

The formation of artistic groups continued in the 1970s, although most of them disintegrated after holding only one or two exhibitions. The Triangle group, the Shadow group, the Academician group, and the July-17 group were among these short-lived associations. All the members of these groups were from the 1960s and 1970s generations of artists. A group that was to influence the modern Iraqi art movement despite the fact it had held only one exhibition was the One-dimension group. Headed by Shaker Hassan Al Said, the circle included Dia Azzawi, Rafa al-Nasiri, Mohammad Ghani, Abdul Rahman Kaylani, Jamil Hamoudi, and others. The importance of this group lies in its formal launching of the Calligraphic School of art based on a theory proposed by Al Said. Its significance will be discussed in subsequent pages.[7]

OFFICIAL PATRONAGE

The July Revolution of 1968 brought the Iraqi Socialist Baath Party to power. The new regime adopted an open-door policy vis-à-vis the arts, although this policy was not entirely benevolent. Once more, the government exploited culture to serve its own purposes, using it as a propaganda tool. By patronizing

art, the state managed to control intellectuals and deter them from opposing its authority. Hence, it succeeded in harnessing culture to serve the one-party system under the guise of official patronage. Since the 1958 revolution, cultural affairs had been part of the Ministry of National Guidance (in effect, the Ministry of Information), which allocated a considerable budget for the arts. In 1968 it began to acquire works of art from almost all practicing Iraqi artists as long as the work was not objectionable under the party line.

The ministry also began holding international and local art exhibitions as well as literary festivals and seminars. *Al-Waṣiṭī*, the first festival, took place in 1972. It was a pan-Arab exhibition of fine arts that was followed by the meeting of the First Congress of Arab Artists in 1973, which resulted in the formation of the Union of Arab Artists. Originally funded by the Iraqi government, which intended it to be a propaganda machine, and torn by the different politics of its members and their Arab governments, the union has done nothing to serve Arab art thus far. It has held only two exhibitions, the first in Baghdad in 1974 and the second in Rabat in 1976.

The government's new open-door policy resulted in several exhibitions in other Arab cities, including Cairo, Damascus, Rabat, and Beirut, which by then had become a venue for Iraqi artists. Official state patronage increased. Simultaneously, the National Museum of Modern Art multiplied its acquisitions of local works of art and began participating in international biennials and exhibitions. Group exhibitions became more frequent, especially those held on national occasions and for important political events. One example was an exhibition held after the bombing of the Iraqi nuclear reactor by Israel in 1981.

The most important annual exhibition in the country commemorates the anniversary of the ruling Socialist Baath Party. The first such exhibition, held in 1969–1970, broadly reflected the scope of activities by Iraqi artists who were supporters of the current regime. It was open to all artists, regardless of their standards. Among artists who organized state exhibitions were Nizar Hindawi and Azzam Bazzaz, while Suhail Hindawi, a young and talented sculptor, became fa-

mous through party exhibitions. The majority of artists living in the country took advantage of their government's cultural policy and profited from the benefits offered to them.

In 1979 the Ministry of Information and Culture converted a traditional Baghdadi house into the Museum for Pioneer Artists. Paintings from the turn of the twentieth century until 1950, including the works of ʿAbd al-Qadir al-Rassam, formed the collection. In 1990 the museum was closed, and it has since been neglected. In 1986 the Saddam Center for the Arts was inaugurated with an extravagant opening. On the occasion, the First Baghdad International Festival of Art took place, titled *Art for Humanity*. It included works of artists from most parts of the world. The center is a gigantic edifice, originally conceived by the government as a supermarket. It replaced the Gulbenkian National Museum of Modern Art, whose permanent collection of Iraqi contemporary art was transferred to the new premises. The museum has remained as a secondary exhibition hall. The collection of the Museum of Pioneer Artists was also moved to the Saddam Center. An archive section was created to document the Iraqi plastic art movement, though its activities thus far have been negligible.

During the 1980s, the government opened an Art College in the Muḥāfadat Bābil (the Governorate of Babil), as well as several art institutes in cities such as Basra in the south and Musil and Sulaymaniya in the north. Iraq's art community had previously been concentrated in Baghdad, so this step relinquished the capital's monopoly on art and at the same time absorbed the increasing number of art teachers who were graduating from the Academy of Fine Arts in Baghdad and other art institutes. The employment of these artists provided a scope for their competence and an opportunity to develop local talent. Meanwhile, art lessons were included in the curriculum of the Ministry of Education's Institute of Applied Arts, and a five-year course in painting, ceramics, and handicrafts was offered at the House of Heritage and Popular Arts (Dār al-turāth waʾl-funūn al-shaʿbīya).[8]

During the eight-year Iran-Iraq war, the authorities multiplied artistic activities to show that cultural

progress was continuing in the country. These activities also served as a distraction from the war. The utilization of art to serve the state, which had began with the 1958 revolution and increased with the 1968 Baathist revolution, reached new heights. Colossal portraits of President Saddam Hussein, sometimes covering entire buildings, appeared in Baghdad and all major cities. Monuments were erected in his name. One such example is the *Triumphal Arch*, consisting of two arms with clasped hands, a cast of Saddam's own arms. Paintings and sculptures depicting the president in various situations, costumes (military, civilian, Arab dress, hunting gear, and such), and among different groups of people (Bedouins, factory workers, Kurds) were made by well-known artists such as Mahoud Ahmad.

Although the 1980s was a decade characterized by vigorous artistic activities, totalitarianism and the cult of Saddam cast a heavy shadow over it. Not all artists benefited from state patronage. Those working with and for the Baath party were highly regarded and encouraged. Many artists had to go along with the regime despite their political inclinations, in order to benefit from the art patronage. Some who conformed were even allowed to travel abroad to take part in exhibitions and seminars, despite an eight-year ban on travel that existed for the general population during the Iran-Iraq war. Only a few artists opted to leave the country rather than benefit under the regime.

After the Iraqi invasion of Kuwait and the ensuing Gulf war, the ban on travel was lifted by the government, and an influx of Iraqi artists came to Jordan in particular. They escaped from the censorship imposed by their government and the dire living conditions in the aftermath of the war and the UN sanctions. Some artists had not left Iraq for more than a decade. Most of them brought their work to sell in Jordan; a few found jobs and stayed on, and those who could obtain visas to countries in North Africa, the West, and the Far East, departed from the area.

THE IRAQI modern art movement has a widespread reputation in the Arab world of being the most advanced among Arab modern art movements and of enjoying the maximum of state patronage. The two are definitely connected. Government patronage took the form of Iraqi cultural centers in Western capitals such as London and Paris, sponsorship of individual artists by sending exhibitions abroad and participating in international biennials, and international exhibitions held in Baghdad on a grand scale. Foreign artists were invited to attend such exhibitions as guests of the Ministry of Culture, which paid their travel expenses and the costs of shipping their works. In these ways Iraqi modern art was introduced to various publics and art critics in many Western and Eastern countries, and Iraqi artists got exposure and became known. Yet this kind of patronage came with a price tag attached. Artists not only had to conform to the state's politics, which did not tolerate any dissidence, but they also had to paint, sculpt, and etch political and national subjects as the government dictated, virtually on a monthly basis. Meanwhile, Iraqi artists living outside their country, deprived of such benefits, earned whatever recognition they got on the strength of their work.

5 ALGERIA

WHEN THE FRENCH army conquered Algeria in 1830, it made the country a part of France rather than a colony or a mandate. As the mother country, France regarded its duty as one of "civilizing" the newly acquired territory and its people. The official language of Algeria became French, education followed the same curricula as in France, and the teaching of Arabic was limited to religious schools where only the Qur'an was taught. Students read French and European history instead of their own, and Algerians were considered French citizens, subject to French law.

The same situation prevailed in the cultural arena. There was a concentrated effort to "civilize" the natives of French Algeria so that they could assert their French identity. Leading philosophers such as Augustin Berque cultivated their own negative views on the Arab-Berber mentality. Berque wrote that "the Berber is not a dreamer. He has no lyrical imagination. His approach never extends beyond the cold contact with objects. The Berber artist is still an artisan." A. Gayet, a specialist in Arab history, wrote, "He [the Arab] is indifferent to the shapes and colors that would provoke emotion from the rest of us. . . . How is his perception so different from ours? . . . The Arab soul no longer belongs to our race."[1] When the country gained its independence in 1962, the majority of Algerians were illiterate in Arabic, as their mother tongue had become French during 159 years of colonization.

ORIENTALIST ARTISTS

In 1832 Eugène Delacroix became the first French painter to visit the newly acquired territory of Algeria. A considerable number of French Orientalists followed in his footsteps. They discovered a new, exotic world that attracted them; some even resettled to live and work in the new province. A few of the Orientalists who visited the country were Gabriel-Alexandre Décamps, Charles-Émile Champmartin, Émile Vernet, Adrien Dauzats, Théodore Chasseriau, Eugène Fromentin, and Edmé-Alexis-Alfred Dehodencq. They portrayed life in Algeria, local customs, and scenery in a romantic genre, through a descriptive, classical figuration. It was the Orientalists who introduced European easel painting into the country. In 1851 the Société des Beaux Arts of Algeria was founded; its mem-

bership was restricted to artists of French origin. In 1900 the Musée d'Alger opened, displaying the latest of their works. Several French Impressionists visited Algeria, including Monet, who stayed there between 1860 and 1862, and Renoir, who visited in 1879.

By 1894 the French Orientalist painters of Algeria were numerous enough to organize an annual salon in Paris where they displayed their work. In 1897 the Société des Peintres Algériens et Orientalistes was founded in Algiers. There was even an École d'Alger in Orientalist painting, which depicted Algerian subjects with compassion toward the natives. In 1907 the French governor, M. Jonnart, founded the Villa Abd el-Tif (Maison des artistes) in Algiers for the benefit of French artists who wanted to work in North Africa. They could work in a free and unrestricted milieu and thus enrich colonial life. A Parisian jury selected the members, and one-year scholarships were offered to two artists among them; in 1920 one of the scholarships was extended to two years. Similar ateliers were created in Constantine, Tlemcen, Ghardaïa, Touggourt, and Fort-National. Throughout the years, ninety artists stayed in the villa to practice painting, sculpture, and etching. Algeria was the country most frequented by French painters who visited North Africa. However, their influence was far stronger on resident non-Arab artists than on native Algerian painters.

The most important Orientalist artist to influence the beginning of Western art in Algeria was Alphonse-Étienne Dinet (1861–1929). A Parisian-born painter, he studied art at the École des Beaux Arts and made several visits to the new province between 1884 and 1888. In 1887, he became so interested in North Africa that upon his return to Paris, he founded the Société des Peintres Orientalistes Français, with Léonce Bénédite as its president. He then studied Arabic at the École des Langues Orientales. In 1889 he became more involved in the Orientalist movement, which by then had gained public support. Dinet exhibited a painting that had an Algerian theme at the 1888 Salon des Peintres Orientalistes in Paris, which brought him a certain degree of fame. With the exception of a few portraits, his works depicted only Algerian subjects.

In 1904 Dinet bought a house in Bou Sa'da and spent his time between Algeria and France. Dinet converted to Islam in 1913, changed his name to Nasr-Eddine, went on pilgrimage to Mecca, and alienated himself from his former Parisian milieu. When he died in Paris, his body was taken to Bou Sa'da for burial. The majority of Dinet's paintings depicted subjects from Islamic legends, Algerian deserts, animated everyday-life scenes, and love scenes against romantic backgrounds that included nubile female nudes bathed in mauve shades. He nevertheless introduced Western academic teaching into Algeria.[2]

MINIATURE PAINTING

Algerian painting evolved under a double identity: an Islamic one based on miniature painting, classical calligraphy, and arabesque decoration, and a Western neoclassical style as implemented by the Orientalist painters.

At the turn of the twentieth century, a trend appeared among the native Algerian artists who had held onto traditional Islamic art and rejected imported Western painting, which was regarded as colonialist. Its initiator, Mohammed Racim (1896–1974), came from a traditional artistic family. In 1914 he began the trend of Algerian miniature painting that differed from its classical precursor. Racim's miniatures were three-dimensional, and he was able to develop a style that simultaneously combined Western and Islamic aesthetics. Another early Algerian artist who practiced both miniature painting and Western figurative art was Mohamed Tammam (b. 1915), a student of Racim. Tammam's elaborate paintings are a record of Maghribi culture. The miniaturist Mohamed Ranem (b. 1925), who painted warm scenes of local ways of life and historical events, showed more naturalistic traits than Racim and Tammam. Ranem became a professor of illumination at the École des Beaux Arts in Algiers and participated in numerous exhibitions held in his country and elsewhere in the Arab world and Europe.

Calligraphy and the art of miniature painting were not merely forms of decoration to these painters, but means of expressing their artistic and national identity. They spread these techniques among their pupils at the École des Beaux Arts, from which a number of

Mohamed Racim,
Horseman, undated.
Watercolor on paper.
Musée National des
Beaux Arts d'Alger.

miniature painters graduated, including Moustafa
Jou'␣t, Moustafa Bilkahla, Miqdani Bou 'Oroor, and
Bou Bakr Sahrawi, who also visited Iran to improve
his technique.[3]

THE WESTERN STYLE

Western art in Algeria was most often practiced by the
descendants of French settlers, whose works were re-
garded as superior to those of Algerian artists. In 1920
the French authorities established the École des Beaux
Arts in Algiers and staffed it with French teachers,
who prepared the students to continue their studies at

the École des Beaux Arts in Paris. Similar schools of
fine arts were also opened in Oran and Constantine.

Between 1914 and 1928, the first group of native
Algerian painters came on the scene. They included
Azouaou Mammeri (b. 1886), who taught drawing in
Fez and who participated in exhibitions in Morocco,
France, Spain, and Algeria. Another was Abdelhalim
Hemche (b. 1906), a graduate of the École des Beaux
Arts in both Algiers and Paris, where he also taught
drawing and practiced both miniature and Western
painting. These two were followed by Binsliman,
Farrah, and Boukarsh. All these artists were known

Left: Mohamed Tammam, *Flower Vase,* undated. Watercolor on paper. Musée National des Beaux Arts d'Alger.

Below: Mohamed Ranem, *Frontispiece,* undated. Watercolor on paper. Musée National des Beaux Arts d'Alger.

Baya, untitled, 1980. Oil on canvas, 75 x 100 cm. Courtesy of the Jordan National Gallery of Fine Arts, Amman.

for their neoclassical style, Algerian landscapes, and genre scenes, following in the footsteps of Orientalist artists.

By the end of the 1930s, Orientalist and neoclassical themes were exhausted and such paintings had deteriorated into debilitated forms of folklore and sycophantic representations. The works of the all-French members of the Villa Abd el-Tif (including Cuavy, Basoulès, Antoni, Berasconi, Assus, Galliero, and de Maisonseul) revolved around Algerian folk culture and Impressionism. They rejected more recent trends in art as being too modern. Algerian painting had reached a standstill after consistently ignoring or repudiating the modern movements in Europe led by Picasso, Braque, Matisse, Klee, and others. Only two artists, Sauveur Galliero and Jean de Maisonseul, broke away from the Villa Abd el-Tif group in the

early 1940s, and they pursued a dual quest for verity and universality. It was a domain above national and individual problems and superseded outward reality: to those two painters, art could only be abstract.

Unlike the case in the other Arab countries, Western art in Algeria was imposed rather than being introduced by the French. Moreover, it also tended to become the monopoly of the French settlers until the 1950s. Because of the reactionary and conservative attitude of the established artists and the art schools in Algeria, the modern post-Impressionist styles penetrated Algeria only in the 1950s. In the interim, early Algerian artists reverted to classical Islamic miniature painting and calligraphy as a countermovement to the widespread Orientalist trend in French-Algerian painting. Most trained artists who emerged in the 1930s and 1940s either followed in the footsteps of

artists of French origin and their Orientalist and neo-classical styles, or they developed a naive style as did their self-taught counterparts.

Nonetheless, a few native Algerian painters did begin to shift from the neoclassical style toward modernism. Ali Khodja (b. 1923) began his artistic career as a miniaturist, depicting traditional Algerian interiors. He later took up easel painting and experimented with the distribution of colored masses throughout the composition, in a style that wavered between Fauvism and abstraction. Bachir Yellès (b. 1921) and Mohamed Bouzid (b. 1929) explored Cubism, Fauvism, and figurative Expressionism while maintaining local themes.[4]

NAIVE PAINTING

In 1947 a fifteen-year-old illiterate Algerian orphan named Baya (b. 1931) was lauded by the French critic André Breton as a child prodigy. Her naive infantile paintings of fantastic animals and creatures were shown at Gallerie Maeght, where Picasso and Braque were represented. Two other naive artists, of earlier generations—Hacène Benaboura (1898–1960) and Mohamed Zmirli (b. 1909)—came on the art scene at the same time as Baya. In 1946 Benaboura took part in his first group exhibition in Algiers, which was followed by other solo and group shows. He won the second Grand Prix Artistique de l'Algérie in 1954 and was named a laureate painter in 1957. Both Benaboura and Zmirli were known for their naive depictions of urban scenes and landscapes of different parts of Algiers. Like Baya, they exhibited their work locally and internationally. It seems that Western art critics in general and French critics in particular had a preference for North African naive painting. They considered it a natural indigenous style befitting an underdeveloped people.[5]

ALGERIAN ARTISTS IN PARIS

A number of Algerian artists went to Paris in the 1950s. Their theoretical and practical knowledge of art had been severely retarded by their limited education under the colonial French administration. The most prominent among this group was Mohamed Issiakhem. When he went to Paris in 1953, he met with other Algerian and North African painters, including

Abdelkader Guermaz (b. 1919), Mohamed Khadda (b. 1930), Choukri Mahmoud Mesli (b. 1931), Bachir Yellès (b. 1921), Abdallah Benanteur (b. 1931), and Ali Khodja (b. 1923), as well as the Moroccans Ahmed Cherkaoui and Jilali Gharbaoui, and the Tunisian Hédi Turki. All suffered from gaps in their art education. The Algerians faced an overwhelming cultural onslaught on their artistic identity. On the one hand, their social base had been shattered by colonialism, and on the other hand, their knowledge of their own history and culture was incomplete.

Mohammed Issiakhem (1928–1986) is considered the pioneer in modern Algerian art. Although he had trained with Omar Racim while studying at the École des Beaux Arts in Algiers, his work was contemporary in both context and style. While in Paris, Issiakhem witnessed the formation of Abstract Expressionism and other styles of modern art, which he quickly

Mohamed Issiakhem, *Mother and Child,* undated. Oil on canvas. Musée National des Beaux Arts d'Alger.

Mohamed Khadda, *Free Alphabet*, undated. Oil on canvas. Musée National des Beaux Arts d'Alger.

adopted. Like most Algerian artists who appeared in the 1950s and 1960s, Mohamed Khadda (1930–1991) was a self-taught painter. He was also considered a pioneer in modern Algerian art for introducing Arabic characters and Berber tattoo signs in his semiabstract works.

Issiakhem and Khadda, along with Geurmaz, Zerarti, and Benanteur, were at the forefront of Algerian modern art. The majority of the Algerian artists who matured in the 1950s and 1960s were self-taught. They made a complete break from the old traditions in painting. Through their travels in France, they came into contact with the latest trends in Western art. Their work, however, differed distinctly from that of French artists. Having had no formal training in art and having suffered deculturalization through colonialism, they wanted their work to portray a national identity through the use of local signs and motifs in abstract formations.[6]

ARTISTS OF THE REVOLUTION

During the years of resistance against the French, a number of artists fought with the National Liberation Army. Fares Boukhatim, who was well known as the artist of the revolution, began painting when he was in the army. He depicted the horrors of the war of independence, in scenes of soldiers in trenches, as well as the life of refugees on the border. He became extremely popular in Algeria, and his works, which were full of nationalist sentiments, were shown in Tunis, Hanoi, Prague, Shanghai, Warsaw, Peking, Havana, and Madrid. Another artist who worked for the Algerian revolution and paid tribute to it in his paintings was Abd Msbahi. Even after independence, artists such as Mardoukh continued depicting nationalistic subjects and glorified the "three revolutions"—cultural, industrial, and agricultural—as well as the Palestinian and the Vietnamese uprisings.

After independence, most Algerian artists living abroad returned to their country to contribute to the development of the modern art movement in Algeria. A number of talented students enrolled at the art academies of the Arab world and Europe, while others studied at the Algerian École des Beaux Arts. The styles and trends they took up varied between the figurative and the abstract.[7]

MUSÉE NATIONAL DES BEAUX ARTS

The French authorities began the Musée d'Alger project in 1900, mainly to exhibit the works of Orientalist artists. In 1930 the Musée Nationale des Beaux Arts was inaugurated in a new building to commemorate the centennial of French rule in Algeria. It holds a collection that shows the evolution of French sculpture from Roman times until the present and a section devoted to North African subjects in French painting by Delacroix, Chasseriau, Fromentin, Dehodencq, Guillaumet, and Lebourg, as well as works by minor painters of the same school.

The collection also includes a few works from the German, Spanish, Dutch, Flemish, French, and Italian schools of the sixteenth, seventeenth, and eighteenth centuries, as well as a nineteenth-century Impressionist collection and paintings by the artists of Villa Abd el-Tif. Since independence, the works of contemporary Arab-Algerian artists have been added to the museum's previous collections.[8]

ARTISTIC SOCIETIES

The National Union of Plastic Arts, founded in 1964, is the only body to which most plastic artists in Algeria belong. It functions under the umbrella of the Ministry of Culture and Information and the Algerian National Liberation Front. The two official bodies materially and morally assist the union, which has chapters in Constantine and Oran (Wahran). It has opened an exhibition hall in Algiers, where it holds shows on national occasions as well as exhibitions by visiting artists. Member-artists have formed several artistic groups within the union, such as the Tattoo group, which draws on folk art, the First group, the 54-Group, and the Young Painting group. The generation of artists that appeared after independence was usually trained at art schools in Algeria, while fewer were trained abroad. Unlike their predecessors, they were able to acquire a formal art education. Their ties with their culture were established as their Arab-Islamic cultural identity was reinstated. The works of postindependence artists of the 1970s and 1980s are mostly abstract and Abstract Expressionist. Either they attempt to depict local subject matter through the manipulation of Arab and Berber signs, or they follow the concepts of international art.[9]

OF ALL THE Arab countries, only Algeria pursued a dual track in its modern art movement, which included a traditional art form. Islamic miniature painting and the European Orientalist school constitute the basis of contemporary Algerian art. Even at present, modern art in Algeria either reverts to native heritage or turns to internationalism.

6 TUNISIA

IN 1881 TUNISIA ceased to be part of the Ottoman Empire and became a French protectorate, a status that ended at its independence in 1955. Foreign artists had visited Tunisia before it came under French rule. The early Orientalists often chose historical events pertaining to North Africa's Roman period as the subjects of their paintings. Stereotypical Orientalist themes, including picturesque landscapes, exotic natives, Bedouins, blind men and women, slaves, executions, and bath scenes, were developed much later, around the turn of the century, by a generation of colonial artists. They displayed their works of Tunisia in the Parisian salons and impressed the public and critics with their exotic subjects.[1]

THE FRENCH INFLUENCE

During their occupation of Tunisia, the French authorities in 1894 founded the Institut de Carthage, which became the most important scientific and cultural institution in the colony. Its function was to assert the cultural and educational legitimacy of the colonial power so as to complement its political and economic activities. In the same year, the Institut de Carthage organized the first Salon Tunisien in Tunis, marking the formal introduction of Western art into the country. The main participant was a young French painter named Jean Chalon. He had been in Tunis for only a few months when he was invited to participate in this exhibition, in the hope that he would attract other artists to join in. His style bespoke the neoclassical and romantic school and depicted narrative genre scenes. However, with the appearance of Impressionism in the 1870s, this style had already started to wane in Europe. Other colonial artists who took part in the first salon were P. Bridet, Paul Proust, Mme. Viola Truelle, Mlle. Geneviève Grégoire, and the sculptor Théodore Rivière. Works were also borrowed from private collectors in the French community to fill the exhibition hall.

Four annual salons were held following this exhibition. However, in 1899 and 1900 financial difficulties disrupted the schedule. In 1901 the salons recommenced and continued until 1907. Other individual and collective exhibitions for local colonial artists took place simultaneously. These artists belonged to one of

two groups: the Société des Amis de l'Art and the Société des Amis des Beaux Arts, with each group organizing its own salon. The Institut de Carthage also sponsored other art events, including exhibitions by Émile Pinchart (1905), Alexis de Broca (1906), and Georges Charpentier (1907).

Thanks to the efforts of Élie Blondel, an official responsible for the artistic section of the institute, the Salon Tunisien was resumed in 1907 and continued until 1914, when it was halted by the outbreak of World War I. It reopened in 1920. The first twenty years of the salon (1894–1914) revealed a slow evolution of artistic activities, hampered by the shortage of money and the difficulty in penetrating colonial social life. At the time the salons were launched, the taste was conservative and opposed to the new trends that were current in Europe. Instead, the Salon Tunisien preferred Orientalism, with all its romanticism and imaginative depiction of the East. Throughout the first two decades, the Salon Tunisien embraced the Orientalist school of art. The general trend was one of narrow and provincial academic traditions, born of the conservative French colonial mentality, which ran counter to the modern trends in Paris.

In 1913, just before the war broke out, the works of three members of the Salon des Artistes Français—Albert Gleizes, Marie Laurencin, and Buissière—were exhibited. They brought with them the first fruits of the new European art. In 1922 Van Dongen displayed his works, and in 1924 Albert Marquet, Maurice Denis, and others also exhibited. However, these modern masters did not make a great impression on local artists.

The Centre d'Art, the first art school in Tunisia, opened in 1923. Its director, M. Boyer, was assisted by Armand Vergeaud. In 1930, the Centre d'Art became the École des Beaux Arts, under the direction of Vergeaud until he died in 1949. Organized much like similar French institutions, the curriculum of the Centre d'Art consisted of applied courses in drawing, painting, sculpture, decoration, and etching, as well as academic courses in perspective and the history of art. The teaching was strictly conservative and followed traditional academic methods. Although it was open

to all nationalities, the Centre d'Art drew its students, whose ages ranged between sixteen and thirty, almost exclusively from Europeans living in Tunis. Until independence in 1955, the number of Tunisian pupils was negligible in comparison with foreign students. However, the institution was instrumental in training several generations of artists.

At the time, numerous foreign colonial artists lived in Tunisia. In addition to the Salon Tunisien, they held many exhibitions: the Salon des Artistes Tunisiens, which took place annually between 1924 and 1934; the Expositions de l'Afrique Française, which alternated yearly between Tunis, Casablanca, and Algiers; annual exhibitions by the students and friends of the École des Beaux Arts; and an exhibition of painters working with the railway system. All these artists formed a mosaic of different styles, trends, and experiments, though none attempted to look deeply into or draw upon the country's cultural heritage. Most of the artistic groups were started by foreign resident artists and dissolved quickly. Examples include the Salon des Artistes Tunisiens, headed by André Delacroix (1924–32), and the Syndicate of Professional Artists, founded after World War II by a decorator working at the Municipality Theater, G. L. Lemonnier, and the Group of Four. Sooner or later, all foreign artists resumed displaying their work at the Salon Tunisien.

The foreign artists who settled in Tunisia collectively influenced the development of local artists by introducing Western art into the country. Among the French artists who interacted with their Tunisian counterparts was Alexandre Fichet (1881–1968). Fichet moved to Tunis in 1902 and became president of the Salon Tunisien from 1913 until his death in 1968. During his tenure, he opened its doors to young artists such as Laurencin and others who brought new ideas and fashions. Fichet was a Socialist and the editor of the newspaper, *Tunis Socialiste,* which opposed colonial policy. He exhibited regularly at the salons in Tunis and Paris and gave drawing lessons at the École des Beaux Arts and several other schools.

Armand Vergeaud (1876–1949), who moved to Tunis in 1910, was an art teacher. Between 1923 and 1949, he taught at the Centre d'Art and then became its di-

rector. Vergeaud was well known for his portraits, including that of the Bey Ahmed Pasha, which hung in the Throne Hall at the palace in Tunis.

Henri Gustave Jossot (1866–1951) was a painter, illustrator, writer, and poster designer. In France he was known as a cartoonist for the larger newspapers at the turn of the century. Though he had often visited Tunisia after 1896, he only settled there in 1912, seeking to escape from Europe. He converted to Islam soon thereafter and became a member of the Salon Tunisien from 1912 onward. In 1924 he joined the Salon des Artistes Tunisiens as a participant and member of the jury.

The Russian Alexandre Roubtzoff (1884–1949) was a graduate of the Imperial Academy of Fine Arts in Saint Petersburg. In 1912 he won a prize at the academy that enabled him to travel for four years to countries of his choice. After a stay in Spain, he reached Tunisia when World War I broke out, followed by the Bolshevik Revolution of 1917. He became a naturalized French citizen and integrated into colonial society, taking part in its artistic life and building a reputation for himself as a portrait painter. Between 1920 and 1950, Roubtzoff exhibited regularly at the Salon Tunisien and other salons in Paris. Most of these resident artists established their own ateliers, where they offered lessons to other artists among the European settlers as well as a few local amateurs.

Pierre Boucherle (1895–1988), of French parentage, was one of the first non-native artists born in Tunisia. He displayed his work regularly at the Salon Tunisien and elsewhere. In 1936, he formed the Group of Four with Antonio Corpora, Jules Lellouche, and Moses Levy. He represented Tunisia at several exhibitions in Paris and London and was one of the founders of the Tunis School in the late 1940s. Moses Levy (1885–1968), who spent his life in Tunisia, Italy, and France, was known for his landscapes and traditional Tunisian themes. During one of his stays in Paris, he met Van Dongen and Dufy, to whom he paid homage in one of his works.

Antonio Corpora (b. 1909) graduated from the École des Beaux Arts in Tunis and worked in the Atelier Armand Vergeaud. He participated in the Salon

Tunisien for the first time in 1929. Apart from the Group of Four, he established a neo-Cubist group and made contacts with the artistic trends current in Europe. Jules Lellouche (1903–1963) was also a graduate of the École des Beaux Arts in Tunis. He participated in the Salon Tunisien and other exhibitions such as the Éxposition de l'Afrique Française from 1921 until he moved to Paris in the 1960s.

Most of this group of Tunisian-born French artists trained at the École des Beaux Arts and the ateliers organized by the older generation. They took part in the Salon Tunisien and taught at the École, but moved to Europe after independence, having in the meantime introduced new artistic schools such as Impressionism and Cubism into Tunisian art. Other European artists who lived in the country were Edmond Küss; Léo Nardus, a painter and art patron; Maurice Picard; Jeannine Varesme; Henri Saada, who taught at the École des Beaux Arts; Frida Uzan; Jacques Arnaud; Edgar Naccache; Pierre Demoutier; and Fernande David. They all displayed their work collectively in Europe and North Africa, mainly at the Éxposition de l'Afrique Française.[2]

EARLY INDIGENOUS TUNISIAN ARTISTS

Modern Tunisian art developed either on the periphery or within the framework of the annual exhibitions organized by the French. Ahmed ben Osman was the first local artist to adopt Western painting styles, while Hédi Khayachi (1882–1948) was the first professional artist in the modern sense of the term. Khayachi used to visit Pinchart's studio before he went to train in Italy. Although he never had a solo exhibition, Khayachi still managed to make a living by painting portraits of the Beys of Tunis (a title given by the Ottomans to the governors of Tunisia) and genre scenes of traditional life according to the Orientalist principles.

Abdulwahab Jilani (1890–1961) also had his initial training at Pinchart's studio. In 1912 he became the first Tunisian Muslim to exhibit at the Salon Tunisien. In 1921 he left for Paris and joined the Académie Julian and the free ateliers of Montparnasse. He participated in the activities of the Paris School and worked with Modigliani, Picasso, Soutine, Chagall, Zadkine,

Yahia Turki, *Boats*, 1929.
Oil on canvas, 33 x 41 cm.
Courtesy of Municipality
of Tunis, Tunis.

and others. Because he spent most of his life in Paris, his artistic vision developed outside his native environment, cut off from his original culture, and he became more a European than an Arab artist.

The second quarter of the twentieth century was a period of national struggle for independence in Tunisia. Many of the resident European artists died, placing the burden of developing the modern art movement squarely on Tunisian artists. The most important to influence the formation of modern art in Tunisia was Yahia Turki (1901–1968). He broke away from the Orientalist stereotypes and expressed, in a free and direct manner, the emotions of simple people. His style opened a new dimension for native artists and added an indigenous quality to local painting. Turki is considered the father of Tunisian painting, and his disciples became the vanguard of Tunisia's modern art movement.

His students included Abdelaziz ben Raïs (1903–1962), who was known for his peaceful landscapes and an economy in the use of color that did not detract from the overall richness of his work; Ali ben Sa-

lem, who composed his works with elements of traditional folk culture in a style inspired by painting on glass and miniatures, and who held several exhibitions in France and Sweden; Hatem el-Mekki (b. 1918), an exhibitor at the 1934 Salon Tunisien, who was known for his mercurial personality and his varied styles, media, and techniques, including watercolor, oil, graphics, and prints; Amara Debbech (b. 1918), whose mature, unconstrained drawings placed him in a special position in the history of modern Tunisian art; and Ammar Farhat (b. 1911).

The early native Tunisian artists were conscious of the rift that separated them from their foreign peers living in the country. They felt that personal genre painting that depicted domes, popular quarters, and cold stereotypes in the *suq* (marketplace) was insufficient to represent their nation and people. They believed in a more humanistic approach toward their country and attempted to portray a sympathetic and realistic view of North Africa without the usual clichés. They thus broke away from the trends of the École des Beaux Arts and tried to incorporate a deeper

meaning in their work. This new direction was initiated by Yahia Turki and continued under Ammar Farhat, whose paintings showed the world of the poor and the deprived, tinged with a certain cynicism.[3]

TUNIS SCHOOL

The earliest artistic group in Tunisia to include Arab Tunisians was the Tunis School, which was founded by Pierre Boucherles at the end of the 1940s. Although this group had neither a manifesto nor a unity of well-defined aims, they were able to present their own interpretation of the country through their works. In their interpretation, certain aesthetic and sentimental values were found in a traditional way of life, folk culture, and their artistic heritage. It was evident in the works of Yahia Turki, Ammar Farhat, Zoubeir Turki, Abdelaziz Gorgi, Ali Bellagha, and Safia Farhat. They diverged from contemporary European styles and tried to revive the two-dimensional forms of Islamic miniatures, the popular tradition of painting on glass, Arabic calligraphy, and the various techniques of local handicrafts. They borrowed elements from their traditional architectural environment.

Members of the Tunis School included pioneers such as Yahia Turki and Ammar Farhat, while others came from the second generation of artists, including Jellal ben Abdallah (b. 1921), Abdelaziz Gorgi (b. 1928), Ali Bellagha (b. 1925), Safia Farhat (b. 1924), Zoubeir Turki (b. 1924), and Hédi Turki (b. 1922). Artists of the third, postindependence generation, among them Hassan Soufi (b. 1937) and Abdelkadir Gorgi (b. 1949), were also involved. Though they all agreed on a number of aesthetic values and viewpoints and pursued a certain discipline, each one developed his or her personal style independently.

The Tunis School played an important role in introducing and developing Tunisian modern art. In the period from independence to the early 1960s, its beliefs and values became synonymous with what art should express in terms of national, spiritual, and material values. In spite of their quest to find a distinctive artistic style, however, members of the Tunis School reverted to folk iconography to assert their national artistic identity. They depicted local subjects and scenes from their milieu with more compassion than the Orientalists. In terms of style, each member of the group cultivated a different manner of representation. They never produced a single unique mode of expression. The only common denominator among them was the choice of subject matter that drew on their national heritage.[4]

ABSTRACTION

The first two to break away from the Tunis School were Hatem el-Mekki (b. 1918) and Hédi Turki. They chose to diverge from their peers' belief in transforming folk values into a symbolic or a thematic painting. This rupture indicated the emergence of new trends among the 1960s generation. They believed that affirming their national and cultural identity meant breaking free of the harmonious ambience of their local environment, cutting loose from their regional constraints and the thematic content of daily life, and benefiting from the experiments of international art. Thus, many artists adopted abstraction, Expressionism, Surrealism, and other contemporary styles in

Abdelaziz ben Raïs, *Portrait*. Oil on canvas.

Rafik Kamel, *Transfiguration*, 1985. Oil on canvas, 145 x 111 cm. Courtesy of the Jordan National Gallery of Fine Arts, Amman.

vogue internationally. Those who opted for symbols searched through their cultural heritage and tried to include the symbols within a contemporary framework. This desire for change and experimentation overpowered the earlier approach of limiting the themes and techniques of art to local issues and developments. The confrontation between the younger and older generations led to the popularity of abstract painting.

The introduction of abstract art into Tunisia raised new questions concerning the aim and meaning of visual art, and it mobilized the entire artistic community. Its direct influence on figurative painters was to force them to pay closer attention to problems of a

purely visual nature, such as the compositional value of a painting through space and color distribution. It also pushed many Tunisian artists into the international arena. Hédi Turki was influenced by Jackson Pollock's Abstract Expressionism and Mark Rothko's color fields after a visit to the United States. Most abstract artists trained in Tunis at the École des Beaux Arts, while a few enrolled at the Technological Institute of Art and Architecture. Seldom did they travel to Paris or Rome to pursue their studies. From this local basis of exposure, many Tunisian artists practiced some form of abstraction at some point during their artistic careers, without being exclusively concerned with abstract art.

By the end of the 1970s, however, the tide of abstraction began to ebb under the influence of a new interest in the figurative, which emerged through Expressionism, neo-realism, and primitive art. By the early 1980s, a number of abstract artists were propelled toward Pop Art and depicted mundane daily scenes, making use of photography; one such artist is Rafik Kamel (b. 1944), who moves with ease between figuration and abstraction. Thus, trends that had started in the United States in the 1960s began to pervade Tunisian modern art within a decade or so.

THE SEARCH FOR A TUNISIAN STYLE

Since the beginning of the Tunisian modern art movement, local artists have been obsessed with a desire to develop a local art style, or what they call an "authentic" style. This desire might be a reaction to the superficiality of the Orientalist school and to academic rigidity as propagated by the early European painters of Tunisia. Yet in a sense, even the Orientalist artists were driven by a desire to relate their work to the country's culture and people, through their choice of subject matter.

They were followed by a generation of Tunisian pioneer artists who broke away from inflexible academic rules in search of an original approach to art. The Tunis School called for realistic representation. With special consideration for the country's cultural heritage, they hoped to offer a sympathetic insight into the customs and values of Tunisia, without exaggerating or overdramatizing its poverty, backwardness, and folklore. This quest to ground Tunisian art in a local environment continued with the rise of abstraction, and, as in other parts of the Arab and Islamic world, was a stage that followed independence from foreign rule. The aim was to discover an indigenous artistic identity in order to assert the artist's individuality.

In the early 1960s, a movement began that attempted to lend local character to abstraction by identifying it with traditional culture. Adherents of this

Najib Belkhodja, *Composition*, 1965. Acrylic on canvas, 30 x 147 cm. Courtesy of Ministry of Culture, Tunis.

trend drew on Arabic calligraphy, elements of arabesque decoration, and architectural forms. They saw the analogy between two-dimensional space in Islamic art and modern European Expressionism and abstraction. This movement divided artists into two groups: one, led by Najib Belkhodja (b. 1933), was based on constructivism of forms; the other, led by Nja Mahdaoui (b. 1933), utilized calligraphic shapes as the basis of the composition.

Belkhodja is a self-trained artist who believes in linking up with international artistic experiences through a critical attitude toward abstraction, rather than a total, blind imitation of the Western model, which he believes has taken place in Tunisia. He has reverted to using calligraphic shapes and elements of Islamic architecture such as domes, arches, and geometric forms in a two-dimensional treatment. Belkhodja's paintings are built on the architectural forms of a city, bound together by cursive and angular shapes that recall the rhythm of Kufic script.

Mahdaoui trained at the Atelier Libre in Carthage before going to the Accademia Santa Andréa in Rome to specialize in graphic art. In the early 1970s, he began working on his calligraphic compositions under the influence of the Iranian painter Hosseyn Zenderoudi. The main element in these compositions is the Arabic letter, which Mahdaoui uses as an illegible element in two-dimensional arrangments. Neither Mahdaoui nor Belkhodja was able to attract a big following.

A third attempt to link Tunisian modern art to the local environment is based on the inclusion of folk signs and symbols, such as Fatima's hand and the evil eye, within a composition.

The abstractionists were not the only artists to defy realism. Although abstraction was a major movement in opposition to the Tunis School, other artists appeared who also refuted the school's doctrines. They were the neo-figurative painters who rejected both the abstractionists' disregard for realism and the superficial classical figuration. Through Expressionism, Surrealism, neo-realism, and primitive painting, they tore reality apart and reconstructed it according to their personal vision.[5]

ALTHOUGH THE REPETITION of traditional Islamic images continued side-by-side with contemporary Western art trends, this duality fostered the desire among Tunisian artists to inject Western artistic styles with local features. However, in spite of all the daring experiments, no distinctive style has set Tunisian contemporary art apart. The most common means by which artists have thus far situated their work in a Tunisian milieu has been their choice of subject matter: traditional forms and signs. The first to undertake original artistic interpretations totally grounded in their cultural background were Najib Belkhodja and Nja Mahdaoui, through their use of calligraphic forms in their abstract works.

7 MOROCCO

MOROCCO WAS THE only Arab province that was neither conquered nor governed by the Ottomans. Therefore, no Turkish influences are found in Moroccan culture and art. Morocco preserved its own art and architectural styles, descendants of a long unbroken tradition that goes back to Islamic Spain. It did not receive the uniform Turkish overlay from the sixteenth century onward, retaining an intact Berber art in the countryside as well as the high style of building in the towns.

The main sources of modern art in Morocco have been Islamic art, the European Orientalist school of painting (introduced after 1912), and Berber handicrafts. The latter display a tendency toward stylized vegetable and animal forms, geometric designs, and signs composed of straight lines and zigzags. All these decorative elements are imbued with mysterious constructions derived from the Berber script, *tifinagh*, which is used in ornamentation and from body tattooing.[1]

INTRODUCTION OF WESTERN ART

As we have seen, European expansion in the nineteenth century instigated a growing interest in North African culture. Numerous Orientalist painters came to Morocco, and Delacroix's visit in 1832 was a milestone in his own artistic career. Henri Matisse visited twice during 1912–13, while Nicolas de Staël lived in Marrakech in the period 1936–37. However, for most Western artists, Morocco signified Tangier, a partly Jewish city that had once been under Portuguese rule and English influence (due to its proximity to Gibraltar). The rest of the country was inaccessible to foreigners because of the dangers of tribal warfare and the fact that Christians were unwelcome unless they were accompanied by an ambassador, in the manner of Delacroix. The fact that Morocco was never under Turkish rule accounted for its individual character and grandiose architecture, which never failed to impress foreign travelers. Besides Delacroix, the most famous of the Orientalists to visit Morocco, several other artists—Alfred Dehodencq, Henri Regnault, and Émile-Aubert Lessore—came to paint in Morocco. Other artists who visited the country included the Italians Stafano Ussi and Cesare Biseo, the Englishman Her-

cule Barbazon Barbazon, the American Louis Comfort Tiffany, the Belgian H. J. E. Evenepoel, and the Swiss Frank Buchser.

The introduction of easel painting into Morocco is associated with the period around 1912, when it became a French protectorate. During this period, a Spanish zone was established on its north Mediterranean coast. The administration of Tangier and the surrounding country had "special characteristics" that meant it was under multinational control, including that of France and Spain. After 1912 several European painters came to live in Morocco and formed the "colonial school." Some were officials in the civil service, while others were professionals, such as doctors and lawyers, whose hobby was painting. They became the elite of the European colony, launching exhibitions and salons and founding artistic societies. Around 1918, the colonial administration transformed historical monuments into ethnographic museums, which included ateliers and exhibition halls. Subsequently, artistic associations such as La Kasbah in Rabat (1924) began to appear.

An example of this first generation of Moroccan painters is Mohamed ben Ali Rbatie (1861–1939), a prolific, self-taught artist who worked with gouache, painting many Moroccan ethnological scenes with a native's sympathetic perspective. He painted marriage, circumcision, and wedding celebrations, Royal Palace ceremonies, feasts, public places, and the like. Rbatie was one of a group of self-taught artists who made the transition to Western easel painting through his naive works.

Others artists managed this process by transforming miniatures and illuminations into free-standing canvases. One such artist was Abdelkrim Ouazzani (b. 1912), who painted themes drawn from the *Arabian Nights* as well as scenes of daily life. He executed several manuscripts, including a Qur'an, thus reviving a classical form of Moroccan art that was on the decline and injecting it with new vitality.[2]

NAIVE PAINTING

During the 1940s, local self-taught artists came in direct contact with resident colonial painters and began imitating their Orientalist style, although in an untrained, primitive manner. Tayeb Lahlou (1919–1972) was directly influenced by the Orientalist French painter Majorelle. Others followed a naive style full of fantasy. A representative of this second trend was Moulay Ahmed Drissi (1923–1973), who said: "What good is it to paint what everybody can see? I want to paint what I alone can see, to share it with others." He transformed the oral folk stories and legends into imagery and in 1945 was discovered by a Swiss couple, both of whom were painters. They bought his work and encouraged him as an artist.

Ben Allal (1924–1995), known as the poet-painter of Marrakech, was another self-taught artist who worked in the same naive narrative style as Drissi. He was discovered by his employer, the French painter Azéma, through whose encouragement ben Allal was able to hold his first exhibition in his native town of Marrakech, in 1948. Ahmed Yacoubi (1932–1987) was discovered in Fez at the age of sixteen by Paul Bowles, an American writer who had taken up living in Tangier before World War II. Yacoubi moved to Tangier, where he entered the cosmopolitan artistic milieu of Francis Bacon, William Burroughs, and Brion Gysen. In 1952 he exhibited his paintings in New York. Similarly, Mohamed Hamri (b. 1932), an illiterate naive painter, was discovered by the American artist Brion Gysen in the 1950s. Later on, professional artists also embraced the so-called naive folk style (among them the painter Chaïbia).[3]

WESTERN TRENDS AND EARLY ARTISTS

While the northern region of Morocco was under Spanish rule, several artists adopted the post-Impressionist styles. However, they were hardly recognized because the Spanish colonial authorities encouraged only Orientalist and naive painting. Few names are found in archives: el-Menebhi, an aristocrat from Tangier; Abdesselam al-Fassi Ben Larbi from Fez; and Jilali Ben Chelan, from Rabat. All their paintings could be classified as neo-Impressionist, in contrast to the work of their contemporaries, the miniaturists and the naive painters. However, none of their works have been found.

Moulay Ahmad Drissi, untitled, 1973. Paint on paper, 50 x 65 cm. Private collection.

After World War II, an academic trend developed when the Escuela de Bellas Artes was established in 1945 in Tetouan, a part of the Spanish protectorate. The school was administered by the Spanish painter Don Mario Bertuchi (1898–1985), who since 1930 had been the director of the École des Arts et Métiers, an institution dedicated to the revival of traditional Moroccan arts. One of the pioneers of Moroccan modern art, Mohamed Sarghini (b. 1923) was the first native to join the Tetouan school, where he later became director. In 1950 the French established a second art school, the École des Beaux Arts in Casablanca. Hassan El Glaoui (b. 1924) is another early Moroccan artist, although he appeared late on the art scene. Coming from a prominent Moroccan family, he trained in

France and did not return to his country until 1965.

Louis Hubert Gonsalve Lyautey, the first French resident-general in Morocco (1912–16 and 1917–26), revealed a particular appreciation for traditional Moroccan culture. He preserved many Islamic monuments and built new administrative buildings and cities (Casablanca) that were in harmony with the existing layout and the landscape around them. His policy of sustaining indigenous crafts was contrary to the systematic destruction of traditional culture that took place in Algeria. Following him, Prosper Ricard, director-general of the Service des Arts Indigènes (Service of Indigenous Arts), organized and directed crafts and continued Lyautey's old policy. He also played an active role in safeguarding the visual heritage of

Morocco by creating an archive of popular artistic traditions. Although Moroccan cultural heritage was unappreciated at the time, it later became a source of inspiration for the paintings and sculptures of modern Moroccan artists.[4]

EARLY MODERN TRENDS

Immediately prior to independence in 1956, contemporary styles of art from the West began to appear in Morocco. They were propagated by the schools of fine art, which helped make Moroccan modern art a profession. With the opening of the Escuela de Bellas Artes in Tetouan and the École des Beaux Arts in Casablanca, the Orientalist school and naive painting

began to lose their popularity. Furthermore, in the 1950s a few isolated painters, including Mahjoubi Aherdane (b. 1929), Meriem Meziane (b. 1930), Mohamed Melehi (b. 1936), Labiad Miloud (b. 1939), Ahmed Cherkaoui (1934–1967), and Farid Belkahia (b. 1934), worked separately to create a broad-based foundation for a modern Moroccan art movement. Emerging after independence, they received all or part of their training in the West. They were preoccupied with the search for a national artistic identity that would take advantage of both their Moroccan heritage and Western art techniques. These artists were instrumental in accelerating the emergence of a modern Moroccan art from the 1960s onward. Their work was

Ahmed Cherkaoui, *Solstice*, 1966. Oil on canvas, 168 x 168 cm. Collection of Nourdine Cherkaoui.

contemporaneous with the literary movement that reflected the same search for an authentic Moroccan identity.

However, the first avant-garde artist of the modern period in Morocco was Ahmed Cherkaoui (1934–1967). In the 1960s Cherkaoui became the first Moroccan artist to make a serious study of the significance of signs and motifs found in tattoos, pottery, jewelry, rugs, and leatherwork across the Atlas Mountains and in other parts of the country. When he included them in his plastic works, he did not copy them but graphically explored their shapes to give a mystical dimension to the composition. For Cherkaoui, color was as important as his Berber signs and motifs. He and his contemporaries of the 1950s generation established the framework in which Moroccan modern art would flourish.

In the 1960s art gained a degree of professionalism, thanks both to the increase in the number of students returning from scholarships abroad and to cultural exchanges between Morocco and Europe. Both of these developments influenced the formation of contemporary Moroccan art. New painters became preoccupied with the issue of a modern art that would foster an independent national identity to interact with the Arab world in particular and the Third World in general.

In December 1963 and January 1964 the International Meeting of Artists (Rencontre internationale des artistes) took place in Rabat. It succeeded in bringing together famous artists such as Picasso, Matisse, Miró, Fontana, Fautier, Dufy, Arp, Zao Wou-ki, Hartung, and Sougaï; the critics Michel Ragon and Pierre Restany and the architects Hausermann and Maymont; as well as a number of then-unrecognized Moroccan artists such as Belkahia, Cherkaoui, Aherdane, ben Allal, El-Glaoui, and Gharboui. The meeting was organized by a friend of Cherkaoui, El Fathemy, who had been the cultural counsellor at the Moroccan Embassy in Paris.

This gathering became a stepping-stone for Moroccan artists into the international art arena. It not only established first-hand contact between local and internationally renowned artists but also, for the first time, created an opportunity for dialogue between Arab and Western painters. After the Rencontre, Moroccan artists were convinced that to be contemporary one did not have to abandon one's own heritage. On the contrary, they came to realize that modernism in art could well coincide with Islamic aesthetics.[5]

MILESTONES

In 1964 Farid Belkahia, the director of the École des Beaux Arts in Casablanca, along with Mohamed Melihi and Mohamed Chebaa, began replacing the old models of Greek statues and still life paintings that students had to emulate, substituting reproductions of Moroccan handicrafts. They also added lessons in Arabic calligraphy to the school's curriculum. Known as the Casablanca Group, they took their art out to the public, with whom they wanted to interact, by displaying their works in the squares of Marrakech instead of in the galleries. They also protested the artistic programs of foreign bodies such as the Club Méditerranée (tourist villages built by a French company all over the world where cultural events are organized to entertain customers).

The Casablanca Group understood that since the colonial period a struggle between two images had taken place: a confused identity represented by pure folklore versus an autonomous artistic experience which dominated literature, theater, and the press. Members of the Association of Moroccan Writers, students, professors, and journalists pursued the same debate as to what was truly national and what merely appeared national.

During the 1970s a number of ateliers and commercial galleries were launched. The art movement thus gained a more professional character. In 1978 the annual Cultural Musim Asilah (cultural season of Asilah) was inaugurated. It is a unique phenomenon in the developing world, for it provides different venues for intellectual and artistic activities. Founded by the poet, journalist, writer, politician, and diplomat Muhammad Benaissa and the painter Mohamed Melehi, the cultural event takes place in their native village of Asilah in the summer and lasts for over a month. Each year it invites poets, writers, politicians, journalists, economists, and scientists to meet at the Afro-Arab Forum, an offspring of Musim Asilah, to

discuss a certain topic. Leopold Sedar Senghor, the former president of Senegal and Crown-Prince El-Hassan bin Talal of Jordan have been among the participants.

Visual artists from all over the world (Arab, African, South American, Asian, Australian) are invited to attend the cultural event and to spend the month working in the workshop or studio of their choice (graphic, sculpture, painting, ceramics). The artists boldly paint the whitewashed walls of the old part of town, which then resembles a gigantic labyrinth-like mural. Artists of other disciplines are invited to perform in the evening, and many local as well as internationally renowned groups give performances in the Moorish setting of the old palace, which serves as the headquarters of the Musim. There is also an art program for the children of Asilah, who are instructed in drawing and painting in the village square or on the beach by local and visiting artists. The whole atmosphere is informal. The Musim has not only revived this once-dead village on the Atlantic Ocean but has also preserved its old quarters and earmarked it as an important cultural forum.

Despite a national artistic endeavor that was both varied and promising, Moroccan artists lacked a proper organization until 1972, when the Association of Moroccan Artists was founded. It followed the creation of the Baghdad-based Union of Arab Artists in the same year. The association, which included forty members, made contact with artists in the Middle East and attended inter-Arab meetings in Algiers (1974), Tunis (1975), Baghdad (1972 and 1974), and other Arab capitals. During those meetings, Moroccan artists discovered their similarities to others, such as the Casablanca group and the One-dimension group in Iraq. They also discovered that contemporary Arab art followed a dual track that drew on Arab heritage while abiding by Western trends. Through their experimentation with calligraphy and the numerous Berber characters and folk motifs, Moroccan artists succeeded in establishing a unique modern artistic language that was unrestricted by academic teachings.[6]

8 | IRAN

THE DECLINE OF Persian art that set in during the eighteenth century paralleled the political degeneration of the country. Conditions similar to those in Turkey also appeared in Qajar Iran. Corrupt and weak rulers, government incapacity, an Afghan invasion, wasteful imperialistic enterprises of the Afsharid Nadir Shah, a succession of civil wars, and loss of foreign markets led to widespread poverty, despondency, and confusion, a climate hardly conducive to the development of the arts. No worthwhile monuments were built in this later period, and old ones became dilapidated through neglect, while standards in the applied arts declined. Artists managed to maintain their standards in just two domains, calligraphy and carpet weaving.

Clumsy and ungainly architecture, garish decoration, and cumbersome furniture flooded Iran, particularly from Russia, and increased contact with Russia and Western Europe began to influence Iranian art. To make matters worse, this type of art caught the fancy of the nobility and deprived the few remaining genuine Islamic artists of valuable patronage. Certain innovations began to appear in Qajar painting during the late eighteenth century, in both media and application, as artists began using oil paints and gradation in color. Portraits, in particular, became popular. However, artists continued to engage in manuscript drawing and lacquer painting.[1]

THE INTRODUCTION OF WESTERN ART

Despite the Western influences that began to appear in eighteenth-century Iran, only at the end of the nineteenth century and the beginning of the twentieth did Iranians, including students, start traveling to Europe in considerable numbers. One of the first artists to do so was Mohammad Ghaffari, known as Kamal-al-Mulk (1852–1940). He first studied painting at Tehran's newly created polytechnic, Dār al-Funūn, and in 1902 went on to study at academies in France and Italy, including the École du Louvre.

Kamal-al-Mulk introduced academic realism into Iran at a time when his countrymen were being exposed to Western technology and photography. He broke with the current formal stereotypes and adopted a naturalistic style that competed with the

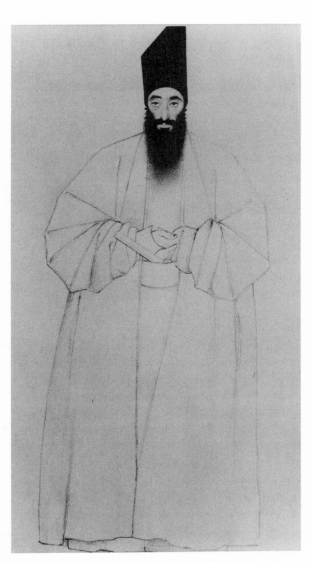

Sani' al-Mulk, *Portrait Sketch*, c. 1855. Pencil on paper, 20 x 35 cm. Muze Iran Bustan, Tehran.

camera in its depiction of fine detail. He looked at nature objectively, and his mastery of draftsmanship allowed him to record his subject matter down to the minutest detail. When he founded the School of Fine Arts in Tehran (Madrasa-ye Sanāye'-e Mustazrafa) in 1911, Kamal-al-Mulk transmitted his newly acquired Western academic style to his students. He introduced and promoted it among the public, despite the fact that it was already dying in Europe. Kamal-al-Mulk consequently became the painter-laureate of the last Qajar shah.

Another prominent Qajar painter was Abul-Hasan Khan Ghaffari, Kamal-al-Mulk's uncle, who had visited Italy in the mid-nineteenth century and studied painting techniques in the museums of Rome and Florence. Upon his return to Iran, Ghaffari did not teach art, however, and the influence of his European training was confined to his own work. Kamal-al-Mulk, on the other hand, was instrumental in introducing easel painting into Iran and fostering basic changes in Iranian painting and art appreciation. Meanwhile, traditional miniature painting in manuscript illustrations and traditional lacquer work were reduced to mere curios that in time gave way to academic easel painting.[2]

FOLK ART

Even though the traditional arts declined, popular art continued to be produced. The poorer classes remained attached to pictorial folk traditions manifested in qahwa-khaneh (coffeehouse) murals and in oil paintings that decorated local coffeehouses. Their themes were taken from stories of the classical Persian epic, Shahnama, and the accounts of the sufferings of Shi'ite martyrs. Votive folk art in shrines and saqqah-khāneh (public water fountain) banners, standards (flags), and symbols of martyrdom expressed in Shi'ite passion plays provided another level of artistic expression for folk artists and would prove to be a rich source of iconography for later modern Iranian artists.[3]

PIONEER ARTISTS

The main source of inspiration for most Iranian pioneer artists was nature, in particular their country's varied landscape. Artistic links with Iran's cultural past were almost indiscernible at first. Only during the mid-1950s did artists begin to search their heritage for inspiration in creating works the public could identify with. Sohrab Sepehri (1928–1980), a leading poet and modern painter, was the first artist to try to assert an Iranian element in his landscapes. Abul Qasim Sa'idi (b. 1926), an artist of Sepehri's generation who studied at the École des Beaux Arts in Paris, created colorful renditions of trees in blossom in which his lines had a strong calligraphic character. Naser Assar (b. 1928), a Paris-based artist, and Manushehir Yakta'i (b. 1922), who paints still lifes and portraits in an Abstract Expressionist manner, are also contemporaries of Sepehri.[4]

THE INTRODUCTION OF MODERN EUROPEAN TRENDS

The Allied forces who occupied Iran during World War II brought increased contact with the West and exposure to Western culture. After the war a number of Iranians traveled abroad to pursue their education, and many studied art in Europe and the United States. In the same period, exhibitions of the works of the Kamal-al-Mulk school took place in Tehran. The most important of these were shows held at the Iran-Soviet Cultural Society (VOKS) in 1946 and a series of exhibitions held at the Mehregan Club (headquarters of the National Teachers Association) in the early 1950s.

Modern Western trends in art were properly introduced into the Iranian modern art movement by artists who had completed their studies in Italy and France. Meanwhile, modernization in the form of a social, political, and cultural onslaught was rapidly overtaking Iranian culture, including art and literature. The most prominent among the new modernists was Jalil Zia'pur (b. 1928). After graduating from the School of Fine Arts at Tehran University, Zia'pur went to France and trained under the Cubist André Lhôte. Upon his return to Tehran, he started an art club and a monthly publication called Khorūs-e-Jangī (the Fighting Cock) with a group of friends in 1949.

Khorūs-e-Jangī, which championed the cause of modernism, became a rallying point for avant-garde painters, poets, and dramatists. The appearance of quasi-Cubist, Expressionist, and even abstract can-

Sohrab Sepehri, untitled, undated. Oil on canvas, 127 x 87 cm. Collection of Mr. Ehsan Yarshater.

vases at Tehran's first exhibitions triggered a public debate on the merits of modern art. The debate lasted nearly three decades and polarized artists and critics, alongside the "new versus classical poetry" controversy.

The 1940s brought about mainly derivative works dependent upon European models. They ranged from Impressionism to Cubism, Surrealism, and, to a lesser degree, abstraction; yet in their effort to master new techniques and assimilate new trends, Iranian artists overlooked originality. In the exhibitions of the 1940s, post-Impressionist masters were the main source of

inspiration, and figurative painting was dominant. On the other hand, Russian and German artists were studied less, and abstraction claimed only a minimal following.[5]

ART PATRONAGE

By the mid-1950s the government had become aware of the importance of patronage for contemporary artists. The Department of Fine Arts (later to become the Ministry of Arts and Culture) recognized the significance of regularly organized major art exhibitions in order to support the modern art movement in Iran

while paving the way for the participation of Iranian artists in international events such as the Venice Biennial. In 1954 Marcos Gregorian (b. 1925) returned to Iran after completing his art training in Italy. He opened the first art gallery in Tehran, the Gallerie Esthétique (1954–59). In 1958 Gregorian organized the first of the five Tehran Biennials undertaken by the Department of Fine Arts. The first four, held at the Abyaz Palace in the Golestan Palace compound, showed only works by local artists. The last Tehran Biennial took place in 1966 at the Ethnographic Museum, this time with the participation of artists from Turkey and Pakistan.

In the first biennial, all the major Western styles of art were represented. With every following exhibition, abstract works increased in number, along with some explicitly Iranian subjects. By the third Tehran Biennial, the styles and techniques of paintings were no longer uniform. It was here that the first national trend in painting emerged, in the works of Hosseyn Zenderoudi, the initiator of the Saqqah-khāneh School. When the last biennial was held in 1966, the organizers were hoping to transform it into an Asian exhibition, hence the inclusion of thirty-seven Pakistani and Turkish artists. Iranian participation was cut from 113 to 38 to create an equilibrium between visiting and national artists. The Tehran Biennial was never repeated after 1966, although the reason for terminating this important artistic event was not made public.

The state began to play an effective role in the development of contemporary Iranian art in the 1970s. The Ministry of Culture opened two exhibition halls, Oftab and Mehrshah, and subsidized privately owned galleries. Artists were sent abroad to participate in international exhibitions such as the Venice Biennial and the Salon d'Automne in Paris. Various government ministries began commissioning artists to execute works for public buildings. A number of modern art museums were also established.

Private collections of modern art were started by Ebrahim Golestan and Kamran Diba, and the Lajevardi family amassed a formidable collection of contemporary Iranian art. Large corporations also started their own collections, following the example of the Behshahr Group, which accumulated around four hundred contemporary Iranian paintings. Heading the list of private collectors was the Empress Farah Pahlavi, who had already built a comprehensive collection of modern Iranian art, which she later donated to various museums in the country. Meanwhile, the late Prime Minister Amir Abbas Hoveyda built up a collection for the Office of Prime Minister.

In 1977 the Tehran Museum of Contemporary Art (*Muzāye Honarhāye M'āser*) was established under the auspices of the Farah Pahlavi Foundation, which was responsible for funding several other museums and cultural centers. Kamran Diba was appointed director of the museum, which was devoted to collecting works by international Western artists ranging from the Impressionists of the last century to the Minimalists and the Conceptualists of the 1970s. The museum consisted of several departments including painting, sculpture, works on paper, graphic art, photography, and architecture. The extensive budget that was allocated by the museum to accumulate Western masterpieces is an indication of the extent of the cultural Westernization that took place in Iran before the 1978 Islamic Revolution.

The museum's plans to build a permanent, in-depth collection of modern Iranian works came to a halt with the outbreak of the Islamic Revolution. After the revolution, the activities of the museum shifted from international art to revolutionary propaganda, although it has recently reinstalled part of its permanent collection. Rotating exhibitions as well as temporary shows by prominent Iranian artists are currently held. They stress photography, graphics (mainly pro-revolutionary posters), and supernaturalistic paintings.[6]

THE TEACHING OF ART

Kamal-al-Mulk, who established the School of Fine Arts (Madrasaye Sanāye' Mostazrifa), the first in Tehran, as noted previously, served as its director until he retired in 1928. Art classes at the new school followed Western academic techniques, and students were trained in these new styles in preference to traditional Islamic ones. The academic training they received was based on a naturalistic figurative technique that depicted the minutest detail in a photography-like rendering. One example is the work of Ravi Samimi. This

approach gained such popularity that it persisted from the 1920s until the mid-1940s. The students and graduates of the Madrasa ignored the new art trends in Europe, such as Cubism, Surrealism, Expressionism, and abstraction. The "modern" Iranian artists, who worked in oils and watercolors, painted Iranian family gatherings, street scenes, landscapes, and floral still lifes in their newly discovered academic style. Less serious painters made copies of central European landscapes depicting snow-clad mountains, scenic lakes, and castles with green pastures in the foreground.

Four years after Tehran University was established in 1934, it opened its School of Fine Art, where a number of Kamal-al-Mulk's disciples took up key positions. For almost a decade, they managed to hold back the advent of modern Post-impressionist schools. Miniature painting in the Safavid style was also practiced by this school of artists.

In 1961 the School of Decorative Arts (Madrasaye Honarhāye Tazyīnī), was created, mainly for graduates of secondary schools who had been refused admission to the School of Fine Arts at Tehran University. The School of Decorative Arts gave diplomas in applied arts, such as interior decoration and graphics. A number of its graduates successfully established themselves, and some critics therefore rated it higher than the School of Fine Arts in training artists. Unlike their peers at the School of Fine Arts, the first teachers at the School of Decorative Arts were instrumental in fostering a less formal approach in the choice of subject matter and media treatment. In the late 1970s, the School of Fine Arts expanded its program and employed a number of prominent artists on its faculty. Meanwhile, the government intensified its program of sending students to European art schools.[7]

ART GALLERIES

Several art galleries that opened in the 1960s and early 1970s in Tehran had the effect of stimulating artistic activities. The short-lived Club Rasht 29 was founded by the architect, painter, collector, and art sponsor Kamran Diba, the sculptor Parviz Tanavoli, and Roxanna Saba. Painters, actors, musicians, and writers

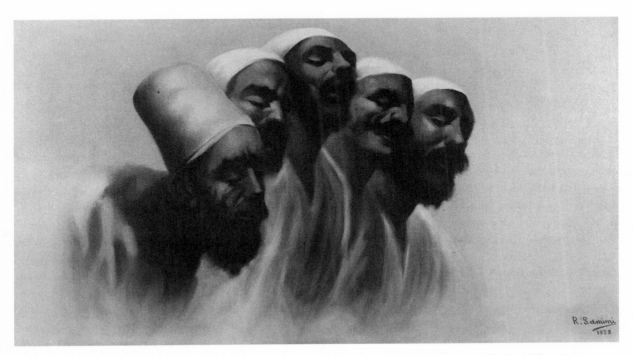

Ravi Samimi, *The Biktashi Dervishes,* 1952. Oil on canvas, 40 x 70 cm. Courtesy of the Jordan National Gallery of Fine Arts, Amman.

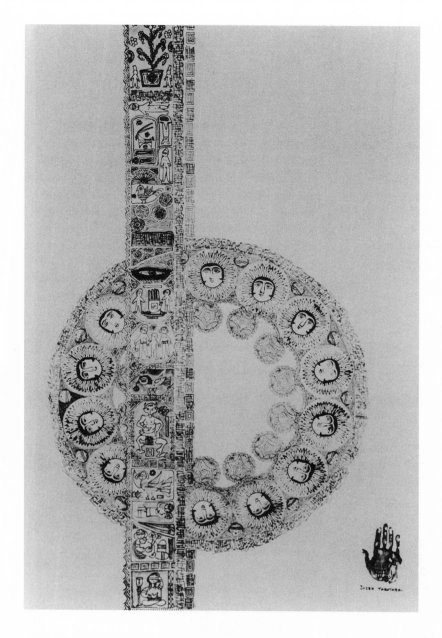

Jazeh Tabataba'i, untitled, undated. Oil on canvas, 188 x 121 cm. Collection of Mr. Ehsan Yarshater.

met there to discuss their work and to attend poetry readings, informal theater performances, and musical recitals. The Club Rasht 29 held Iran's first auction of contemporary art, which was attended by Empress Farah Pahlavi and Prime Minister Hoveyda, both of whom were among the most prominent collectors in Iran.

Foreign cultural societies and centers such as the Iran-American Society and the Goethe Institute also held regular exhibitions for local artists.[8]

LOCAL TRENDS IN ART

Since the 1950s Iranian artists have sought a local style that would distinguish their work from current inter-national trends. In the first attempts to give Western styles local features, artists chose Iranian themes. For example, they painted peasants and women wearing the *chadur* (a piece of cloth worn by the masses that covers a woman from head to toe) in Cubist or other well-known European styles. Some of the works incorporated motifs borrowed from ancient reliefs of Persepolis and Islamic manuscripts. The interpretation of local subject matter through Western techniques was not always successful nor was it appreciated by the Tehran Biennial juries. Some artists grew tired of emulating Western trends and sought to establish a school of Persian painting whereby they could assert their individuality and cultural identity. They were encour-

aged by the cultural establishment, which hoped to foster the emergence of a national school of art.

Prior to the Islamic Revolution, the Iranian government pursued a dual path in its quest for modernization. On the one hand, it spared no effort in pushing the country into the mainstream of Western culture and technology, and on the other, it tried hard to evoke the people's pride in their ancient past. This pride manifested itself through celebrations such as that held by Shah Mohammad Reza Pahlavi in Persepolis in 1971, on the occasion of the 2500th anniversary since Cyrus had founded the first Iranian empire. As for the Islamic tradition in the country, a concerted effort by the government to ignore and even push it into obscurity continued until the revolution. In spite of the official policy that tried to obscure religion and the role of Islamic culture, the only original

modern trend in Iranian art resulted from an inquiry into Shi'ite heritage and religious rites. The search led to the beginning of a national artistic identity: the Saqqah-khāneh group.

The *saqqah-khāneh* is a small public water fountain found in the old quarters of every town and village in Iran. It is set in a recessed niche with a cistern and a brass bowl, where passers-by may help themselves to a cool drink. It is similar to the *sabīl* (public drinking fountain), and is built by individuals as an act of piety and benevolence to commemorate Imam Husayn's martyrdom. Husayn, the grandson of Prophet Muhammad and the third Shi'ite Imam, died at Karbala' during a battle with the Umayyad army (680 A.D.), after being tortured for two hot and waterless days. Thus, the saqqah-khāneh is regarded as a holy place where vows are made and candles are often kept

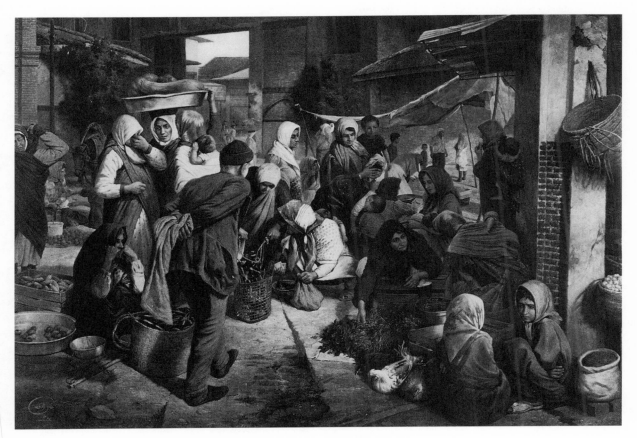

Mahdi Mohammad Ali Zadeh, *Bazaar*. Oil on canvas, 160 x 110 cm. Artist's collection.

burning. The pious also display green and black drapes around it and engrave decorative signs and verses from the Qur'an on its protective wrought-iron grillwork and the sides of the cistern. The whole arrangement is a specimen of popular religious art.

The main propagators of the Saqqah-khāneh trend were Hosseyn Zenderoudi, Qandriz Pilaram, Mas'ud Arabshahi, Sadeq Tabrizi, Mansur Qadriz, Parviz Tanavoli, Naser Ovisi, and Jazeh Tabataba'i. They drew on Iran's Shi'ite cultural and religious heritage, using traditional folk motifs and Arabic calligraphy and blending them within modern compositions, executed in Western techniques. (The Saqqah-khāneh group is further discussed in chapter 14.)

After the Islamic Revolution, official patronage of avant-garde art ceased, and works following the latest Western styles were not displayed. Instead, the Tehran Museum of Contemporary Art exhibited naturalistic works in the style of Kamal-al-Mulk, as well as propagandist or revolutionary works. Also on display were Surrealist paintings illustrating the theme of martyrdom, with elements similar to those used by the Saqqah-khāneh artists, yet in different renditions. The only style that did not suffer a setback was calligraphic painting. Meanwhile, most art galleries closed down, museums halted their activities to revise their policies, and a number of established artists left the country.

A revival in the visual arts has since taken place, expecially in cinema. Iranian films have won international awards. In painting, the revival took the shape of a return to the classical style in figurative painting, depicting as closely as possible the ideal form of nature, as in the works of Mahdi Mohammad Ali Zadeh. Less work is done in the Western post-Impressionist and Modern styles, and still fewer experiments are related to the Iranian Saqqah-khāneh group. For a country that is trying to go back to an Islamic way of life, a disturbing dichotomy results when artists turn to purely classical Western aesthetics, in a three-dimensional imitation of nature, instead of drawing on the stylization, abstraction, and two-dimensionality found in classical Islamic art.

Above: Ismail Shammout, *Where To?* 1953. Oil on canvas, 125 x 95 cm. Courtesy of Mr. Ismail Shammout.

Right: Madiha Omar, *Hanging Gardens,* 1962. Oil on canvas, 116 x 81 cm. Courtesy of the Jordan National Gallery of Fine Arts, Amman.

Right: Jamil Hamoudi, *People Are Equal Like the Teeth of a Comb*, 1976. Oil on canvas, 145 x 100 cm. Courtesy of the Jordan National Gallery of Fine Arts, Amman.

Below: Osman Waqiallah, untitled, 1991. Watercolor and collage on paper, 58 x 41 cm. Courtesy of the Jordan National Gallery of Fine Arts, Amman.

Top: Kamal Boullata, *Huwa,* 1988. Silk screen, 40 x 40 cm. Private collection.

Left: Kamal Boullata, *Revolution,* 1978. Silk screen, 61 x 50 cm. Courtesy of the Jordan National Gallery of Fine Arts, Amman.

Above: Wijdan, *Karbala'*, 1992. Mixed media on hand-made paper, 62 x 98 cm. Private collection.

Right: Wajih Nahle, *Al-Fatiha,* 1972. Gold leaf and polyester on wood, 150 x 122 cm. Artist's studio.

Facing page, top: Khairat al-Saleh, *The Creation 2.* Gouache, gold leaf, and ink on paper, 46 x 70.5 cm. Courtesy of Mrs. Suha Shoman.

Facing page, bottom: Ahmad Moustafa, *Qur'anic Fugue,* 1976. Silk screen, 65 x 90 cm. Courtesy of the Jordan National Gallery of Fine Arts, Amman.

Above: Ahmad Moustafa, *God Is the Light of Heaven and Earth,* 1987. Oil and watercolor on hand-made paper, 125 x 76 cm. Courtesy of Dr. Ahmad Moustafa.

Right: Parviz Tanavoli, *Hich,* undated. Bronze, 17 x 5 x 5 cm. Courtesy of the Jordan National Gallery of Fine Arts, Amman.

Right: Mahmoud Taha, untitled, undated. Glazed ceramic, 40 x 40 x 9 cm. Courtesy of the Jordan National Gallery of Fine Arts, Amman.

Below: Ahmad Moustafa, *Still Life of Qur'anic Solids,* 1987. Oil and watercolor on hand-made paper, 125 x 76 cm. Courtesy of Dr. Ahmad Moustafa.

Left: Shaker Hassan Al Said, *Letters and Colors,* 1991. Oil on wood, 120 x 120 cm. Courtesy of the Jordan National Gallery of Fine Arts, Amman.

Below: Etel Adnan, *Allah,* 1987. Mixed media on paper, 30 x 75 cm. Courtesy of the Jordan National Gallery of Fine Arts, Amman.

Ramzi Moustafa, *Allah,* 1988.
Acrylic on canvas, 153 x 85 cm.
Courtesy of the Jordan
National Gallery of Fine Arts,
Amman.

Left: Ali Omar Ermes, *The Letter Kāf*, 1979. Mixed media on paper, 65 x 95 cm. Courtesy of the Jordan National Gallery of Fine Arts, Amman.

Below: Shaker Hassan Al Said, *Wall Strip no. 4*, 1992. Mixed media on wood, 122 x 122 cm. Courtesy of the Jordan National Gallery of Fine Arts, Amman.

Above: Khalid Khreis, untitled, 1992. Mixed media on paper, 70 x 50 cm. Courtesy of the Jordan National Gallery of Fine Arts, Amman.

Left: Mahmoud Hammad, *Calligraphy,* 1985. Oil on canvas, 60 x 75 cm. Courtesy of the Jordan National Gallery of Fine Arts, Amman.

Right: Khalid Khreis, untitled, 1990. Mixed media on paper, 65 x 49 cm. Courtesy of the Jordan National Gallery of Fine Arts, Amman.

Below: Nja Mahdaoui, *Calligraphic Composition,* undated. Silk screen, 27 x 39 cm. Private collection.

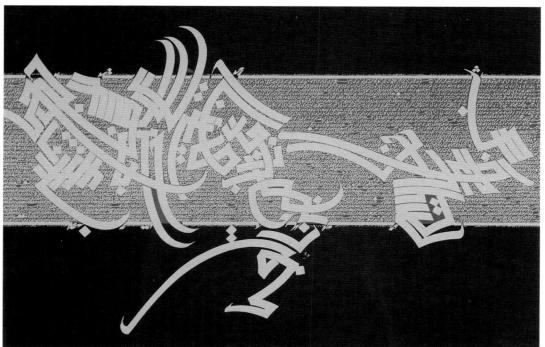

Right: Rafa al-Nasiri, untitled, 1967. Etching, 35 x 25 cm. Gulbenkian Foundation. Courtesy of Rafa al-Nasiri.

Below: Rafa al-Nasiri, *Nature's Visions,* 1981. Acrylic on canvas, 120 x 100 cm. 1981, Courtesy of the Jordan National Gallery of Fine Arts, Amman.

Above: Vladimir Tamari, *Jerusalem*, 1991. Watercolor on paper, 60 x 80 cm. Courtesy of Mr. Ismail Shammout.

Below: Issam El-Said, untitled. Oil on canvas, 65.5 x 55.5 cm. Courtesy of Mrs. Dina El-Said.

Right: Dia Azzawi, *What Al-Nifari Said to Abdullah no. 3*, 1983. Mixed media on paper, 110 x 75 cm. Courtesy of the Jordan National Gallery of Fine Arts, Amman.

Above: Issam El-Said, *Happy Feast,* 1981.
Mixed media on paper, 31 x 28 cm.
Courtesy of Mrs. Dina El-Said.

Right: Issam El-Said, *I Once Had a Bulbul,*
1967. Mixed media on paper, 25 x 25 cm.
Courtesy of Mrs. Dina El-Said.

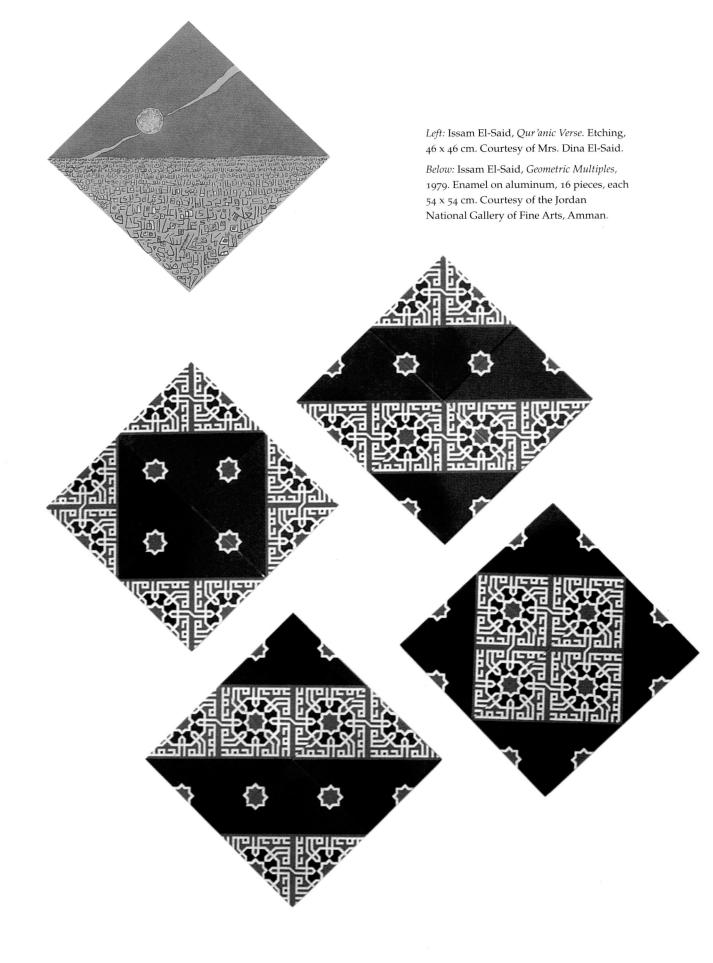

Left: Issam El-Said, *Qur'anic Verse.* Etching, 46 x 46 cm. Courtesy of Mrs. Dina El-Said.

Below: Issam El-Said, *Geometric Multiples,* 1979. Enamel on aluminum, 16 pieces, each 54 x 54 cm. Courtesy of the Jordan National Gallery of Fine Arts, Amman.

9 SYRIA

DAMASCUS HAS BEEN famous for its traditional crafts as far back as the Umayyad period in the eighth century. Since at least the mid-nineteenth century, however, these crafts have experienced little growth or evolution in traditional designs and forms. In metalwork, inlaying, weaving, and woodwork, craftsmen repeated ad infinitum the old forms and motifs, but for all their dexterity and skill they showed no innovation. The lack of development in Islamic crafts, along with the strong influences coming from abroad, was the background for the penetration of Western artistic styles and aesthetics into Syria.

Wall painting has been practiced in Damascus, the regional capital of the Ottoman province Bilād al-Shām, since the sixteenth century. The earliest example, now in the Berlin State Museum, consists of wood panels from an Aleppo room that date to 1600. More recent examples are the 1,737 wall panels in the Qasr al-'Azim in Damascus, and those of Qasr al-'Azim at Hama, which date to 1830. Other painted wall panels can be found in old Damascene residences such as Dar al-Siba'i, Dar al-Mujallad, Dar Huraniyya, and Dar Jabri. In Aleppo, similar paintings are found in Dar al-Dallal and Bayt Ajiqbash, as well as the Kaylaniyya in Hama. The themes of the painted wooden wall panels are analogous to Ottoman examples in Turkey. Private homes and public baths had murals depicting bouquets of flowers and vases, fruit bowls, sea views, landscapes, and views of Istanbul, Mecca, Medina, and Jerusalem, which were totally devoid of human figures. The artisans who made these sorts of paintings were anonymous decorators, whom we know only by their signatures. The most famous were Abu Sulayman al-Khayat, his sons, and his two assistants, Ahmad Mahfud and Nadir Odabashi.

Painting on ceramic tiles was also found. Large murals were made up of individual small, color-glazed square tiles depicting views of Mecca and Medina or merely floral and geometric designs. Two known artists of painted ceramics are Muhammad al-Dimashqi, who has one work dating to 1726 in the Islamic Museum in Cairo, and Fadil bin 'Ali bin 'Umar al-Dahir al-Zabadani al-Safadi (1760–?), who was known for his landscapes.

Three other common types of painting in Syria in the second half of the nineteenth century were Christian church icons, painting on glass, and on textiles. Icon painting may well have developed in Syria during the Byzantine period and continued into the nineteenth century. The Syrian artists Yusuf al-Mussawir and his son Ni'mat al-Halbiyan developed a local style derived from indigenous tradition in the early eighteenth century. Between 1809 and 1821, the Greek painter Michel al-Kriti lived in Syria and trained local artists, initiating a new Western trend in icon painting that evinced greater skill in figuration. Among the well-known Syrian icon painters were Jurji al-Mussawir, Ni'mat Nasir al-Humsi, and Butrus al-'Ajami, who left a number of iconographic paintings done in an impersonal naive style. The icon painters were minor clergy of simple stock who painted to satisfy their religious needs and those of their parishioners, not to attain fame through their art. There is a wealth of local icons in churches throughout Syria, though a full survey of them has never been undertaken.

The second type of painting, on glass, may have been introduced by the Ottomans into Syria. These panes of glass illustrated popular stories such as *A Thousand and One Nights*, *'Antar and 'Abla, Abū Qāsim al-Ṭanbūrī*, and *al-Zīr Sālim*. They were based on folk literature that extolled courage, love, chivalry, generosity, and faithfulness, albeit poorly written in a colloquial Arabic. The glass paintings frequently decorated coffeehouses, where the stories they illustrated were recited by the *ḥakawātī*, a storyteller who moved between popular coffeehouses at fixed times, usually in the evening, to entertain the customers. (It would take him several days, sometimes weeks, to reach an end to a story, thereby securing the continuous presence of his audience.)

Unlike painted murals, glass paintings included human and animal figures and often depicted a mounted hero and fighting scenes. They were also hung in shops in the old *sūq* (marketplace). The subjects were painted on the reverse side of a glass pane, in bright, primary colors and a simple naive style, without any consideration for depth or anatomy. The painter usually wrote the name of the depicted personage above his or her picture. People commissioned popular painters to make copies of the originals. Some copies were carefully executed, while others were badly done.

Mutwalli Muhammad 'Ali al-Mussawir (1880–1963), Harb al-Tinawi (1883–1973), and his son Subhi are among the best-known glass painters. Al-Tinawi continued to make glass paintings until he died, selling them to collectors and tourists for a nominal price. A shy and modest person, he was oblivious of his fame, refused to talk to journalists, and hardly took notice of the exhibitions of his works that his customers mounted in Beirut and Paris.

The third style of visual art in nineteenth-century Syria was the practice of painting on textiles, a craft of long standing in the area. These stylized pictures are usually painted on calico in bright colors, and, like painting on glass, they are concerned with popular stories and their heroes. They were also used to decorate coffeehouses, shops, and private homes of the lower classes.

Syria experienced the first European influences through Ottoman art. As early as the end of the eighteenth century, European-influenced Ottoman decorative styles in wall painting began to appear in the houses of Aleppo and Damascus. Local artists gradually turned to Western art styles and adapted them to their native art forms. By the late nineteenth century, it was common for Syrian notables and politicians to have their portraits painted, and imaginary landscapes painted in pastiche, postcard style also began to appear on the walls of their houses. Such works were made by Bishara al-Samra, an early portrait painter who also portrayed religious subjects. However, the first painters to adopt Western techniques were anonymous amateurs who practiced their art in a copied manner far from the limelight, leaving no recorded information on them or their work.

By the twentieth century, painting had become alienated from its traditional places of appearance: murals, books, and the surfaces of artifacts such as lamps, vases, and other utensils. Free-standing easel painting gradually became the norm. The early beginnings of a Western-style art movement in Syria came much later than in Lebanon and took about four decades to gain momentum. Two styles in art have influ-

enced the earliest known Syrian painters: the Ottoman classical style of copying nature and the Orientalist style of the Western painters who visited the Levant. At times the two fused into an early Syrian type of representation. The best-known artist since the Ottoman period was the soldier-painter Tawfiq Tariq (1875–1945), who is considered the earliest pioneer of modern Syrian art to introduce oil paints and canvas. Through his strong personality and his skill, he was able to win the public's admiration and respect and to impose his highly naturalistic style on the works of the students he trained in his Damascus studio.

Munib al-Naqshabandi (1890–1960) was another pioneer. In his home town of Aleppo, he owned a studio where he offered painting lessons. Nothing of significance is known of al-Naqshabandi's private life. His painting *The Entry of the Arab Army into Aleppo,*

depicting King Faisal's armies marching into his hometown after ending Turkish rule in 1918, was the first work to deal with a contemporary subject related to an important national event. This became a model emulated by his students. Several other young artists, contemporaries of both Tariq and al-Naqshabandi, worked on their own in the same academic style. They included Nadim Bakhash and Nadim Naqshabandi in Aleppo; 'Abd al-Hamid 'Abd Rabbu, 'Abd al-Wahab Abu'l-Su'ud, Michel Kirsheh, George Khoury, Khalid Ma'ad, and Sa'id Tahseen in Damascus; and Subhi Shu'aib in Hims.[1]

ORIENTALIST AND IMPRESSIONIST INFLUENCES

With the end of Turkish rule in 1918, King Faisal I, the son of Sharif Husayn bin 'Ali of Mecca, ruled over an Arab government in Syria from March 8 to July 25,

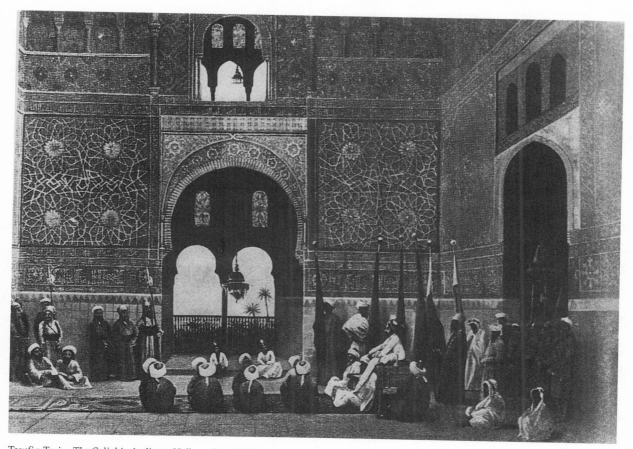

Tawfiq Tariq, *The Caliph's Audience Hall,* undated. Oil on canvas, 46 x 24 cm.

Nasir Shoura, *Town of Maaloula*, 1988. Acrylic on canvas, 77 x 59 cm. Courtesy of the Jordan National Gallery of Fine Arts, Amman.

1920, when French armies defeated Faisal's troops. The country fell under the French Mandate until its independence in 1946. The years between 1920 and independence witnessed the profound influence in Syria of French Orientalist painting and Impressionism. The former recorded historical events with particular emphasis on detail, while the latter took the artists out of their studios into nature and gave priority to color and light. These influences were exerted through visiting French artists. Jean Carzou, a Frenchman born in Aleppo in 1905, whose Armenian-Syrian father was a photographer, also influenced local art. After his father's death, Carzou left to Paris where he established himself. He made frequent visits to Syria and Lebanon, often exhibiting his work there.

Maurice Denis visited Damascus in 1921 while Van Dongen, Kandinsky, and Kokoschka also made short trips to the country. During the mandate, Syria's high commissioner, General Weigand, awarded the painter Jean Charles Duval a scholarship to the Institut Français de l'Art Islamique in Damascus. Duval recorded different parts of Damascus and its environs in his paintings, as well as the castle in Aleppo and other Syrian landscapes and cities, including Hama and Hims. Another French artist who sojourned for some time in Syria was Michelet; he made a considerable

number of paintings before leaving in 1946. Although there is no record of their having trained young local artists, the foreign painters were instrumental in introducing Western painting into Syria by exposing the public to their work.

The first artists to free painting from its blind imitation of nature and search for a distinctive individual style were 'Abd al-Wahab Abu'l-Su'ud (1897–1951), on whose early works the influence of Tawfiq Tariq is evident; Sa'id Tahseen, (1904–1986) who in 1943 became the first artist to establish an artistic society in Syria, the Arab Society of Fine Arts; and Mahmoud Jalal (1911–1975), a painter and probably the first Syrian sculptor.

The influence of Impressionism reached Syria in the interim through indigenous artists who had gone to Europe on scholarships, as well as visiting foreign artists. The two most prominent early Impressionist artists were Michel Kirsheh (1900–1973) and George Khoury (1916–1975). Kirsheh was a prolific artist who went to Paris and was greatly influenced by French Impressionism, which he adopted in depicting the environs and streets of Damascus. Impressionism was also the focus of the painting lessons he taught in secondary schools, which left an indelible imprint on a generation of students. Khoury was a self-taught artist who also promoted Impressionism through teaching in secondary schools. Along with other self-taught artists such as 'Abd al-Hamid 'Abd-Rabbu, Subhi Shu'aib, Ramzia Zumbarakchi, Khaled al-'Asali, Ghalib Salem, Farid Bakhash, and Khalid Ma'ad, he made every effort to introduce art to the general public and to gain its acceptance.[2]

EARLY ARTISTIC ACTIVITIES

This first generation of pioneers formed small groups that held sporadic exhibitions, which were encouraged by some foreign missions and embassies. The first group show in Syria took place in 1928 as part of the Exhibition of Ancient and Modern Crafts. The second one was held during the Damascus Fair of 1936.

Prior to World War II, Mussolini's government in Italy had offered Syrian students a group scholarship, bringing Mahmoud Jalal, Salah Nashif, Rashad Qusaibati, and Suhail Ahdab to Italy to study art. The

Italian government hoped to disseminate Italian culture in Syria, but this was not welcomed by the French authorities, who put a halt to all further scholarships. In 1938 the first group of students returned from Italy just as the French authorities sent a second group (Nasir Shoura, Nazim Ja'fari, and Sharif Orfali) to Egypt for their art training. Members of both groups became pedagogue-artists who were instrumental in shaping the modern art movement in Syria. Until the end of the 1930s, Syria produced a very limited number of painters. Most artists who were active during the interwar period had studied in Paris or Rome and had returned with a purely academic concept. Those who embraced Impressionism did so at a time when it was already passé in the West.[3]

ART GROUPS AND EXHIBITIONS

By the 1940s artists began to sense a need for more organized associations that would give their work the recognition it deserved. They realized the necessity for specialized exhibition space and the significance of spreading art education and appreciation among the public. They first joined existing clubs such as the House of National Music (dār al-Mūsīqa al-Waṭanīyah), which had a fine arts branch. It was replaced a few years later by the Damascus National Club for Sports (al-Nādī al-Rīyadhī al-Waṭanī). The club's art section held an independent group exhibition for foreign and local artists in 1941 at the Law Institute. That same year young artists from the two clubs joined to form a new group, Studio Veronese. They chose a green paint tube (vert Veronese) as their emblem.

The only art education accessible at the time came from the few available art books and periodicals, and from the occasional foreign exhibition that came to Damascus, such as the Polish Exhibition held at Hotel l'Orient in 1944. This show introduced modern art to Syrian artists. Studio Veronese became the nucleus for the Arab Society of Fine Arts, which was established in 1943 and offered art lessons at its center. In 1944 the new society held a major group exhibition at the Institut Laïque. It included Syrian artists from all over the country as well as resident foreign artists.

Meanwhile, a widespread political movement in the country called for an independent Syria. One of the

earliest nationalistic art manifestations took place after French soldiers attacked and burned the Parliament building, killing its Syrian police garrison. Several members of the Arab Society depicted the incident in their paintings. They also painted large, symbolic works portraying the colonial authorities' mistreatment of the people, and carried them in a demonstration organized in commemoration of the first anniversary of the evacuation of French troops from Syria.

The long years of World War II brought suffering in the form of severe rationing of food and other materials, while internal resistance to the French occupation became increasingly violent. The public was indifferent to modern art. With very rare exceptions, art appreciation among the affluent was limited to collecting traditional Islamic pieces such as Persian carpets, Syrian inlaid furniture, Islamic artifacts, and Chinese porcelain. These collectibles were simultaneously utilitarian and a means of investment, while paintings and sculptures were regarded as worthless because they were inexpensive and did not serve any purpose. Modern artists worked under difficult conditions, without any support from the public, and those who persevered did so out of dedication and belief in their profession.

Realism and figurative art were the norm among Syrian artists. Painters who wanted to work from life had to get written permission from the authorities to paint outdoors; otherwise they were subject to various forms of harassment. Furthermore, art supplies were difficult to find. At times, artists had to improvise to be able to work at all. They used to grind natural color granules used for house painting, mix them with linseed oil, and insert the mixture into empty toothpaste tubes. Instead of canvas, they used empty wooden tea boxes, which they broke down into boards and then painted on them after preparing the surface. In the later stages of the war, some artists managed to get permits from the Supply Authority to buy wood for their paintings, just like carpenters.

Matters improved with the end of the war. In 1948, a major exhibition of the Paris School was held at the Institut Laïque in Damascus and included works by Picasso, Modigliani, and Van Dongen. Through this exhibition, Syrian artists were further exposed to modern Western art trends.

The formation of artistic societies has continued since the 1950s. The Society of Art Lovers, whose founders were intellectuals and artists, including Michel Kirsheh and Nasir Shoura, was founded in 1950. In 1965 the Syrian Artists Association was established; practicing painters and sculptors were among its membership. Art societies were formed in Syria's other major cities as well. In Aleppo, an artistic society was founded in 1956. Its most important contribution to local artists was the opening of the Assarian Academy, where the Syrian-Armenian artist Kaplan offered art classes for budding local talent. In Hama, a similar society started in 1955, offering regular painting classes by the painter Suhail Ahdab. The Circle of Social Totality and the Arts was founded in Damascus in 1961, replacing the Artists Association, while the Society of Friends of Art was formed in 1963 and remains active today.

All the art associations played an important role in the development of modern art in Syria. They created venues and opportunities for young artists, writers, and poets to meet, exchange ideas and opinions, and develop new concepts. New painting engendered a heated discussion among the members, although the artists, who were driven by their love of art, received hardly any income from selling their work.[4]

THE INFILTRATION OF MODERN TRENDS

The end of France's Mandate over Syria in 1946 marked the beginning of an active modern art movement that witnessed a rapid development in the field of plastic arts. New talent began to appear after the war. Syrian artists concentrated on local subjects and indigenous qualities, thereby fostering a closer rapport with the public. Art became more generally appreciated as the public began to look more favorably upon painting and sculpture. Though the prevalent style was still Impressionism, it grew local characteristics through the choice of a subject matter that depicted scenery from the countryside and the old quarters of Damascus and other Syrian cities. The public's preference for this kind of representation was

reflected in its popularity. Other styles such as Surrealism also appeared, through which highly symbolic works were created. However, Surrealism was never widely accepted, and realism continued to dominate the art scene.

A second generation of pioneers appeared in the 1950s, giving the Syrian art movement momentum. Nasir Shoura (1920–1992) was the leader of Syrian Impressionism, and until 1960 he was the major artist of that style. Fateh Moudarres (b. 1922), who developed a highly personal Expressionist style that he called "surrealistic and figurative with a strong element of abstraction," is one of the leaders of the modern art movement in Syria. Among the first Syrian artists to look for a genuine Arab identity in his work and one of the first to liberate his work of realism was Adham Isma'il (1922–1963).

Besides the three artists mentioned, Salah Nashif (1914–1970), Rashad Qusaibati, Robert Malki (b. 1923), Nazim Ja'fari (b. 1918), and Fathi Muhammad (1917–1958) are also considered among the second generation of Syrian pioneers and catalysts of the modern art movement. Most of them trained in either Egypt or Italy and worked in the field of art education, where they gave students the benefit of their experience. They searched for individual styles through personal experiments and research. Between 1938 and 1960, they were active in forming artistic societies that played an important role in educating the public about art. Through this group of artists, the art movement graduated from the realistic stage, with its simple intellectual background, to an advanced stage that tried to construct its own cultural personality.

Borrowing from Arab-Islamic traditions continues among a group of Syrian artists who draw on calligraphy, miniatures, folk art, and the arabesque. Artists combine these traditions with others and reintroduce them from a new perspective and context in different styles (among which abstraction is foremost). Elias Zayyat (b. 1935) draws on techniques and shapes found in the icons of the Eastern church to express his politics and philosophy concerning national and humanitarian issues. Nazir Nab'a (b. 1938) includes legendary women as the center of his paintings, sur-

rounding them with traditional motifs of jewelry, furniture, costumes, fruits, and flowers. Nash'at Zu'bi (b. 1939) represents complex issues in the two-dimensional perspective of Arabic miniatures that depict old houses, popular quarters, and public baths. Ghayath al-Akhras (b. 1937) draws on craft decorations incised on swords and woodwork to create his indigenous style. Ahmad al-Siba'i (1935–1988) imitated children's drawings to represent the problems of rural areas. Khuzaima Alwani (b. 1934), who studied at the École des Beaux Arts in Paris, makes use of mythological monsters as symbols of evil that overpower man. Through a deceptively simple format and straightforward technique, he presents humanity's dilemma in choosing between right and wrong, justice and injustice. Using universal themes, he draws from his society's past and present in a highly symbolic manner.[5]

Elias Zayyat, *Maaloula Shrine*, 1989. Oil on canvas, 80 x 60 cm. Courtesy of the Jordan National Gallery of Fine Arts, Amman.

THE GROUNDING OF MODERN ART IN THE SYRIAN MILIEU

After the Suez War of 1956, a widespread trend among many Syrian artists was the search for new styles and means by which they could confirm their national artistic individuality. In 1958, when a union between Syria and Egypt was declared (1958–61), Gamal Abdul Nassir's call for opposing the West found a strong response at almost every level of Syrian society. Artists began rejecting Western art and looked into their Arab-Islamic heritage to express their political and social views. However, they also realized that modern art trends could be linked to their own cultural heritage. Inspired by Western artists such as Henri Matisse and Paul Klee, who had rebelled against their own classical Western art teachings, the heritage revival movement picked up momentum. Coupled with the political events and the general mood of the country, it induced artists to develop individual styles that led in several new directions.

In the early 1960s, a young group of artists began to surface. Their audacious experimentations enriched the modern art movement, opening new horizons for those who followed them. At this stage in the development of Syrian modern art, Impressionism was declining as two new styles gained predominance. The first trend was Expressionism and Abstract Expressionism; the second was abstraction. Those who pursued Expressionism utilized newly discovered forms borrowed from their pre-Islamic classical heritage and reintroduced them in a modern Western style. Their adherents depicted political and social upheavals in Syria and the Arab world by using strong colors and distorted figures in order to capture the general mood of the public and create a rapport with it. They linked their personal suffering and anguish with the general political climate and interpreted them in various Expressionistic styles. Expressionism continues to be popular among Syrian artists.

Meanwhile, subject matter in Syrian art became as important as the plastic formation of a painting. Most artists concentrated on the problems caused by the political and social changes taking place. Mamdouh Qashlan (b. 1929), a graduate of Rome's Accademia di

Sami Burhan, *Unity,* 1980. Oil on wood, 30 x 30 cm. Courtesy of the Jordan National Gallery of Fine Arts, Amman.

Belle Arte, painted displaced village women living in the city and drew on elements from primitive folk art to establish his artistic identity. Burhan Karkutli (b. 1937), an artist of Palestinian origin, portrayed ordinary events in the lives of simple people and used motifs from folk paintings to depict social and political themes.

The most tragic of the sociopolitical artists was Louai Kayali (1934–1978). He was a highly gifted painter with a distinct individualistic style. His disappointment in the political developments in the region put him in a depression that ended in suicide.

The second major trend in Syrian art was abstraction. It moved away from the national and personal levels while drawing mainly on calligraphy. Its advocate was Mahmoud Hammad (discussed in chapter 16), the first Syrian artist to abstract Arabic letters and include them in compositions as structural elements. Others are the Rome-based painter Sami Burhan (b. 1929), who arranges his letters in a constructivist manner, and Muhammad Ghannoum (b. 1949), who employs traditional Arabic calligraphy in a modern rendition, using classical scripts such as Kufi and Nasta'liq.

ART EDUCATION AND PATRONAGE

During the French Mandate, the authorities showed interest in the applied arts and opened a Department of Crafts at the Institut des Études Orientales (whose director at the time was Jean Sauvaget). Craft schools for boys and girls were later established in Damascus and Aleppo. In 1946 art and crafts courses were added to the curricula of teachers' training schools. Since independence, the government's interest in the arts has grown gradually. In 1950 fine art was placed under the management of the Directorate-General for Archaeology and Museums, which organized an annual Syrian group exhibition. In 1958 the directorate was transformed into the Ministry of Culture and National Guidance, with a separate Directorate for Fine Arts, and took on the supervision of all artistic activities.

In 1959, during the short-lived union with Egypt, the College of Fine Arts was established in Damascus, with Egyptian instructors forming the bulk of its faculty. It included departments for architectural design, painting, sculpture, etching, and graphics; it was modeled on the College of Fine Arts in Cairo. The Department of Architectural Design moved to the College of Architecture in 1972, and the College of Fine Arts became part of Damascus University, with Syrians replacing non-Syrian Arabs and foreign teachers. Consequently, more Syrian artists eventually found positions related to their training.

In 1956 a new wing was added to the Damascus National Museum where a collection by prominent contemporary Syrian artists is permanently on display. Later on, similar wings for Syrian modern art were added to the national museums in Busra, Aleppo, Dayr al-Zur, and Raqqa. During 1963–80, the Ministry of Culture opened fine art centers in all Syria's governorates, *muḥāfadāt,* where a two-year course having no prerequisites is available free of charge. Anyone can attend and graduate with a diploma. The Syrian government created the Cooperative Housing Society for Artists, which assisted artists in building houses and studios for themselves. The number of art exhibitions increased as government agencies took over the supervision of all artistic activities, establishing rules for major exhibitions and collecting art

works. The number of state and privately owned exhibition halls grew, allowing artists to communicate with a larger public. Art criticism became an integral part of daily and weekly publications. Through informed critics, issues such as modernism versus traditionalism were discussed in the papers, arousing the interest and curiosity of the general public.

The Union of Fine Arts was created in 1969. It includes all working artists, whose rights it defends, and organizes the art movement. In cooperation with the Ministry of Culture, it launched a major annual exhibition at the Damascus National Museum, which has been held regularly, under the patronage of President Hafiz al-Assad.

Like Iraq, Syria is ruled by the Socialist Baath Party. The annual exhibition in Syria is also governed by party politics and takes place on the party's anniversary. While the government does not manipulate art, its scope of cultural patronage is very limited, and it does not tolerate dissidence from any artist. The personality cult has, however, influenced the arts as statues of al-Assad (made by established sculptors) have been erected in every city and town. Portraits of the president are de rigueur in every exhibition organized by any government body. However, unlike Iraq, official patronage is negligible in Syria, and the standards of official cultural events are low.

By the end of the 1960s, the Syrian art movement had gone through much experimentation and research, attaining a level of maturity that helped crystallize its future development. Through official bilateral cultural agreements, the number of exhibitions from abroad increased, as did local exhibitions held in newly opened private galleries. These kinds of activities, along with the steady improvement in art criticism, helped spread art appreciation among the public and built up a demand for works of art. In 1980 *Al-Ḥayāt al-Tashkīlīya* (Artistic life), a new art review dealing with art in Syria and the Arab world, appeared.

A number of expatriate Syrian artists chose to emigrate, mostly to the West, though some went to Lebanon. Marwan Qassab Bashi, Burhan Karkutli, and Ibrahim Khuzaima live in Germany; Sami Burhan and Mustafa Yahya have settled in Italy; Ghayath al-Akhras, As'ad 'Arabi, Yaqdan Attasi, Izzedin Shammout,

and Sakhr Farzat have established themselves in France; and Mukhlis al-Hariri and 'Ali Arnaout reside in the United States. In contrast, Abdul Qadir al-Na'ib and Alfred Bakhash have gone to Beirut.[6]

By this time, the second generation of pioneer artists had succeeded in establishing their own artistic language within a broad spectrum that included personal interpretation. These maturing artists had trained at the hands of the previous generation and their audacity gave the movement a new impetus.

THE SEARCH FOR a national artistic identity reached its peak in Syria at the end of the 1960s. New trends drew mainly on local folk motifs and mythological characters taken from the country's classical and Islamic heritage. Yet artists were concerned with a search for an Arab rather than an Islamic identity.

The new trends were presented within a modern concept and through a new form of realism that was at times tinged with personal expressions. Arabic calligraphy, arabesque patterns, naive folk painting, iconographic forms, handicraft designs on Damascene woodwork and metalwork, and archaeological figures from Busra and Palmyra were all utilized in the quest to create a uniquely Syrian art. Ancient legends, Christian icons of the Eastern church, popular traditions, Arabic and Islamic miniatures, and intertwined motifs used in local crafts became sources of inspiration for contemporary political and social symbolism. All these experimental efforts registered the artists' endeavors to express personally the conflicting political, social, and economic realities that had spread throughout the Arab world.

The search for continuity between past and present in some way seems to revolve around depicting the land itself. Whenever Syrian artists have sought their identity, they have reverted to their surroundings, which in their eyes embodied a strong sense of continuity. As one of the most ancient Arab cities, Damascus has always appealed to artists with its old quarters, classical architecture, and traditional environs.

Since the beginning of the twentieth century, painters have portrayed the old quarters of Damascus, Aleppo, and other towns.

In the 1970s, two types of realism emerged. The first sensitively delineated the local surroundings and archaeological sites in a style that emphasized the beauty of the country in great detail. The second type of realism treated nationalistic and humanitarian subjects such as war, aggression, poverty, and oppression. It endeavored to seek out the connection between image and reality in an exaggerated manner. It chose to express an idea to the viewer instead of recording visual imagery. It should be noted that under totalitarian and socialist regimes, some artists tend to overdramatize certain themes and national events in an attempt to please the authorities and market their art. This inevitably results in weak compositions and mediocre artistic standards.

Since its independence in 1946, Syria has experienced a series of political changes, including coup d'états, the multiparty system, totalitarianism, socialism, military dictatorship, and one-party rule, which have dramatically drawn artists into their country's politics. This kind of involvement has induced some to adopt Symbolism, Expressionism, Surrealism, and abstraction, by which they could express their conformity with or dissent from the system. On the whole, most Syrian artists seem to be obsessed by political and nationalistic issues, and their work is content-oriented. Those who chose to stay away from sociopolitical commentary have reverted to a realistic style in rendering landscapes, still lifes, and urban scenes. The outcome has been a dichotomy in artistic tendencies. The first is direct and realistic, characterized by straightforward recording of towns and landscapes. The second tendency is Expressionistic and Symbolic, following modern Western art styles. It has introduced its own aesthetic language and interpretations, combining heritage and past experience with introspection. Followers of the second trend assert their artistic identity with thematic content.

10 JORDAN

SITUATED ON THE furthest outskirts of Istanbul's cultural umbrella, Jordan, under Turkish rule, showed Ottoman artistic influence only in its architecture. Jordan's population was a mixture of nomadic Bedouins, peasants, and townspeople during the Ottoman era. Its indigenous art forms were limited to local handicrafts—textile and rug weaving, embroidery, niello work on silver (introduced by the Circassian émigrés), goldsmithing, pottery, painting on glass, woodcarving, and calligraphy. Hardly any traces of Western art existed in the country.

Transjordan (modern Jordan) was founded in 1921 by Amir 'Abdullah, the son of the Hashemite leader of the Arab Revolt, Sharif Husayn bin 'Ali of Mecca. Like Palestine and Iraq, Jordan passed under British Mandate in 1922, while Lebanon and Syria were mandated to France. Transjordan faced the formidable task of building a modern infrastructure with limited natural resources. Upon its independence in 1948, the Emirate of Transjordan became the Hashemite Kingdom of Jordan.

THE ORIGINS OF MODERN ART

In the 1920s and 1930s a few artists came to live in Transjordan. It was through them that the initial seeds of modern art were sown. The Lebanese pioneer Omar Onsi (1901–1969) was the first of these. He came to Amman in 1922 and, at the request of Amir 'Abdullah, remained until 1926, teaching English to the Amir's two sons, Talal (later King Talal) and Nayef. At the time, Onsi was only twenty-one years old and had no formal art training. During his stay, he painted watercolors of the desert and the Jordan valley, which he later presented as part of his portfolio to the Académie Julian in Paris, where he was accepted. However, he did not train any local talent.

Ziyaeddin Suleiman (1880–1945), a Turkish painter (who might have had some art training while living in Paris), moved to Amman in 1930. He painted Jordanian landscapes and portraits in a classical manner with Impressionistic overtones. As a writer who contributed to the local papers and periodicals, he befriended many intellectuals and politicians, among them Amir 'Abdullah. The amir, who was himself a man of letters, convinced Suleiman to settle in Am-

man permanently. Suleiman held the first one-person exhibition in the country in 1938 at Amman's Philadelphia Hotel. It was a great success and almost all his works were sold, although this appreciation on the part of the public was more for the personality and standing of the artist than for his art.

The third early painter to come to Jordan was the Russian George Aleef (1887–1970), who lived in Palestine after fleeing from the Bolshevik Revolution. In 1948 he arrived in Amman with Palestinian refugees and started teaching Russian and painting at his home. A number of amateur artists became his students, including Muhanna Durra and Rafik Lahham. In 1967 he moved to Beirut, where he spent his last three years. Aleef was the only early artist to train and improve local talent. He made numerous landscapes of Palestine and Jordan and recorded scenes from Jerusalem and other cities, as well as Russian landscapes recalled from memory. He adhered to an academic realism with naive overtones in his paintings.

The last of the early artists, Ihsan Idilbi (1924–1997), is a self-taught painter of Syrian origin. He moved to Amman with his family and painted Jordanian and Syrian landscapes and town sites in a studied, naive manner. In the 1940s and 1950s, Idilbi was quite an active participant and organizer of exhibitions, such as the first group show he arranged at Amman's Ahli Club in 1942.

The outstanding contribution of the early artists to the modern art movement in Jordan was their effectiveness in introducing Western painting to the public and developing art appreciation among their friends and acquaintances. More than any other artist, Ziyaeddin Suleiman managed to familiarize the public with easel painting, introducing such work into Jordanian homes as part of wall decorations. Like Onsi, he was a personal friend of Amir 'Abdullah and enjoyed royal patronage. The royal palace acquired many works by these early artists.

PALESTINIAN ARTISTS IN JORDAN

At the outset of the first Arab-Israeli war and the creation of the State of Israel in 1948, hundreds of thousands of Palestinian refugees poured into Jordan during the first few weeks of fighting. They were followed by thousands more, all in need of housing, ba-

Ziyaeddin Suleiman, *Downtown Amman*, 1932. Oil on canvas, 55 x 73 cm. Courtesy of the Jordan National Gallery of Fine Arts, Amman.

sic services, employment, and schooling. Jordan had to cope overnight with a population that had almost doubled and that depended solely on its meager resources and on foreign aid.

In 1949 Jordan's annexation of the West Bank—the part of Palestine that was not occupied by the Israelis—joined the fate of the two peoples on the banks of the River Jordan. Among the refugees were many Palestinian artists who were given Jordanian citizenship. Other artists had been born to parents of Palestinian origin living in Jordan, making it difficult to draw a sharp line between the Jordanian and Palestinian art movements from the 1950s onward. West Bank artists came to Amman to exhibit their work, and Palestinian artists were employed by the Ministry of Education as art teachers at government schools and teachers' training colleges. Others (including Afaf Arafat, Kamal Boullata, and Ahmad Nawash) were sent on government scholarships to study art in Italy, England, and France. Even after the West Bank was occupied by Israel in 1967 and an independent Palestinian government was declared in 1988, many artists of Palestinian origin have chosen to be recognized as Jordanian.

THE BEGINNING OF AN ART MOVEMENT

Early Jordanian artists of the post-1948 period were all self-taught amateurs who practiced painting as a hobby. The first artistic activities started in the early 1950s through exhibitions held by literary clubs such the Arab Club (al-Muntada al-ʿArabī), founded by an Islamic scholar, the late Sheikh Ibrahim Kattan. In 1952 the first artistic group, Nadwat al-Fann al-Urdunniya, was formed. Like similar societies elsewhere in the Arab world, its main purpose was to spread artistic appreciation among the public and to encourage amateur artists to practice painting and sculpture. Among the members who later took up art professionally were Rafik Lahham and Muhanna Durra.

The government sent the first group of students on art scholarships to Europe in the late 1950s. Rafik Lahham, Muhanna Durra, Ahmad Nawash, and Kamal Boullata went to Italy, while Afaf Arafat was first sent to England and then to the United States for her master's degree. The number of cultural clubs and exhibitions gradually increased. Foreign cultural centers such as the British Council, the Goethe Institute, and the French and American Cultural Centers were active in encouraging the arts, in both Amman and Jerusalem. They held exhibitions for local and visiting artists and sponsored lectures and musical events. These activities inspired both the artists and the public and helped expose one to the other.

CONTEMPORARY ARTISTS

By the early 1960s, those students who had studied abroad, either on their own or on scholarships, began to return. Each was a pioneer in his own right, establishing the base for modern art in Jordan. Rafik Lahham (b. 1932) was the first Jordanian artist to work in printmaking after coming back from his studies in Rome and New York. He also was the first to organize his fellow artists in societies and associations and has always lived according to what he preached regarding the efficacy of group work.

The leading modern Jordanian painter in the 1960s was Muhanna Durra (b. 1938). He opened a studio in Amman in the 1960s where he trained a number of young artists, and was the only local painter to cultivate his own students at the time. Even today touches of his style can still be detected in other artists' works. Durra was the first artist to introduce post-Modern styles, especially abstraction, to Jordanian artists and the public and encourage his students to take them up. Ahmad Nawash (b. 1934) was the first painter in Jordan to take up nationalistic and humanitarian subjects in his art. Wijdan (b. 1939), a painter, art historian, and lecturer, in 1979 founded the Royal Society of Fine Arts in Amman which in 1980 created the Jordan National Gallery of Fine Arts. Wijdan has since dedicated her life to promoting Arab, Islamic, and Third World artists and building bridges between different cultures around the world.

A second group of artists returned to Amman in the mid-1960s after completing their art training. They included Mahmoud Taha (b. 1942), the leading Jordanian ceramist, who introduced the art of ceramics into Jordan. Others were Aziz Amoura (b. 1944), Yasser Duwaik (b. 1940), Nasr Abdel Aziz (b. 1942), Saleh Abu Shindi (b. 1945), Tawfic Sayed (1939–1996), Mah-

Rafik Lahham, *Jerusalem*, Wood print, 46 x 24 cm. Courtesy of the Jordan National Gallery of Fine Arts, Amman.

Muhanna Durra, *Composition 3*, 1977. Oil on canvas, 75 x 95 cm. Courtesy of the Jordan National Gallery of Fine Arts, Amman.

moud Sadeq (b. 1945), and the sculptor Kuram Nimri (b. 1944). Unlike their earlier peers, most of the young artists of the 1960s trained at Arab art colleges and academies in Baghdad, Cairo, and Damascus. After obtaining their first degrees, they went to either Europe or the United States for their postgraduate studies. Upon their return to Jordan, they taught at the Institute of Arts and Music, government secondary schools, or the Department of Fine Arts that was later established at Yarmouk University.

This group of artists sowed the seeds of modern art concepts among their students, nurturing a new generation of painters and sculptors. For more than two decades, the artists of the 1960s have been the main force on the art scene in Jordan, and they are the foundation on which modern Jordanian art has been built.

ART PATRONAGE AND ACTIVITIES

During the 1960s, the government's contribution to the arts increased. The Ministry of Tourism started sending Jordanian works of art to international fairs and exhibitions, beginning with the New York World Fair of 1965. Others in Damascus, Baghdad, Bari,

Rome, Copenhagen, and Berlin followed. In 1966 the Department of Culture and Arts was created within the Ministry of Youth, with the objective of supporting and fostering fine arts, theater, and literature. In 1977, this department became the Ministry of Culture.

In the 1960s, the main venues for local exhibitions in Amman and Jerusalem were mainly foreign cultural centers and big hotels. Exhibitions were held quite often, and a segment of society began collecting works by local artists. These new patrons were primarily young professionals—doctors, architects, and engineers—who became conscious of the importance of art collections.

However, in June 1967 the second Arab-Israeli war abruptly halted this period of thriving artistic activity. In six days, Israel occupied the Sinai and Jordan's West Bank, dividing both the land and its people. West Bank artists were cut off from Jordan, and some emigrated to Europe and the United States. The military defeat and political setback gave rise to a new trend in art and literature in the Arab world. It was a pessimistic trend that revealed the bitterness and disappointment of artists and intellectuals with their

leadership. It also carried a nationalistic message opposing the Israeli occupation. It is hardly surprising that between 1967 and 1970 the pace of art development in Jordan slowed considerably, given the harsh political and economic realities that the country faced in these years.

Artistic movements began to stir once again in the early 1970s. The appointment of Muhanna Durra as director of the Department of Arts and Culture in 1971 benefited the art world of Jordan. He founded the Institute of Arts and Music, which included well-established artists among its teachers, including himself. They nurtured a number of second-generation artists, some of whom continued their studies in Europe and then returned to establish themselves. Their painting styles varied, and they expressed themselves through individual approaches that ranged between Expres-

sionism and abstraction. Their training, whether in Western or Arab academies, directed them toward current international styles. Like their peers in other Arab countries, they turned to local landscapes and folk motifs as the means of asserting a national artistic identity.

In 1975 Fahrelnissa Zeid (1901–1991), an artist of Turkish origin and a prominent figure in Turkish modern art (she was a member of the D-Group), moved from Paris to Amman. She was married to the Hashemite Prince Zeid Al-Hussein, the youngest son of Sharif Husayn bin 'Ali of Mecca. A seasoned and versatile artist, she started a studio in Amman, the Art Institute of Fahrelnissa Zeid, where she gave painting lessons to a group of society women. Four of her students, including Suha Shoman and Hind Nasser, distinguished themselves and became established in their

Mahmoud Taha, *Nostalgia for Jerusalem,* 1987. Glazed ceramic, 60 x 84 cm. Courtesy of the Jordan National Gallery of Fine Arts, Amman.

Fahrelnissa Zeid, *Black Pearl*, 1958. Oil on canvas, 152 x 102 cm. Courtesy of the Jordan National Gallery of Fine Arts, Amman.

own right. Her students emulated her abstract style and Byzantinesque portraits. She introduced abstract painting to the public on a grand scale. As she was the great-aunt of King Hussein, Zeid's one-person and group exhibitions with her students would be inaugurated by the king and queen and would receive full media coverage. Those who had never been to an exhibition went to see her shows and were exposed to her large abstract canvases. Although other artists had done abstract work since the 1960s, their work was never shown to the public in the same way.

An outstanding artist of the mid-1970s is Ali Jabri (b. 1943), who because of his sensitivity toward the conservation of heritage, has been instrumental in saving and preserving many old monuments and sites.

ART INSTITUTIONS

In 1979 the Royal Society of Fine Arts was established in Amman—a private, nonprofit organization dedicated to the promotion of visual arts in Jordan and the Islamic world. In 1980 the society founded the Jordan National Gallery of Fine Arts, the first of its kind in

Ali Jabri, *Pella Diptych* (A and B), 1984. Mixed media and montage, 70 x 100 cm each. Courtesy of the Jordan National Gallery of Fine Arts, Amman.

the country. It is thus far the only art gallery in the world that collects works by Islamic and Third World artists. (The Grey Art Gallery and Study Center at New York University has about five hundred contemporary works from the West as well as from India, Iran, Japan, and Turkey. The collection is mostly prints, works on paper, and traditional jewelry and textiles, bequeathed by Ben and Abby Grey. The gallery is not expanding its collection.)

The permanent collection of the National Gallery comprises more than fifteen hundred works by established artists from more than thirty countries, extending from Southeast Asia to Africa. The gallery has a computerized information center on Arab and Islamic artists, a reference library, and a conservation department. It obtains art scholarships and holds workshops and seminars on art and museum management.

From its inception, the gallery set high standards for Jordanian artists through its discriminating choice of exhibitions and works for the collection. It has held more than seventy-five important exhibitions from Europe and the Middle East, displaying works by major contemporary artists, including Henry Moore, Barbara Hepworth, Debré, Zao Wou-ki, Vierra de Silva, Pierre Soulage, Mahmoud Mukhtar, Faik Hassan, Omar Onsi, and others. It has exhibited original works of art by established Western and Arab artists for the first time in Jordan. The gallery's regular cultural activities have opened new perspectives for local artists and the general public. It has also been instrumental in introducing Jordanian and modern Islamic art abroad, organizing exhibitions from its permanent collection in Turkey, Poland, France, England, Bangladesh, Italy, Egypt, the United States, and Canada. It has taken exhibitions to other Jordanian cities and even to remote villages such as Wadi Musa, where villagers and Bedouins were able to see Western-style paintings for the first time in their lives.

In 1989 the Royal Society of Fine Arts, in cooperation with the Islamic Arts Foundation in London, organized the largest exhibition of contemporary Islamic art to be held in the West: Contemporary Art from the Islamic World, held at the Barbican Center in London. It included 254 works by 107 artists from 19 Islamic countries, ranging from Brunei in Southeast Asia to Morocco. The exhibition catalog records the development of fine art in the countries represented. It is the first such reference to be written on modern art from countries such as Brunei, Libya, and Yemen.

In 1988 the Shoman family of the Arab Bank created the Shoman Foundation, a cultural-scientific institution to promote science, literature, and arts in the Arab world. At the initiative of Suha Shoman, herself a painter, the foundation opened an art gallery where exhibitions were held as well as literary evenings, concerts, and lectures. In 1993 the foundation bought a house built at the turn of the century, restored it, and converted it into an arts center called Darat al-Funun. The center has an art library of books and videos, exhibition halls where there are visiting exhibitions and a permanent show of contemporary Arab art for sale (the center does not charge a commission on any art sales), and a graphics studio created in cooperation with the Royal Society of Fine Arts. A demanding patron, Shoman makes every effort to build Darat al-Funun on high artistic standards. The Shoman Foundation and the Arab Bank contribute a great deal towards the promotion of cultural projects in Jordan and the Arab world.

ART EDUCATION

In 1952 the first art institute was founded in Jordan. Jean Kayaleh, an ophthalmologist, violinist, and art lover, opened the Institute of Music and Painting in central Amman. He brought the Italian artist Armando Bruno (1930–1963) to take charge of the institute. Bruno, the first Western art teacher in Jordan, instructed his students in the basics of anatomical drawing and perspective. A demanding pedagogue, he encouraged his students to paint from nature and produce portraits from life. The institute became a meeting place for young artists and intellectuals and was the first endeavor to formalize art training in Jordan. However, when Bruno emigrated to the United States in 1962, the institute closed down.

Basic art education in Jordan has been organized in the form of art lessons in primary and secondary schools since the early 1960s. Because artists cannot make a living from selling their work, most are employed as art teachers in government and private

schools. Since the Institute of Arts and Music opened in 1971, it has offered courses in painting, sculpture, ceramics, and etching. Its program is that of a foundation course in art.

In 1980 a Fine Arts Department was established at Yarmouk University in Irbid. It is the first institute of higher education to offer a degree in fine art and includes well-established painters like Aziz Amoura, Ahmad Nawash, and Mahmoud Sadeq among its faculty. Since the end of the Gulf war, a number of Iraqi artists, notably Rafi al-Nasiri, have also joined the faculty. Since 1990 thirteen private universities have been established in Jordan. Most of them have a Department of Fine Arts and include local artists on their faculty.

The founding of both the Jordan National Gallery of Fine Arts and the Fine Arts Department in 1980 is an important milestone in the development of modern art in Jordan. The gallery gave the art movement a formal character through its continuous activities. It provided a regional center of high standards for Arab and Islamic artists, where they could exhibit their works and conduct research. It simultaneously exposed Jordanian and contemporary Islamic art to the West. Through the National Gallery's fund-raising campaigns and programs for schoolchildren, Jordan's general public got involved in art patronage for the first time, and it has become conscious of a Jordanian art movement.

By providing formal art training at the university level, the Department of Fine Arts at Yarmouk University has augmented the number of art students and supplied the Ministry of Education and the commercial market with instructors and graphic artists. It also provides opportunities for established artists who have studied abroad to train talented students.

ART SOCIETIES

In the 1950s and 1960s, a number of art societies and clubs appeared. They flourished for a few years but then had to close down for lack of funds. In 1974 the Artists Association was founded with the express aim of helping its members promote their work by arranging local exhibitions and by participating in biennials and other exhibitions held in the Arab world. Almost all established artists in Jordan are members of the association. However, because of financial weakness it faltered, and it was relatively ineffectual until 1995, when the painter Khalid Khreis (b. 1952) was elected its president. He moved the premises to an old house, restored it, and began an active schedule of exhibitions and lectures for the association.

MODERN ART IN Jordan developed at a time when art schools and groups were on the wane and individual experiments were gaining ground. Thus, modern Jordanian artists worked on individual levels and, much like their peers in the region, have been concerned with discovering and establishing a Jordanian style and asserting their Arab cultural identity. To this end, they depict local subject matter and draw on folk motifs and Arabic calligraphy within an international framework.

11 PALESTINE

AS LATE AS 1948, fine art in the Western sense of the word had not fully developed in Palestine. The traditional and folk arts and crafts predominated: embroidery, pottery making, weaving and straw work, calligraphy, icon painting, wood engraving, stone carving, mosaics, and mother of pearl work. Ottoman mural painting and pictorial art in the style of the Turkish soldier-painters were unknown in Palestine.

In 1917 the country came under British rule. Unlike the French colonists, the British Mandate authorities did little to further the cultural development of the countries they controlled. They were primarily interested in training qualified civil servants. In Palestine, art education and art patronage were low on their list of priorities. Furthermore, the internal clashes between Arabs and Jews, coupled with uprisings and general strikes against the British, did little to encourage the authorities to send students on art scholarships or to include art classes in school curricula.

In 1927 Jamal Badran (b. 1909) was the first Palestinian to study at the School of Arts and Decorations (Madrasat al-Funūn wa'l-Zakhārif) in Cairo, where he specialized in painting, Islamic design, and calligraphy. Many traditional artists, such as Yusef Najjar and Muhammad Siam, were trained in calligraphy, arabesque design, and applied arts at Badran's studio and workshop, which he opened in Jerusalem in 1940 with his two brothers, Khairy and 'Abd al-Razzaq. Despite Badran's skill in three-dimensional painting, his chosen practice was Arabic calligraphy and Islamic design, which he skillfully mastered. He could trace intricate patterns, interspersed by Kufic letters, without the aid of a ruler or compass.

In the 1930s approximately fifteen Palestinian students went to Cairo to study at the School of Decorative Arts (Madrasat al-Funūn al-Zukhrufiyah) and the School of Applied Arts (Madrasat al-Funūn al-Tadbīqīyah). Because of the strong influence of Palestinian crafts, especially embroidery, young Palestinians were generally not keen on Western art. Most of those who studied applied and decorative arts became teachers of crafts, design, and art education in Palestine and other Arab states.

The earliest known Palestinian painter of modern times was from Jerusalem's Sayegh family (c. 1910).

Jamal Badran, *Study for a Mosaic Panel*, 1992. Gouache on paper, 51 x 91 cm. Courtesy of the Jordan National Gallery of Fine Arts, Amman.

He ran a shop next to the Church of the Holy Sepulcher where he sold his own, mostly religious oil paintings to Christian pilgrims as souvenirs. He occasionally painted landscapes and still lifes and restored church icons and paintings. Another early artist was Tawfiq Jawhariya (c. 1920), a prolific painter, who also made a living by selling his religious paintings to pilgrims and tourists. Both artists had virtually no impact on the early development of modern Palestinian art, for they both painted to make a living and were uninterested in creating a local artistic movement. Sayegh and Jawhariya may have been influenced by the works of Orientalist artists who came to Palestine, but as no records exist, this issue remains speculative.

The first individual who can be regarded as a Palestinian modern artist was Hanna Musmar (1898–1988), the son of a construction worker who, after the death of his father, was sent to a German boarding school where he studied ceramics. In 1920 he enrolled at a fine arts college in Germany, where he spent three years pursuing his chosen field. Upon his return, he founded the first ceramics factory in Nazareth, where he manufactured hand-painted vases. After 1948 his work developed to include murals and sculptures in pottery and ceramics dealing with national events and tragedies.

The first Palestinian to study painting in Europe was Fadhoul 'Odeh (b. 1906). He went to Florence on a scholarship secured by an Italian priest from the Convent of Nazareth in 1922. The priest, who was an art teacher at the convent's school, had noticed 'Odeh's early talent. 'Odeh taught music and painting upon his return, choosing biblical themes and landscapes as his subjects. In 1948 he was among the refugees who went to Sidon in Lebanon, where he continued to teach but did not participate in any known exhibitions.

Daoud Zalatimo (b. 1906) is a self-taught artist who was introduced to oil painting during his visits to Sayegh's shop and through his friendship with Tawfiq Jawhariyah. He joined the few summer courses in painting and crafts organized by the Educational Administration in Jerusalem. Since 1925 he has taught painting and crafts in Khan Yunus and then in Lydda, where he paid special attention to discovering new talent (among whom was Ismail Shammout, who was to become the official painter of the PLO). Zalatimo painted huge canvases of historical events and personalities, such as the *Entry of 'Umar bin al-Khattab into Jerusalem, The Siege of Granada,* and *King Faisal I.* He also depicted famous monuments and landscapes in situ, using a simple naive style that differed from that of the Orientalists.

Fatima Muhib (b. 1920) was the first known Palestinian woman to study art. She graduated from the College of Fine Arts in Cairo in 1940 and obtained her

M.A. in fine art from Hulwan University in 1942. She is known for her portraits of Arab leaders and scenes of Jerusalem. Other early women artists were Sofie Halaby from Jerusalem and Lydia Atta from Bethlehem. The former studied art in Paris and excelled in soft watercolors of Palestinian landscapes and detailed wild flowers, while the latter painted scenes of churches and domes. However, Atta left few works behind when she emigrated to Australia in 1940.

Most early Palestinian artists were untrained amateurs. Those who were trained, such as Fatima Muhib, blindly imitated the styles they were taught. Early Palestinian painting was figurative, using oils, watercolors, and pastels to depict landscapes, still lifes, portraits of historical and contemporary personalities, and biblical themes. Not a single group or one-person exhibition was held in Palestine before 1948.

Fatima Muhib, *Portrait of King Abdullah,* 1963. Oil on canvas, 75 x 50 cm. Courtesy of the Jordan National Gallery of Fine Arts, Amman.

To cover the Palestinian modern art movement, one has to deal with artists living in Israel and the Occupied Territories separately from those living in the diaspora. The matter is complicated by the fact that Palestinian artists were uprooted, first in 1948 and then in 1967. After Lebanon's civil war broke out in 1975 and the Israeli invasion of the country in 1982, many Palestinians living in Lebanon moved elsewhere.

Following the creation of the State of Israel in 1948, Palestinians, among whom were a number of artists, were dispersed throughout the other Arab states. Some took up the nationality of their adopted countries, and those involved in art were included in the art movements of their countries of residence. For example, Jabra Ibrahim Jabra (1921–1995) from Bethlehem, a pioneer among Palestinian artists in Expressionism and Cubism, took up residence in Iraq in 1948. One of the best-known Arab art critics and historians, he was active in the modern art movement in Iraq. Juliana Seraphim from Jaffa and Paul Guiragossian from Jerusalem joined the Lebanese modern art movement. In contrast, artists like Ismail Shammout, Samia Zaru, Samira Badran, and Kamal Boullata have kept their identity in the diaspora and have always been identified as Palestinians.[1]

MODERN PIONEER ARTISTS

The most prominent Palestinian artist is the pioneer Ismail Shammout (b. 1930), who enrolled at the College of Fine Arts in Cairo. He held the first one-person exhibition in Palestine—in 1953 in Gaza—and arranged the first group exhibition for Palestinian artists, in Cairo in 1954. Shammout was not only the first modern Palestinian artist to study art formally after 1948 but was also the originator of a content-oriented movement that focused on Palestinian subjects, the suffering of the people, and the loss of their motherland. Furthermore, he was the first to utilize those subjects in the service of his people's cause.

Another modern Palestinian pioneer is Tamam Akhal (b. 1935), the first Palestinian woman artist to acquire formal art training after 1948, when her father sent her to study at the Higher Institute for Women Art Teachers in Cairo in 1953. After taking part in the 1954 Palestinian group exhibition in Cairo, she mar-

Tamam Akhal, *Siham and Maysoun,* 1989. Oil on canvas, 60 x 77 cm. Courtesy of the Jordan National Gallery of Fine Arts, Amman.

ried Ismail Shammout. As a couple, they have been most effective in introducing modern Palestinian art to the world.

In 1949 the Gaza Strip came under Egyptian sovereignty. The government began to provide Gaza with art teachers and supplies, thus invigorating art education and introducing art classes to talented youth. In Jordan, Lebanon, and Syria, Palestinian students followed the governments' curricula and became part of the art movement in each country. Between 1953 and 1965, about one hundred young Palestinian men and women, almost half of them from Gaza, studied art in different institutions in Cairo, Alexandria, Baghdad, Damascus, London, Rome, Paris, Leipzig, Dresden, Tokyo, Washington, D.C., and Madrid. Some were sent on scholarships by Arab governments and the others went on their own.[2]

PALESTINIAN ARTISTS WITHIN ISRAEL

Little is known of individual Palestinian artists living in Israel between 1948 and 1955, probably because there was little artistic activity of any consequence in that period. Art education was never part of the high school curriculum in Arab schools (which were separate from Jewish schools). Whenever there happened to be art education classes in junior schools, artistically unqualified teachers were appointed.

The pioneers among Palestinian artists living in Israel were Jamal Beyari from Jaffa, Ibrahim Hanna Ibrahim (b. 1936) from Raini near Nazareth, Abed Younis, and Daher Zidani who studied art in Leipzig in 1968 and lived and painted in Galilee for a few years before emigrating to Germany. Due to lack of encouragement and opportunity, Ibrahim migrated to the United States and Younis to Japan. The only support given to Palestinians inside Israel came from the Israeli Communist Party, which encouraged Palestinians to safeguard their political and cultural identities and which organized mixed cultural and intellectual activities with Israeli intellectuals. Abed Abidi (b. 1942) from Galilee was the first Palestinian artist to exhibit his work in a one-person show in Tel Aviv, the center of Israeli art, in 1962.

Following the 1967 war, the position of Palestinian artists in Israel remained problematic. They were recognized as Palestinians neither by Israeli institutions nor by the West Bank and Gaza artists, and they were out of touch with artists in Arab countries. The Israelis considered them Israeli artists because they held Israeli passports, ID cards, and citizenship, which led some to join the Israeli Artists Association. Abed Abidi joined in 1964; Khalil Rayan in 1980; Suad Nasser, Therese Assam, Michael Toma, Kamil Dow, and Assad Azi in 1981; Ibrahim Hijazi in 1982; and Daoud Hayek

in 1983. As there are no Palestinian art schools in Israel or the Occupied Territories, all except Abed Abidi trained at Israeli art schools. However, almost all Arab-Israeli artists confirm their Palestinian cultural identity.

The only means by which a Palestinian artist can gain recognition in Israel is to be assimilated within Israeli mainstream art, which relates directly to the Western tradition. Overtly political art by Arab-Israeli artists would most probably be ignored by an Israeli spectator or critic as not being art and contrary to Zionist ideology. Consequently, a number of artists (Assem Abu Shakra, Assad Azi, Ibrahim Nubani) joined the Tel Aviv School and despite their compromise were able to maintain some indigenous element in their work.

Liberal Israeli intellectuals and artists did recognize their Palestinian colleagues and some cooperated in joint projects. In an Arab-Israeli village called Sakhneen, in 1978, the Israeli artist Gershon Knespel and Abidi executed a monument in bas-relief entitled al-Miḥrāth (The plow) that showed the Palestinians' attachment to the land and commemorated Land Day. (The commemoration marks the day in 1976 when six protesters were shot dead by the Israelis, during a general strike and demonstration called by Palestinians to protest against Jewish-Israeli land confiscation.) The memorial is located in the cemetery where the protesters were buried. During the 1970s, there was increased contact between Palestinian and Israeli artists, and Betsalel School of Art in Jerusalem, a Zionist institution, began to accept Palestinian students, albeit in a token manner.

Meanwhile the activities of Arab-Israeli artists increased to include art lessons for young people at evening classes and art exhibitions at Arab villages and cities (including Haifa, a predominantly Jewish city with a sizable Arab population). An apprentice system was established whereby young artists would work alongside established artists in their studios to gain experience and learn practical techniques. Abed Abidi had Walid Kashash, Ibrahim Nubani, Osama Said, and Bashir Makhoul to train as his apprentices or students.

In 1985 two major joint exhibitions took place. The first, entitled Place Scape, included four Palestinian and ten Israeli artists. Its theme was the landscape of Jerusalem. The second exhibit, Israeli and Palestinian Artists against Occupation, was held in Tel Aviv. A statement published in the catalog protested the arrest of a Palestinian artist, Fathi Ghabn, in Gaza on a charge of using his paintings as a means to incite against the Israeli occupation authorities. The protest was signed by the Organizing Committee of the Participating Israeli Artists (Zvi Goldstein, Mosche Gershoni, Abed Abedi, and David Reev).

A sculpture of Assad Azi (b. 1955), who studied art at Haifa University, the Accademia di Belle Arte in Carrara, Italy, and Tel Aviv University, was exhibited in the Haifa Museum. Between 1967 and 1989, more than 150 one-person and group exhibitions by Palestinian artists were held in Israel and the Occupied Territories. This interaction has exposed Arab-Israeli artists to new Western trends, resulting in interesting work.[3]

ARTISTS IN THE OCCUPIED TERRITORIES

Since 1967 the work of Palestinian artists under occupation reveals anger and resentment. Working under difficult and sometimes very disruptive conditions, artists have attempted to express their defiance in their art. Artists living in the West Bank and Gaza Strip have resorted to nonviolent expressions of nationalism in their work in order to be able to display their paintings without offending and incurring the wrath of the occupying authorities.

Isam Badr (b. 1948) from Hebron is a graduate of the Academy of Fine Arts in Baghdad (1973) and the Tbilisi Academy of Fine Arts in Georgia, within the former Soviet Union, where he obtained a degree in ceramics. Doves, the walls of old Jerusalem, and geometric rug motifs are some of the symbols he integrates in his paintings to confirm his identity.

Suleiman Mansour (b. 1947) from Bir Zeit has moved to total abstraction and new media after a period of symbolic figurative art and stylized realism. He uses straw, chalk, lime, clay, animal fat, and natural dyes such as indigo to construct his abstract and stylized works on wood. Although none of his works carries any trace of open resistance or politicization,

Tayseer Barakat, *The Birds*, undated. Oil on wood, 31 x 97 cm. Courtesy of the Jordan National Gallery of Fine Arts, Amman.

by using materials from his own environment and boycotting Israeli art materials, Mansour has made a strong but subtle statement while avoiding Israeli harassment.

Tayseer Barakat (b. 1959) is a Gazan graduate of the College of Fine Arts in Alexandria (1983). His attachment to the land is reflected in the earth colors of his expressive, pastoral compositions, which show influences of the modern Egyptian school in his stylization of animal and human figures.

Leila Shawa (b. 1940), who lives in London, spends part of each year in her hometown of Gaza. She is one of the few artists whose work carries a direct message against occupation, although she has not shown such paintings in the Occupied Territories. In her latest period, Shawa chose the graffiti-covered walls of Gaza to indicate the repression of communication imposed on her hometown by Israeli occupation. She transferred her photographs of the walls to large silk-screen prints on canvas, overdrawn with her own abstract signs, which carry a factual message of the public's irrepressible right to be heard in its own community. Shawa is the first Arab artist to mix photography with painting and graphic art and the first to utilize realism as well as symbolism in depicting a sociopolitical subject.

In 1964, when the Palestinian Liberation Organization was created, Shammout was appointed director of arts at the PLO in Beirut, thereby giving Palestinian artists the official patronage they lacked. He has since organized numerous exhibitions in the Arab world and abroad and has been using art as a political instrument to serve the Palestinian cause.[4]

ART GROUPS

In 1969 the Palestinian Artists Association was established in Amman; the following year it created chapters in occupied Jerusalem and Ramallah and eventually moved to Beirut and then to Kuwait. The association attempted to integrate the art movement into an organized body that would coordinate artistic activities and protect the rights of Palestinian artists in the diaspora. In 1972 the PAA held its first meeting in Jerusalem, home of its intended headquarters. Several exhibitions by members of the association have been held, including Nabil Anani, Suleiman Mansour, Isam Badr, Tayseer Sharaf, and others.

Because of the nationalistic subjects depicted, the Israeli authorities halted the activities of the PAA and eventually closed down its branches. They confiscated some of the works and prohibited all exhibitions by its members, some of whom were detained. They also banned artists from using the colors of the Palestinian flag (red, black, green, and white) in their works. The association nevertheless continued to open branches in countries where a considerable number of Palestinian artists lived. It also cooperated with the Union of Arab Artists in organizing traveling exhibitions of Palestinian art.

Meanwhile, the Palestinian theater group, al-Ḥakawātī, which was founded by poets, artists, actors, and playwrights living in Palestine prior to 1948, cre-

ated an active cultural program that included plays, musical recitals, exhibits, lectures, discussions, and shows of traditional costumes. It worked closely with the PAA, and after the latter was shut down, it began to organize art exhibitions and invited artists from abroad to display their work. Al-Ḥakawātī became popular in Palestine among Arabs and Israelis alike and it toured Europe and the United States. Upon the group's return to Palestine, the authorities once again interfered and censored its plays and other activities on the grounds that they were a security threat. Al-Ḥakawātī remained entirely at the mercy of the authorities as to when and how to function.

In 1980 the military governor of the West Bank ordered the closing down of the only art gallery in the Occupied Territories, Gallery 79 of Ramallah. The Palestinian artist Fathi Ghabn was arrested in 1984 and sentenced to six months in prison because he had used the colors of the Palestinian flag in a painting. Liberal Israeli artists and intellectuals issued a declaration denouncing the repressive measures of their government against Palestinian artists, as mentioned earlier. In 1988 three more artists, Adnan Zubaidi, Jawad Ibrahim, and Khalid Hourani, were arrested. Sympathizers hope these difficult and even dangerous conditions for artists will be eased after the signing of the peace accord between Israel and the Palestine Liberation Organization.[5]

PRISON ART

A phenomenon particular to Palestinian artists is prison art. Among the thousands who have been put behind bars by the occupying authorities, a few have taken up painting. Using white handkerchiefs and colored crayons smuggled into prison, these self-taught prisoner-artists create emotionally charged

Leila Shawa, *Walls of Gaza Series,* 1994. Silk screen, 39 x 59 cm. Courtesy of the Jordan National Gallery of Fine Arts, Amman.

Zuhdi al-Adawi, untitled, 1983. Paint on cloth, 30 x 30 cm. Courtesy of Mr. Ismail Shammout.

compositions that cannot be related to any particular known style. The works are at the same time realistic, symbolic, Surrealist, Expressionist, and naive. They are no larger than 30 x 30 cm, the size of a handkerchief, the only material available for painting in prison.

Among the prison artists are Mohammad Rakwi, Mohammad Abu Kirsh, Zuhdi al-Adawi, and Mahmoud Afana, all of whom are serving life sentences and living under great duress. Their materials are smuggled into prison and their work is likewise smuggled out. They use limited colors and depend on symbolism to express their anger and frustration. One of their main symbols is the Palestinian flag, included in most of the works. Palestinian prison artists

constitute a closely knit art group that employs the same subject matter and media.[6]

CULTURAL CENTERS

In 1978 work began on the the Rashad Shawa Cultural Center in Gaza. The man behind it was the well-known politician and mayor of Gaza, Rashad Shawa, who, amid all the chaos in his hometown, wanted to establish a center that would cater to the intellectual needs of his people. The building was completed in 1988 and it began operating in 1992. However, due to the *intifādha* (the Palestinian uprising), an official opening never took place.

The center, which is the biggest cultural institution in Arab Palestine, has a public library, auditoriums,

exhibition halls, a theater, and other facilities for both children and adults. It has held concerts, art shows, plays, workshops, and seminars. Since the establishment of the Palestinian Self Rule Authority in Gaza, the Palestinian Parliament has been holding its meetings at the center.

PALESTINIAN ARTISTS LIVING ABROAD

Many of the Palestinian artists dispersed throughout the world have been successful in building careers in art in the countries where they reside. Kamal Boullata (b. 1942), from Jerusalem, went on a scholarship from the Jordanian government to the Accademia di Belle Arte in Rome and then continued his art training at the Corcoran Art Museum School in Washington, D.C. He emigrated to the United States after the 1967 war and taught a course—Modern Arab Culture—at Georgetown University. Samir Salameh (b. 1944), from Safad, trained in Damascus before going to the École des Beaux Arts in Paris, where he settled. Vladimir Tamari (b. 1942), from Jerusalem, studied art at the American University in Beirut and the Saint Martin School in London before moving to Tokyo in 1970. Samira Badran (b. 1954), the daughter of Jamal Badran, trained at the College of Fine Arts in Cairo and at the Accademia di Belle Arte in Florence; she lives now in Barcelona.

DESPITE THE POTENT influence of traditional Islamic and local craft in Palestine that was current through the 1950s—and despite the number of early artists who showed this influence—Western-style painting (and sculpture, to a much lesser degree), has become the norm. The plight of the Palestinian people divided its artists into four groups: those living in Israel, those living under occupation, those residing in other Arab countries, and the group dispersed in Europe, the United States, and the Far East. Whether directly or otherwise, they have all experienced the tensions and existential stress created by the political realities of their homeland. Therefore, they are united in their work by a common theme: the political and social issues linked with the loss of their nationhood. Even those born outside Palestine and integrated into the art movements of their host countries have shown strong national bonds. They frequently visit their families in the Occupied Territories and Israel and create a content-oriented art that deals with the difficulties of their people.

This kind of obsession with one's country is certainly unique in the history of Arab art and has affected other Arab as well as Israeli artists. Art for Palestinian artists has become a passionate and introspective means by which they safeguard their identity in a hostile environment and propagate their cause throughout the world.

12 SUDAN

SUDAN IS THE largest and the most culturally diverse of all African countries. It became a political entity after the Turkish-Egyptian conquest of the region in 1821. It is a country with a pharaonic, African, Coptic, and Islamic cultural background, but modern art, specifically painting, is a recent phenomenon in Sudanese culture, having emerged only in the 1940s. There were no major cities in Sudan until the country gained independence from the British in 1951. It was primarily a country of villages.

The capital, Khartoum, was a British creation with a large foreign community, including British, Copts, and Greeks. Nomadic crafts in leatherwork, metalwork, weaponry, weaving, and jewelry were the most common forms of visual art. No high tradition of Islamic architecture or applied arts ever existed in Sudan. Besides local handicrafts, poetry and music were the main forms of artistic expression, while calligraphy was practiced because of its bond to the Qurʾan, although it never reached the level of sophistication attained in other Islamic countries.

FOLK ARTISTS

In the 1920s, poets dominated the Sudanese literary world. They were public orators and performers who delivered religious, historical, mystical, and romantic messages, extolling past glories. In their poems, they used a certain imagery that fused tradition with the force of drama. In the second half of the 1920s, untrained folk artists, in large towns such as Khartoum, Wadi Medni, and the al-Ubayid, began to respond to this mental imagery and to the new Western painting tradition they were exposed to. They painted naive works of local girls in folkloric dress, landscapes representing rural and urban life, and important Sudanese historical figures, using primary colors and most of the time disregarding the laws of perspective and light and shade. Working with ordinary house paints and enamels for metal surfaces, they painted on wooden planks and a native cotton fabric called *dammūrīya,* which they stretched on wood frames.

The best-known folk artists were Giha, who was a skilled painter, sign designer, and magician; Ali Osman, who achieved wide recognition; a man nick-

named 'Uyun Kadis (cat's eyes) for his ability to copy portraits and to draw figures; and Ahmad Salim, who developed a style indistinguishable from the so-called academic style. Osman worked at the Graphic Museum, which in fact was a health museum created by the British to educate the local population in disease prevention and sanitary health. The English supervisor at the museum provided Osman with imported oil paints, making him the most sophisticated painter among his peers. In a way, those early primitive artists introduced easel painting to Sudan. They were well liked in Khartoum and used to show their work in popular coffeehouses and restaurants. Ahmad Salim exhibited his work at the Grand Hotel in Khartoum as late as 1965. Some of the works of these early artists, which were bought and at times commissioned by prosperous urban families, were displayed in private homes, restaurants, and cafés, introducing a new art form and aesthetics directly to the public.[1]

THE TEACHING OF ART

In 1902 the British established Gordon Memorial College, a secondary school to train civil servants, teachers, and judges. Handicraft classes were part of its curriculum. By the end of the 1930s, drawing lessons in pencil as well as classes in Arabic and English calligraphy were introduced into primary schools and at Gordon Memorial College, which offered the highest level of education. The three late educators, 'Abd al-Qadir Taloudi (a painter and sculptor), al-Khair Hashim (a painter), and 'Abd al-'Aziz al-'Atbani (a sculptor and designer), had graduated from Gordon Memorial College and continued their studies at the colleges of Fine Arts and Applied Arts in Cairo. Upon their return to Sudan, they joined the faculty of Gordon Memorial College and were the ones to establish art education in the country in the 1930s.

In the 1940s, craft lessons were included in the intermediate and secondary forms and advanced-level classes. In 1946 the School of Design was founded in Omdurman for talented graduates of Gordon Memorial College and the Institute of Education (Bakht al-Rida). In 1947 the School of Design was moved to Khartoum to become part of Gordon Memorial College. Its dean, the Anglo-Frenchman Jean-Pierre Greenlaw, was previously an inspector of art classes for the government; he developed the curriculum as a vocational center teaching practical skills in carpentry, architectural draftsmanship and drawing, surveying, and design. He was assisted by John Cotrell from the United Kingdom. In 1948 the pedagogue Shafik Shawki (b. 1923), who had graduated from Goldsmith College in London, was appointed assistant to Greenlaw. Thus, he became the first Sudanese to join the faculty of the School of Design and was the link between the local students and the foreign teachers. Shawki was a talented painter whose teaching career left him little time to practice his art. Most of Sudan's later artists were trained by him.

When the Khartoum Technical Institute was founded in 1950, the School of Design was moved from Gordon Memorial College to become the Art Department at the Khartoum Technical Institute. John Cotrell was the head of the department, which had sections for calligraphy, painting, drawing, pottery, printmaking, and textile design. Art education, however, focused mainly on the history of Western art. The institute was initially conceived to train designers and artisans and to graduate qualified art teachers for the colonial administration; the institute later became the Khartoum Polytechnic and now Sudan University of Technology. In 1964 the department became the College of Applied and Fine Arts, affiliated with Sudan University of Technology.

In 1945 the Department of Education (later Ministry of Education) sent the first group of art teachers abroad on scholarships. They were Shafik Shawki, Jamal al-Din Mubarak, 'Abd al-Razzaq 'Abd al-Ghaffar, Ahmad 'Ali Hamad, Kamal Mubarak, and Kamal al-Jak, and they all attended Goldsmith College at the University of London. The second group of scholarship art teachers went to Egypt and England in 1946. 'Abd al-Razzaq Mitwalli and Idris al-Banna were sent first to the Institute of Art Education in Cairo, then to Goldsmith College. Al-Banna, an accomplished artist, later became vice president of the Presidency Council in the 1980s. 'Abd al-'Aziz Abu 'Affan, Ibrahim Daw al-Beit, and Bastawi Baghdadi

enrolled in Goldsmith College, while Osman Waqialla attended Camberwell School of Arts and Crafts. Waqialla became Shawki's assistant at the School of Fine Arts in 1949.[2]

MODERN ART TRENDS

Unlike developments in other Arab countries, the Sudanese search for a national artistic identity dominated the works of its artists well before the Western art styles of the colonial power's culture, almost nonexistent beyond the urban centers, became prevalent. Because of the absence of an early Western art tradition in Sudan and the pervasive presence of indigenous handicrafts, local trends in art appeared natu-

rally in Sudanese paintings of the 1940s and 1950s. The artistic output of the first generation of modern artists was imbued with an indigenous character, while international styles in art appeared only in the works of later generations.

Among the early artists were Bastawi Baghdadi (b. 1927), an eminent artist of the first generation; Osman Waqialla (b. 1925), the first to explore the visual and thematic qualities of Arabic calligraphy; Ibrahim al-Salahi (b. 1930), one of the early Arab calligraphic artists; and Ahmad Shibrain, who drew on his Arab-African background. The last three were the first to experiment with imbuing modern Sudanese art with a local character (discussed in chapter 14).

Bastawi Baghdadi, *The Mourning Women,* 1971. Oil on burlap, 75 x 95 cm. Courtesy of the Jordan National Gallery of Fine Arts, Amman.

Kamala Ibrahim Isahaq, *Loneliness*, 1987. Oil on canvas, 103 x 103 cm. Courtesy of the Jordan National Gallery of Fine Arts, Amman.

ARTISTIC GROUPS

Sudanese modern art developed at an accelerating pace between 1950 and 1960. Three main art movements appeared in the country. The most important was the Old Khartoum School, formed by a group of painters and sculptors who embarked on discovering a Sudanese identity through their work. The members amalgamated African and Islamic artistic traditions and modern techniques to come up with an indigenous Sudanese artistic personality.

In contrast, the New Khartoum School, the second art group formed in Sudan, borrowed less from the country's past cultural heritage and claimed to be more Western oriented in media and techniques. Yet in reality, the Old and New Khartoum Schools are rather similar, except that the Old School had more depth and spontaneity in its works. Artists of the New School use Sudanese imagery combined with local materials such as basketwork and collage. The New

Khartoum School has been criticized for accommodating its style to appeal to tourists, and its critics claim that artists who joined after 1970 have neglected the original aim of restoring their cultural heritage in the process.

The third Sudanese group was the Crystalists, founded in 1978 by Kamala Ibrahim Isahaq, who was also a member of the Old Khartoum School, and two of her students, Muhammad Hamid Shaddad and Nayla Al-Tayib. It was the only early group to publish a manifesto, where avant-garde existential beliefs and those of other European art movements were proclaimed. It was intended as an indirect critique of the Old Khartoum School. It stated that the essence of the universe was like a transparent crystal cube whose nature was regularly changing according to the viewer's position, the degree of light, and other physical conditions; within the cube human beings were prisoners of a foolish destiny. It was the closest movement to current Western art styles, shunning influ-

ences from Sudan's cultural past. Kamala Ibrahim graduated from the College of Fine Arts at Khartoum University and the Royal College of Art in London. After joining the Crystalists, her work began to take a more international aspect, and her distorted subjects, reminiscent of Francis Bacon's figures, increasingly addressed feminist problems in her country.

A fourth group was the School of the One (Madrasat al-Wahid), founded in 1986 by a number of artists led by Ahmad Ibrahim Abdal Aal (b. 1949), a student of al-Salahi and Shibrain. This group tied its claim to internationalism in the arts with an acute awareness of the artists' Sudanese heritage in a Founding Manifesto which will be discussed in chapter 14.[3]

ART MATERIALS

Most Sudanese artists make use of local materials such as wood, burlap, inks, and natural dyes while employing local techniques in their artwork. The result is the distinctive indigenous character of Sudanese modern art. During a two-week visit to Sudan in February 1988, I saw how difficult Western art materials were to obtain. Whenever they were available, their prices were prohibitive for artists because they were imported and paid for in hard currency. In the College of Fine Arts at Khartoum University, Majdoub Rabbah, who was then the dean, said that the college was unable to provide even colored pencils for the students, let alone oils, canvas, and watercolors. Very few artists could afford to import their art materials from Egypt.

During my visits to artists' homes I was shocked by the conditions in which most of them lived. A typical situation would be a family of six or more children, a meager income from a civil service job, and the absence of any kind of official patronage. Because of the deteriorating economic and political conditions—civil war in the south, military rule, and repeated coups

d'état—Sudan is probably one of the few Islamic and Arab countries where government patronage of the arts is almost entirely absent and artists are left to fend for themselves. Furthermore, in the few cases where government positions exist, party politics and political affiliations determine the appointment of artists. There have been restrictions on freedom of expression recently, and artists have not fared well under the so-called orthodox Islamic trend that has been imposed on the country.

MANY ESTABLISHED ARTISTS have left Sudan, draining its talent. Mohamed Omer Khalil lives in New York; Ibrahim al-Salahi moved to Qatar; Osman Waqialla, Muhammad Ahmed Abdulla, Muhammad Hassan Abdul Rahim, and Siddiq al-Tejouni reside in England; and Rashid Diab has settled in Madrid. Those who have remained in the country work under impossible social, political, and economic conditions. Nevertheless, Sudan has produced a considerable number of accomplished artists whose works testify to their talent, diligence, commitment, and innovation. Moreover, in spite of the impossibly dire conditions of life in Sudan, Sudanese artists manage to overcome their difficulties by finding local materials and executing works of international standards.

In one way the mass exodus of talent has had a positive effect on Sudanese contemporary art. As in their native country, in their diaspora Sudanese artists have not unconditionally accepted Western traditions in art. To their Western training they add their own visual vocabulary of iconography, symbolism, and at times, local technique. Some have managed to transcend national boundaries to come up with styles that incorporate African, Arab, Islamic, and Western components, creating truly international trends.

13 THE ARABIAN PENINSULA

THROUGHOUT HISTORY, most parts of the Arabian Peninsula have been isolated from the rest of the Islamic world. However, even before the advent of Islam, trade connected the ports of the southern and southeastern coasts, as well as Mecca and the northern cities bordering Byzantium, with Africa, the Indian Subcontinent, Persia, and Mediterranean countries. As trade routes changed, the commercial ties between Arabia and the rest of the world weakened. Only the Hijaz, where Mecca and Medina have enjoyed special religious status since the rise of Islam, maintained ties with the rest of the Muslim world. When the great Muslim empires rose and fell, their cultural achievements hardly affected the peninsula. Nevertheless, Ottoman influence was reflected in the Mosque of the Prophet in Medina and the Haram Mosque at Mecca, which were restored and enlarged by the Ottoman government because of their religious significance.

COUNTRIES IN THE PENINSULA

Like the rest of the Arab world, Najd, Hijaz, and Yemen came under Ottoman rule in the sixteenth century, but if Iraq and Jordan were backwaters of the Ottoman Empire, the newly annexed areas of Arabia were even further removed. The eighteenth century saw the rise in Central Arabia of the Wahabis, a new sect of zealous Muslims who wanted to purge Islam and restore it to its alleged primitive strictness. The movement declined in the late nineteenth century but was rekindled in 1902 by 'Abd al-'Aziz bin 'Abd al-Rahman Al Sa'ud (Ibn Sa'ud), the founder of the Sa'udi dynasty.

During the first quarter of the twentieth century, Ibn Sa'ud, with the help of the British, was able to create for himself a kingdom that extended from the Persian Gulf to the Red Sea, at the expense of the Ibn Rashid family in Ha'il (1921) and the Hashemite family in Hijaz (1924). He declared himself sultan in 1926 and, with the blessings of Great Britain, founded the Kingdom of Saudi Arabia, which comprised Najd and Hijaz, in 1932. In 1933 the Arabian American Oil Company received its first concession in Saudi Arabia, providing a source of income to the Saudi government and people such as they had never dreamed of in their previous spartan nomadic lives.

Oman and the eastern coast of the Arabian Peninsula came under Portuguese rule in the sixteenth century. In the nineteenth century, the coastal area of south and east Arabia passed under British influence. It was politically divided into the Aden Colony, the Aden Protectorate, and the Sultanate of Masqat and Oman, while the Gulf coast was ruled by Trucial Oman States and the sheikhdoms of Qatar, Bahrain, and Kuwait. All of them depended, in varying degrees, on Great Britain and were under her protection through bilateral treaties. Yemen continued to be ruled by the Zaydi Imams, who had been in power since 1592 under the nominal suzerainty of Istanbul. The Aden Protectorate became the independent Republic of South Yemen in 1967.

In 1968 the British announced their intention to withdraw their military forces from the Persian Gulf within three years, leading to the creation of the states of the United Arab Emirates, Bahrain, Qatar, and Oman. Kuwait had gained independence in 1961. The Arabian Gulf Co-operation Council was established in 1981 as an economic and political union of the United Arab Emirates, Bahrain, the Kingdom of Saudi Arabia, the Sultanate of Oman, Qatar, and Kuwait. The council consists of oil-producing states that share a similar historical, cultural, and political background.

At the start of the present century, Arabia, being geographically isolated, was far from any outside cultural influences, apart from Hijaz and its sacred association with Islam. The people in the peninsula gratified their need for artistic expression through crafts, the most common of which were weaving, embroidery, silver and gold jewelry making, wood carving, and naive two-dimensional decorative paintings on boats, walls, and doors of houses and mosques. Craftsmen found the inspiration for their designs, choice of color, and subject matter in their environment. This type of self-contained inspiration borrowed little from outside. On the coasts, foreign influence came mainly from the East, the Indian Subcontinent and its islands, and was evident in the imports of glass and pottery. However, local crafts declined once oil was discovered, as the interests of the Western powers in the Arabian Peninsula rose and the car and cement (used in replacing local mud-brick architecture

with high-rise buildings) became central to the lives of the people.[1]

THE INTRODUCTION OF WESTERN ART CONCEPTS

Three factors were instrumental in introducing Western art into the Arabian Peninsula. Western art concepts first penetrated Arabia in the 1950s through the modern educational system. Although the earliest modern schools were sporadically founded—as early as 1912 in Kuwait, 1919 in Bahrain, 1925 in Saudi Arabia, 1926 in Oman, 1951 in Qatar, and 1953 in Sharjah—until the 1930s and 1940s, the most common form of education in Arabia was the traditional *kuttāb*. A group of young children would assemble around a tutor, in his house or in the mosque, to memorize the Qur'an and learn discipline and good manners.

However, a modern educational system gradually replaced the traditional one, and by the 1950s, schools teaching a variety of subjects became the norm. These modern schools also assumed additional roles. They became community centers for social and cultural activities, including public gatherings, sporting events, plays, and exhibitions. For example, in Kuwait, school buildings served as marketplaces to sell foodstuffs, books, and other commodities, as well as providing a venue for wedding celebrations. These various social activities fostered an interaction between the local community and the school that catered to the needs of the people.

For children, the school replaced the village square, where they used to play most of the time. The classroom became the arena where they found guidance in drawing lessons, under each country's Department of Education programs. The Departments of Education in Saudi Arabia and the other Gulf countries introduced drawing lessons into their curricula, followed by painting, both taught according to the competence of the art teachers employed.

The first country to include art education in its curriculum was Kuwait in the 1940s. These classes were rudimentary, taught by local instructors who had no art training whatsoever. A modern educational system required qualified instructors, and teachers were imported from Iraq, Egypt, and Palestine. Art instructors were among them although none was an established

painter. Those who came to teach in Saudi Arabia and the Gulf were attracted by the material benefits offered to them, and they became instrumental in molding the talent of the first generation of artists in the 1950s. The works of those locally trained artists consisted of portraits and landscapes done in a primitive style that loosely followed basic academic principles of three-dimensional drawing and easel painting. Some artists copied well-known works by European Renaissance painters. Only one teacher in Kuwait was known to rely on materials found in his own environment, such as clay and coconut fiber.

Scholarships from governments are the second element that helped introduce Western art trends into the region, as educational authorities in Saudi Arabia and the Gulf started sending students abroad to study art. The first art scholarship recipient from the peninsula was the Kuwaiti Mojab Dossari (1921–1956). In 1945 he attended the Institute of Decorative Arts in Cairo and, after graduation, was sent to London for a year to acquaint himself with Western art by visiting museums. The Bahraini Ahmad Qassim Sinni (b. 1933) followed Dossari with a scholarship to England in 1952.

The Saudi government sent Abdul Halim Radwi to Italy in 1961, while Jassim Zaini, the first Qatari to study abroad, went to Baghdad in 1965. From the United Arab Emirates, Muhammad Yousif, Hamad Sweidi, Mohammad Idrous, Obaid Srour, and Ibrahim Moustafa were sent to Cairo, Baghdad, and Damascus in the mid-1960s. The number of students of art trained outside the peninsula has steadily increased. When these artists return home, they transfer what they have seen and learned abroad into their countries' evolving artistic movements.

The formation of art societies in the Arabian Peninsula has played a significant role in the development of its modern art movement and is the third factor in the introduction of Western art. The earliest were the Kuwaiti Society of Fine Arts and the House of Saudi Arts (1967), followed by the Modern Art Society in Bahrain (1969), the Saudi Arabian Society for Culture and Arts (1973), the Kuwaiti National Council for Culture (1973), the Emirates Society for Fine Arts (1980), and the Qatari Society for Fine Arts (1980). All these societies, whether publicly or privately founded, re-

ceived official subsidies and were instrumental in furthering the arts. They arranged exhibitions at home and abroad, established contacts with other Arab and international artistic institutions, started collections of works by local artists, awarded prizes in the fine arts to local and Arab artists, and spread artistic awareness among the public.

Members of artistic groups were not bound by any single style or school. In their own way, these societies assumed a role that resembled that of artists' associations and unions in other countries. They were a mixture of art fraternity, art institute, artists union, and government cultural department.[2]

KUWAIT

Beginning in 1936, Kuwait was the first country in the region to implement a modern school system and the first to grant scholarships in the arts. Its modern art movement is the oldest among those in the peninsula. The Kuwaiti government has taken major steps in promoting education and culture, through various measures and institutions. For example, even before its independence (in 1961), Kuwait hosted the 4th Arab Literary Conference in 1958, thereby setting a precedent for other Gulf states. On that occasion, the first major group exhibition was held, with the participation of Kuwaiti and resident Arab artists.

A new phenomenon to appear in the Arab art world in 1960 was the creation of the Free Atelier for Fine Arts in Kuwait. It was the brainchild of Hamid Hamida (probably Egyptian), an inspector of art education, who proposed the establishment of a center for amateur artists under the supervision of the Department of Education (later to become the Ministry of Education). The center provided art classes free of charge for national and foreign resident art students and furnished the necessary studios and art materials. Artists and amateurs could join classes in painting, sculpture, and printmaking in a free and unrestricted atmosphere.

The department opened the Free Atelier as a nucleus for an arts college. In its early stages, the Free Atelier accepted only male students. Daytime and evening classes were taught, so that amateurs, students, and practicing artists could attend. The Free

Khazaal Al-Qaffas, *Kuwaity Sailor,* 1982. Watercolor on paper, 45 x 35 cm. Courtesy of the Jordan National Gallery of Fine Arts, Amman.

Atelier immediately became a great success, despite the fact that it did not offer any certificate. Because it does not grant a degree, the Free Atelier is an unofficial institute, and its graduates are not elegible for the civil service on the basis of their training.

In 1972 the atelier became the responsibility of the Ministry of Information, which was transformed into the governing authority for all artistic and cultural affairs in Kuwait. The atelier was transferred to a new location in a traditional Kuwaiti house, owned by Jabr Jassim al-Ghanim, which consisted of two exhibition halls; a library; several studios and workshops for painting and printmaking; facilities for bronze casting; and a kiln for ceramics. A diploma was granted to three-year participants, and there was also a five-year diploma. At this point, the Free Atelier became a publicly supported studio, strictly for the benefit of Kuwaiti artists, explicitly excluding residents of other nationalities and amateurs. The first instructors at the Free Atelier were art teachers from the Department of Education, working overtime. Established Kuwaiti artists later took over all teaching responsibilities.

The great success of the Free Atelier surpassed the expectations of its founders and sponsors. It provided

Kuwaiti artists with an opportunity to train in art and exhibit their work. Following in the footsteps of Kuwait, Qatar opened a Free Atelier in Doha in 1980, and in the same year, Oman started the Atelier of Plastic Arts in Muscat.

A second development in Kuwait in 1961 was the state support of full-time artists in the form of a monthly salary given for two or more years, which enabled them to fully dedicate themselves to their creative pursuits. Issa Saqr (the first artist to benefit), Khalifa Kattan, Badr Qattami, and Abdallah Kassar all received full government stipends, and Qatar followed suit. Until the Iraqi invasion in 1990, Kuwait was quite developed in the field of culture and the arts.

In 1983 the Kuwait National Museum was opened with a splendid ceremony. The guest list included most of the internationally established authorities and collectors in the field of Islamic art. The greater part of the museum housed the comprehensive private collection of Nasser and Hussa al-Sabah, and a much smaller part displayed works of contemporary Kuwaiti painters and sculptors. However, during the Iraqi invasion of Kuwait (1990) the museum was ransacked and burned. The Islamic collection, which was packed and crated and sent to Iraq, was later returned through UN intervention, yet the contemporary fine arts collection was lost.

Kuwaiti artists were considered pioneers among their peers in the peninsula. The first artist to set a trend of painting only local subjects was Mojab Dossari. Among other pioneer artists were Mohammad Damkhi (1943–1967), Ayoub Hussein (b. 1932), Khalifa Kattan (b. 1934), Mahmoud Al-Radhwan (b. 1939), and Badr Qattami (b. 1942). Most Kuwaiti art is figurative, depicting local landscapes and still lifes. Surrealism also claims a strong following; its leading exponents are Yousuf Al-Qattami, Hameed Khazaal (b. 1951), Khazaal Al-Qaffas (b. 1944), Sami Mohammed (b. 1943), and Sabiha Bishara (b. 1949).

One of Kuwait's pioneer artists is Abdul Rasul Salman (b. 1946). A graduate of the Teachers Training Institute who trained as a calligrapher, he uses a stylized type of script in rich colors as the basic form for his compositions. His style varies among Surrealism, romantic realism, and calligraphic. The only Kuwaiti artist to have established himself abroad is Basil Al-kazi (b. 1938), who has settled in California.[3]

SAUDI ARABIA

Until the late 1950s and early 1960s, there were no trained modern artists in Saudi Arabia. Nevertheless, after Kuwait, Saudi Arabia was one of the first countries in the region to understand the importance of art education. The Institute of Art Education was founded in 1965, followed by the Colleges of Art Education at Umm al-Qura University in Mecca and Abd al-ʿAziz University in Jeddah. The General Directorate of Youth, established in 1973 and headed by King Fahad's son Faisal, has responsibility for all cultural and artistic activities. It sponsors all artistic societies. One is the Saudi Arabian Society for Culture and Arts (1973), which has branches in Jeddah, Dammam, and al-Ahsaʾ. It held its first exhibition in 1975. Another is the House of Saudi Arts (Dar al-Funun al-Saʿudiya) (1980), which for the first time in 1981 invited other resident Arab and foreign artists to participate in an exhibition.[4]

Aside from depictions of the king's and the royal family's portraits, Saudi nationalism in art expresses itself in narrative and genre paintings that portray the transition from a traditional to a modern lifestyle. Among the artists who express this transition are Safeya Binzagr, in her primitive style, Abdullah Al Sheikh, and Abdulaziz Al Khbairi.

The first of the early Saudi artists to be sent abroad was Abdul Halim Radwi (b. 1939), who trained at the Accademia di Belle Arte in Rome and later obtained his Ph.D. in art history from Spain. A painter and sculptor, he stresses the importance of drawing from one's own cultural heritage in a modern rendition. Radwi is currently the head of the Jeddah branch of the Saudi Arabian Society for Culture and the Arts. Another early pioneer painter is Mohammed Mossa Al-Saleem (b. 1939), who began painting and teaching art in the late 1950s without any previous formal art training. Aside from a few fragmented calligraphic paintings, his work mainly depicts desert landscapes.

Abdul Halim Radwi, *Folkloric Dance,* 1987. Oil on canvas, 90 x 70 cm. Courtesy of the Jordan National Gallery of Fine Arts, Amman.

Abdel Aziz Ashour (b. 1962) is a young artist and a trained calligrapher. In his calligraphic paintings, he tries to ground his art in the local culture by mixing geometric and floral arabesque motifs, Islamic architectural shapes of domes and arches, along with Arabic letters, words, and sentences, in two-dimensional decorative compositions. This kind of mixture tends to weaken the constructional aspect of the work, lending it a certain superficiality. This is a handicap found in the works of many Arabian artists who combine local crafts motifs with calligraphy for the sole purpose of bestowing an Arab and Islamic identity on their work.

The most prominent Saudi painter is Faisal Samra (b. 1955). He is the only Saudi artist who has suc-ceeded in achieving artistic self-realization through his highly expressive and individual style, which avoids traditional materials, motifs, styles, and clichés.[5]

QATAR

Qatar is a small country of less than half a million inhabitants that became independent in 1971. During the last ten years, the contemporary art movement in Qatar has been stimulated, thanks to trained artists returning from Egypt, Iraq, France, Italy, and the United States. Qatari artists are all relatively young. The two pioneers are Jassem Zeini (b. 1943), a graduate of Baghdad Academy of Fine Arts in 1968 and a

Above: Abdul Aziz Ashour, *Composition no. 1*, 1987. Oil on canvas, 85 x 98 cm. Courtesy of the Jordan National Gallery of Fine Arts, Amman.

Left: Hassan Al-Mulla, *Intersection*, 1988. Acrylic on canvas, 89 x 115 cm. Courtesy of the Jordan National Gallery of Fine Arts, Amman.

Rashid Swar, *Boats*, 1982. Watercolor on paper, 14 x 27 cm. Courtesy of the Jordan National Gallery of Fine Arts, Amman.

founder of the Free Atelier, and Sultan Alsileity (b. 1945). All other Qatari artists were born after 1950.

Like their counterparts in neighboring countries, most Qatari painters have depicted local scenes and customs. A few, such as Hassan Al-Mulla (b. 1952), have adopted a form of Surrealism, while two abstract painters, Ali Hasan (b. 1957) and Yussef Ahmad (b. 1955), employ calligraphy in their compositions. Apart from Ahmad, no other artist in the peninsula has yet developed an original and innovative style of calligraphic painting.

BAHRAIN

Although Bahrain became independent only in 1971, the very early sparks of its modern art movement were kindled around 1952, with the departure of Ahmad Sunni on a scholarship to England, and the formation of the Arts and Literature Club (Nadwat al-Fann wa'l-Ādāb). The club preceded other artistic societies that encouraged amateur painters, actors, and musicians. In 1956 the first group exhibition in Manama displayed works by amateurs.

The modern art movement arose very recently, when the Bahrain Art Society was founded in 1983. Besides sponsoring exhibitions inside and outside the island-state, the society has been offering courses in painting, interior design, pottery, sculpture, Arabic calligraphy, and photography. It is also concerned with artists' welfare and with bridging the gap between them and the community through publications, public relations, and other means of communication.

Among the older Bahraini artists are Abdul Aziz bin Muhammad Al Khalifa, Ahmad Qassim Sinni (b. 1933), Abdul Karim Orayid (b. 1936), Rashid Oraifi (b. 1949), Nasser Youssef (b. 1940), Rashid Swar (b. 1940), and Abdullah Al-Muharraqi (b. 1939). In general, most of them conform to a realistic style, depicting local scenes and portraits as a means of cultural identification. The majority of Bahraini artists were trained in either Cairo or Baghdad. As a result, their work reveals the influence of Egyptian and Iraqi artistic trends. In their illustrative, realistic style, most of these artists refrain from using Expressionist and Surrealist styles.

Balqees Fakhro (b. 1950) and Abdel Latif Mufiz (b. 1950) are two of the very few artists who have developed individual expressive and abstract styles. Representatives of calligraphic art are Badie Al-Sheikh (1955) and Abdul Elah Al-Arab (b. 1954). The former employs Arabic characters within an abstract compo-

sition, similar to the works of Iraqi artist Dia Azzawi, while the latter, himself a calligrapher, uses a legible geometric Kufic, very similar to the style of the Palestinian artist Kamal Boullata.[6]

UNITED ARAB EMIRATES

The United Arab Emirates is a union of several sheikhdoms, including Sharjah, Fujairah, Ras al-Khaimah, Abu Dhabi, Dubai, and Ajman, which all became independent in 1971. Sharjah is the home of the Emirates Fine Arts Association.

Abdul Qadir Al-Rayis, *The Palestinian Intifada*, 1988. Oil on canvas, 113 x 80 cm. Courtesy of the Jordan National Gallery of Fine Arts, Amman.

Abdel Latif Mufiz, *David*, 1988. Oil on paper, 195 x 75 cm. Courtesy of the Jordan National Gallery of Fine Arts, Amman.

The art movement in the Emirates dates to the mid-1970s, when artists sent on scholarships returned from Egypt, Iraq, Syria, England, France, and the United States. Most artists obtained either teaching positions or employment in the Ministry of Education and other government bodies concerned with culture and youth. The Emirates Fine Arts Association, which has been instrumental in arranging exhibitions in the UAE and other Gulf and Arab countries as well as France, Japan, and India, includes all practicing artists, who also participate in its management.

As in neighboring countries, the strongest artistic trend in the Emirates is a realistic one that mostly records traditional scenes and seldom political subjects. Among its adherents are Abdul Qadir al-Rayis (b. 1951), Muhammad al-Qasab, Ibrahim Mustafa (b. 1953), Abdar Rahman al Zainal, Muhammad Mundi,

Issam Shreida (b. 1953), Abd al Karim Sukar, Obaid Srour (b. 1955), and Muna al-Khaja. The Surrealists include Salih al Ustadh (b. 1957), who has studied in California and produces works similar to Dalí's, and Hisham al-Mazloum, a graduate of the Al-ʿAin University. Husain Sharif (b. 1961) and Thoraya Amin are young artists whose work is Expressionistic and abstract.

One of the most prominent artists in the Emirates is Muhammad Yousif (b. 1954), who studied in Cairo. He is the director of the Fine Arts Association and also manages the Sharjah theater. Yousif is a versatile artist who paints, sculpts, works in clay, and acts. After studying in London, Hassan Sharif (b. 1956) embarked on an experiment dealing with the relationship between pictures and words. He tries to represent what he calls visual poetry; however, this experiment needs time to develop into a distinctive style. All the pioneer artists in the UAE were born in the early 1950s, which reflects the youth of the modern art movement in the country.[7]

YEMEN

Despite Yemen's ancient and rich cultural heritage, the dawn of a modern art movement began only in the mid-1970s. A few amateur painters without any formal training organized occasional group exhibitions. Realizing the need for trained artists, the state sent students on scholarships. In the 1980s, when these students returned, the number of professional artists increased, with one-person shows taking place and annual group exhibitions.

When the former Democratic Republic of South Yemen embraced socialism at its independence in 1967, the government imposed restrictions on the few existing artists. It urged them to depict nationalistic subjects pertaining to social and political issues in accordance with its political agenda. The major exponent of this kind of revolutionary art was Ali Awad Ghaddaf (b. 1947), although since he moved to Germany in the 1980s, his work has been influenced by German Expressionism.

The most prominent Yemeni artist is Fuad al-Futaih (b. 1948), who trained in the Federal Republic of Germany. He opened the first exhibition hall, Gallery Number One, in Sanʿa in 1986 in an endeavor to form the nucleus of an art center. The general trend in Yemeni modern art is a realistic style depicting local customs and landscapes. Among its followers are Saeed Alawi (b. 1953), Hakeem Al-aʿakel (b. 1965), Abdulgalil Al-Suroor (b. 1948), Abdul Rahman Al-Saggaf (b. 1960), Adnan Jamman (b. 1960), and Hashem Ali (b. 1945). Al-Futaih's stylized figuration and calligraphic motifs are the most sophisticated among his peers, while Amin Nasher (b. 1953), Mazhar Nizar (b. 1958), and Yasin Ghaleb (b. 1956) are among the few who have adopted Expressionism.

In 1987 the Yemeni Artists' Society was established to help artists exhibit their works and raise the public's interest in art. Despite the recent discovery of oil, Yemen is not a rich country. Its government's patronage of culture and the arts is therefore not on a par with that of oil-producing countries such as Kuwait and Saudi Arabia. However, a Department of Plastic Arts within the Ministry of Information is concerned

Ali Awad Ghaddaf, untitled, 1993. Mixed media on canvas, 120 x 100 cm. Courtesy of the Jordan National Gallery of Fine Arts, Amman.

Fuad al-Futaih, *Heaven and Earth,* 1971. Silk screen, 54 x 39 cm. Courtesy of the Jordan National Gallery of Fine Arts, Amman.

with artistic affairs. No formal art lessons are taught in the schools, although the number of scholarships to other Arab countries, as well as to Eastern and Western Europe, is on the increase. Al-Futaih has recently been commissioned to execute the first public sculpture in Yemen, indicating a rising level of public awareness of the arts and public patronage.[8]

OMAN

The modern art movement in Oman began in the early 1980s with the establishment of the Atelier for Fine Arts in Muscat, which provides free lessons in drawing and painting as well as art materials for amateur art lovers. Gradually the government began sending students on art scholarships to Egypt and Iraq. The main artist in those formative years was Anwar Khamis Sonia (b. 1948), who trained in Bahrain before studying art in England. Like the majority of Omani artists, Sonia paints local landscapes and scenes of daily life in a naturalistic manner with naive overtones.

So far, the most avant-garde Omani modern artists are two self-taught sisters, Rabha bint Mahmoud (b. 1949), who paints Expressionistic canvases in bright colors, treating environmental subjects and women's issues; and Nadira bint Mahmoud (b. 1959), a lawyer

Left: Anwar Khamis Sonia, *Old Door,* 1988. Watercolor on paper, 45 x 30 cm. Courtesy of the Jordan National Gallery of Fine Arts, Amman.

Below: Rabha Bint Mahmoud, *Omani Women,* 1992. Oil on canvas, 92 x 120 cm. Courtesy of the Jordan National Gallery of Fine Arts, Amman.

Muna Qasbi, *Qa'ba Door*, 1987. Mixed media on glass, 80 x 80 cm. Courtesy of the Jordan National Gallery of Fine Arts, Amman.

by training, who is the only Omani abstract painter. The leading Omani calligraphic artist is Mohammed al-Sayegh (b. 1959), who employs Arabic letters in abstract compositions and contrasting bright colors.

In 1988 the Ministry of Culture founded the Muscat Youth Biennial for young artists from Asia, Europe, and the Arab world. In 1992 the Omani Society of Fine Arts was founded in Muscat, under the auspices of the royal court. Most art exhibitions take place at the Cultural Club (al-Nādī al-Thaqāfī) in Muscat, the main venue for all cultural activities in the capital.

WOMEN ARTISTS IN THE ARABIAN PENINSULA

In spite of the social restrictions imposed on women in Arabia, a considerable number, mainly painters, have established themselves as artists. Among them are Soraya al-Baqsami (b. 1952), Sabiha Bishara (b. 1949), and Nesrin Abdullah from Kuwait; Mounira Mosly (b. 1952), Mona Qasbi (b. 1959), Safeya Binzagr, Salma Al-Kuthiri, and Badria Al-Jassim from Saudi Arabia; Najat Hassan and Amina Seif Majid from UAE; Safiya Swar, Haya Al Khalifa, Balqees Fakhro (b. 1950), and Samiha Rajab from Bahrain; and Maryam Abdul Karim, Rabha bint Mahmoud (b. 1949), and Nadira bint Mahmoud (b. 1959) from Oman.

In Saudi Arabia, where women are still veiled in public and where strict social codes enforce segregation of the sexes, artists hold two exhibition openings: the first, official one for men and the second for women. Nevertheless, some women painters participate in mixed exhibitions even though they cannot attend their own openings.

FOREIGN ARTISTS

The economic boom that followed the oil price rise of 1971 brought a considerable number of foreign companies to Arabia. Among their personnel and dependents were some amateur artists and art lovers who tried to encourage the arts. One such attempt was the creation of the Dubai Art Society in 1976 by Caroline

Mounira Mosly, *Circle within Circles*, 1988. Mixed media on burlap, 100 x 43 cm. Courtesy of the Jordan National Gallery of Fine Arts, Amman.

Jackson and the artist Mary José. The society held a few exhibitions for local artists, but its most important contribution was inviting foreign artists to exhibit in Dubai. At the same time, al-Mathaf Gallery in London, which specializes in Orientalist works, began sending artists to the Gulf countries to paint portraits of royalty, local scenes of horses, falconry, *suqs,* and the fast vanishing nomadic customs of desert life.

Most of those artists are primarily illustrators. They depict subjects geared to their main customers—the local upper class—in a highly representational style. However, such art works might one day form more personalized records of a vanishing way of life than does the camera. Despite the high prices that their works fetch, none of the visiting painters have any influence on local talent nor are they given the chance to do so. They simply arrive, are taken to exotic and secluded areas, make their sketches, watercolors, and oils, and leave.[9]

ART STYLES AND CHARACTERISTICS IN THE PENINSULA

The paintings made during the 1950s and 1960s throughout the Arabian Peninsula are characterized by their primitive figurative style. The painters adhered to no consistent school or style but depicted their subjects realistically and in basic colors. The increase in the number of scholarships granted by the government, and the ensuing exposure to Western art, led to a departure from the old, rather rigid subject matter, and a new era of experimentation with various Western art schools and current trends gradually began. Those experiments ranged from in-depth studies to superficial imitations, both of which blindly followed visual shapes without examining the foundations of the Western schools that were being followed. The most popular styles of painting were Impressionism, Expressionism, Cubism, and Surrealism. In the 1960s, the Kuwaiti Abdallah Taqi (b. 1940) was the first artist in the area to depart from academic restrictions and turn to abstraction.

Oddly, Surrealism has been quite popular among artists in the peninsula. It can be assumed that these artists found in the symbolism and dreamlike signs a means of venting their frustrations and breaking away

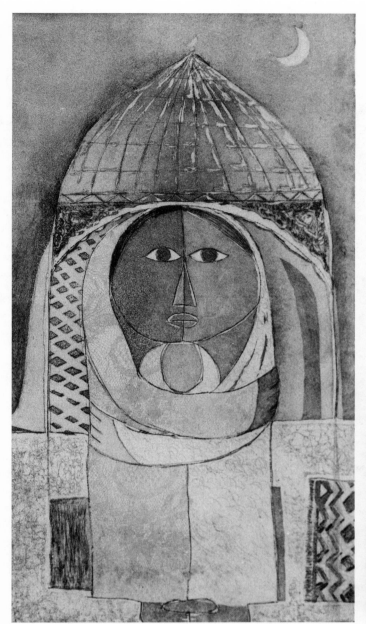

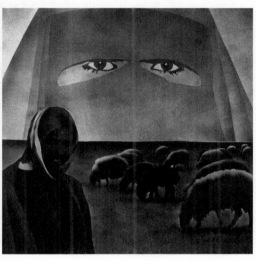

Left: Nasser Youssef, *The Two Sisters*, 1988. Etching, 45 x 23 cm. Courtesy of the Jordan National Gallery of Fine Arts, Amman.

Below: Jassem Bu Hamid, *Sheep Herder*, 1988. Air brush on canvas, 49 x 49 cm. Courtesy of the Jordan National Gallery of Fine Arts, Amman.

from their social and cultural inhibitions and restrictions. As in other Islamic countries, a considerable number of painters have incorporated Arabic letters and Islamic arabesque motifs in their works. However, with a few exceptions, there has been little innovation in this kind of painting. In general, the popularity of calligraphic works may be attributed to their salability, given the public's enjoyment of, and preference for, the written word.

Regardless of style and artistic worth, paintings by Gulf artists—whether of cities or landscapes, still lifes or portraits, realistic or Surrealistic, abstract or calligraphic—have one common denominator: the choice of subject matter, which draws on everyday life and indigenous culture. The first painter to champion local subjects was the Kuwaiti Mojab Dossari, mentioned earlier. Other early artists from the area followed his example. The most common subjects among painters are the sea, the desert, and life in their own communities.

Long before oil was discovered, the sea and the desert isolated the people of the Arabian Peninsula, while remaining a source of inspiration for their poetry. With the discovery of oil, societies in the peninsula were suddenly exposed to fundamental social and economic change at a more rapid pace than in

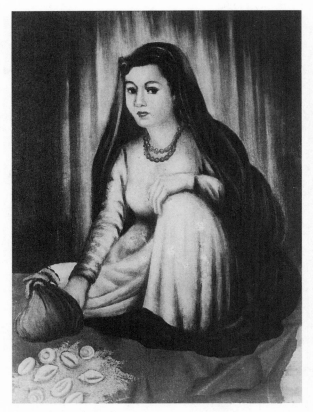

Mojab Dossari, *The Fortune Teller*, undated. Oil on canvas. Private collection.

other Islamic and Arab countries. The tradition-bound communities, which had been able to safeguard most of their customs for centuries, began to lose their grip on cultural continuity. Their oil brought upon them sudden and overwhelming affluence and a massive exposure to the technological and commercial aspects of Western civilization. Faced with this pressure, Arabian artists have made an attempt to preserve on canvas their traditions, recording for posterity those cultural practices that have disappeared or may well do so with time.

UNTIL RECENTLY, the peninsula had not established direct artistic contacts with the West, unlike the countries of the Levant. Even when artists of the peninsula had begun to use Western media—oils, watercolors, gouaches, canvas—they did not adopt Western aesthetics. The early works of local artists were mostly still lifes of coffee pots, daggers, and dates, or traditional landscapes and portrayals of camel races, sword dances, stallions, market scenes, courtyards, and old mud-brick structures that have since been replaced by concrete high-rise buildings. All were executed in an imitative manner, and the highly illustrative style and choice of subject matter were meant to please a newly wealthy clientele, eager for culture through nostalgia and alarmed at losing its heritage, yet keen on catching up with the West.

Official patronage by the governments of the oil-producing countries has been instrumental in the development of modern art in the region. A side effect of the lavish patronage given to the arts is the multitude of annual awards and prizes dispensed by the different ministries, departments, and artistic societies. Most artists are winners of gold, silver, or bronze medals or certificates of appreciation, some several times over. Consequently, these awards have been rendered meaningless in other Arab countries.

Meanwhile, Gulf nationalism has been expressed in the scores of portraits of the ruling kings, emirs, and sheikhs, which range from amateurish naive renditions to highly professional likenesses, by both native and foreign artists. However, this is not the kind of portraiture that is made under dictatorships. In Arabia, these portraits are a continuation of a traditional concept, the love of the tribe for their chief, who embodies the role of a guardian and caretaker.

The modern art movements in the countries of the Arabian Peninsula are all relatively recent. They are a good example of art development in an affluent area that lacked historical exposure both to Western aesthetic conventions and to a sophisticated Islamic art heritage. Despite extravagant patronage by governments, few innovations have been generated by their artists. This indicates that a rich cultural background and exposure to and interaction with other civilizations, cultures, and traditions, over a considerable period of time, are integral factors in the maturity process of any art movement.

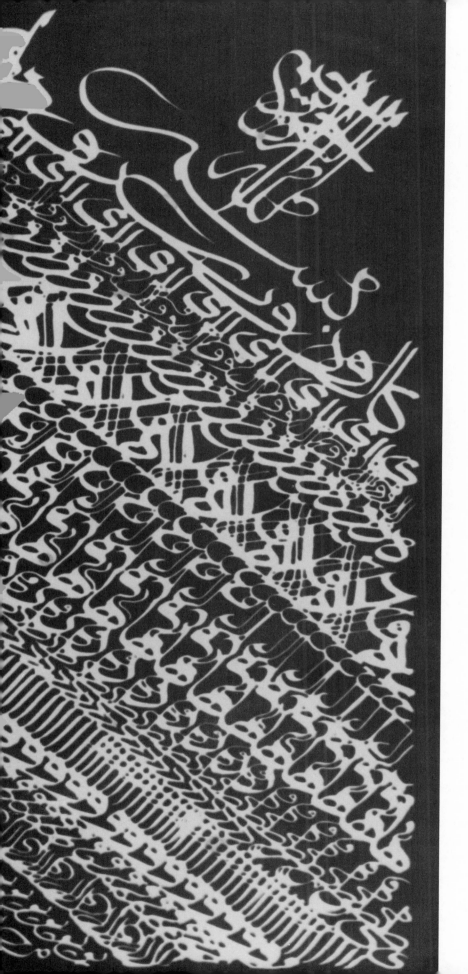

II ~ ORIGINS
AND OVERVIEW

14 GROUNDING MODERN ART IN THE LOCAL ENVIRONMENT

By the turn of the century, Western art forms, mainly easel painting and sculpture, had replaced the traditional arts among Islamic artists from areas that had an early Western-oriented art movement, such as Turkey, Lebanon, Egypt, and Tunisia. This process was part of the alienation that engulfed modern artists. It cut them off completely from the roots of their artistic heritage and forced them to start learning painting and sculpture from naught. They began to study art as novices, severing all ties with their own visual heritage.

Furthermore, as economic, political, and military ties with the West were strengthened, the resulting physical and cultural foreign domination led to a loss of confidence in the artists' own heritage, and to feelings of inferiority about the past. Paradoxically, this rupture was the first stage of an artistic awakening in the Islamic world. It also came at a time when traditional Islamic art, with the exception of calligraphy, had stagnated.

The development of modern art in the Islamic world is associated with three stages, which apply to almost all Islamic countries regardless of time.

The shortest way for Islamic artists to "catch up" with Western art was to adapt to its traditions and aesthetics. They were introduced to European works by Western teachers at the newly created art schools and through paintings in the homes of foreigners, the local aristocracy, and the wealthy elite of the artists' countries. During the learning stage, the artists in training copied nature through portraits, landscapes, and still lifes of wine bottles and flower vases, done after the classical methods of the Renaissance and the Orientalists.

Ironically, the same artists who so enthusiastically followed the Western example were surrounded at home by local architecture and handicrafts having Islamic characteristics, types, and motifs. Yet the would-be artists completely ignored them, for the very simple reason that the output of their own civilization and culture came to represent reactionary values, of which they were ashamed in light of the progressive ideas coming from the West. Advances in the West, beginning with the French Revolution and Napoleon's Egyptian expedition, as well as the liter-

ary, philosophical, and artistic movements that started in Europe in the nineteenth and early twentieth centuries, also had the effect of liberating Islamic artists from the weight of traditions. They offered a means by which to realize national aspirations based on the doctrine of liberty and equality.

After being introduced to and trained in the academic style, which was almost extinct in Europe, Islamic artists gained a measure of confidence. They became aware not only of the discontinuity between their present and the past, but also between themselves and the general public, their artistic creativity and the actual world around them. At this second stage of self-discovery, they tried to bridge the gap by choosing local subjects and themes with which the public could identify. Thus, portraits of peasant women replaced those of nymphs and society women, while scenes of Turkish, Lebanese, Egyptian, Iraqi, Iranian, and Syrian countryside were painted in great numbers.

Simultaneously, communications with the West had increased, causing a considerable number of artists to develop beyond Western academicism and Impressionism and to take up post-Impressionist styles. At this second stage, the artist's link with the present and the future was at best confused, eventually bringing a new identity crisis that was to persist through the third stage of the Islamic artist's evolution.

After World War II, Western colonialism in the Middle East was in retreat. People in the region began to turn toward their roots, dig into their heritage, and take a new pride in their nationalism and newly found political independence. This cultural awakening led to the third stage in the development of contemporary art in the Islamic world. It came about after several decades of relaxing in the security of depicting local scenes through recognized international styles such as Impressionism and post-Impressionism.

Gradually, a growing number of Islamic artists woke up to the fact that they were not after all Westerners, no matter how hard they strove to be such. Although they were well trained in Western art theories and techniques, modern Islamic artists had no artistic identity of their own. Their means of identification was confined to depictions of their immediate

environment, which any foreign visiting artist could have portrayed. Thus, Islamic artists confronted a new dilemma. They felt torn between their present, which was so obviously influenced by the West, and their past and its traditions, which embodied the only means by which they could safeguard their threatened identity. Thus they entered the third stage in their development.

During the search-for-identity stage there were three groups of artists. The first ones continued their work with local subject matter and made the jump from academic figuration and Impressionism to Expressionism, Cubism, Surrealism, and even abstraction without any hesitation. The second group tried to identify their work with their cultural heritage. The third group believed that art was universal and found no reason to identify with their own culture in their

Ismail Fattah, *Ashtar,* 1988. Mixed media on paper, 160 x 120 cm. Courtesy of the Jordan National Gallery of Fine Arts, Amman.

Hamid Nada, *Folk Tale*, 1989. Oil on wood, 120 x 110 cm. Courtesy of the Jordan National Gallery of Fine Arts, Amman.

art. Regardless of the style they chose, this third group concentrated on improving the quality of their work in an effort to attain international standards, while making no attempt to give their work a local character.

The new problem that presented itself to artists who wanted to identify their work with their cultural heritage was how to create a genuine visual form by manipulating their Western training, leaving behind Bedouin portraits, palm trees, and mud huts. Following a period of alienation from earlier Islamic art, during which artists were geared toward European trends and techniques, there came a period of self-discovery. In their quest to replace the Western models they had been trained to seek, individual contemporary Islamic artists investigated their past. Their search led them to reestablish their bonds with their own cultural patrimony. They delved into their history and went beyond the Islamic period, and they tried to examine the factors that had led to the foundation of their civilization.

During the third stage of their development, a period of cultural awakening and reorientation, artists dug into their own history and explored the ancient civilizations that had once flourished in their countries. Egyptians probed pharaonic and Coptic art; Iraqis drew on Sumerian and Babylonian traditions; the Sudanese investigated their African and Coptic legacies; the North Africans returned to their African

and Berber roots; Jordanians explored their Nabataean past; the Turks investigated their Byzantine and Seljuk patrimony; and the Iranians examined the pre-Islamic periods under the Achaemenids and Sassanians.

Consequently, stylized forms replaced naturalistic renditions in figurative paintings, while folk motifs and iconography became part of Expressionist and abstract compositions. Examples include the statues of the Egyptian Mahmoud Mukhtar, who revived pharaonic traditions in sculpture, as we have seen, and the paintings of the Iraqi Ismail Fattah, who repeatedly included massive Babylonian human figures in his compositions. Egyptians Hamid Nada and Minhatallah Hilmi incorporated hieroglyphic signs in their work. Some artists incorporated indigenous motifs within their abstract compositions, as did Ahmed Cherkaoui from Morocco and Abdel Basit Khatim from Sudan, who borrowed from Berber and African folk art, respectively.

A second source of inspiration to be explored by contemporary artists in their search for a genuine, contemporary Arab-Muslim identity was Islamic art, particularly two-dimensional miniatures and intricate arabesque designs found in illuminations, metalwork, and architectural decoration. Miniatures became a model for painters who sought a replacement for Western naturalistic figurative art, while arabesque patterns constituted a rich repertoire for abstract artists. Fahrelnissa Zeid (1901–1991), a Jordanian artist of Turkish origin, was inspired by Byzantine portraits,

Fahrelnissa Zeid, *A Feast in the Desert*, 1957. Oil on canvas, 132 x 182 cm. Courtesy of the Jordan National Gallery of Fine Arts, Amman.

Above: Suad Attar, *Birds and the Moon*, 1981. Etching, 50 x 37.5 cm. Courtesy of the Jordan National Gallery of Fine Arts, Amman.

Left: Yalçin Gökçebağ, *Game*, 1980. Oil on wood, 60 x 65 cm. Courtesy of the Jordan National Gallery of Fine Arts, Amman.

medieval stained glass windows, as well as Turkish miniatures, thus making use of a variety of artistic traditions.

Among artists who turned to the two-dimensionality of Islamic art and decoration were Yalçin Gökçebağ from Turkey, Suad Attar from Iraq, and Suraya al-Baqsami from Kuwait, while Khairat al-Saleh from Syria reinstated floral and geometric patterns in her paintings. Simultaneously, a number of artists drew on indigenous popular traditions such as shadow the-

ater, folk tales, and local handicrafts. They took their themes as well as their forms from popular legends painted on glass, fabric, or paper, and rearranged them within modern formulations. The Lebanese artist Rafic Charaf (b. 1923) first looked for inspiration into the folk tales about ʿAntar and ʿAbla (stories from the pre-Islamic era about a dark-skinned hero named ʿAntar, who fell in love with his fair cousin ʿAbla, whose father refused him as a suitor because of his poverty). Charaf therein discovered some of his own

Soraya al-Baqsami, *Cemetery from the East,* 1989. Watercolor on paper, 45 x 49 cm. Courtesy of the Jordan National Gallery of Fine Arts, Amman.

Left: Rafic Charaf, *The Charm,* 1972. Mixed media on paper, 24.5 x 30 cm. Collection of Mr. Ramzi Saidi.

Below: Nuri Abaç, *The Shepherd,* 1979. Oil on canvas, 65 x 65 cm. Courtesy of the Jordan National Gallery of Fine Arts, Amman.

cultural roots. He later reverted to Arabic calligraphy in a symbolic manner, taking verses from the Qur'an and mixing them with primitive and abstract signs in vivid colors. Khaled Asram (b. 1939) from Tunisia and Nuri Abaç (b. 1926) from Turkey were also inspired by folk culture.

These artists tried to find a style with which they could identify, in an attempt to differentiate their works from those of their Western peers. However, these styles were individual experiments and their effects at the time were confined to the particular artist's work. Meanwhile, several artistic groups that sprouted throughout the Islamic world before the 1950s had the intention of linking their work to their heritage and local environment. They included the Çalli Group in Istanbul, the Tunis School, and the Pio-

Khalid Asram, untitled, 1985. Oil on canvas, 90 x 71 cm. Courtesy of the Jordan National Gallery of Fine Arts, Amman.

neers Group in Baghdad. They painted landscapes from their countries and daily activities of ordinary people, as well as social festivities and customs such as weddings and religious ceremonies. However, their main focus continued to be portraiture of local subjects. The principal means by which members of artistic groups identified with their national culture was the themes of their art. What mattered to them was the proficiency with which they depicted their subjects while following the familiar European styles of art.

LOCAL ART MOVEMENTS

In the search for an authentic artistic identity, several art groups were formed. Their members made collective efforts to find a distinctive art style. Several are described here.

The Society of Artistic Propaganda

The Society of Artistic Propaganda, which was founded in Egypt in 1928, was the first group to concentrate on style rather than subject matter. Its goal was to free contemporary Egyptian art of foreign influences. The society was headed by Habib Gorgi (1892–1965), an artist-pedagogue who became disillusioned with contemporary painting. Instead, he centered his hopes on children.

Gorgi believed that every child was born a natural artist whose spontaneous creativity could be developed into original talent, provided the child received proper encouragement. He took peasant children from Harraniya village in Giza to his school and left them on their own to mold their clay figures, without instructing them or criticizing their works. The results were works done in an infantile naive style. Gorgi's school of art was later expanded by his son-in-law, the architect Wissa Wassef, and eventually became a world-famous tapestry center.[1]

The Baghdad Modern Art Group

The Baghdad Modern Art Group was the first in the Islamic world to succeed in developing a local style that drew on indigenous sources while taking full advantage of Western art concepts and techniques. It was also the first to call for inclusion of a message within art, by combining local iconography with international artistic trends. The moving force behind this group was the Iraqi Jawad Salim.

Salim was the first Arab artist to express a conscious quest for a distinctive Arab style and to conduct deliberate experiments along that road. He came to recognize and appreciate the aesthetic values of ancient art while working among the small Sumerian statues and colossal Assyrian marbles at the Directorate of Antiquities in Baghdad. He began looking into the history and folk culture of Iraqi society. Salim took al-Wasiti, the renowned thirteenth-century Abbasid painter, as his model. He explored al-Wasiti's illustrations as well as the incised figures on Islamic metalwork of the same period and folk motifs.

Salim discovered the graphic possibilities within Arabic calligraphy and incorporated words and verses into his compositions. However, this work was not meant to introduce calligraphy as an important component in his art. It was merely intended to add an authentic cultural touch to his paintings. While studying abroad, Salim was also influenced by the works of Henry Moore and Picasso. An example of his westernizing experience is his *Woman with a Coffee Pot,* where he used a linear style, subtracting volume and reducing the shapes to their basic outlines.

Unlike the pioneer Egyptian and Lebanese artists who painted what they saw of their country's people and landscapes, Salim intellectualized folk motifs as symbols to denote an Iraqi artistic identity. He believed that the artist's duty was to interpret his society by depicting the current events in his country. Thus, he became the mirror of Iraq's social conditions. Salim, a painter and sculptor, executed his most mature paintings in the 1950s. He established an Iraqi style of painting that drew heavily on formal and folk heritage. His style awakened a latent sense of nationalism and induced many Iraqi artists to emulate him.

Salim had misgivings about practicing painting and sculpture simultaneously. In the late 1950s, he decided to relinquish painting and concentrate on sculpture, which culminated in the creation of his *Monument of Freedom,* a 50-meter-long and 8-meter- wide bas-relief in bronze that was commissioned by the new military junta in Iraq in 1958. The mural, with its twenty-five connected figures, was conceived as an Arabic verse in

the usual distich form, but without actually incorporating any letters. This work, considered Salim's masterpiece, embodied his artistic search, concepts, and experience of twenty years. In it he was able to realize his dream of combining Iraqi artistic traits with his Western training.

The lines of the composition were inspired by the linear quality of Arabic characters, while the stylized forms were taken from Sumerian and Babylonian sculptures. Selim's style inspired other Iraqi and Arab artists to develop indigenous forms within their work. Ironically, because Salim refused to portray the president of the Revolutionary Council, Abdul Karim Qassim, in one of the monument's figures, he was refused permission to travel abroad for medical treatment. He died almost a prisoner in a Baghdad hospital, after a doctor who admired his work gave him a free bed.

In 1951 Salim founded the Baghdad Modern Art Group (as noted in chapter 4). Its goal was to foster an awareness of Babylonian and Arab traditions and to express them through contemporary Western styles of art. The first to issue a manifesto in Iraq, the Baghdad Group of Modern Art strove for an Iraqi artistic identity without disengaging from other cultures and without returning to provincialism. It announced "a new trend in painting [that] will solve the [artistic] identity problem in our contemporary awakening by following the footsteps of the 13th century [Iraqi] painters [meaning al-Wasiti]." The new generation of artists found a guiding light in the early legacy of their forefathers: to "serve local and international culture." The group took upon itself the task of improving the public's artistic awareness and taste so that it could appreciate modern art.

Besides Salim, the group included Shaker Hassan Al Said (a painter), the late Khalid al-Rahhal (a sculptor), Qahtan 'Awni (an architect and artist), Faraj 'Abu (a painter), Mohammad al-Husni (a sculptor), Khalil al-Ward (a sculptor), Abdul Rahman Kaylani (a sculptor), Rasul 'Alwan (a painter), Fadil Abbas (a painter), Jabra Ibrahim Jabra (an art critic and painter), as well as Salim's English-born wife, Lorna, his brother Nizar, and sister Naziha, each of whom was an accomplished painter in his or her own right. All the artists named embarked on a search for identity through the employment of folk motifs and iconography in Cubist and Expressionist styles that would include a message

Jawad Salim, *Woman with a Coffee Pot*, 1957. Watercolor. Private collection.

Jawad Salim, *Monument of Freedom* (detail), 1959–61. Bronze, 50 x 8 meters. Baghdad.

and a philosophy within the work of art. The Baghdad Group of Modern Art thus attempted to establish the foundation for contemporary Iraqi art in a local environment.[2]

The Old Khartoum School

Through the calligraphy classes taught at the School of Design in Khartoum, Sudanese artists became aware of the graphic value of calligraphy as early as the mid-1940s. In the mid-1950s, a group of pioneer artists formed the Old Khartoum School, as we have seen. The term *Khartoum School* was coined by Dennis Williams, a scholar and art critic from Trinidad, who taught in the College of Fine and Applied Arts in the early 1960s. It was taken up by Western art critics although it does not apply to a "school" according to Western art circles. Its early patrons were Western expatriates, art critics, collectors, foreign tourists, the cultural centers of Western countries, and a small segment of upper-middle-class Sudanese. Its main supporters were Osman Waqialla, Ibrahim al-Salahi, Ahmad Shibrain, Taj Ahmad, and Majdoub Rabbah. The group's aim was to marry African cultural traditions from the south, Islamic visual traditions from the north, and local customs. Their motto was "Do not borrow unless you need to," by which they called for full exploration of Arabic calligraphic forms as well as folk motifs.

Waqialla took it upon himself to draw the attention of his students to "the other dimension of calligraphy," regardless of whether it was Arabic or English. He urged them to look into calligraphy and not at it, and to visualize letter forms as living elements. Al-Salahi had been familiar with Qur'anic script since his childhood: his father, who was a Muslim cleric and teacher, had run a Qur'anic school in his house. Al-Salahi became fascinated by the shapes of Arabic letters and the space created between them, which he uses in his paintings, along with masklike figures. Shibrain was attracted to the graceful posture of the letter forms and the intricate weaving of their lines. Unlike Waqialla, who had trained as a calligrapher, both al-Salahi and Shibrain took up calligraphy to develop individual calligraphic styles of painting.

The members of the Old Khartoum School succeeded in creating a distinctive approach to art that was decidedly Sudanese in nature. It employed traditional Islamic motifs and Arabic characters, along with African patterns of human, animal, and natural elements. The Old Khartoum School did not issue a

manifesto because its members considered it a needless Western gesture. The members followed their instincts, and their works emerged naturally to reinterpret their heritage, through modern but indigenous concepts. Instead of embodying a philosophy, their nonthematic and decorative artwork gave importance to design and the integration of African motifs with abstract forms of Arabic characters.

According to Waqialla, the Old Khartoum School did not develop an explicit style because its members did not work together as a group, although they were bound by a concept. Despite the efforts put forth by its members, they never worked cohesively and dispersed in the mid-1960s, before their efforts had a chance to mature and crystallize into a definite style. Nevertheless, the members of the Old Khartoum School started the calligraphic movement in Sudan.[3]

The Saqqah-khāneh Group

During the Third Tehran Biennial in 1962, Hosseyn Zenderoudi displayed paintings of geometric patterns covered with talismanic writings on a background of yellow, orange, red, and black, recalling Shi'ite religious ceremonies. A leading art critic, Kerim Emami, used the word Saqqah-khāneh (see chapter 8) to describe the feeling invoked by Zenderoudi's new works. The name caught on and became identified with works that drew on subjects from Iran's repertoire of decorative motifs, as well as Persian calligraphy.

Emulating Zenderoudi, other Iranian artists began incorporating religious iconography as well as calligraphy into their compositions, thus popularizing the Saqqah-khāneh movement. These artists included Parviz Tanavoli, Faiman Pilaram, Mas'ud Arabshahi, Sadeq Tabrizi, Naser Ovisi, and Jazeh Tabataba'i. They researched cults, rituals, and folk traditions from which they borrowed. Their paintings and sculptures bore direct links to Iran's cultural and religious heritage. Thus, for the first time in Iran, artists broke away from well-known international styles, adopted indigenous forms and iconography, and translated them into a modern artistic language using Western techniques and media.[4]

The Casablanca School

In 1964 a group of painters teaching at the École des Beaux Arts in Casablanca took what was then a daring step among Moroccan artists. They introduced the teaching of Arabic calligraphy and local crafts into the school's curriculum. The artists were Farid Belkahia, Mohamed Melehi, and Mohamed Chebaa. Belkahia, the director of the school, believed that the teaching of art in schools of fine arts should be a field for new experiments, with research carried out in certain areas. Prior to 1964, no courses in Arabic calligraphy were taught in any of the Moroccan fine arts institutions. Belkahia wanted to demonstrate that apart from its formal application, calligraphy could be a means to investigate the plasticity in its forms that would be implemented in graphic art.

Reproductions of local handicrafts were displayed in the classrooms and corridors of the École des Beaux Arts to replace copies of Greek models and European landscapes. In workshops directed by Chebaa and Melehi, the pupils studied the geometric principles of Arabic calligraphy, as well as its constructional values and movement, which could be utilized as signs. They were exposed to the visual richness of popular art, studied the history of local crafts such as rug weaving and jewelry, and were made to do graphic exercises (geometric forms in black and white) as well as create jewelry and design carpets. The three pedagogue-artists, Belkahia, Chebaa, and Melehi, insisted that their pupils work with their hands in order to break the distinction between crafts and fine arts—which is a totally Western concept alien to the philosophy of traditional Islamic art—and thus reconcile the past with the present. This learning experience was followed by a practical experiment.

The artist-teachers, who became known as the Casablanca School, felt the need to break away from academic teachings and naive painting of the past, on the one hand, and foreign cultural influences on the other. They wanted to allow Moroccan painting the freedom to express creativity and make its own choices, far from imported academic restrictions. Accordingly, they boycotted the exhibition halls run by foreign embassies, in particular the French. In 1965 they held the

first exhibition by an independent group of artists, and in 1969 they displayed their work in the square facing Jami' al-Fnā Mosque in Marrakech, where popular crafts and performers such as snake charmers, fire eaters, and soothsayers are on display.

Although individual Moroccan artists such as Cherkaoui have used folk signs in their abstract work from the 1950s, the artists of the Casablanca School were the first to work as a group in their search for a local style. Furthermore, they used the same materials employed by native craftsmen when creating their art. Belkahia replaced his oils and canvas with beaten brass, skin, henna, saffron, and natural dyes. Melehi painted his abstract works in enamel paints. Chebaa however, continued to use conventional materials.

The three artists initiated their students in local design, as a model to emulate in place of the European classical aesthetic. In their exhibitions, they displayed their work in popular surroundings instead of galleries and exchanged their sophisticated gallery-goers for the simple people of the streets. In their works, they drew on forms found in local carpets, tattoos, and tribal jewelry, as well as ancient Berber and Arabic characters. Members of the Casablanca School succeeded in founding an indigenous artistic movement that gave Moroccan modern art impetus as well as character.

The School of the One

The latest art movement to be concerned with grounding its country's modern art in the local milieu began in Khartoum in 1986. A group of artists headed by Ahmad Ibrahim Abdal Aal (b. 1949) and including Ibrahim al-Awaam, Muhammad Hussein Al-Fakki,

Farid Belkahia, untitled, 1981. Henna on hide, 117 x 175 cm. Courtesy of the Jordan National Gallery of Fine Arts, Amman.

Mohammad Abdallah Oteibi, and Ahmad Hamid Al-Arabi founded the School of the One (Madrasat al-Wahid), which propagated a modernistic path for art, based on the artists focusing on their personal heritage. According to its Founding Manifesto, "The School of the One is a Sudanese visual art school with Islamic, Arabic and African identity. It stands on the foundation of the civilized heritage of the people of the Sudan, in which Arabic and Islamic culture has ingeniously mixed with local African culture. . . . Therefore it advocates the need for a dialogue between creative individuals of all orientations. Creativity is the total sum and ultimate goal around which creative beings should gather, without conflict. . . . [They] stress the importance of aesthetic and artistic research in institutions of higher education, especially the Khartoum College of Fine and Applied Arts which must be enabled to fulfill its role in cultural, social and economic arenas. This can be achieved through a well grounded curriculum and modernization of its teaching tools. . . . members of the School of the One believe that freedom is the essence of religious and moral responsibility. Freedom is a basic demand of all artists, as it is a demand of all people. Freedom is a means of revival and nation building. At the same time, it is the only means of victory in the struggle against weakness, dogmatism, fear and poverty. Artists of the School of the One believe that there is an urgent need for developing civilized unifying concepts, for the purpose of recreating a healthy Sudanese people who are able and productive in their lives."

From its manifesto, members of the School of the One seem to have a clear vision of the importance of cutting through their country's ethnic pluralism to reach a Sudanese national culture, while treating all cultural groups with equal respect and consideration. This dialogue on art, literature, and culture, accompanied by critical writings on the pertinence of contemporary art and literature to culture and society, was current among Sudanese intellectuals in the 1970s before a crackdown by the government which silenced their voices; it was resumed in the 1980s and once again silenced after the coup d'état in 1989 and the emergence of the current so-called Islamic government.[5]

ALL THESE INDIGENOUS artistic movements, including the Baghdad Group of Modern Art of Iraq, the Old Khartoum School of Sudan, the Saqqah-khāneh Group of Iran, the Casablanca School of Morocco, and the School of the One of Sudan, shared three principal traits.

1. *They identified with their subject matter by drawing on local themes and motifs, though always within the framework of well-known Western styles such as Expressionism, Cubism, and abstraction.*
2. *The trends set by these four artistic groups in Iraq, Sudan, Iran, and Morocco extended to the generations of artists that followed them, who continued their search for a local style unaffected by Western principles of art.*
3. *None of these art movements spread beyond the geographic boundaries of their country of origin.*

Throughout the search for an identity in the development of modern art in the Islamic world, there were a number of artists who, in spite of drawing on local subject matter, were not particularly satisfied with practicing art styles that were alien to their cultural background. Nor were they happy about expressing their feelings on large Expressionist and abstract canvases covered with "warm oriental colors" and two-dimensional folk motifs. Indeed, these artists began doubting the validity of what they had been doing, for they felt that they had done too many paintings that reflected their culture and environment in an Occidental fashion. They questioned whether Western art schools suited their taste and temperament, and whether they answered the needs of their public.

It was at this point that individual Islamic artists embarked on a new search for an Arab-Islamic style in modern art. The continuity and revival of calligraphy, the only original Islamic art form to survive the atrophy of the rest of the tradition, was to become instrumental in reuniting contemporary Islamic artists with their cultural roots.

15 CONTINUITY THROUGH CALLIGRAPHY

BY THE SECOND half of the twentieth century, a new art movement began to take shape out of the need felt by Arab and Islamic artists to ground imported art styles in the local environment. They had already proved their aptitude in learning the theories and in applying Western aesthetics as well as refining their ability in diverse media. Artists had reinterpreted their past heritage in a modern artistic language but had reached a stage in their development where they had to rebuild their own artistic personality in order to develop their individuality. They were no longer satisfied with drawing on figures and signs taken from their traditions. They wanted to supersede all that had been done and to reach a truly original context in both execution and content.

The solution was to develop a style that would relate to their cultural heritage while benefiting from their Western artistic training. The answer emerged in what I term the Calligraphic School of Art (al-Madrassa al-Khattīya Fī'l-Fann), which includes calligraphic painting *(taṣwīr khattī* or *lawḥa khattīya)* and calligraphic sculpture *(naḥt khattī),* as opposed to the art of classical Arabic calligraphy—*fann al-khatt al-ʿarabī.*

THE CALLIGRAPHIC SCHOOL OF ART

The Calligraphic School of Art is based on the use of the Arabic alphabet. Although the common term used by most Arab art historian and critics is *al-Madrasa al-Huruffiyah,* the term proves to be both inadequate and inelegant, for it literally translates as "School of Letterism." The foundation of the calligraphic movement in modern Islamic art is the traditional Islamic art of calligraphy. It was the central nature of calligraphy as a medium of Islamic art and aesthetics that led Muslim artists to return to the Arabic alphabet in a search for an artistic identity. It is the application of the calligraphic Arabic letter that gives these works their aesthetic value.

Only in cultures where calligraphy exists as an art, as in China, Japan, Korea, and the Islamic world, do we find a visual aesthetic expression based on the use of letters and characters as a graphic element.

Early Calligraphic Artists

The Calligraphic School of Art emerged as individual young artists working in isolation of each other, in both the West and the Islamic world, developed toward this Islamic artistic tradition. Initially, probably none of them envisaged that his or her efforts would flourish as a full-fledged school of art in the span of a few decades.

The first Arab artist to carry out research on the relationship between Arabic calligraphy and Western abstract art was Madiha Omar (b. 1908) from Iraq. Since her childhood, Omar has been fascinated by the calligraphic and arabesque decorations on Islamic buildings in Syria, Turkey, and Iraq. However, her interest in the graphic elements of calligraphy did not emerge until her early years in the United States. In 1944–45 she came across a book on calligraphy by Nabia Abbott, which included a chart on the development of Arabic characters in North Arabia. She discovered that letters were actually abstract forms and began experimenting with them in her work.

She showed her first calligraphic paintings to the Islamic art historian Richard Ettinghausen, who urged her to continue along the same lines and told her that no one had yet used calligraphy in modern Islamic art. Encouraged by Ettinghausen, Omar embarked on an experiment that culminated in an exhibition of twenty-two of her paintings at the Georgetown Public Library in Washington, D.C., in 1949. This was the first-ever exhibition of modern Islamic calligraphic works of art, and it took place in a Western capital.

To accompany the exhibition, Omar wrote an English declaration entitled *Arabic Calligraphy: An Element of Inspiration in Abstract Art,* She explained how, during her art studies in the United States, she had come to analyze Arabic letters and discovered how their graphic qualities had evolved over the centuries into their present forms. For her, each letter, in addition to its plastic shape, contained an individual meaning. For example, the letter *'ayn* (which has no equivalent sound in English), apart from its cursive configuration, signifies the eye with which a human experiences sight and gains knowledge, as well as the spring of water that is the source of life.

Omar's style wavered between realism and abstraction. She used Arabic characters as the main components of her semiabstract paintings, transforming them from simple shapes into animated and meaningful figures that embodied certain concepts. By reducing her letters to their basic shapes, she liberated them from the confines of words and transformed them into intellectual and expressive images. Omar saw in her letters perfect forms with dynamic properties that embodied abstract and symbolic meanings as well as particular ideas.[1]

Throughout his career as an artist, the Iraqi Jamil Hamoudi (b. 1924) rarely produced a calligraphic work that was devoid of figures. Beginning in the 1940s, he worked within the confines of a Surrealistic style, portraiture, and nudes, then moved on to Cubist compositions in which he incorporated letter forms. At times, he depicted landscapes in a linear manner. Hamoudi's calligraphy began to evolve in the 1970s. By then, he had developed an expressive style that mixed letters and words with pictorial forms. Usually the words that were the title of the painting would be integrated within the plastic composition. An example is his painting *People Are Equal Like the Teeth of a Comb,* a title that might sound strange to a Western ear but is actually a quotation of the Prophet Muhammad advocating equality among human beings. Within the cubist construction of the work, the title in Arabic, *al-nās swāsīya ka'asnān al-musht,* is incorporated in a composition of calligraphic shapes intersected by triangles, a crescent, and a comb. Almost all his titles are graphically interpreted within the work itself. Since the 1980s, Hamoudi's style has attained maturity in both form and color.

Hamoudi claims to have initiated the application of Arabic calligraphy in modern Arab art as early as 1943. In 1986 he claimed that two calligraphic paintings of his had been done in 1945. However, the Iraqi art historian and critic Jabra Ibrahim Jabra, as well as the painter and art historian Shaker Hassan Al Said, a contemporary of Hamoudi, both confirm that the artist had not worked on calligraphy until he went to Paris in 1947.

By the mid-1950s, other Arab and Islamic artists had become aware of the value of calligraphy in plastic

Said Akl, *Writing*, 1954. Ink on paper, 15 x 24 cm. Artist's studio.

works. One such artist was the Lebanese Said Akl (b. 1926), who used letters from the Arabic as well as Latin alphabets in their abstract forms, either linked by handwriting or separated by geometric and irregular shapes. In the 1970s, he developed simplified calligraphic symbols that stylistically blended with the whole composition. Throughout his career, Akl's treatment of epigraphy has been within the realm of abstraction.

Another Lebanese artist involved in calligraphy is Wajih Nahle (b. 1932), who attended Moustafa Faroukh's studio between 1948 and 1953. There he mastered the technique of academic realism and the use of color. He began incorporating calligraphy into his work in the early 1950s, thus commencing his search for indigenous forms and an Arab style at an early stage in his artistic development. He drew his first calligraphic work in 1954, the same year as Said Akl. However, unlike Akl's, Nahle's drawing was representational, composed of words and sentences in the tradition of classical Iranian calligraphic figures in human and animal forms. Nahle continued to develop his compositions by incorporating traditional motifs from classical miniatures with Qur'anic verses and alphabetical characters. It was not until later that Nahle abstracted the letters and made them the sole component of his compositions. On the whole, his calligraphic works vary between classicism and modernity.[2]

Meanwhile, the Sudanese artists and founders of the Old Khartoum School, Osman Waqialla (b. 1925), Ibrahim al-Salahi (b. 1930), and Ahmad Shibrain, had begun experimenting with Arabic characters in their paintings. Waqialla is a calligrapher who seeks to free calligraphy of its habitual milieu by exploring its graphic qualities. He first started trying out calligraphic forms within a modern context in the mid-1940s, while still in Khartoum.

Despite his exposure to Western art after moving to London, Waqialla has continued his work in Arabic

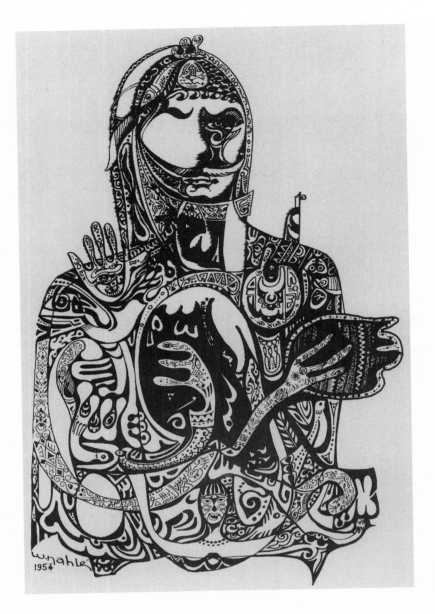

Wajih Nahle, *The Warrior,* 1954. Ink on paper, 35 x 25 cm. Artist's studio.

calligraphy. He uses his formal training as calligrapher to create both traditional and modern works. He executes works in the classical Ottoman *Tajwīd* style, which is still used in manuscripts and architectural decoration. Simultaneously, he creates modern calligraphic paintings in which he manipulates the graphic quality of the letters within a thematic treatment. At times, Waqialla includes newspaper collages with gouache and watercolor in his abstract compositions. Calligraphy and calligraphic compositions are the means by which he asserts his Arab-Sudanese identity within an international aesthetic framework.

Al-Salahi explored Coptic manuscripts, trying to discover the arts of African Sudan through them. He also became fascinated by the ingenuity of Islamic art.

Al-Salahi's previous knowledge of Coptic manuscripts led him to experiment with Arabic calligraphy, which he began to include in his paintings. In calligraphy, al-Salahi saw a means of communication as well as a pure aesthetic form. In his more recent figurative, monochromatic works in pen and ink, one can easily detect the potency of letter signs in the construction of the work.

Shibrain works in etchings with ink washes, but his best pieces are his carved wooden platters, in which he embodies his country's different artistic influences and techniques. As mentioned earlier, Sudanese artists take advantage of the material found in their environment. Wood is a traditional Sudanese material and large carved platters were used to serve food to im-

portant guests. Shibrain takes such platters and carves their convex surface and stains the patterns with natural dyes that are used in local crafts; the compositions are made up of Arabic characters and African tribal iconographic symbols. Alongside the indigenous media and the techniques of carving and staining, the African influence in Shibrain's untitled disk is apparent in the uniform decorative lines and dots, borrowed from folk handicrafts such as calabashes, as well as the stylized Arabic script, which seems to be part of the integrated African motifs.

Shibrain employs calligraphy as a visual element impregnated with religious and spiritual values. In his culture, any written piece of paper is revered and cannot be defiled because whatever words it carries might have been mentioned in the Qur'an, and even newspaper fragments found on the ground are picked up, folded, and put in a wall crevice or a tree. Shibrain

combines calligraphy with local decorative signs to benefit from his country's cross-cultural heritage of Islamic and African traditions, to which he is sensitive. He chooses wood for its durability and considers his carvings both a revival of the past and a contemporary form of art. Shibrain looks at artistic creativity as a never-ending physical and cerebral exercise that simultaneously carries a visual as well as a mental message, and is in constant motion through new experiments and research.

Hosseyn Zenderoudi (b. 1937), the initiator of the Saqqah-khāneh Group, claims to have used epigraphy not for its absolute beauty but for its textual importance and the mental impressions that only calligraphy can provide. He prefers to use the word "writing" instead of "calligraphy." Despite Zenderoudi's statement concerning the reason behind his incorporation of epigraphy in his work, the script he employs in his

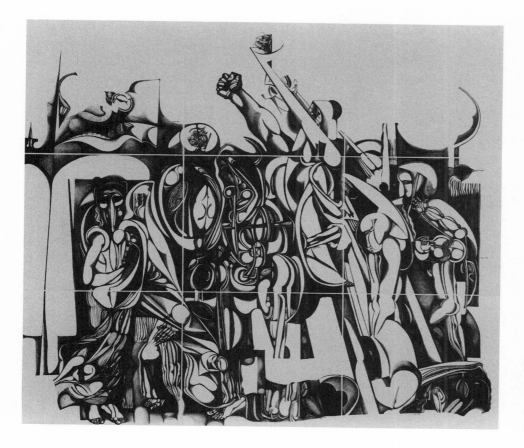

Ibrahim al-Salahi, *The Inevitable*, 1984–85. Pen and ink on paper, 65 x 74 cm. Private collection.

paintings is always classical. His series of silk-screens on the theme *Homage to a Master Calligrapher,* which pays tribute to a calligrapher through the words of the Qur'anic *Surat al-Fātiḥa,* are just such an example. The artist superimposes verses of repeated *Thuluth* script over boldly painted backgrounds that have no ties with any traditional calligraphic compositions. He thus mixes a traditional religious text with a modernistic manner of execution and medium. In his recent calligraphic works, he incorporates both Arabic and Latin signs.

Zenderoudi believes that he was responsible for the development of modern calligraphic painting in the Arab world. He could well be the founder of the Saqqah-khāneh Group in Iran and a source of inspiration for several Arab artists, but the calligraphic school in the Arab world had already come into existence before the 1960s, as we have seen with the work of Madiha Omar. Furthermore, two other Iranian artists had already employed calligraphy in their works before Zenderoudi. One of these was Mohammad Saber Fiyouzi (1909–1973), who experimented with calligraphic paintings after World War II, though he never exhibited his work during his lifetime. The other was Naser Assar (b. 1928), who showed works based on calligraphic lines in 1953, while living in Paris. Zenderoudi's advantage, however, was that he received an early exposure, both locally and internationally, after winning a prize at the Paris Biennial in 1958 and then a prize at the São Paulo Biennial, and thus he became well known.[3]

Each of the artists named here worked alone, in total isolation from his contemporaries. In Washington, Paris, Beirut, Khartoum, and Tehran, each young artist

Ahmad Shibrain, untitled, undated. Mahogany wood, 55 cm. Private collection.

Hosseyn Zender-
oudi, *Homage to a
Master Calligra-
pher,* 1986. Etching,
56 x 76 cm.
Courtesy of the
Jordan National
Gallery of Fine
Arts, Amman.

Adnan Turani, *Abstraction*, 1980. Oil on canvas, 55 x 50 cm. Courtesy of the Jordan National Gallery of Fine Arts, Amman.

who was experimenting with calligraphy thought that he or she was the first to embark on a new artistic discovery. In fact, Ahmad Shibrain, who lived in Khartoum, was unaware of the work done by his two countrymen, Waqialla and al-Salahi, who were living in the same city.

As for Jawad Salim, despite incorporating words and sentences in his paintings in the mid-1950s, he cannot be considered a calligraphic artist or a follower of the Calligraphic School of Art because he never used calligraphy as a central component in his compositions. The words in his works were meant to be a suggestion, in order to clarify and support the message of the painting and help the public comprehend it. Although the formations of his shapes, in particular those in the *Monument of Freedom*, were taken from the horizontal and vertical flow of Arabic epigraphy, it cannot be ignored that the strong figurative trend in Salim's work supersedes any calligraphic suggestions.

In the light of the manner in which calligraphic art evolved, it is difficult to pinpoint the artist who launched the Calligraphic School of Art in the Islamic world. However, by holding the first-ever exhibition in Washington, D.C., in 1949, comprising strictly calligraphic works, accompanied by a written statement, Madiha Omar can be fairly assumed to be the first artist in the modern Islamic world to formally inaugurate the Calligraphic School of Art. Furthermore, she became the first artist to display calligraphy in the Arab world during her exhibition in Baghdad in 1952.

In the 1960s the calligraphic movement in art gained momentum, reaching its peak in the 1980s. Artists throughout the Islamic world discovered in calligraphy a means to assert their identity, as well as to demonstrate their artistic versatility in a personal creative manner far removed from Western traditions. Even Turkish artists, who had been alienated and disconnected from the Arabic alphabet since Ataturk's 1928

language reform, began using calligraphic forms in their plastic works. Examples are the works of Adnan Turani (b. 1925), who included obscure letter shapes in his abstract compositions; those of Erol Akyavaş (b. 1932), who integrated legible religious sentences in his abstractions to play an explanatory role in his *şūfī* series *Passion of al-Hallaj;* and the abstract series *Homage to Calligraphy,* by the New York–based artist Burhan Doğançay. However, for an obvious reason, calligraphic art in Turkey has not been as widespread as in the Arab countries and Iran.

BY THE EARLY 1990s, the tide of calligraphic trends in art began to ebb. They were replaced with various tendencies toward realism and figurative renditions. Nevertheless, a considerable number of calligraphic

artists continued to develop and perfect their styles. The Calligraphic School is more apparent in paintings than in sculpture, though a number of ceramists have used letters in their work.

A disadvantage of the Calligraphic School is the amount of poor-quality work that has passed itself off as calligraphic art. Appreciation of calligraphic works that contain classical scripts and religious texts is not limited to connoisseurs of modern art. Consequently, many individuals who dabble in art, as well as a few established artists, have produced works in which calligraphy was exploited to please the general taste and appeal to the religious sensitivity of the public, without having any artistic value. The aim of these artists has been material gain through commercialization. Such works are excluded from this study.

Burhan Doğançay, untitled, 1985. Acrylic on canvas, 101.6 x 101 cm. By kind permission of the artist.

16 SUBJECTS AND STYLES OF THE CALLIGRAPHIC SCHOOL OF ART

IN TERMS OF subject matter, the Calligraphic School of Art treats two main themes. The first theme in modern calligraphic art is of a religious nature. Works that deal with religious subjects communicate either a spiritual or a moral message through quotations from the Qur'an, the Traditions of the Prophet, one or more of the attributes of God, or, more seldom, just a simple classical proverb. Some works are composed of a single letter or a number of individual letters, as opposed to quotations. These letters carry an iconographic meaning, such as the ones at the beginning of Qur'anic verses.

For example, the letter *alif, lām, mīm,* or *nūn* immediately conveys to the Muslim viewer a sacred significance, as in the watercolor and china ink work *Letters from the Qur'an,* by the Sudanese Ibrahim al-Awaam (b. 1935). Another example of religious subject is the silk screen entitled *Hūwa* (Him, meaning God in Sufi idiom), by the Palestinian Kamal Boullata (b. 1941), in which the writing in a geometric kufic script forms the whole composition.

The second theme in calligraphic art is of a secular nature and divides into three types: sociopolitical, literary, and decorative. The sociopolitical type, which manipulates artistic aesthetics as a vehicle of social criticism and political opposition, or which relays a nationalistic message, is new in the Islamic world. Rarely has the art of calligraphy or any other art form in classical Islamic artistic traditions been exploited as a means to reflect the social or political conditions of a nation. Sociopolitical subjects in modern Islamic art started to emerge in Turkey during the second decade of the twentieth century, at the time of the War of Independence. Such art was bolstered after Kemal Atatürk came to power.

In the 1920s, the theme of Egyptian nationalism was manifested in the sculptures of Mahmoud Mukhtar, who paved the way for other Egyptian artists to express nationalist sentiments. During the 1940s, as the Syrians struggled for their independence, a few artists began to include nationalistic subjects in their repertoire. In the 1950s, after the first Arab-Israeli war in 1948, the sociopolitical trend gained slight momentum in the Arab world. At its inception, it was manifested in figurative works, and only in the 1960s did it occur

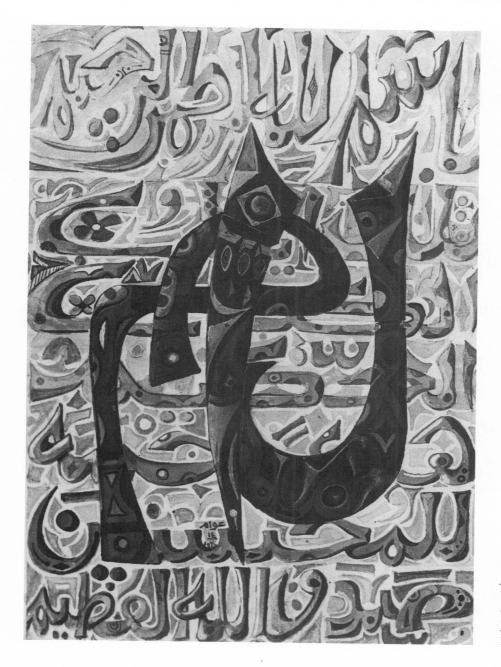

Ibrahim al-Awaam, *Letters from the Qur'an,* 1985. Watercolor and china ink on paper. Courtesy of the Jordan National Gallery of Fine Arts, Amman.

in calligraphic paintings, becoming widely used following the defeat of the Arabs in the Six-Day War of 1967.

The most important factor in the composition of the sociopolitical type of calligraphic painting is the significance embodied in the message itself and its intellectual effect on the literate viewer. A major subject has been the Palestinian problem, which has dragged on since the late 1940s, causing a great deal of pain and disappointment among the Arabs toward their leadership and toward the superpowers. The situation has been further aggravated by a realization of inter-

national double standards in dealing with all Arab-Islamic issues. A sense of despondency among Islamic intellectuals, particularly the Arabs, has been reflected in their literary and artistic output. In the plastic arts, this despondency bred a sense of inadequacy that either fell short of or superseded visual imagery. This sense of powerlessness led artists to reinforce their figurative art with written texts in order to strengthen the impact of the message they wanted to convey.

Most political paintings pertaining to the Palestinian problem are distinguished by a depressing element that sometimes borders on the macabre. An ex-

Left: Adnan Yahya, *If I Did Not Survive*, 1987. Mixed media on paper, 83 x 70. Courtesy of the Jordan National Gallery of Fine Arts, Amman.

Below: Etel Adnan, *Dedicated to Pablo Neruda*, 1983. Gouache and ink on paper, 25 x 300 cm. Private collection.

ception is Kamal Boullata's silk screen *Thawra* (Revolution), in which he repeats the word *thawra* in geometric kufic, superimposing it to form a patterned design with an effective graphic construction and strong colors. Other calligraphic paintings also deal with social statements on poverty or social injustice, and sometimes the message combines more than one meaning. An example of sociopolitical art is found in the work of the Palestinian Adnan Yahya (b. 1960). He has included in his mixed-media Expressionistic painting *If I Did Not Survive* verses of poetry that emphasize the tragedy of his countrymen living under occupation.

On a broader humanitarian level, Wijdan (b. 1939) from Jordan abandoned all figurative representation at the onset of the Gulf war in 1991. In a personalized script, she employed Arabic verse to portray the eighth-century battle of Karbala' in Iraq, where the martyrdom epic of the Prophet's grandson Husayn took place. Through couplets, prose, diacritical marks, signs, conflicting brushstrokes, and colors, she portrays a calamity that for her became the epitome of tragedy, betrayal, and injustice committed against human beings, including Dachau, Palestine, Vietnam, Bosnia, Somalia, Lebanon, Afghanistan, Chechnya, Zaire, Cambodia, Uganda, Sri Lanka, Kurdistan, and Iraq.

The second type of secular calligraphic work is literary in nature, either prose or poetry, and relates either to classical or modern Arabic, Persian, and Urdu literature. Throughout the history of Islam, belles lettres have been closely connected to visual, decorative expressions. Poetry intertwined with geometric and floral arabesque covered the walls of eleventh-century al-Hamra' Palace in Granada. Verses of the classical Persian poets, Sa'di and Nizami, were often incorporated within miniatures illustrating their poems during the Safavid (1501–1732) period in Iran.

When the modern calligraphic art movement appeared, artists of different generations, using various media, incorporated prose and poetry into their paintings, etchings, sculptures, and ceramics. At times, whole poems were included in a work of art. For example, the Lebanese artist Etel Adnan (b. 1925) delineated the verses of contemporary poets such as the

Iraqi Abdul Wahab al-Bayati and the Chilean Pablo Neruda, among others, in a clear script, emphasized by thick lines of watercolors. By presenting literary themes through visual art, the modern calligraphic artist is thus reverting to old artistic concepts in Islamic culture but using a new means of expression: modern media and techniques.

In the decorative type of calligraphic art, works generally manipulate the aesthetic configuration of the Arabic letter in a purely abstract manner. They transmit the Western value of "Art for art's sake" and are devoid of any moral or cultural significance. The Omani Mohammad Al-Sayegh (b. 1959), in an untitled oil on canvas, has created a foreground of a multitude of the first letter in the Arabic alphabet, *alif*, against a sky background with the Hindu swastika, the symbol

Mohammed Al-Sayegh, untitled, 1992. Oil on canvas, 95 x 62 cm. Courtesy of the Jordan National Gallery of Fine Arts, Amman.

Yussef Ahmad, *Calligraphic Composition*, 1983. Silk screen, 40 x 30 cm. Courtesy of the Jordan National Gallery of Fine Arts, Amman.

of regeneration. Although legible, the letters, as pure graphic shapes, convey no message and their value lies in their arrangement and color. Another artist, Yussef Ahmad, a Qatari, has drawn a multitude of words in his *Calligraphic Composition*, forming an abstract arrangement. In his work, Ahmad uses words for their variety of shapes, to build up large abstract forms.

The popularity of Arabic calligraphy among Islamic artists can be attributed to several causes. First, calligraphy not only forms a link with the artist's religious, literary, and artistic heritage, but it is also a living presence that is still effective. Second, the versatility of Arabic calligraphy, in either its regulated or its free styles, offers the modern artist unlimited plastic and graphic possibilities, which can be manipulated and executed through traditional as well as modern techniques and media. Likewise, calligraphy can be employed in the depiction of spiritual as well as commonplace subjects. Finally, Arabic calligraphy appeals to and satisfies the literary aesthetic of Muslims, especially Arabs, whose artistic expression since pre-Is-

lamic times has been mainly poetry. What an artist cannot express figuratively, he can express in writing. Likewise, what a viewer cannot comprehend visually, he can read in a work of art. One word can explain a plastic composition by conveying a mental image from the artist to the receiver.

STYLES OF THE CALLIGRAPHIC SCHOOL

The Calligraphic School of Art in the Islamic world has thus far not been properly analyzed and categorized, either by art historians and critics or by artists, not least because the development of the various calligraphic styles was not a concerted group effort or the product of one local school of art. It emerged out of diverse trends that evolved from each artist's individual experiments and preferences. The artist who employed epigraphy in his or her compositions did so on a personal basis, without knowing what result the work would bring.

As for the art groups that called for the inclusion of calligraphy in their work, such as the Old Khartoum School and the Saqqah-khāneh Group, none of their members proposed a clear definition of how calligraphy should be employed in art. They formed loose groups who agreed, in principle, to assert their artistic identity through the use of Arabic calligraphy as well as other folk and indigenous motifs. Unlike groups in the West, such as the Impressionists or Cubists, groups of artists in the Islamic world never framed their ideas within a clearly defined set of concepts. Consequently, it took a considerable amount of time for the different calligraphic art styles to develop and mature. Meanwhile, the majority of calligraphic artists have moved from one style to another, at times unconsciously, believing that all are uniform as long as they include Arabic characters, regardless of type of script or its place in the composition.

However, the artists themselves, through their work, have unconsciously divided the calligraphic theme in art into three main styles, which have gradually developed since the 1950s. In examining the spectrum of calligraphic works, one finds a pure calligraphic style, an abstract style, and calligraphic combinations. Each of these styles split into two or more substyles. In this study, the terminology for the

first two styles is based on the type of script employed and its place within the composition of the work. The third style, calligraphic combinations, is so called because it combines both script and figurative subject matter. All through, the typology has been determined according to the nature of the script and the role it plays in the composition of the work of art.

The rest of this chapter will identify and define the typology of calligraphic styles that exist within the modern Calligraphic School of Art, giving examples of artists who are associated with each.

It should be noted here that rarely does an artist subscribe to one style in particular. Artists using calligraphy usually move freely between the various styles that make up the repertoire of calligraphic art. This fluidity makes it difficult to assign an individual artist to a particular category. However, some calligraphic artists have kept one style throughout their career. Whenever possible, these artists in particular will be cited as examples.

Pure Calligraphy

The first major style of the Calligraphic School of Art is pure calligraphy. It includes works composed only of letter forms, which make up both the background and the foreground of the composition. The Arabic alphabet forms the entire subject matter and composition. The form it takes can be a letter or a group of letters, a word, words, sentences, paragraphs, or any combination. It should be noted that any letter from the Arabic alphabet, apart from its visual and graphic impact, even when taken on its own, has a certain significance. In the mind of the literate viewer, who is thus also the reader, it transmits connotations on more than one level. Out of the pure calligraphic style, four branches have developed.

THE NEOCLASSICAL STYLE

The first branch is the neoclassical style, which is based on one of the traditional schools of classical Arabic calligraphy and adheres to an established set of rules in its execution. This branch endeavors to revive classical Islamic calligraphy with very little change and innovation in scripts and motifs. The modernity lies mainly in the conception of the work and

the materials used by the artist. Works in the neoclassical style are directly related to traditional calligraphy, although sometimes the artist may present a new arrangement of classical motifs in his composition. Neoclassical works, despite being executed in new media, using modern techniques, are the authentic modern descendants of classical Ottoman and Persian individual calligraphic pieces *(muraqaʿat)*. They usually have either religious or literary subjects. Within this category are the works of Wajih Nahle (b. 1932) and Khairat al-Saleh (b. 1940).

The Lebanese artist Wajih Nahle began his calligraphic paintings in the neoclassical style. As we have seen, his first calligraphic work in ink on paper, *The Warrior*, done in 1954, reveals the influence of Iranian figurative calligraphy. An example of what he calls his Golden Period, between 1970 and 1973, is the neoclassical painting *Al-Fātiḥa*, in gold leaf and polyester on wood. Nahle divides the surface into two parts. In the upper part, which occupies more than two-thirds of the composition, there is a square in which he creates a *shamsa* (little sun; in book illumination a disk or rosette ornament) made up of a polygon surrounded by *Surat al-Ikhlās* (chapter 112, the Qurʾan).

Nahle frames the Qurʾanic text with twelve rosettes that encircle calligraphic and geometric patterns or stylized figures—a horseman, two musicians, birds, and a half-human, half-animal figure that could be a reference to *al-burāq* (a mythical being on which the Prophet Muhammad ascended to heaven). All the figures in the rosettes are clearly repetitions of those found in classical Islamic miniatures, as well as on pottery and in metalwork decoration. In the lower third of the composition, there is a rectangle of three equal parts. The upper and lower ones containing the text of *Surat al-Fātiḥa* (the opening chapter in the Qurʾan), and the one in the middle consists of an arabesque design. Nahle's affinity to traditional calligraphic works is apparent in the Kufic script of his text, the illumination in gold leaf, and the arabesque and classical figuration.

Nahle's personal innovation is the arrangement of his composition, placing the text at the bottom of the painting instead of at the center. A second innovation is the use of a new material, polyester, for the calligraphic work. The example described here demonstrates how contemporary artists, while adhering to classical scripts and decoration, develop modern renditions without falling into the trap of tedious repetition or excessive innovation.

Khairat al-Saleh's paintings combine either a letter, a word, a Qurʾanic verse, or a line of poetry with imagery that embodies the significance of the writing. In her painting *The Creation,* in which she uses gouache, ink, and gold leaf on paper, al-Saleh has employed a western Kufic script in thick embossed gold strokes, on a royal blue background flecked with golden spots. The Qurʾanic text that is the central theme of the painting deals with the creation and is rendered in the form of an open page from the Qurʾan. Framing the two pages are decorative elements of trees, flowers, clouds, and waves, illuminated in miniature technique. Vegetal decorative forms are also reproduced near the text, on the inner side of the pages.

Al-Saleh has used a classical script of a known Qayrawani calligrapher of the eleventh century, ʿAli al-Warraq. Although her decorations are also inspired by the art of traditional illumination, they are less regulated than her models, which were never meant to hang on a wall. In Islamic culture, pages from the Qurʾan were never torn out to be framed, and the illusion of two open pages in a free-standing painting is entirely modern. Moreover, such heavy illumination was usually meant for frontispieces and end pieces of a manuscript. Al-Saleh has been innovative in exploiting traditional forms of the art of the book, within the modern concept of a free-standing painting that incorporates a devout message as well as aesthetic value.

MODERN CLASSICAL STYLE

The second branch of the pure calligraphy style is the modern classical, which incorporates a traditional script within a modern composition. In this style, the artist produces one of the traditional scripts in a new rendition, experimenting with colors, forms, composition, and media. The artist might elongate the letters of the script, although without affecting the basic rules that govern their disposition. All artists who follow this style combine the discipline of a traditional calligrapher with the freedom of a modern artist. They use

classical scripts but take the liberty of rearranging the calligraphy in a contemporary composition, including color, texture, or layout.

The artist to reach the greatest perfection of the modern classical style is the Egyptian *sāniʿ* Ahmad Moustafa (b. 1943). In Islamic tradition, the sāniʿ is a person who, in executing his art, shows skill, creativity, and training that has been passed on from master to apprentice. The closest translation in English would be craftsman-artist.

Moustafa's skill and dexterity in drawing produce optical illusions through script, creating three-dimensional Qur'anic still lifes and scriptural landscape. In his early works such as *Qur'anic Fugue,* Moustafa uses overlapping and interlinked letters to create a composition in which the foreground and the background compete to take control of the painting. He produces a visual tension that has become a basic characteristic of all his work.

Moustafa's most important recent paintings deal with Qur'anic verses executed in superimposed, three-dimensional, spatial forms. They transmit a sense of the metaphysical, derived from the written word and its meaning. In his *Still Life of Qur'anic Solids,* an oil and watercolor painting on handmade paper, the scriptural characters determine the planes, shapes, and sizes of all the forms in the composition. The floor pattern is based on verse 2 of *Surat Āl ʿImrān:* "God, there is no deity save Him, the Ever-lasting, the Self-Subsistent Fount of All Being" (Qur'an 3: 2), while the suspended three-dimensional shapes reiterate: "Behold, everything have we created in due measure and proportion" (Qur'an 54: 49).

Moustafa's taut compositions supersede regional Arab trends while adhering to the spirit of Islamic aesthetics. The superimposition of two different scripts, such as geometric Kufic over cursive *Thuluth,* and the effect of optical deception not only animate his compositions but add a spirituality outside the limits of time and space.

In his highly accomplished calligraphic paintings, Moustafa combines the strength of tradition with the originality of innovation, interpreted through the sensitive brush of the master artist and the facility of modern technology. In creating a complicated visual imagery, as in his oil and watercolor painting on handmade paper *God Is the Light of Heaven and Earth,* his aim is not to prove his skill or talent but, in a very humble way, to show the infinite power of God, the Ultimate Sāniʿ. His message is simple: if a mere mortal can achieve such complicated beauty, how much more can an Infinite Creator do!

Recognized in London as a major artist, Moustafa was the first Arab artist to be given a one-person exhibition at the Royal College of Arts, in 1990. Through such recognition, he has proved that contemporary Islamic art can be universal.[1]

THE MOST RECURRENT subjects in the modern classical style are those related directly or indirectly to religion. However, not all works employing traditional scripts deal with spiritual themes. We seldom find pieces such as the untitled ceramic spheres and disks of the Jordanian Mahmoud Taha (b. 1942), in which writing in the form of *Tughrāʾ* (the seal of Ottoman sultans; elaborate, intertwined script) is employed as a decorative element. The Iranian Parviz Tanavoli (b. 1937), a member of the Saqqah-khāneh Group, has made a series of sculptures in bronze entitled *Hich,* meaning "nothing" in Farsi, utilizing Nastaʿlīq script for its pure aesthetic value.

Through the pure calligraphic style, the modern artist is able to manipulate both the form without and the concept within the letter or word. Sometimes other elements are incorporated into the structure of the work, usually in the form of conventional Islamic decorative motifs, mostly copied from traditional miniatures, and arabesque patterns. Yet these visual shapes play a secondary role in the composition. By choosing religious subjects, the Islamic artist returns to his cultural roots while utilizing the techniques of his time. Many contemporary artists from the Islamic world have spent years at Western art schools, whether in their country or abroad. This training has been instrumental in making the artistic transition to modernity.

CALLIGRAFFITI

The third branch of the pure calligraphic style is calligraffiti. It is an ordinary script that has no rules, belongs to no known school of calligraphy, and differs

from one handwriting to the other. The inclusion of personal handwriting within a modern composition allows the artist a great deal of freedom in application and execution. I term it calligraffiti because, although the writing itself is inspired by calligraphy, it is also close to graffiti scribbling. In this style, the artist strips the letters of their classical restrictions and takes them to their very basic, rough shapes. All ties with tradition are severed in order to create a personalized image of the letter.

In calligraffiti, artistic creativity begins with the act of breaking down the original archetypal character, then reshapes it into a personal symbol, free from the dictates of tradition. Because calligraffiti does not require proper training in classical calligraphy as a prerequisite, and because artists experience tremendous freedom in its practice, it has become the most popular calligraphic style among contemporary Islamic artists. The following are significant calligraffiti artists.

Painting, to Etel Adnan (b. 1925) from Lebanon, is a language without limitation through which she expresses herself verbally and graphically. In her mixed media work on Japanese paper, which opens like a book in the shape of an accordion, the name *Allah*, written in black, is repeated in vertical and horizontal uniformly spaced lines. Each word is painted over with a different color in a haphazard manner. The methodical arrangement of the words, which are the only recognizable shapes in the composition, contrasts with the disorderly distribution of color that covers them, creating an interesting blend of rhythm and ambiance in the composition.

A second calligraffiti artist is Ramzi Moustafa (b. 1926) from Egypt. In his paintings and sculptures, Moustafa often repeats the name *Allāh* as a basic motif. In one such example, an oil and acrylic on canvas, the word *Allāh* is haphazardly written in white paint. The arrangement is outlined by colored strokes and lines in a quite disorganized fashion. The graphic composition here enhances and emboldens the message in the painting.

A prominent calligraffiti artist is the Iraqi painter, art historian, and theorist Shaker Hassan Al Said (b. 1925). His "one-dimension" theory is the result of Shaker Hassan's observations during the years he has spent in France and in his native country. He observed that it was during the Renaissance that Western artists first portrayed three dimensions, or perspective, in their paintings. Two of the dimensions are real (length and width), while the third (depth) is a visual illusion. This illusory dimension is the one that Shaker Hassan took on in his work, calling it the one-dimension. Through it, he tackles the problems of color, form, and surface by way of informal or accidental art.

For Shaker Hassan, a written character made up of a line with a single dimension plays an important role as a dimension within itself. It is a means that carries free visual possibilities of form and mystic symbolism, rather than a linguistic end. He deconstructs writing, reduces the letter to its elementary form, and turns it into a *ṣūfī* symbol, in isolation from its outward meaning. (The adjective *sufi*, meaning mystical, transcendental, spiritual, is a term Shaker Hassan insists on using to describe his work.) He uses the Arabic letter as a starting point, and through its line discovers its plastic nature. The well-known Arab art critic Jabra Ibrahim Jabra has gone as far as defining Shaker's "one-dimension" as the link between man and God in infinity. For Shaker Hassan, it is as an amalgamation of the spiritual and graphic qualities of the Arabic letter. As long as writing is achieved by drawing a line, which is the dividing element between two surfaces and two levels, it should have a single dimension. This is the element that Shaker Hassan employs in his works.

In 1971 Shaker Hassan formed a group of artists who use writing in their work: the painters Jamil Hamoudi, Madiha Omar, Rafa al-Nasiri, Dia Azzawi, Nouri Rawi, and Hashim Samarji; the sculptor Muhammad Ghani; the ceramist Saad Shaker; and the renowned calligrapher Hashim al-Baghdadi. The group held its first and only exhibition in Baghdad that same year. In the exhibition catalog, Shaker Hassan explained his theory based on the usage of the Arabic letter. Not all the artists of the One-dimension group followed the same style as Shaker Hassan, for this was never a true school of art. However, all use the Arabic letter as a base for their compositions, applying it as a plastic shape as well as an intellectual symbol.

Shaker Hassan sees Western abstraction as a negative force. He replaces it with what he calls the contemplative vision of the one-dimension, a positive force that unifies humanity with the universe. In his philosophy, human ego is a negative force in the positiveness of the world. For him, the real nature of things can only be associated with those feelings stemming from the human subconscious and inner being. The empty canvas represents the ego, and the letters of the alphabet represent the positive force. Using individual letters of the alphabet as an art configuration is a version of the contemplative vision that tries to sense the unity of our two worlds: the world of thought through language and the plastic world of observation.

Shaker Hassan has been inspired by scribbles on old abandoned walls impregnated with the marks of time. He considers the cracks on these walls to be continuous vague writings in a painting developed by a sequence of accidents within the environment. A good example is his painting *Letters and Colors*, where the artist's job was to introduce the accidental work to the viewer. He interprets it by adding his own scribbling—of ambiguous letters, legible words, numbers, and signs—to the illegible and uninterrupted "writings" of the cracks in an effort to introduce a new form of technical expression. He has used anti-collage (decollage), in which he tears off parts of the painting's canvas to show the wood behind it. The overall picture, in itself, expresses a state of consciousness close to a state of ecstasy.

Shaker Hassan considers spontaneity an essential component of his contemplative vision. In his view, a child's scribbling and an adult's graffiti, in their modesty and naïveté, express the instinctive nature of the human soul, in its conscious and subconscious manifestations. For him, the one-dimension joins man to God in infinity through the most common and humble lines. Furthermore, the act of the artist's hand in touching the paper is equivalent to the act of *fanā' al-dhāt,* which, in the language of mystics, means "lost in contemplation of God, and insensible to all else."[2]

Shaker Hassan rejects the use of traditional scripts in classical calligraphy as regressive and confined to a time in the past. He prefers graffiti as more indicative

Shaker Hassan Al Said, *Objective Contemplations,* 1984. Oil on board, 120 x 120 cm. Private collection.

of the present. Sometimes he replaces a letter with its numerical equivalent according to the science of *al-jafr,* the numerical symbolism of letters. In his *Objective Contemplation,* the letter *ha'* is replaced by the number 8, next to the letter *ba'.* By replacing one letter with its numerical equivalent, Shaker Hassan thus writes the word *hub,* meaning love, in an enigmatic mystical language. In his *Wall Strip no. 4,* Shaker Hassan cancels all legible scribbles, giving an overall effect of half-erased signs on an old wall surrounded by vague letter shapes. The result intrigues the viewer and makes him or her wonder about the meaning of the work. Despite the highly abstract quality of his letters, Shaker Hassan believes they emanate signs that carry certain *ṣūfī* messages.

Shaker Hassan is a painter who has embarked on a mystical voyage through a contemporary form of art. His aim is to incorporate the spiritual and the temporal, with the former overpowering the latter.[3]

FREEFORM CALLIGRAPHY

The fourth branch of the pure calligraphy style is freeform calligraphy, a script that balances the classical type and calligraffiti. This studied modern script,

which several artists have developed, differs from traditional scripts by having no fixed rules. However, freeform styles are more regulated than graffiti and have a certain aesthetic appeal.

A prominent painter of freeform calligraphy is the Libyan artist Ali Omar Ermes (b. 1945). His compositions fall into two groups. Paintings in the first group consist of either an Arabic letter as a central focal point or a word executed in a thick brush stroke against a plain or colored background. At times, Ermes writes poems and quotations around his central letter to create an interesting visual balance in the composition. In some works, Ermes's script is close to *Maghribī*, an Arabic script developed in North Africa, in others to *Dīwānī*, created in Ottoman Turkey for use in official edicts. However, the freedom in the flow of the brush that paints the calligraphic signs is far removed from the restricted discipline of a calligrapher, and the signs are thus closer to a personal script.

The second group of Ermes's paintings are made by repeating a single letter or multiple letters. The letters fill the entire space of the painting with colors and abstract shapes that create visual images reminiscent of the marbled paper, *ebru*, of later Islamic book illumination. The texts in these compositions look like a graphic design more than they resemble legible script. Ermes never uses Qurʾanic or religious quotations. A poet himself, he employs the profane literature of the pre-Islamic *Jahiliya* and early Islamic poets in his paintings. In others, the text is a simple explanation of the letters themselves.

Ermes has found in Arabic calligraphy a graphic and literary language by which he identifies with his culture. He is a devout Muslim, who expresses his piety by shunning religious texts so as not to abuse them and uses calligraphic forms written in a freeform script. He regards his abstract work as having four dimensions: visual, historical, literary, and artistic. For him, a work of art is judged successful only when it communicates with the viewer. The mental process between the painting and the beholder is as important as the motion of the composition. Ermes considers the use of Arabic text in his paintings as a bonus for those who can comprehend it; for those who cannot, it is an invitation to explore further and attempt to learn more about the paintings. His quest is to continue working within the mainstream of international art and to contribute to it by adding new elements available in Islamic culture, without compromising his own Islamic cultural traditions. Judging by Ermes's success in the West, he is one of the few Islamic artists who has succeeded in propagating his culture in a modern way, without betraying its origins or becoming xenophobic.[4]

Abstract Calligraphy

The second style of the Calligraphic School is abstract calligraphy, which subtracts form as well as meaning. According to the *Phaidon Dictionary of 20th Century Art*, "The twentieth century concept of abstract art is of an art devoid of figurative images which does not seek to represent other visual experiences: it commands its own autonomous terms of reference" (p. 1). Abstract calligraphy fits within this definition comfortably; the artist manipulates the visual aesthetic aspect of the Arabic letter as a structural element in the composition.

The abstract quality of Arabic characters serves the artist in an unrestricted manner and on his own terms. He builds up his abstract work without having to refer to a recognized school of art or to follow any set rules. There are two branches of abstract calligraphy: legible script and pseudoscript.

LEGIBLE SCRIPT

The first branch of abstract calligraphy is legible script, in which the artist maintains the outward form of the letter or letters and employs them in a purely graphic manner, without taking meaning or connotation into account.

Although Arabic writing always carries some significance, it becomes an abstract set of symbols when the letters lose their meaning. Yet they lose their meaning only when they cease to be legible, through the distortion of their forms. Nevertheless, I include works of art with legible letters under the abstract style because the artists themselves have meant their works to be abstract. They have employed letters in

their original shapes, which according to the artists become abstract as long as no meaningful word is formed.

One such artist is the Syrian Mahmoud Hammad (1923–1988). Hammad was responsible for establishing the Calligraphic School of painting in Syria. He took letters and transformed them into the main component of his compositions. He neglected their legible significance and utilized their plasticity of shape. In his monochrome formations, Hammad was concerned with the placement of the abstract calligraphic shapes and their visual and constructional effect within the space of the composition, more than he was concerned with their meanings. In his painting *Calligraphy,* the shapes of certain letters, such as *dāl, wāw,* and *hā,* are quite distinct, though they serve no purpose other than being the principal components of the abstract composition. On the other hand, the viewer might be able to form a word out of them, which enhances the enigmatic nature and potential of the letters.

PSEUDOSCRIPT

The second type of abstract calligraphy is pseudoscript, which consists of unrecognizable forms based on Arabic characters. Several Islamic artists have succeeded in exploiting the original shape of the letter as an integral component of the whole composition while denuding it of its legibility. They have come up with a pseudoscript in configurations obscurely related to the Arabic alphabet. At times these shapes are clearly recognized, while at others their relationship to legible signs is quite difficult to determine, although the overall effect is unmistakable.

In pseudoscript, the artist usually transforms the letters into unrecognizable lines and dots, thus sapping them of their linguistic significance. The artist leaves only visual plastic characters to incorporate within the composition. The letters and words in this style cannot be deciphered or read and do not need a literate viewer to appreciate them aesthetically. Obviously, pseudoscript does not carry a message within its letters, so this calligraphic form becomes a silent constructional pattern similar to the arabesque.

An artist who has treated calligraphy in this purely abstract manner is the Tunisian Nja Mahdaoui (b.

1937). In his misleading compositions, which are built entirely on signs, one might think at first glance that there is a legible text because the shapes of the letters seem familiar. Yet any attempt at reading the text is futile. Although some of the letters are discernible, they serve no purpose other than the structural. At times they look more like Chinese characters than Arabic, though there is no doubt about their origin. Mahdaoui utilizes various traditional and modern media in his work. He uses ink on parchment and animal skins as well as oils, acrylics, watercolors, gouache, canvas, polyester, wool, and brass to create his paintings, etchings, tapestry, and murals. It is the fluidity inherent in the art of calligraphy, which traditional master calligraphers have manipulated to develop diverse scripts, that Mahdaoui exploits in a controlled manner, to meticulously build up his abstract compositions.

From the number of artists who adhere to abstract calligraphy, it can be assumed that it is the most popular among all the calligraphic styles. Artists have found in it the freedom of a modern trend as well as a reference to their cultural heritage.

A number of artists have totally denuded epigraphy of its recognizable shapes and turned the characters into abstract configurations. One such pseudocalligraphic artist is Khaled Khreis (b. 1956), from Jordan.

A well-read and well-trained artist, Khreis has always been searching for new elements in his paintings. Throughout his travels and studies in the West, Khreis wondered about the issue of identity, whether he was an Eastern or a Western artist. As a consequence, in 1979 he became attracted to his cultural background and began experimenting with Arabic calligraphy. He found in it not only a solution that mustered indigenous forms in a modern aesthetics, but also an approach that suited his linear tendency in painting and etching. By then he had reached a stage where he had lost interest in three-dimensional figuration and was more attracted to two-dimensional representations, in which Arabic letters fit well.

Meanwhile, he also began to study the works of other Arab artists who had worked with calligraphy, such as Shaker Hassan Al Said, Rachid Koraichi, and Nja Mahdaoui. In 1990 Khreis's exploration of the

graphic aspects of letter forms intensified. He was not interested in classical calligraphy because he felt that the employment of traditional script would be repetitive. He believed that the only possible innovation was to reorganize the letters in a new composition, so he turned to abstracting the characters.

Sometimes he kept the letter unfinished, insinuating a word, while leaving the viewer to complete it in his mind, inspired by the hues, tones, and architecture of the composition. As exercises in spontaneity, Khreis began to splash colors on the painting's surface and to intersect them with calligraphic signs in which he saw, besides the literal, linguistic value, a humanitarian and cultural dimension as well as compositional and aesthetic elements. At times, Khreis painted and wrote with his left hand to rid his work of any controlled effect. He felt that the movement of Arabic writing, from the right to the left, paralleled the movement from the external to the internal or the mind to the heart, which he experienced when working on small pieces that he cradled in his arm. However, not all letters were abstract for Khreis; in some he saw a human figure, a bird, a tree, or an insect.

Khreis's paintings are as cerebral as they are visual. The blues and ochres in his work come spontaneously from the sky and the desert of his country, and the integration of the two with the horizon. The shape of an arch is repeated in his abstractions. He sees in it the *mihrab* (a niche in the mosque indicating the direction of Mecca, which Muslims face when praying), through which a Muslim reaches a metaphysical state, or the window for hope. The relationship between darkness, light, and color represents the spiritual side of man, while line, embodied in the letter, stands for the emotions.

Khreis never ceases analyzing his work, intellectually as well as aesthetically. He works in a state of expressive emotionalism, painting without any preliminary sketches or preconceived ideas. Instead, Khreis prepares himself emotionally and allows accidental, unconstrained movements and spontaneity to determine the final result in his art. In spite of the role chance plays in the creative process of Khalid Khreis, his abstraction is not the work of an artist who paints randomly. It is a controlled, sensitive expressiveness in

which the artist's emotions and intellect equally determine the visual end result. Every mysterious, enigmatic symbol, including the symbols of Arabic letters, is the outcome of a cerebral process.[5]

THE IRAQI ARTIST Rafa al-Nasiri (b. 1940) has included abstract calligraphy in his work in both its legible and conjectural forms. He first discovered the value of Arabic letters in 1967–68 when he was in Portugal on a grant from the Gulbenkian Foundation in Lisbon. This period was his turning point from figurative art to abstraction. Visually, the letter became the most important motif in his work. Behind this transition lies the search for an artistic identity different from what was then prevalent in European art, particularly artistic trends that al-Nasiri found in Portugal. In 1976–77 nature, which hitherto had been overpowered by his freeform alphabet patterns, began to appear in his paintings, while the letters began to dissolve and become part of the background details.

Al-Nasiri started dividing his compositions into two spaces: earth and sky, separated by a horizon. At this stage of his artistic development, nature began to occupy a more central position in his compositions, and new visions of the desert and his environment were revealed through his emphasis on the horizon line. A depth appears in his *Nature's Vision,* which makes it more of a landscape than a flat composition. In these images, the foreground consists of a large calligraphic mass that contains smaller illegible signs. For al-Nasiri, this new approach carried Oriental spiritual meanings that related to Chinese mysticism and that differed from Shaker Hassan's Sufism. The letter, in its symbolic significance, became an iconographic factor that defined the spirit of the work. In later works, the letters began to disappear and were replaced by the diacritical marks that accompany Arabic script; they were meant to signify the letter itself.

Since 1967 the Arabic letter, in both its pseudoscript and legible script forms, has represented a spiritual connection between Rafa al-Nasiri and his work, a means by which he identifies himself. In its spoken and written forms, it is part of both his cultural history and his present life. Rafa al-Nasiri is a good representative of the abstract calligraphic style in both its

القدس لنا
والنصر لنا

Burhan Karkutli, *Jerusalem*, 1975. Ink on paper, 65 x 45 cm. Courtesy of Mr. Ismail Shammout.

branches, legible script and pseudoscript. He has made full use of abstract epigraphy. Having thoroughly researched the relationship between the letter and the compositional space, he strikes a delicate balance between the two, so that neither one distracts from the other. Throughout his artistic development, al-Nasiri has worked with Arabic characters as both recognizable and abstract forms, as overt and symbolic representations, and as central and peripheral motifs in his compositions.[6]

Calligraphic Combinations

The third main style of the Calligraphic School of Art is calligraphic combinations, which mix calligraphy with other elements to create a work of art. Arabic script forms part of the composition, while the rest is made up of either figurative shapes or expressive symbols. Calligraphic combinations differ from the neoclassical branch of pure calligraphy, which includes decorative elements in the composition. The

former is free of conventional rules and styles, while the latter abides by traditional script types and configurations.

Calligraphic combinations use letters, words, and sentences as part of an overall composition that basically relies on realistic or abstract patterns and symbolic motifs. Sometimes the letters themselves are highly significant in the overall composition regardless of their relative size. The inclusion of a single word within a composition can carry a message that makes it the defining element. As an example, the writing in a cityscape entitled *Jerusalem*, by the Palestinian artist Burhan Karkutli (b. 1932), takes up barely one-tenth of the composition. However, to the literate viewer it is the defining element: "Jerusalem is ours, Victory is ours." To the illiterate viewer the message is lost, although the writing conveys a point through the simplicity of its design, in contrast to the cluttered figures around it.

Rachid Koraichi, *Tell al-Zaʿtar,* 1979. Etching, 48 x 35 cm. Courtesy of the Jordan National Gallery of Fine Arts, Amman.

Although most subjects of the calligraphic combination style are of a secular nature, works of religious orientation are also found among this group. There are two branches of calligraphic combination: central calligraphy and marginal calligraphy.

CENTRAL CALLIGRAPHY

Central calligraphy incorporates calligraphy as a significant component in a composition that it shares with other shapes and motifs. The importance of the subject is accentuated by the inclusion of a word or words, regardless of the area they occupy or their position. Whether the Arabic characters spell out a small word or a whole paragraph, in the foreground or the background, they clearly signify the message of the art work. An example is the painting *al-Quds* by the Palestinian Vladimir Tamari (b. 1942), which contains only the word *al-Quds* (Jerusalem). However, its graphics and position make it an overpowering element of the composition.

The etching entitled *Tell al-Zaʿtar,* by Rachid Koraichi (b. 1947) from Algeria, refers to the massacre of Palestinians during the Lebanese civil war. Barely legible writing forms the background of the work, and over it are superimposed distorted figures and the clear words *tell al-zaʿtar.*

Majdoub Rabbah (b. 1933), a Sudanese, developed a "solar engraving technique" originally used by traditional artists in decorating calabashes and gourds. He mixes African religious symbols with Arabic calligraphy. Rabbah's burned-wood *God Multiplies* consists mostly of African tribal decorations; he adds no more than two words, which adequately define the subject.

MARGINAL CALLIGRAPHY

In the second branch of calligraphic combinations, marginal calligraphy, writing plays a small role in the overall composition, regardless of the space it occupies. Marginal calligraphy is at times executed in the manner of a well-known art style such as Expressionism, Cubism, or abstraction. In some works, writing is part of a decorative element in the foreground, as in an etching of Hedi Labban (b. 1946) from Tunisia, *The Wounded Bird.* Pseudocalligraphy in the foreground might be mistaken for a continuation of the surrealis-

Above: Hedi Labban, *The Wounded Bird*, 1987. Etching, 36 x 49 cm. Courtesy of the Jordan National Gallery of Fine Arts, Amman.

Left: Majdoub Rabbah, *God Multiplies*, 1981. Burnt wood, 50 x 32 cm. Courtesy of the Jordan National Gallery of Fine Arts, Amman.

Upper left: Mohamed Melehi, untitled, 1981. Enamel on wood, 120 x 100 cm. Courtesy of the Jordan National Gallery of Fine Arts, Amman.

Left: Muna Saudi, *The Lover's Tree*, 1977. Etching, 73 x 36 cm. Courtesy of the Jordan National Gallery of Fine Arts, Amman.

Above: Kamal Amin Awad, untitled, undated. Etching, 45 x 30 cm. Courtesy of the Jordan National Gallery of Fine Arts, Amman.

Facing page, top: Omar Abdallah Khairy, *Nativity*, 1976. China ink on wood, 60 x 95 cm. Courtesy of the Jordan National Gallery of Fine Arts, Amman.

Rakan Dabdoub, *A Woman's Thoughts*, 1975. Oil on wood, 100 x 100 cm. Courtesy of the Jordan National Gallery of Fine Arts, Amman.

tic folk signs that constitute the major part of the work.

In some works, writing, whether clear or obscure, is no more than part of the background of the main theme, although it might occupy a sizable part of the composition. Its purpose is to provide a setting for the principal characters and figures rather than to be the content, as in the central calligraphic branch. Among such works are an untitled etching by the Egyptian artist Kamal Amin Awad (1923–1980), and *The Lover's Tree*, by Jordan's Muna Saudi (b. 1945), in which detailed writing in the background sets off the principal figures in the foreground by providing a contrast in size and shape. Mohamed Melehi (b. 1936) from Morocco has included Arabic words at the base of an untitled composition of enamel on wood, as part of a design inspired by the sea wave. In *A Woman's Thought*, by the Iraqi Rakan Dabdoub (b. 1940), the Arabic letters are a vague graphic pattern blending with other figures. In *Nativity*, by Omar Abdallah Khairy (Sudan, b. 1939), the writing is barely visible in the crowded composition.

Dia Azzawi, *The Mu'allaqat—Pre-Islamic Poetry,* Etching, 50 x 70 cm. Private collection.

Not all those who use calligraphic combinations are true calligraphic artists. Some sporadically include calligraphy in their compositions, either to clarify the subject or as a decorative element, but they do not use it as the major motif in their paintings. Thus, these artists should not be regarded as part of the Calligraphic School.

THE IRAQI PAINTER Dia Azzawi (b. 1939) is a calligraphic artist who has used both branches of calligraphic combinations, and most of his works fall into that category. Poetry is the overpowering influence in these compositions, which Azzawi sees as a continua-

tion of illustrated poems from classical Islamic miniatures. His etching series on pre-Islamic poems, *Al-Mu'allaqat,* is done in the central calligraphic style. Each etching is made up of figurative and decorative fragments alongside verses written by the pre-Islamic *jahiliya* poet represented in the work. Although the poems themselves may not be easily deciphered, the names of the poets denoted are clear.

An example of Awazzi's marginal calligraphic work is *What al-Nifari Said to 'Abdullah,* in which calligraphic signs constitute the sole decorative element in the figurative composition. Rarely does Azzawi create a work of pure calligraphy. A prolific painter, skilled

colorist, and accomplished graphic designer, he varies the size of his works between miniatures and large murals. Almost all of Azzawi's calligraphic compositions include arabesque patterns, folk and religious symbols, abstract shapes, or heavily sculpted figures from Iraq's historical past. Whatever source he draws from, Dia Azzawi's compositions display a distinct harmony among the various shapes and strong colors.

MANY ARAB AND Islamic artists move freely between different calligraphic styles and branches of the same style. An example of such versatility is the Iraqi artist Issam El-Said (1939–1988), a rare talent who succeeded in establishing himself in the West.

El-Said's paintings contain pure calligraphy (modern classical, calligraffiti, and freeform) as well as abstract calligraphy and calligraphic combinations. In his painting *God the Omnipotent*, a verse from the Qur'an is written in classical *Thuluth* script, yet the

execution is totally modern in composition, color, and media, putting the work within the modern classical category. In an untitled work from the 1960s, the composition is reminiscent of the Ottoman *tughra* (the seal of Ottoman sultans, in elaborate, intertwined script), but the writing is simply abstract calligraphic shapes, with no meaning whatsoever.

Although El-Said was not a practicing Muslim until the early 1980s, he was always attracted to the Qur'an by the mental imagery called up by its verses. Its rich language appealed to his artistic sensitivities, and he transformed the words into colors and shapes by means of calligraphy. In his painting *Qur'anic Verse*, freeform calligraphy and calligraffiti are used to represent the meaning of the religious text in a desert-like landscape.

However, not all of El-Said's works are of a contemplative nature. He was also inclined toward the frivolous. This is apparent in his marginal calligraphic

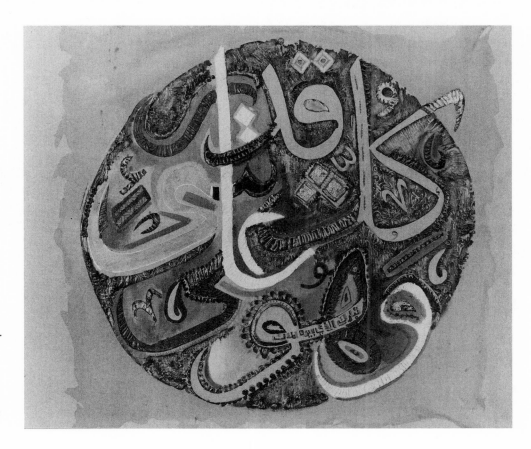

Issam El-Said, *God the Omnipotent*, 1981. Acrylic on raw canvas, 91 x 91 cm. Courtesy of the Jordan National Gallery of Fine Arts, Amman.

Top left: Issam El-Said, *Allah,* 1977. Etching,
37 x 37 cm. Courtesy of Mrs. Dina El-Said.

Top right: Issam El-Said, *Allah,* 1977. Etching,
37 x 37 cm. Courtesy of Mrs. Dina El-Said.

Above left: Issam El-Said, *Allah,* 1977. Etching,
37 x 37 cm. Courtesy of Mrs. Dina El-Said.

Above right: Issam El-Said, *Allah,* 1977.
Etching, 37 x 37 cm. Courtesy of Mrs. Dina
El-Said.

combinations ʿĪd Mubārak (Happy feast) and *I Once Had a Bulbul* (an Iraqi nursery rhyme). The two works depict the lighter side of life, recalling the old Baghdadi musical traditions and the children's songs of his childhood years. The two compositions are filled with traditional decorations, folk iconography including a blue stone to ward off the evil eye, and vibrant colors.

In 1975 El-Said began to include neoclassical calligraphy in his pure calligraphic works. His preference was for geometric Kufic, in which he saw endless graphic and compositional possibilities. He began with a simple design of the word *Allāh,* a composition of Kufic letters in a geometric shape. This became the foundation from which he developed his complicated compositions. One example is his *Geometric Multiples* in enameled aluminum, made up of sixteen squares that are identical in geometric design. In the composition, all of the squares can be rotated so that the basic

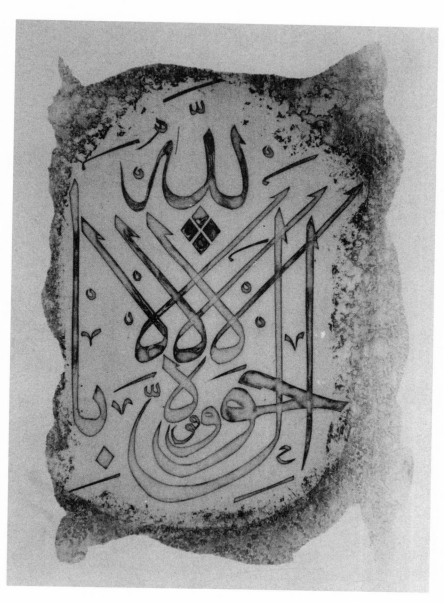

Issam El-Said, *From the Qur'an,* 1981. Etching, 35 x 26 cm. Courtesy of Mrs. Dina El-Said.

design, calligraphic in origin, changes into numerous combinations of complex patterns. The effect is that the composition appears animated and flexible.

Besides being one of the first Iraqi graphic artists, El-Said introduced a new technique in Arab graphic art by engraving a pattern on several zinc plates and organizing them in various configurations and combinations, the same approach seen in his geometric etchings. During this period, El-Said used other traditional scripts in his paintings, such as the *Thuluth* in *From the Qur'an*, in which he tried to give the effect of classical writing on old parchment.

Calligraphy had so potent an effect on El-Said that even works devoid of it, such as his etching *Five Women*, betray the clear influence of the continuous flowing lines found in the Arabic script *Musalsal*.

From this review of El-Said's works, it is clear that this agile and prolific artist chose the Calligraphic School as the main course for his work, moving freely between its main and secondary styles as he deftly manipulated diverse media. (Although it is important to define the various calligraphic styles, the categorization of an artist under a particular division or a subdivision is unimportant. All that matters for the present purpose is that he or she belongs to the Calligraphic School.)

UNCONSCIOUS CALLIGRAPHY

The characters of Arabic script are also the means by which non-Arab Islamic artists write their languages. It therefore exerts a powerful psychological attraction for them. The divine revelation enshrined in the

Issam El-Said, *Five Women*, 1977. Etching, 41 x 55 cm. Courtesy of Mrs. Dina El-Said.

Salah Taher, untitled, 1982.
Acrylic on board, 40 x 30 cm.
Courtesy of the Jordan National
Gallery of Fine Arts, Amman.

Qur'an, revealed through the Prophet Muhammad in Arabic, is believed to confer a holiness on the Arabic alphabet. Consequently, I have observed that many works by noncalligraphic, contemporary Islamic artists contain unconscious calligraphic forms disguised in human, animal, and abstract shapes. Furthermore, in its incessant practical application in everyday life, Arabic is a vehicle for mundane purposes. Because of its ties with religion and its continuous daily use,

many artists cannot but be affected by the configurations of the Arabic alphabet.

Examples of what I term the unconscious use of calligraphic patterns are the shrouded figures in the Egyptian Salah Taher's (b. 1911) untitled painting, where the flowing lines resemble those of the letter *alif;* and the Jordanian Muna Saudi's (b. 1945) untitled granite sculpture, which resembles a modern representation of the word *Allāh,* although the artist had no

intention of incorporating calligraphy. However, no such works can legitimately be termed calligraphic, because there has been no intention to use calligraphy, as either an essential or a marginal component.

In Islam, an act is judged by the intention (*nīyya*) of the doer, so accidents cannot qualify as acts. Therefore, calligraphic forms that appear by accident in the works of Islamic artists do not identify their creators as calligraphic artists. Growing up in a country saturated with traditional Islamic art forms leaves an imprint on contemporary Islamic artists, and the traces of calligraphy, however accidental, can be seen in their work.

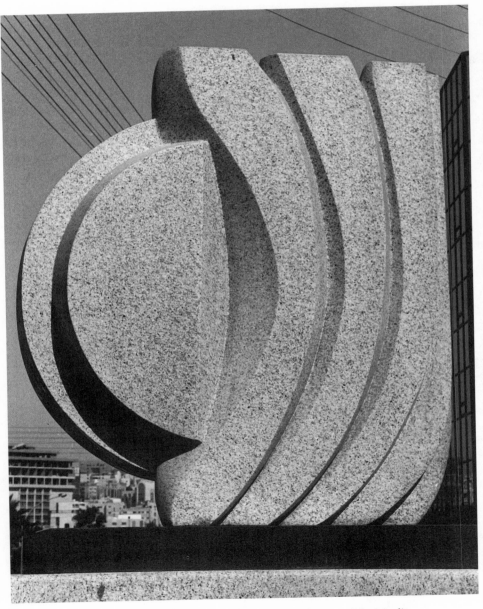

Muna Saudi, untitled, 1983. Granite, 179 x 152 x 70. Courtesy of Amman Municipality.

CONCLUSION

WESTERNIZATION IS A state of mind. It takes place only when the recipient is psychologically ready to cross cultural boundaries, abandon Eastern traditions, and adopt those of the West. It differs from the process of cross-cultural fertilization because it requires a total shift from the theoretical and cultural framework of the East.

The decline of traditional Islamic art, however, is not related to the extension of Western culture into the Islamic world that began with the Crusades of the tenth and eleventh centuries. On the contrary, a strong civilization is receptive only to positive influences, which should enhance its own modes and traditions. Although Muslims responded to earlier influences coming from Greece, Iran, India, and China, they did not make a complete cultural switch, as they did in the twentieth century, but adapted the newly acquired cultural patterns to their own aesthetics.

SINCE THE TURN of the century, Western art forms have displaced traditional Islamic artwork throughout the world of Islam. Islamic artists of the twentieth century have embarked on a new experience, with a radical change in their creative expressions. For them, the introduction to academic training was in itself a revolutionary step.

Paradoxically, Western aesthetics was one part of the new culture that the Islamic world wholeheartedly embraced. Although at the beginning artists approached three-dimensional easel painting with apprehension, it soon became the main mode of visual expression. Their training in Western art forms and techniques, at institutions abroad or at home, gave them the basis for developing their own contemporary aesthetics, by combining their Western education with their cultural heritage. Through Western-style painting, Islamic artists worked at creating their own artistic identity, either by depicting local subject matter or by borrowing traditional signs and motifs from their past.

After five decades of following international styles in painting and sculpture, modern Islamic artists succeeded in developing a new aesthetic with which they could identify: the Calligraphic School of Art. Their Western-oriented training has served them well in

drawing upon their Islamic cultural background. A new cultural personality has evolved, in the form of the Calligraphic School.

The majority of Islamic scholars and traditionalists perceive a continuity only in architecture—if they see any continuity at all. The development of certain architectural features such as the dome and the arch, which have been reemployed in modern mosques and dwellings, is accepted as the natural evolution of traditional shapes. Even newer building materials such as cement and aluminum are not looked down upon. This acceptance may be related to the functional quality of a building, which complies with the Islamic requirement that every creative effort serve a practical as well as an aesthetic purpose.

However, art in its global definition has greatly changed. The evolution that has taken place in the West since the Middle Ages and during the Renaissance has moved art from the realm of the soul to that of the senses. The same applies for Islamic art. Since the last century, Islamic artists have turned to Western aesthetics. The devitalizing of Islamic civilization, coupled with the spread of Western culture and superior Western technology, has caused an evolution of technique and mode of expression among artists in the Islamic world. In other words, contemporary Islamic art has been divorced from utilitarian use.

Islamic artists in the twentieth century had the choice of either aping the West or evolving their own style while benefiting from modern training. The search for identity has led artists back to their Islamic roots, where they find a basis for successful evolution. The love-hate relationship with the West could have led the Islamic artist to isolationism, which would have killed any creativity. However, in the quest for a means of individual expression that would draw on Western training and materials, the contemporary Islamic artist has found a middle ground in the modern Calligraphic School of Art. Through its principles, artists can continue to be creative without severing themselves from either the past or the present. Thus, the Calligraphic School of Art is a combination of both Islamic and modern Western teachings, provided it abides by certain Islamic aesthetics that prevent it from reaching a degree of vulgarity and ugliness.

Islamic art has borrowed from previous civilizations throughout its history. Even after its own styles matured, the intercultural exchange continued, without having a deleterious effect on Islamic aesthetics. For example, the influence of Chinese painting on Ilkhanid miniatures of the thirteenth century seeped down to Persian miniature painting of the sixteenth century and after and was considered part of the Islamic Safavid school of miniature painting. Similarly, when contemporary Islamic artists develop new and sometimes revolutionary styles by borrowing from Western principles and techniques and mixing them with Islamic art traditions, their work should also be acknowledged as Islamic.

Had there not been an art of calligraphy in Islamic civilization, there would be no modern calligraphic art. Therefore it is irrelevant whether or not the various styles of the Calligraphic School adhere to classical traditional scripts. Any development in style must evolve from a foundation. As long as the foundation and the aesthetics are clearly established, there can be continuity. One should also take into consideration the worldwide changes that have occurred in the concept of art in this century, as well as the conditions in which contemporary Islamic artists live.

Given the attempts in the Islamic world to ground contemporary art in a local environment, a new question must be raised: What is the relationship between national and international art? How can a contemporary Islamic artist relate to international art, in an ever-shrinking global village, and at the same time preserve his or her cultural identity?

Artists such as Henri Matisse, Paul Klee, and Vassily Kandinsky were inspired and influenced by the East. In turn, their works have been instrumental in revealing the graphic value of Arabic calligraphy and two-dimensional painting to Islamic artists such as Jawad Salim, Jamil Hamoudi, Nja Mahdaoui, Mohamed Chebaa, Shaker Hassan Al Said, Khalid Khreis, and Rafa al-Nasiri. The chain of smooth artistic exchanges between East and West continues with a younger generation of Western artists such as Hans Hartung, Brion Gysen, Soulage, Georges Mathieus, Jean Degottex, André Masson, Juan Miró, Lee U Fan, Henri Michaux, Simon Hantai, and Jean Fautier. In-

spired by Arabic calligraphy, they in turn have created abstract works that fall within the definition of international art. There is no way contemporary artists can isolate themselves from external influences in a world dominated by such advanced means of communications as we have today.

However, there are two major differences between Western artists influenced by Arabic calligraphy and Islamic calligraphic artists. Once more, it should be mentioned that each letter of the Arabic alphabet is associated with the beginning of certain words or with the opening verses of the Qur'an. The association takes place in the subconscious of the literate viewer. If the artist using those letters is himself or herself illiterate in Arabic, then to both the artist and the viewer they are no more than silent abstract shapes.

The Islamic artists closest to the Western artists who pursue calligraphy are Easterners who have adopted abstract calligraphy, in particular the pseudoscript. Nevertheless, the two artists cannot produce identical works because the intention or *nīyya* of each is different. The transformation that the Islamic artist brings about in the Arabic characters, from the legible to the incomprehensible, comes first and foremost as a result of understanding their inherent significance, be it apparent or esoteric. On the other hand, given the absence of the dimensions of meaning and literary association, the Western artist's employment of the same characters is superficial, except when the artist is versed in the language.

The second point that separates the Western abstract artist from the contemporary Islamic calligraphic artist is tradition. Each of the two belongs to a different civilization and has lived and grown in a distinctly different environment. Tradition cannot be transplanted or acquired, for it is built into one's subconscious. No matter how much either artist tries to borrow from the other, their respective heritages will interfere with their artistic output.

The art of Arabic calligraphy is an integral part of Islamic art and will always be part of the tradition of Islamic artists. At this point a quotation from James W. Allan, the keeper of Eastern Art at the Ashmolean Museum in Oxford, seems appropriate: "For to me, as a western Christian curator of Islamic art collections, it is above all in Arabic calligraphy that Islamic identity belongs. And it is my belief that it is the ability of contemporary artists to express that calligraphic tradition in a contemporary way that will bring Islamic art once again into the forefront of artistic expression world wide."[1]

The contemporary Calligraphic School of Art, prevalent throughout the Islamic world, is grounded in its own culture and has an aesthetic value that pleases both the eye and the soul. It is the natural continuation of Islamic art in the twentieth century.

Abdal Aal, Ahmad Ibrahim (b. 1949) (Sudan), is a writer, painter, and sculptor. Abdal Aal graduated from the College of Applied and Fine Arts in Khartoum before continuing his training at the Université du Bordeaux in France. He takes his subjects and media from his immediate environment and creates abstract paintings and sculptures incorporating indigenous symbols, rendered in a modern fashion.

Abu'l-Su'ud, 'Abd al-Wahab (1897–1951) (Syria), was born in Nablus in Palestine. He moved with his father, an officer in the Turkish army, to Sidon and Beirut before going to Cairo to study art and to practice his hobby of acting. In 1914 he settled in Damascus, where he married and taught painting and drama at a secondary school. He later went to the Académie Julian in Paris and studied painting at the studio of Le Doux Chauviak. One of the early pioneers of Syrian modern art, he painted historical events such as the Arab conquest of Spain in a detailed figurative manner. He also used historical events as subjects for the plays he wrote. In thirty years of teaching painting, Abu'l-Su'ud instilled in his students a regard for nationalistic subjects and a certain freedom from rigid academic rules.

Ahmad Ibrahim Abdal Aal, *A Body in Space*, 1980. Bronze and wood, 46 x 30 x 50 cm. Courtesy of the Jordan National Gallery of Fine Arts, Amman.

Adnan, Etel (b. 1925) (Lebanon), is a poet, philosopher, literary critic, designer, ceramist, and painter. She studied philosophy at the Sorbonne in Paris, the University of California, and Harvard University and taught philosophy of art at more than forty universities and colleges throughout the United States. She has published six books of poetry and fiction. After establishing herself in the literary field, Adnan discovered her inclination toward visual expression and took up visual art. She experimented with various media, and the poet in her is always present in her calligraphic paintings, ceramics, and tapestry. Most of her works are abstract illustrations of poems. She scribbles verses on painted backgrounds, using accordion-like folios suggestive of Oriental manuscripts.

Ahmad, Yussef (b. 1955) (Qatar), received a B.A. from Hulwan University in Egypt and a master's degree in fine arts from a California university. After numerous experiments with calligraphic compositions and scripts, Ahmad has attained a distinctive style of transforming letters into pure abstract signs. On raw canvas, he arranges them in rhythmic monochrome areas. Even when he employs legible sentences, he concentrates on the construction of his compositions rather than on legibility and content. His works display both careful composition and spontaneity.

Akhal, Tamam (b. 1935) (Palestine) was among the refugees who fled to Lebanon after the 1948 war. She painted postcards in Beirut and sold them to add to her family's meager income. The pioneer Lebanese artist Moustafa Faroukh noticed her work while visiting the Maqaṣid School, where she was studying, and recommended that she continue her art training. Her father arranged for her to study at the Higher Institute for Women Art Teachers in Cairo in 1953. She thus became the first Palestinian woman artist to acquire formal art training after 1948. In 1954 she participated in an exhibition organized by Ismail Shammout. It was the beginning of an artistic collaboration that led to their marriage. Akhal proceeded from style to style, from realistic Expressionism, through which she depicted the Palestinian tragedy, to an individualistic,

colorful style that showed a nostalgia for her native land. Her paintings display harmonious colors and simple lines even in treating emotional Palestinian subjects.

Akl, Said (b. 1926) (Lebanon), first trained at the Académie Libanaise des Beaux Arts. He lived in Paris from 1951 to 1954, devoting himself to research and the study of art. On later trips to the French capital, Akl visited the studios of Waldemar George, Marc Saint-Saëns, and Jean Picart Le Doux. In 1954 Akl painted his first canvas using calligraphic signs to build up an abstract composition. His works, which are almost purely cerebral, give the impression of spontaneity and a keen imagination, with a developed sense of design and balance.

Al Said, Shaker Hassan (b. 1925) (Iraq), graduated in 1954 from the School of Fine Arts in Baghdad, where he was taught art history by Jawad Salim. In becoming acquainted with the works of Cézanne, Picasso, Braque, and Klee, Shaker Hassan studied how European artists used line in their paintings, in contrast to Arab artists' concentration on mass. In 1955 he was sent on a government scholarship to Paris, where he spent his first year learning the language and taking classes at Académie Julian. The following year, he enrolled at the École des Arts Decoratifs. Because of his age he joined the École Supérieure des Beaux Arts as a special student under Professor Legueult, who has had the greatest influence on his art training.

In 1959 Shaker Hassan returned to Baghdad and fell under the influence of the style of the thirteenth-century Iraqi miniature painter al-Wasiti. He began to incorporate motifs such as a cock and a moon in his paintings, in a futile attempt to creatively answer his spiritual and visual needs.

The year 1962 was critical for Shaker Hassan's spiritual, artistic, and cultural development. The political situation in Iraq was deteriorating with the infamous Mahdawi trials, which passed a death sentence on any person who opposed the military regime. They were followed by the Shawaf revolt in Musil, where thousands were massacred. The atmosphere in the country

was extremely oppressive. It threw Shaker Hassan into a clinical depression. He went to several psychiatrists but none could help him. Having been interested in religious studies since 1958, he read the works of the mystic philosopher al-Hallaj during his self-imposed seclusion and was drawn to Sufism, in which he found great spiritual relief.

Within one week of his ṣūfī (mystical) discovery, Shaker Hassan began to write profusely on art for the first time in his life, and his career as an art theorist took off. Meanwhile, the spiritual element in his life affected his artistic expression. He gave up the depiction of all figures in his work, and Arabic letters became the central subject of his compositions. By 1969 Shaker Hassan had developed the concept of what he termed "one-dimension."

Ali, Ahmet (Şeker Ahmet Paşa) (1841–1906) (Turkey), was an Ottoman soldier-painter who was nicknamed Sugar (şeker) because of his gentleness and mild disposition. Sultan Abdülaziz sent him to Paris, where he studied for almost eight years under Louis Boulanger and Jean-Léon Gérôme. He developed a taste for Millet, Courbet, and the painters of the Barbizon School. He then spent one year in Rome before returning to Istanbul, where he was appointed art instructor at the military academy. Although he had studied for years with the academic masters of the time in Paris, there is no trace of academicism in his works. His personal style shows a certain simplicity and naïveté.

Amoura, Aziz (b. 1944) (Jordan), graduated from the Academy of Fine Arts in Baghdad in 1970, where he trained with the pioneer Iraqi painter Faik Hassan. He went on a scholarship for his master's degree to the Pratt Institute in the United States, graduating in 1983. A dedicated teacher, Amoura has trained many students of different age groups at his own studio and the Department of Fine Arts at Yarmouk University. During his early period he made Impressionistic portraits and landscapes of the Jordanian countryside but gradually changed to political subjects in black-and-white pointillism. In his latest works, Amoura incorporates calligraphy in neorealistic compositions.

Ayyad, Raghib (1892–1982) (Egypt), a graduate of the School of Fine Arts in Cairo (1911), was a catalyst in the founding of the Egyptian Academy in Rome. In 1925 he was sent on a scholarship to Rome, and he taught at the College of Applied Arts upon his return. Ayyad then went on to teach at the School of Fine Arts and became director of the Museum of Modern Art in 1950. Ayyad's religious works, which portray churches throughout Egypt and monasteries in the desert, are charged with spirituality. His students followed his example of choosing Egyptian subjects and interpreting them through Expressionism.

Azzawi, Dia (b. 1939) (Iraq), studied archaeology at the Faculty of Arts at Baghdad University, graduating in 1962. He took art lessons from Hafid Drubi at the College Atelier while attending evening classes at the Institute of Fine Arts. In 1976 Azzawi was appointed art consultant at the Iraqi Cultural Center in London. By arranging exhibitions for Arab and Iraqi artists at the center, he was able to introduce Arab art to the British public. Showing the influence of Jawad Salim and his training in archaeology, Azzawi's work is dominated by folk motifs, arabesque patterns, and Assyrian and Babylonian figures with stone-like shapes and features. Since the late 1960s, Azzawi has added Arabic calligraphy to his artistic vocabulary, which he uses expressively.

Badran, Jamal (b. 1909) (Palestine), was the first Palestinian to study at the School of Arts and Decorations in Cairo. In 1934 he was sent on a three-year scholarship to the Central School of Art and Design in London, where he trained in ceramics, metalwork, textile design, and book binding. In 1940 Jamal opened the Badran Studio and Workshop in Jerusalem with his brothers Khairy and 'Abd al-Razzak. Many traditional artists (such as Yusef Najjar and Muhammad Siam) were trained in calligraphy, arabesque design, and applied arts at Badran's studio. In 1947 Amir 'Abdullah of Transjordan (later King 'Abdullah of Jordan) commissioned the Badran Studio to make a wedding gift for Princess Elizabeth (later Queen Elizabeth II)—an olive wood chest with painted Islamic designs and silver inlay.

In 1953 Badran temporarily moved to Damascus, where he taught crafts at the Teachers Training College. He then spent ten years in Libya as a Unesco expert in crafts and art education. In 1962 he returned to Ramallah and opened an atelier where he worked with leather, wood, and metal. After al-Aqsa Mosque in Jerusalem was destroyed by arson in 1968, he recreated some of its architectural decorations for its renovation. Badran also made calligraphic paintings in the classical Arabic scripts and embellished them with traditional arabesque designs.

Baghdadi, Bastawi (b. 1927) (Sudan), studied design at the Gordon Memorial College in Khartoum, graduating in 1946, then went on to Goldsmith College in London, graduating in 1949. Upon his return to Khartoum, he was appointed an instructor to train art teachers and later he continued his studies at the Pratt Institute in New York. Baghdadi addresses the issue of artistic identity by depicting Sudanese scenery and characters in an accomplished stylized manner, using burlap collages with oils.

Baya (b. 1931) (Algeria) is a self-taught artist, who began painting and working with clay in 1943. Baya's style was based on infantile dreams and imagination expressed in naive-Surrealistic forms. Although she constantly used the same figures, she was unable to explain her works rationally. Orphaned at the age of five from a poor family, Baya directed her grief toward a world of birds and animals and through her sincerity captured the attention of France's established artists. When she had an exhibition at Gallerie Maeght in Paris, Picasso took her to his country home in Vallauris and observed her while she kneaded clay into animal forms. She stopped working between 1952 and 1967, when she was busy bearing children and raising a family. At the age of thirty-six she resumed painting in watercolor in the same dreamlike fashion.

Belkahia, Farid (b. 1934) (Morocco), started painting at the age of fifteen. When he was twenty years old he went to the École des Beaux Arts in Paris (1954–59) and then received a scholarship to study theatrical design in Czechoslovakia. Upon his return to Morocco

in 1962, he was appointed director of the École des Beaux Arts in Casablanca (1962–74). While in Paris, Belkahia was influenced by the works of George Rouault and Paul Klee. A member of the Casablanca School, he became preoccupied with popular signs and motifs, numbers, Arabic calligraphy, and characters taken from the Berber script, *tifinagh*. Belkahia paints on hand-stretched hides, using henna and other natural colors (*sumaq* and saffron, for example) as his pigmentation, much like traditional craftsmen working in leather and rugs.

Berk, Nurullah (1906–1982) (Turkey), was a painter, art educator, writer, and critic who trained at the Academy of Fine Arts in Istanbul and the École des Beaux Arts in Paris. During his second sojourn in Paris, he worked with André Lhôte and Fernand Léger and became an advocate of Cubism and Constructivist methods. He is meticulous in his work, with a preference for well-placed geometric shapes in balanced formations and restrained colors.

Farid Belkahia, *Homage to Gaudi,* 1990. Watercolor on paper, 20 x 18 cm. Courtesy of the Jordan National Gallery of Fine Arts, Amman.

Çalli, Ibrahim (1882–1960) (Turkey), was a 1910 graduate of the Academy of Fine Arts in Istanbul. Çalli spent the years immediately before World War I in Paris on a scholarship. He trained at Fernand Cormon's workshop and eventually distinguished himself as an artist. Upon his return to Istanbul, he was appointed to the Academy of Fine Arts, which he injected with an independent approach and freshness of vision far beyond its former imitative skill. Neither a realist nor a fully fledged Impressionist, Çalli applied his oil paints directly onto the canvas with quick, agile brush strokes, without lengthy preparations and sketches. His nudes, portraits, still lifes, and occasional landscapes are full of vitality. He was inspired by the Turkish War of Independence and executed paintings that emphasized nationalistic feelings and concepts. He was an innovator who exerted great influence upon the younger generation of artists during his thirty-year teaching career.

Cherkaoui, Ahmed (1934–1967) (Morocco), first went to Paris to train at the École des Métiers d'Art. He then enrolled in the École Nationale des Beaux Arts, then studied at the Academy of Fine Arts in Warsaw. Upon his return from Poland, he was sent to Paris on a Unesco scholarship to research Arabic calligraphy and signs in Berber art. He was the first Moroccan artist to develop his own abstract style, which is simultaneously Western and indigenous. His untimely death deprived Arab art of one of its early painters, who scientifically investigated local folk traditions to be reemployed in art as original characteristics.

Corm, Daoud (1852–1930) (Lebanon), came from the mountains of Lebanon and in 1870 went to Rome and enrolled at the Institute of Fine Arts, where he trained under the official Italian court painter, Roberto Bompiani. During his five years in Rome, Corm studied the works of Renaissance artists and was influenced by Raphael, Michelangelo, and Titian, whose styles he assimilated in his paintings. He gained official recognition when he was commissioned to paint the portrait of Pope Pius IX, and later became one of the official painters attached to the Belgian Court of King Leopold II.

Upon his return to Lebanon, many distinguished personalities in the Levant and Egypt asked him to paint their portraits. He made a portrait of Khedive Abbas II of Egypt in 1894 and left a wealth of religious paintings in churches in Lebanon, Syria, Egypt, and Palestine, as well as training a number of aspiring young artists, including Habib Srour and Khalil Saleeby. His portraits remain a gold mine of information about the national costumes worn at the end of the nineteenth and the beginning of the twentieth centuries. His religious paintings point to delicate feelings and a deep faith, after the manner of Leonardo da Vinci and the Italian Renaissance painters. They illustrate his view of the human body as the essence of beauty, devoid of sensuality and voluptuousness.

Durra, Muhanna (b. 1938) (Jordan), graduated from the Accademia di Belle Arte in Rome in 1958. A gifted, prolific, and temperamental artist, he established his own distinctive style at an early stage in his career. His highly expressive monochrome portraits and his fractured landscapes reveal his dexterity at manipulating color, tonality, and the distribution of masses. In 1971 he was appointed head of the Department of Arts and Culture, giving the art movement in Jordan great impetus. In 1983 he became ambassador of the Arab League and was posted successively to Tunis, Rome, Egypt, and Moscow.

Ermes, Ali Omar (b. 1945) (Libya), went on a scholarship to the Plymouth School of Architecture and Design, from which he graduated in 1970. Upon his return to Libya, he took up photography and began writing and working in the visual arts section of the magazine *All Arts*. Ermes went back to London in 1974 as the visual arts consultant to the director of the World of Islam Festival that took place in 1976, during which he participated in arranging exhibitions on Islamic culture and classical art. This offered him the opportunity to travel throughout the Islamic world and meet the artists and calligraphers who would participate in the festival. In 1975 Ermes returned to Libya and worked in publishing and art, traveling frequently. In 1981 he moved with his family and settled in London. Most of Ermes's compositions, which

always revolve around calligraphy, are done in ink on paper. Occasionally, he uses acrylics, and recently he has been experimenting with oil on canvas.

Farhat, Ammar (b. 1911) (Tunisia), a founder of the Tunis School, was to become one of the most important figures in the history of Tunisian modern art. A self-taught artist from a humble background, he earned a living as a manual laborer. In spite of his early hardships, Farhat never compromised his high aesthetic values. His realistic works in oils and gouache depict his urban surroundings and his relationship with people from different social classes, including laborers, small shopkeepers, and street musicians. Farhat's experience of growing up in an impoverished milieu, yet becoming one of the great artists in the country, is reflected in his work. He was able to penetrate the visual arts scene, which was monopolized by European artists living in Tunisia, by breaking away from the Orientalist style to portray the reality of Tunisian society with its different classes.

Glaoui, Hassan El- (b. 1924) (Morocco), painted in secret during his childhood, as his father was preparing him for a more serious career. One day General Goodyear, the founder of the Museum of Modern Art in New York City and a friend of El-Glaoui's father, saw his work and encouraged him to continue. He held his first show in 1952 at Gallerie Weill in Paris, after which he enrolled at the École Nationale des Beaux Arts and spent fifteen years in the French capital working with Émilie Charmy. In 1965 he returned to Morocco and has since concentrated on painting horses, which are his passion, in his two-dimensional, miniature-like style and bright colors.

Güran, Nazmi Ziya (1881–1937) (Turkey), was a leading Impressionist painter and a master at capturing light on objects. As a youngster, he had observed Paul Signac work in Istanbul and was influenced by him. A graduate of the Istanbul Academy of Fine Arts, Güran went to Paris, where he spent five years training in the studios of Marcel Bachet and Cormon, then returned to Istanbul to teach at the academy. Always working in the open air, Güran painted scenes of the Bosphorus and the Golden Horn, capturing the play of the Mediterranean sun on water and nature, and experimenting with the plain colors of traditional miniature paintings.

Haidar, Kadim (1932–1987) (Iraq), graduated from the Iraqi Institute of Fine Arts (1957) and was sent on scholarship to the Central College of Art in London (1957–62). In 1965 he held an exhibition in Baghdad that became a milestone in the history of Iraqi modern art. It was the first one-theme exhibition held. On display were forty paintings depicting the martyrdom epic of the Prophet's grandson Husayn, who was massacred with seventy-seven members of his family by the Umayyad army at Karbala' in Iraq in the seventh century A.D. It was also the first time that an Iraqi artist had used a historical theme with religious connotations to portray human tragedy in a symbolic and stylized manner.

Hamdi Bey, Osman (1842–1910) (Turkey), was an Ottoman painter who left for Paris at the age of fifteen. Working for twelve years in the ateliers of Gérôme and Boulanger, he became totally Westernized in his views and painting technique. His portraits exude an inner peace and tranquillity that compensates for their inanimate appearance. Hamdi followed in the footsteps of the nineteenth-century European Orientalist painters by depicting minute architectural details and photographic images. In his multitude of large genre paintings, he rendered every material fold, floor crack, and decorative motif with meticulous precision. He was accordingly considered a noteworthy member of the Orientalist movement in European painting of the last century. A dynamic person, Hamdi was involved in various activities including international relations and archaeological excavations, as well as becoming the director of the Archaeological Museum and the Academy of Fine Arts.

Hammad, Mahmoud (1923–1988) (Syria), began his career as a member of the Republican Guard before giving in to his talent and becoming an art teacher. He was sent on scholarship to the Accademia di Belle Arte in Rome (1953–57), where he was influenced by

European academic figurative art. He followed this style at the beginning of his artistic career in executing most of his political themes, such as the Syrian-Egyptian Union in 1958. In 1963 Hammad was appointed instructor at the College of Fine Arts in Damascus, later becoming its dean. After 1966 his exploration of the plasticity of Arabic calligraphy led him toward abstraction. He was one of the first Syrian abstract artists to link his style to his local environment by using Arabic letters.

Hamoudi, Jamil (b. 1924) (Iraq), began his career in Baghdad as a self-taught artist. In 1941 he sculpted busts in a naturalistic manner and became acquainted with the Polish artists who were influential at the time (see chapter 4). In 1944 Hamoudi taught drawing and history of art at a Baghdad school while attending classes at the Institute of Fine Arts, from which he graduated in 1945. In 1947 he was sent by the government to Paris to continue his research in art. He took courses at the École des Beaux Arts, Académie Julian, and the École du Louvre. During the same year, Hamoudi began to write a thesis on Assyrian-Babylonian art at the Faculté des Lettres of the Université de Paris, while carrying out research on epigraphy and Assyrian-Babylonian languages at the École des Hautes-Études. During his stay in France, Hamoudi experienced a reaction against Western materialistic culture. By reverting to the abstraction of the arabesque and the spirituality found in Arabic calligraphy, Hamoudi tried to unite modern European aesthetics with his Eastern heritage in his oils and watercolors.

Hassan, Faik (1914–1992) (Iraq), received a government scholarship to train at the École des Beaux Arts in Paris, from which he graduated in 1938. Upon his return to Iraq, he put together an extensive exhibition in Baghdad, where his cultivated skill in academic painting and his aptitude in the employment of color were evident. After meeting the Polish artists who came to Iraq as officers with the Allied forces, Hassan freed his style of academic restrictions and took up Impressionism. He moved on to Cubism, abstraction, and Expressionism, only later to return to Impression-

ism. For more than four decades, he taught at the Institute of Fine Arts, thus passing on his experience to generations of students, many of whom emerged as prominent artists.

Throughout Hassan's artistic career, the subjects of his paintings continued to express the main feature of his identity. He painted simple city dwellers, peasants, Bedouins, and horses, and portrayed the despair and superstitions of the poor on emotionally charged canvases. Since the beginning of the 1980s Hassan has painted horses and genre scenes in a naturalistic figurative manner, but some of his works began to show signs of repetition and fatigue.

Issiakhem, Mohammed (1928–1986) (Algeria), faced tragedy at an early age. While he was working on a home-made bomb in 1943, to throw into the American military camp, the bomb exploded and killed two of his sisters and a nephew. Issiakhem himself fell into a coma, staying in hospital for two years and emerging with his left arm amputated. Between 1947 and 1951, he enrolled first in Algiers' Société de Beaux Arts and then in the École des Beaux Arts, while simultaneously training in miniature painting with the traditional miniaturist Omar Racim. In 1953 he continued his studies at the École Nationale Supérieure des Beaux Arts in Paris working in Legueult's painting atelier and Georg's printing workshop and graduating in 1958.

The foremost pioneer of modern Algerian art, Issiakhem was one of the founders of the National Union of Plastic Arts after independence, and he held a number of exhibitions in Algeria and abroad. He was attracted by left-wing sentiments and traveled to Vietnam (1972) and Moscow (1978–79). In his thickly layered, symbolic compositions, man is always the central figure, ambiguously crowded by a jigsaw of forms, signs, and blotches in neutral, somber colors. In his highly expressionistic works, woman becomes the ultimate symbol of drama and silent suffering.

Jabri, Ali (b. 1943) (Jordan), read fine arts and architecture at Stanford University in California, graduating in 1965. He then went to Bristol University in England, where he read English literature, and gradu-

ated in 1970. Obsessed with the preservation of Arabic culture, he depicts in his neorealist style national events such as the Arab Revolt, historical monuments, and archaeological sites of Jerash and Pella, as well as Jordanian landscapes and scenes of old Amman, Aqaba, and Cairo. He has developed an interesting technique in mixed media, employing montage and superimposed figures, paying meticulous attention to detail. He is sensitive to the encroachment of concrete buildings on the countryside, and has attracted the authorities' attention to the importance of preserving neglected old houses and converting them into functional buildings.

Kayali, Louai (1934–1978) (Syria), started painting in 1945 and held his first exhibition in 1952 in his hometown of Aleppo. After studying law briefly, he was sent on a scholarship, in 1958, to the Accademia di Belle Arte in Rome, where he remained until 1961. A highly gifted person, Kayali, while still a student, won several awards and medals in Italy. He developed a style distinguished by its strong and elegant lines that define his figures in well-balanced and tightly fitted compositions. Though some of his work seemed to resemble the social realism in Russia, Kayali's massive figures were more humane. They were not clichés but evinced a distinctive individuality.

Kayali held his most important exhibition, *For the Cause,* in April 1967. It toured Syria's major cities and consisted of thirty black-and-white works in charcoal. The theme of the exhibition was the struggle of the Arab individual against his sad reality, portrayed in immensely expressive compositions of tortured figures. When the Six-Day War broke out in June of that year, Israel's victory and occupation of Arab territories threw Kayali into a deep depression and pushed him to destroy his thirty displayed paintings. He never recovered from his depression and stopped working for years. He retired from his teaching post and went to live in Aleppo, where he resumed work in seclusion. In 1978 Kayali burned to death, having allegedly committed suicide.

Khreis, Khaled (b. 1956) (Jordan), was sent on a government scholarship to Hulwan University in Cairo (1973–78), after which he went to Spain. In Barcelona, he attended the Escuela de Bellas Artes to train in painting, while at the same time studying sculpture at the Escuela de Artes Aplicadas y Artisticos Oficios (School of Applied Arts). In 1979 Khreis enrolled at the Escuela Internacional Pintura Mural, San Cugat, to train in mural painting. He then traveled through Italy and took courses in sculpture (1983–89). Khreis returned to Barcelona to continue his studies in lithography at the Escuela de Artes del Libro and to prepare for his Ph.D. at the Faculty of Fine Arts at the University of Barcelona, from which he graduated in 1993. His dissertation was "The Role of the Arabic Letter in Modern Art."

Khreis appreciated the works of Matisse for their simplification of form and color, and Klee's work influenced him by the relationship between line and letter. In Barcelona, Khreis came across the works of the Spanish artist Antoni Tapies, who was inspired by old walls and the effect of lines and cracks on them. Tapies gave Khreis the incentive to use new materials such as wood, discarded cardboard sheets, metal pieces, marble powder mixed with glue, and collage. Khreis was also influenced by other Spanish artists such as Daniel Argimon and Antonio Clavée Saura, who had also worked with unconventional materials. The result of such influences is a total abstraction of form and letter signs in his work.

Lahham, Rafik (b. 1932) (Jordan), graduated from EN ALC (Ente Nationale Addestramento Lavoratori Commercio) and San Jacomo Institute in Rome (1962). At the Rochester Institute of Technology in New York (1967), he studied painting and etching and became the first Jordanian artist to work in printmaking. Lahham has painted classical portraits, figurative landscapes, stylized cityscapes, abstract themes, compositions of Nabataean figures, arabesque motifs, and calligraphy, alternating his media among oils, gouaches, watercolors, and etchings. He has lately been concentrating on calligraphic works, using words imbued with spiritual and religious meaning. He works in one of the classical Arabic scripts, within

Rafik Lahham, *From My Country*, 1983. Oil on canvas, 70 x 50 cm. Courtesy of the Jordan National Gallery of Fine Arts, Amman.

compositions where color and shape are the main elements. Lahham was the first Jordanian artist to use calligraphy in his work.

Lifij, Avni (1889–1927) (Turkey), was discovered by Osman Hamdi Bey, who after one year at the academy sent Lifij to Paris with the support of Crown Prince Abdülmecit, who remained a life-long friend, patron, and student of the artist. In Paris, Lifij studied at the École des Beaux Arts and in Cormon's workshop, but refused to be influenced by stereotypes and clichés. He also studied the frescoes of Puvis de Chavannes in the Sorbonne and the Panthéon. Though he valued the naturalistic modifications introduced by de Chavannes, the mural he painted in Istanbul after his return, *Municipal Works in Kadiköy*, did not manifest any identifiable traces of the French artist's influence. Lifij produced countless drawings and black-and-white sketches with a passion, unlike his contemporaries. A melancholic atmosphere pervades his extraordinarily soft, colorful oil paintings. At an early age, Lifij showed a remarkable talent in his exceptional control over subtleties of interpretation, with an unfailing confidence and power of execution.

Mahdaoui, Nja (b. 1937) (Tunisia), received his art training in the Free Atelier in Carthage. He studied modern art history at Dante Alighieri Academy in Tunis and graphic art at the Accademia Santa Andrea in Rome. He passed through different periods of figurative art, including Surrealism, and worked with collage before establishing his calligraphic style, through which he was able to come to terms with his own artistic identity. Mahdaoui plays with Kufic characters, turning them into graphic signs, utilizing their elasticity and plasticity to the maximum.

Melehi, Mohamed (b. 1936) (Morocco), graduated from Tetouan's Escuela de Bellas Artes in 1955. He then embarked on a series of trips to Europe and the United States, studying art and doing research. Upon his return to Morocco, he became a teacher at Casablanca's École des Beaux Arts (1964–69) and was a member of the Casablanca School. In the form of the sea wave, Melehi discovered a synthesis between traditional art and contemporary expression. His variations of the wave, which he borrowed from popular crafts, became his central theme in creating modernistic abstract renditions, which sometimes include geometric forms and illegible Arabic calligraphy.

Meziane, Meriem (b. 1930) (Morocco), started as a self-taught artist. Her father was the first officer to become a general in the Moroccan army after independence. Meziane held her first exhibition in Malaga, Spain, in 1953, followed by several others throughout Morocco. In 1959 she graduated from the Academia San Fernando de Bellas Artes in Madrid, where she later settled with her family. Meziane is a figurative painter who depicts local architecture, nostalgic landscapes, and scenes of festivities from southern Morocco. She pays special attention to the details of costumes and jewelry in recording popular traditions.

Moudarres, Fateh (b. 1922) (Syria), is one of the leaders of the modern art movement in Syria. After finishing his secondary education, he became an English teacher. Moudarres carried a box of colored crayons in his pocket for spontaneous compositions. He created landscapes, then scraped the colors with a razor. A

Meriem Meziane, untitled, 1977. Oil on canvas, Private collection.

poet, novelist, painter, and sculptor, he is well versed in art history and philosophy. After an early period of realism, he became, in the 1940s and 1950s, a Surrealist painter who explained every work to his public with verse and prose. Between 1954 and 1960, Moudarres studied at the Accademia di Belle Arte in Rome. After returning from Europe, he developed a highly personal Expressionist style that he called "Surrealistic and figurative with a strong element of abstraction." His subjects were influenced by Syria's classical traditions, with which he became familiar in the halls of the National Museum of Damascus. Before leaving for Paris to study at the École des Beaux Arts, between 1969 and 1972, he passed through a period close to abstraction, in both style and subject matter. Since 1967 his themes have become political without losing their personal language of symbols and legends. A painter with an accomplished sense of composition and balance of color, Moudarres has trained more than

one generation of artists in his classes at the College of Fine Arts in Damascus.

Moustafa, Ahmad (b. 1943) (Egypt), graduated with distinction in 1966 from the Department of Fine Arts at Alexandria University, where he was immediately employed as a full-time lecturer in painting and stage design (1966–73). Between 1974 and 1976, he took sabbatical leave and studied advanced printmaking at the Central School of Art and Design in London, finishing his M.A. in 1978. He became a part-time lecturer on Arabic calligraphy at the same school between 1980 and 1982. In 1989 he finished his dissertation and received the first Ph.D. granted by St. Martin's College of Art and Design in collaboration with the British Museum. In his thesis, Moustafa dealt with "proportional script," or *al-khaṭṭ al-mansūb*, as defined by the Abbasid calligrapher Ibn Muqla (A.D. 886–940). Moustafa has lived in London since 1974, painting and working on his research. Despite his training as a modern figurative artist, he has succeeded in mastering the art of classical calligraphy and developing a

Fateh Moudarres, *Christ the Child of Palestine,* 1989. Oil on canvas, 77 x 59 cm. Courtesy of the Jordan National Gallery of Fine Arts, Amman.

contemporary calligraphic style. A true Islamic artist, Moustafa combines the perfection of skill and training with talent and innovation.

Moustafa, Ramzi (b. 1926) (Egypt), is a painter, ceramist, and sculptor. Moustafa began his art career in the 1940s and graduated from the Accademia di Belle Arte in Bologna, Italy, in 1955. He then continued his studies at the Royal College of Art in London (1956), after which he went to Paris to work independently for one year. In 1974 Moustafa received a Ph.D. in philosophy from Denver University in the United States. In the 1960s, he began to investigate an approach to art that drew on his Islamic heritage and took up calligraphy in his paintings. A versatile artist, Moustafa moves with ease between figuration and abstraction in his works.

Mukhtar, Mahmoud (1891–1934) (Egypt), who grew up as a peasant, arrived in Cairo when he was seventeen years old to enroll at the School of Fine Arts. After graduating, he became the first Egyptian to be sent on an art scholarship abroad. During the initiation ritual at the École des Beaux Arts in Paris, he was stripped naked by his companions, covered with paint, and paraded as a Ramsis in the streets; overindulging in liquor the same evening, he shed all inhibitions and, in his words, became a Parisian. Nevertheless, he managed to safeguard his Egyptian identity. He later held regular exhibitions at the Salon des Artistes Français in Paris, just as he did in Cairo, where he was considered one of Egypt's national heroes.

Mukhtar's early works evinced a romantic trait reminiscent of nineteenth-century Orientalist sculptures and had a narrative, thematic quality. Like Iraq, Egypt had a long tradition of figurative sculpture that dated back to pharaonic times. In his later works, Mukhtar revived this tradition, which had been dormant for about three thousand years. He was the first modern artist to work with pink Aswan granite, a material extensively used by Ancient Egyptians. He was often commissioned by the government, and his gigantic works were publicly displayed. His most famous sculpture was *Egypt's Awakening:* a rising sphinx and the stylized figure of an unveiled Egyptian peas-

ant woman standing next to it. The sculpture embodied pharaonic civilization rising from the new Egyptian nation. The woman at its side personified the people and coincided with Egypt's feminist movement, which called for the emancipation of women.

Mukhtar's sculpture *Aïda,* inspired by Verdi's opera, was displayed at the Grand Palais in Paris in 1912. In 1925 Mukhtar won a gold medal, also in Paris, for his bust of the Egyptian singer Umm Kulthum. In 1930 he became the first Egyptian to hold a solo exhibition in Paris, and the French government bought his work *Nile Bride* for the Tuileries Museum. Mukhtar was also the first local artist to have his sculptures publicly displayed in Egypt. In 1938 the Egyptian government opened the Mukhtar Museum, the first in the Arab world devoted to the works of an individual artist.

Naba'a, Nazir (b. 1938) (Syria), was influenced by the early Syrian Impressionists before traveling to Cairo (1959–65) to study art. While working as an art teacher in Dayr al-Zur, he became fascinated with popular traditions and ancient legends. Back in Damascus, he taught at the College of Fine Arts and painted political works and posters before going to Paris to continue his art studies at the École des Beaux Arts. In Paris, his research led him to be devoted to floral details and vegetal motifs, through which he expressed his subjects with great simplicity in symbols. After returning to Damascus, he once again joined the faculty of the College of Fine Arts. In Naba'a's newer paintings, women are at the center, surrounded by traditional motifs of jewelry, furniture, costumes, fruits, and flowers, executed with great precision and charged with symbolic messages.

Nagy, Muhammad (1888–1956) (Egypt), studied law at the University of Lyon in France, graduating in 1910. He then spent four years in Florence, investigating Renaissance art and architecture. Upon his return to Egypt, Nagy went to Luxor to examine first-hand pharaonic treasures and monuments. After World War I, he traveled to Giverny in France, where he befriended Albert Marquet and Claude Monet, who introduced him to French Impressionism. In 1925 he became a diplomat and was posted to Brazil and France. Nagy

resigned from the Foreign Service five years later and dedicated himself to painting.

In 1931 the government sent him on a one-year artistic mission to Ethiopia, where he painted some exceptional landscapes and local religious and social celebrations. He also made portraits of Emperor Haile Selassie I, members of his court, and churchmen in their ceremonial robes. Nagy's Ethiopian works were exhibited at the 1932 Salon du Caire and caused a sensation among the public. That same year, Nagy founded the Alexandria Atelier and became its president. In 1935 he established the Cairo Atelier for Artists and Writers which remains an important cultural association, second in size only to the Artists Union.

One of Nagy's works was acquired by the Tate Gallery following a one-person exhibition in London in 1937. He was the first Egyptian director of the Higher School of Fine Arts (1937–39), after which he was appointed director of the Museum of Modern Art in Cairo. In 1947 he became president of the Egyptian Academy of Fine Arts in Rome. Nagy started out as an Impressionist, then moved on to Expressionism in his portraits and landscapes, using strong colors and well-balanced forms.

Nasiri, Rafa al- (b. 1940) (Iraq), graduated from the Academy of Fine Arts in Baghdad in 1959 and decided to go to China instead of the West. He spent four years (1959-63) training at the Central Academy of Fine Arts in Peking. In 1967-78, when he was in Portugal on a grant from the Gulbenkian Foundation in Lisbon, he discovered the value of Arabic letters and made the transition from figurative art to abstraction. This transition was also motivated by his discovery of a new medium in painting, acrylic. Al-Nasiri returned to the paintbrush, also working in woodblock printing and in graphics.

In contrast to the techniques of etching and wood carving, painting in acrylic forced al-Nasiri to practice certain movements with his wrist, which recalled the Chinese brush technique he had learned during his earlier training. In 1989 al-Nasiri went back to China, renewing his ties with Chinese art. Once again, he began to employ Arabic characters as an integral component in composition. At the outset of the Gulf crisis on

Ahmad Nawash, *Opposite Directions*, 1985. Oil on wood, 55 x 65 cm. Courtesy of the Jordan National Gallery of Fine Arts, Amman.

August 1, 1990, al-Nasiri's style changed to pure abstraction, in which he vaguely identified the letters by dots and obscure signs. After the Gulf war he moved to Jordan, and Arabic characters found their way back into his work, regaining their previous importance in the composition.

Nawash, Ahmad (b. 1934) (Jordan), graduated from the Accademia di Belle Arte in Rome (1964) and the École des Beaux Arts in Bordeaux, where he studied graphics and etching. He later spent two years at the École des Beaux Arts in Paris (1975–77). A leading modern Jordanian artist, Nawash developed an individual style of disfigured, infantile shapes in dreamlike compositions that defy gravity and perspective. His subjects are mostly political, often the plight of Palestinians, seen from a broad humanitarian perspective and through his own symbolic language.

Omar, Madiha (b. 1908) (Iraq), was born in Aleppo of a Circassian father and a Syrian mother. She first attended the Teachers' Training School in Beirut, then continued her secondary education at the Sultaniyya School in Istanbul. There she was encouraged by the Turkish pedagogue-artist Ali Riza during one of his visits to the school. Omar became one of the first women to be sent on scholarship to England by the

Iraqi government. While she was studying at the Maria Grey Training College in London, from which she graduated with honors in painting and handiwork in 1933, Omar's artistic talents became apparent to her teachers. Upon her return to Baghdad, she was appointed a painting instructor at the Teachers Training School for Women. In 1937 she took a one-year leave of absence and went to London and Paris to visit museums and galleries and to further acquaint herself with Western art.

When Omar returned to Baghdad, she was appointed head of the Department of Arts and Painting at the Teachers Training School for Women. She held that position until 1942, when she resigned and accompanied her diplomat husband to his new post in Washington D.C. She took a course in art criticism at George Washington University in 1943 and the following year enrolled at the Corcoran School of Art to study painting and sculpture, graduating in 1950. Arabic characters are part of her paintings.

Rabbah, Majdoub (b. 1933) (Sudan), graduated from the College of Fine Arts in Khartoum before going to the Central School of Art in London (1958). He subsequently traveled to Japan, where he studied new techniques in decorative design and printing. He works on natural wood with a variety of techniques—burning, drawing, and carving—to execute his calligraphic compositions, incorporating local signs and motifs. He developed a technique in printmaking which he calls "solar engraving": with the aid of commercial magnifying lenses, the sun's rays are concentrated to burn patterns into hardwood boards, resulting in low relief etchings which are later enhanced with locally made natural colors and dyes. This procedure is similar to "hot rod iron" engraving, which is used by traditional artists to decorate calabashes and gourds.

Racim, Mohammed (1896–1974) (Algeria), was the son of Ali Racim, a traditional craftsman who became famous toward the end of the nineteenth century for his miniatures, illuminations on glass, and wood carvings, which decorated the interiors of many Algerian houses. The artist's uncle Omar also worked in the family atelier, where Racim had his initial apprentice-

ship, showing a keen sense of design and color. At an early age, Racim enrolled in the Algerian École des Beaux Arts, where he practiced Western three-dimensional painting. After graduation, he left for Paris and was employed in the Department of Manuscripts at the Bibliothèque Nationale, where he studied Islamic manuscripts.

Majdoub Rabbah, *God Multiplies*, 1981. Burned wood, 50 x 32 cm. Courtesy of the Jordan National Gallery of Fine Arts, Amman.

A grant allowed Racim to travel to Spain and study Islamic art in Cordoba and Granada. Subsequently, he went to London, where the specialist on Iranian studies, Sir Denison Ross, helped him gain access to Islamic collections in various museums. By then, Racim had embarked on a quest to develop an authentic Algerian style that was related to his own heritage. After receiving the Médailles des Orientalistes in 1924 and the Grand Prix Artistique d'Algérie in 1933, his fame was established. The same year, he became a teacher of miniature painting at the École des Beaux Arts in Algiers, working with the specialist G. Marçais while assuming a missionary role in spreading this Islamic art form. When Racim, a celebrated miniaturist and calligrapher, participated in the 35th Salon des Artistes Algeriens (1935), his portrait of the head of the Académie d'Alger was given priority over his three-dimensional miniature paintings, which interpreted daily Algerian scenes.

Rbatie, Ali (1861–1939) (Morocco), worked for the English painter John Lafort, who taught him to paint. Rbatie moved between various jobs and places: he was a laborer at the firm of Saint-Louis in Marseille (1918), a soldier in the Tabors Espagnols regiment (1925), and an employee at the Bank of Bilbao in Tangier (1929). After opening and managing an art gallery for two years in Tangier (1933), he first became an art restorer and then a baker (1937). Throughout his various jobs, Rbatie never stopped painting. He exhibited his works in London (1916), in Marseille (1919), and in Rabat (1922), when he was patronized by Prosper Ricard, Director-General of Fine Arts in Morocco. A prolific self-taught naive painter who depicted Moroccan popular customs, festivities, and scenes from everyday life, Rbatie also held several exhibitions in Tangier, which were a success with the public.

Sabri, Ahmad (1889–1955) (Egypt), graduated from the School of Fine Arts in 1914. Between 1919 and 1923, he went to Paris on his own and studied painting at the Académie de la Grande Chaumière and Académie Julian. Upon his return, Sabri worked for some time drawing insects at the Ministry of Agriculture. He then transferred to the Ministry of Public

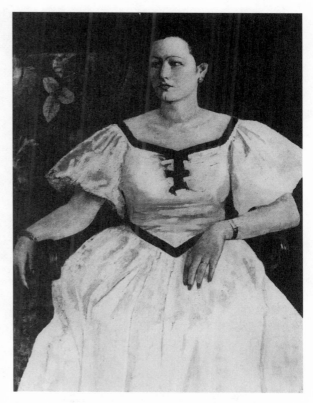

Ahmad Sabri, *A Woman in Yellow Dress,* 1938. Oil on canvas, 107 x 89.5 cm. Museum of Modern Art, Cairo.

Works, which funded his scholarship to Paris, where he trained with Paul Laurant and Emanuel Faugere. He exhibited his painting *The Nun* at the Salon d'Automne in the Grand Palais and won a gold medal. Upon his return to Egypt in 1929, Sabri taught at the School of Fine Arts and later became chairman of the Painting Department at the College of Fine Arts in Cairo, where he remained until his death. During his last years, he gradually lost his eyesight and had to give up painting.

Said, Issam El- (1939–1988) (Iraq), was the grandson of the late Iraqi Prime Minister Nouri El-Said. He lost both his grandfather and father during the 1958 revolution in Iraq and settled in London. He was a prolific artist, designer, art historian, architect, and expert on Islamic art. He read architecture at Corpus Christi College at Cambridge (1958–61) before going to Hammersmith College of Art and Design (1962–64). El-Said

Mahmoud Said, *Dancer with Musicians*, 1949. Oil on canvas. Museum of Modern Art, Cairo.

worked in graphics, oils, enamel on aluminum, and paleocrystal (a transparent material of cold-cast polyester resin, which he developed through long research and experiments).

Despite his self-imposed exile in England, El-Said felt a strong attraction to his native country, which appeared in his stylized drawings and etchings of Baghdadi scenes, recording local customs and ceremonies. His profound knowledge of Islamic design gained him the commission to design the interior of the London Central Mosque and Islamic Cultural Center (1976–77), as well as the Aloussi Mosque (1982–88), and the al-'Aboud Mosque (1984), both in Baghdad. He was a consultant for the master plans of the two

foreign firms that designed King 'Abd al-'Aziz University in Jeddah (1977–78) and Imam Muhammad Ibn Sa'ud Islamic University in Riyadh (1978–79).

Besides painting and etching, El-Said designed carpets and furniture, as well as architectural exteriors and interiors. He was well known for his research on theories of Islamic design and architecture, based on scientific equations published in *Geometric Concepts in Islamic Art*. He wrote the book in collaboration with Aysha Parman. El-Said was a member of "Christies' Contemporary Artists" group, which established his reputation as a painter in London. From 1981 until he died, he was engaged in research in Islamic art for his Ph.D. at University of Newcastle-upon-Tyne. His un-

timely death deprived the Arab art movement of one of its most cultured and intellectual artists. El-Said began incorporating sentences and words into his work in the early 1960s. It was probably his self-imposed exile and the nostalgia for his homeland that made him draw on traditions from Iraqi folklore and popular songs and quotations. He continued to use calligraphy in his work until his death.

Said, Mahmoud (1897–1964) (Egypt), was a lawyer by profession who came from a prominent family; his niece, Farida Zulfikar, later became Queen Farida of Egypt. Said studied painting in Alexandria under Emilia Casanato and Antonio Zanin between 1914 and 1916. Starting in 1920, he traveled extensively in Europe for ten years, looking at as much Western art as possible. While in Paris, he joined the Free Atelier at the Académie de la Grande Chaumière, where he trained in painting for one more year. Back in Egypt, Said suffered from a lack of recognition by his family because in those days Egyptian society did not regard art as a serious profession. Only foreigners showed any kind of appreciation for his work.

In 1947 Said resigned from his legal career and dedicated himself entirely to painting, taking part in the yearly Salons du Caire and Alexandrie, as well as the Venice Biennials of 1948, 1950, and 1952. Unlike the Orientalist artists who preceded him, Said painted sculptural figures meant to simplify everyday events, ignoring details and turning every figure into an archetype. His individual style displayed a mixture of Cubism and Expressionism. After he died, the Ministry of Culture bought his home in Alexandria and transformed it into a gallery, where forty of his works were permanently displayed. (Unfortunately, most of them were damaged when they were secretly taken to Israel for an exhibition during Anwar Sadat's rule). Despite being a member of the old aristocracy, Said was the first Egyptian artist to be honored with the State Appreciation Award for Art, in 1959.

Salahi, Ibrahim al- (b. 1930) (Sudan), a student of Osman Waqialla, studied at the School of Design at Gordon Memorial College in Khartoum. After graduating in 1951, he worked as an art teacher at Wadi Sayidna

Secondary School near Omdurman. In 1954 al-Salahi was sent on a scholarship to the Slade in London (1954–57). During his stay in Europe, he visited Florence to enhance his knowledge of Renaissance art. In 1957 he returned to Sudan to become head of the Painting Department at the School of Fine and Applied Arts in Khartoum. In 1962 Unesco sent al-Salahi on a tour to the United States, South America, Paris, and London. After returning to Sudan, he found himself isolated from his own people by the ideas he had acquired abroad; hence, he began searching for a Sudanese artistic identity by traveling throughout the country to record local architecture and designs used in decorating utilitarian objects, such as utensils and prayer rugs. A founder of the Old Khartoum School, Al-Salahi is one of the first Arab artists to draw on his culture in order to establish a distinct artistic identity. His concern is the internal structure of the work, which he depicts in black and white. He believes that all images can be reduced to lines. In 1975, after his brief imprisonment in Sudan, he chose self-exile and left the country to live in Doha, Qatar, and Oxford, England.

Saleeby, Khalil (1870–1928) (Lebanon), started to draw at an early age, using the charcoal tips of spent matches. In 1886 he enrolled at the Syrian Protestant College, which later became the American University of Beirut. In 1890 he left to further his art training in Edinburgh, where he met the American painter John Singer Sargent, who advised him to go to the United States. In America, he married a young woman from Philadelphia. When he returned to the British Isles, he lived first in Edinburgh, where one of his paintings won the gold medal at the Edinburgh Salon of 1889, and then in London. Saleeby went to Paris and became a pupil of Puvis de Chavannes. He also met Pierre Auguste Renoir, who greatly impressed him. In 1898 he returned to London, where he gained fame as a portrait painter. Saleeby returned to Lebanon in 1900 and taught art at the American University of Beirut.

Saleeby painted numerous portraits of friends, dignitaries, and, most often, his wife. Influenced by Reynolds, Sargent, and the Impressionists, he made graceful nudes and strong portraits that emphasized

the character of his models. This bold, emancipated artist came to a sudden and brutal death when he was senselessly assassinated with his wife in Beirut in 1928.

Saleh, Khairat al- (b. 1940) (Syria), is a self-taught artist who read English literature at Cairo University before going to England for postgraduate studies in English poetry and drama. She did research at the Victoria and Albert Museum and the British Library, where she studied illuminated Islamic manuscripts. Al-Saleh decided to take part in reviving her Arab heritage through her literary work as well as her art. She wrote a book on Arab fables and learned techniques for the application of gold leaf, inspired by Islamic illuminations and European medieval manuscripts. Al-Saleh attended Richmond Adult Community College starting in 1987 to train in pottery and etching. She then began making works on paper, including Kufic script in its geometric, floriated, and foliated forms.

Salim, Jawad (1921–1961) (Iraq), a pioneer of Iraqi modern art, was sent on a scholarship to Paris (1938–39). When Germany invaded France, he transferred to Rome (1939–40), and after Italy entered the war he returned to Baghdad. Salim was then appointed head of the Sculpture Department at the Institute of Fine Arts and at the same time worked in the Directorate of Antiquities in Iraq. During this period, he met the group of Polish artists who were in Baghdad during World War II and who introduced him to post-Impressionist art styles. After the war, Salim was sent to the Slade in London (1946–48) to continue his training. Salim intellectualized the usage of folk motifs in modern plastic art.

Samra, Faisal (b. 1955) (Saudi Arabia), is a graduate of the École Nationale des Beaux Arts in Paris. He has discarded the academic approach and cast off his draftsman's ingenuity for a highly expressionistic individual style. He works in oil on wood or unframed canvas, using thread and bamboo sticks and other unconventional media. His works give expression to a

Faisal Samra, *Nabatiyat Series,* 1996. Mixed media, 26 x 18 cm. Private collection.

state of "mental movement" derived from his nomadic background. After moving to Paris, Samra was able to break away from repetitive folk culture and to free himself of conventional forms such as the human body, dealing instead with primary abstract figures.

Sarghini, Mohamed (b. 1923) (Morocco), was the first Moroccan to join the Escuela de Bellas Artes in Tetouan. He later continued his art training at the Academia San Fernando de Bellas Artes in Madrid. One of the very early pioneers of modern art in Morocco, Sarghini exhibited his works for the first time in 1941. He painted in a figurative style influenced by the Spanish School of contemporary Spanish artists such as Tapies. He later became the director of Escuela de Bellas Artes in Tetouan.

Sepehri, Sohrab (1928–1980) (Iran), graduated from the School of Fine Arts at Tehran University before specializing in lithography at the École des Beaux Arts in Paris (1957) and in woodcut techniques in Tokyo (1960). Sepehri was adept in graphics and painting, both of which showed the influence of Japanese design. He participated in the Venice Biennial of 1950 and the São Paulo Biennial of 1963; he also held one-person exhibitions in New York and Paris. In his semi-abstract, simple style with watercolor effects, Sepehri painted landscapes of the countryside around his native Kashan, trying to assert an Iranian element in his art. In his later period, Sepehri made a series depicting tree trunks and included his poetry within the composition.

Seyyit, Süleyman (1842–1913) (Turkey), was an Ottoman soldier-painter who attended the École des Beaux Arts in Paris and regularly visited the studios of Robert Fluori and Gustave Boulanger. After nine years in Paris and one year in Rome, he returned to Istanbul to take up teaching. He also contributed to two newspapers and was an advocate of free speech, which caused the authorities to ignore him while most of his colleagues were promoted to higher ranks. Seyyit's promotion to the rank of major came after one of his still life paintings was shown to the sultan. Though he painted portraits, none of them left his studio; he was known for his landscapes and still lifes. He used unmixed paints in thin transparent layers that gave his uncluttered compositions a certain freshness and brightness. Seyyit's skilled treatment of light and color depicts sensitivity and a fond rapport with his subject matter.

Shammout, Ismail (b. 1930) (Palestine), showed early promise while still in school in Lydda, where Daoud Zalatimo discovered his budding talent and introduced him to oil paints and perspective. His father, a simple fruit and vegetable merchant, was not enthusiastic about his son's passion for art and discouraged him from pursuing it as a career. At the time, it was fashionable to paint baroque flowers and birds on wedding dresses, and Shammout practiced this kind of painting to earn additional income for his family.

This convinced his father that one could after all earn a living as an artist. Shammout also painted landscapes and portraits in a classical style.

In 1948 Shammout was among the refugees who reached Gaza, where he lived in a refugee camp and worked as a street vendor. Eventually, he became a teacher in a school for refugees, where art supplies were available to him. He chose subjects from his new environment, drawing and painting makeshift tents, and women and children waiting in long queues for food and water, all in a style similar to the figurative art that he had practiced in Lydda. He showed his work for the first time in 1950, at the school where he taught and, in the same year, made his way to Cairo, worked as a commercial artist, and became the first Palestinian to enroll at the College of Fine Arts. He trained under famous Egyptian artists such as Ahmad Sabri, Hussein Bikar, and Husni Banani and came into contact with other pioneer artists, including Raghib Ayyad, Gamal Saggini, Abdul Hadi Gazzar, and Youssef Kamel, who was the dean of the College of Fine Arts.

During his three years of training, Shammout painted Palestinian subjects in a classical, realistic manner. He ignored new trends because he wanted to communicate with his public and make them understand the message in his work. In 1953 he was too intimidated to show his work in Cairo so he took his paintings to Gaza and held the first one-person exhibition in Palestine. Following his graduation in 1954, he arranged the first Palestinian group exhibition ever in the Egyptian capital. It was entitled *The Palestinian Refugee* and was inaugurated by President Gamal Abdul Nassir.

After the exhibition, Shammout left for Rome and received a scholarship from the Italian government to study at the Accademia di Belle Arte. He went to Beirut in 1956, worked for two years with UNRWA, and opened a commercial advertisement office. In 1976, Shammout's style changed as the emphasis on perspective waned in favor of simple forms and minimal details, concentrating more on the theme and the message in the work. The expressiveness in his paintings took over the composition and replaced his previous figurative realism.

Ismail Shammout, *Setting the Pigeons Free*, 1994. Oil on canvas, 81 x 100 cm. Courtesy of the Jordan National Gallery of Fine Arts, Amman.

Shawa, Leila (b. 1940) (Palestine), is a painter, educator, and jewelry designer who lives in Gaza and London. Her first art training was at the Leonardo da Vinci School of Art in Cairo (1957–58), after which she went to Rome and attended the Accademia di Belle Arte (1958–64) and the Accademia St. Giaccomo (1960–64). During 1960–64 she attended summer courses at the Oscar Kokoschka School of Seeing in Salzburg, working under the Austrian Expressionist himself.

Upon her return to Gaza, Shawa was appointed supervisor for arts and crafts education in UNRWA schools (1965–67) and a Unesco lecturer of child education at Teachers Training Courses for UNRWA teachers (1966–1967). Between 1967 and 1975 she lived in Beirut and became a full-time painter and children's book illustrator. She executed massive stained glass windows for the Rashad Shawa Cultural Center in Gaza, founded by her father. In 1987 she settled in London, where she continues to work full-time on her

art. Shawa's paintings are distinguished by both her bold style and subject matter. After an early period of depicting fictional Oriental cities and horses, she reverted to controversial themes in her work. The first was of women prostitutes in Beirut. A second subject was the imposition of the veil on women in Gaza, which later took on a wider scope by including self-imposed restrictions on Arab women. Her recent work carries political and humanitarian messages.

Shibrain, Ahmad Mohamed (Sudan), is a designer, interior decorator, painter, graphic artist, wood-carver, and teacher. He works in various media, using elements taken from various cultures, including Islamic, Nubian, Meriotic, and African. He emphasizes a symbolic use of colors taken from the Sudanese landscape: blue and bluish-green represent the Blue Nile; red, yellow, and brown represent the earth and traditional indigenous architecture. Shibrain, who was one of the

Leila Shawa, *The Prisoner,* 1988. Oil and acrylic on canvas, 102 x 76 cm. Courtesy of the Jordan National Gallery of Fine Arts, Amman.

initiators of the Old Khartoum School, served as secretary general of the Council of Arts and Letters (1963–66) and dean of the College of Fine Arts in Khartoum (1975–80).

Shoura, Nasir (1920–1992) (Syria), rebelled against his family tradition of becoming a doctor or a pharmacist and showed an early inclination toward art. In 1939 he went to Italy to pursue his art studies but was obliged to return because of the war. Between 1943 and 1947, he joined the School of Fine Arts in Cairo. In 1950–51, he went to Paris and Italy to gain a first-hand knowledge of art movements in Europe. Shoura believed in the concept of "art for art's sake" and was the leader of Syrian Impressionism, which he continued to promote among his secondary school students and later at the College of Fine Arts in Damascus. The majority of his work is Impressionistic Syrian countryside landscapes. This was followed by an abstract period that lasted until 1980, when his shapes changed into a sort of vegetal abstraction though his colors remained those of the Impressionists, soft and radiant. His last stage was an individual modern realism that focused once again on Syrian villages. In muted colors, Shoura built up organically patterned surfaces that made up his stones, earth, and nature.

Tahseen, Sa'id (1904–1986) (Syria), was a self-taught artist who, as a youth, had witnessed the great famine that befell Damascus between 1914 and 1918. This catastrophe greatly affected him and was reflected in his work. His subject matter included townscapes of old Damascus, with its narrow streets, traditional houses, as well as wedding ceremonies, historical and current events, and historical and humanitarian themes such as the battles of Yarmuk and Qadissiya, the founding of the Arab League, and scenes of hunger and poverty. During the 1950s, Tahseen attained official recognition and his works filled the walls of the Presidential Palace, the Ministry of Foreign Affairs, and Syrian embassies abroad. His narrative style, with bright impressionistic colors, had a naive quality attributable to his lack of formal training. He paid little attention to per-

spective and concentrated instead on the sound construction of the composition.

Tariq, Tawfiq (1875–1945) (Syria), was a soldier-painter born to a Turkish father and Damascene mother. One of the early pioneers of Syrian modern art, he was influenced by his many Turkish artist-friends and his military training in Istanbul. He was gifted architect, decorator, cartoonist, and painter whose early repertoire was limited to portraits of well-known figures and to landscapes, meticulously copied from prints and photographs. The first artist in Syria to use oil paints, Tariq became well known among high officials, who paid him handsomely for their portraits. In 1923 the French Mandate authorities sent him on a scholarship to study architecture in Paris. After this trip, the Ottoman influence in his work was replaced by the academic style, keeping him outside the circle of the modern art movements that were current in France, including Impressionism. He also painted landscapes of Damascene scenes, sometimes from nature, and imaginary tableaus of famous battles and historical events.

Tariq moved freely among Jerusalem, Haifa, Sidon, and Beirut. His fame preceded him everywhere he went, and he would be asked by town notables to make their portraits. When he went on pilgrimage, he became the first modern artist from his country to depict the Prophet's Mosque in Medina. A skilled and precise figurative painter, he paid great attention to the minutest details in his documentary-like works.

Turki, Yahia (1901–1968) (Tunisia), was a self-taught painter who entered the civil service at a young age and became a pioneer of Tunisian modern art. He participated in the Salon d'Automne of 1922 in Tunis. In 1923 Émile Pinchart offered him a scholarship at the École des Beaux Arts in Tunis after seeing his work at the Salon Tunisien, whereupon Turki resigned his civil service position to study art. He attended art classes for a few months only, however, preferring the freedom of spontaneously treating subjects taken from his environment to the restrictions of academic training. It

was a difficult choice because Tunisian artists were not treated with the same respect accorded to foreign artists. Turki nevertheless persevered and created a framework for operating in the Tunisian environment, which led to a deeper correlation between his works and the Tunisian way of life. With direct, cheerful colors and minimum detail, he portrayed the old city of Tunis and its inhabitants going about their everyday life, thus breaking away from the dramatic Orientalist stereotypes.

Waqialla, Osman (b. 1925) (Sudan), graduated from both Gordon Memorial College (1945) and the School of Design (1946) in Khartoum. He was among the second group of Sudanese scholarship students to study abroad. After graduating from Camberwell School of Arts and Crafts in 1949, Waqialla returned to Sudan and taught with the pioneer pedagogue Shafik Shawki at the School of Design at University College in Khartoum. Waqialla then left for Cairo to study at the School of Arabic Calligraphy, where he was trained by the professor of calligraphy Sayyid Ibrahim, graduating in 1951. Along with Shafik Shawki, Waqialla founded the College of Fine and Applied Arts in Khartoum, where he taught painting between 1949 and 1954. He was also a founder of the Sudanese Literary Guild (1950) and the Association of Sudanese Artists (1951). In 1954 he formed Studio Osman in the center of Khartoum. It became a meeting place for artists and intellectuals, executing major art assignments after Sudan's independence, including the calligraphy on the first Sudanese currency. When in 1955 the BBC employed Waqialla in its Arabic service, he moved with his family to London but kept his studio going in Khartoum until 1964. In the cosmopolitan environment of London, Waqialla benefited from its museums, galleries, libraries, and contact with the latest developments in Western art. A member of the Old Khartoum School, he manipulates calligraphy for its graphic qualities and content.

Wijdan (b. 1939) is a painter, art historian, and lecturer. She got her B.A. in history from the Lebanese Ameri-

can University (formerly Beirut College for Women) (1961), and her Ph.D. in history of Islamic art from the School of Oriental and African Studies (SOAS), University of London (1993). She began her career as a diplomat and was the first woman to enter the Ministry of Foreign Affairs in Jordan and the first woman delegate to represent her country at UN meetings in Geneva and New York (1962–66). Wijdan trained in art with Armando Bruno and Muhanna Durra. She developed a textured style of layers of various hues which she works over with a palette knife to achieve a shimmering effect of color and light. Since 1979 she has been experimenting with the usage of Arabic calligraphy as a graphic element of the composition. In her *Karbala' Series,* she has incorporated signs, letters, and Arabic poetry with strong primary colors to express her indignation toward human injustice.

Zayyat, Elias (b. 1935) (Syria), started his art studies in Sofia and then continued in Cairo (1958–62). His early works were realistic and carefully recorded the details of very rigid figures. In 1965 he moved toward a poetic Expressionism in his nudes and portraits, discarding the restraints of his academic training. By 1966 he broke into monochrome abstractions, which sometimes included local decorative motifs inspired by Damascene woodwork. Since 1967 he has been gradually moving to a hybrid style, mixing realism and abstraction in an epic vision that unites poetry and popular legends with political and philosophical symbols. He also draws on techniques and shapes found in the icons of the Eastern church to express his politics and his philosophy concerning national and public-spirited issues. Zayyat's paintings constitute a separate world that includes its own vocabulary, symbols, and autonomous vision.

Zeid, Fahrelnissa (1901–1991) (Jordan), was a truly international artist. Turkish by birth and Arab through marriage (she was married to the Hashemite Prince Zeid, the youngest son of Sharif Husayn of Mecca), at the beginning of her life she lived in Istanbul. There she trained at the Academy of Fine Arts before going

to the Académie Ranson in Paris. She was a member
of the D-Group in Istanbul and the Paris School. She
spent most of her life among Baghdad, Berlin, Lon-
don, and Paris, accompanying her husband, who was
an ambassador of Iraq during the monarchy. Zeid
spent the last twenty years in Amman, working on her
art and training a limited number of students. A pro-
lific, versatile, and ingenious artist, she was capable of
working, with the same ease, on miniatures in water-
colors and china inks or on gargantuan abstract can-
vases.

Zenderoudi, Hosseyn (b. 1937) (Iran), first studied art
at the Secondary School of Fine Arts for Boys, before
going on to the School of Decorative Arts in Tehran.
He exhibited his calligraphic works for the first time at
the Third Tehran Biennial in 1962, when they were
described by the art critic Kerim Emami as Saqqah-
khāneh works, and the expression came to define a
trend in art that draws on Shi'ite folk heritage.
Zenderoudi was the initiator of the Saqqah-khāneh
School in Iran and one of the early calligraphic artists
in the Islamic world; he believes that Islamic symbols
and motifs "exist within one's own blood," and that
eventually they involuntarily appear in the work of
the artist.

NOTES

CHAPTER 1

1. Sözen, *The Evolution of Turkish Art and Architecture,* 151, 320; Ataöv, *Turkish Painting,* 13; Levey, *The World of Ottoman Art,* 135–36; Renda, "Modern Trends in Turkish Painting," 229–30; Renda, "Traditional Turkish Painting," 77.
2. Renda, "Traditional Turkish Painting," 69–77; Asher, "The Art of the Print in Turkey," 421.
3. Asher, "Art of the Print in Turkey," 421–22.
4. Erol, "Painting in Turkey," pp. 91–92, 94, 96, 107.
5. Mansel, *Sultans in Splendour,* 11; Çizgen, *Photography in the Ottoman Empire 1839–1919,* 15–16, 22–23.
6. Bisharat, "Turkey," 271; Erol, "Painting in Turkey," 94, 105, 121; Ataöv, *Turkish Painting,* 13.
7. Bisharat, "Turkey," 272; Erbil, "Development of Turkish Sculpture," 136–38; Ataöv, *Turkish Painting,* 40.
8. Ataöv, *Turkish Painting,* 40–41.
9. Ataöv, *Turkish Painting,* 22–26; Erol, "Painting in Turkey," 149, 156–60; Bisharat, "Turkey," 272–73.
10. Erol "Painting in Turkey," 172–81, 198–201; Bisharat, "Turkey," 42–44.
11. Çizgen, *Photography in the Ottoman Empire,* 13–14; Bisharat, "Turkey," 247.

CHAPTER 2

1. Iskandar, Mallakh, and Sharouni, *Thamānūna sana min al-fann,* 4–5, 11–14; Jullian, *The Orientalists,* 133–45; Hourani, *A History of the Arab People,* 282–83; Hussein, "Egypt," 33.
2. Hussein, "Egypt," 34.
3. Iskandar, Mallakh, and Sharouni, *Thamānūna sana,* 69–78.
4. Ibid., 29, 98–99.
5. Hussein, "Egypt," 33, 34–36; Iskandar, Mallakh, and Sharouni, *Thamānūna sana,* 15–17, 47–48, 59–65, 88, 100–101, 140–41; Karnouk, *Modern Egyptian Art,* 43.
6. Hussein, "Egypt," 34–35, 37; Iskandar, Mallakh, and Sharouni, *Thamānūna sana,* 83, 108–10, 113–19, 128–30, 149–53, 159.
7. Hussein, "Egypt," 36; Iskandar, Mallakh, and Sharouni, *Thamānūna sana,* 167–73, 175–76.
8. Hussein, "Egypt," 36–37.

CHAPTER 3

1. Hitti, *History of the Arabs,* 729; Carswell, "The Lebanese View," 16; Lahoud, *Contemporary Art in Lebanon,* xxix, xxxi.

2. *Lebanon—The Artist's View*, 107, 109–10, 114; Bahnassi, *Ruwwād al-fann al-ḥadīth fī'l-bilād al-ʿarabīyah*, 95.

3. Lahoud, *Contemporary Art in Lebanon*, xxxi–xxxiii.

4. Carswell, "The Lebanese View," 17.

5. *Lebanon—The Artist's View*, 104, 128.

6. Lahoud, *Contemporary Art in Lebanon*, xxxix–xl; *Lebanon—The Artist's View*, 105 and chronology.

7. Carswell, "The Lebanese View," 17–18.

8. Lahoud, *Contemporary Art in Lebanon*, xl–xliii.

9. *Lebanon—The Artist's View*, chronology.

10. Sayegh, "Thamānīnāt al-fann al-lubnānī waʾl-asʾila al-ṣaʿba ," *Finoon Arabiah*, 51–53; *Lebanon—The Artist's View*, chronology.

CHAPTER 4

1. Al Said, *Fuṣūl min tārīkh al-ḥaraka al-tashkīlīyah fī'l-ʿirāq juzuʾ awwal*, 25.

2. Ibid., 43–45.

3. Ibid., 55–61, 72–76, 81–88, 96, 99–114; Salim, *L'Art contemporain en Iraq*, 41, 52; Mudaffar, "Iraq," 159–60; Jabra I. Jabra, interviewed by author, Amman, July 21, 1992.

4. Mudaffar, "Iraq," 162; Al Said, *Fuṣul*, 95; Jabra, *The Grassroots of Iraqi Art*, 54.

5. Mudaffar, "Iraq," 160, 162–63; Jabra, *Grassroots of Iraqi Art*, 8; Salim, *L'Art contemporain en Iraq*, 78.

6. Mudaffar, "Iraq," 163–64.

7. Ibid., 164–66.

8. Ibid., 166–67; interview by author with Jabra, Amman, July 21, 1992.

CHAPTER 5

1. Mediene, "Algeria," 16.

2. Sijelmassi, *L'Art contemporain au Maroc*, 17; Mediene, "Algeria," 16; Fazekas, *La Villa Abd-el-Tif et ses peintres*, 63; A. Louati, "La Vie artistique," 40.

3. *Musées d'Algerie II*, 69, 89.

4. Bahnassi, *Al-fann al-ḥadīth fī'l bilād al-ʿarabīyah*, 58, 131; Mediene, "Algeria," 16–17; Mardoukh, "*Dirāsa ʿan wāqiʿ al-fann al-tashkīlī al-jazāʾirī*," 64–65; *Musées d'Algerie II*, 70–79, 90.

5. *Musées d'Algérie II*, 91.

6. Mediene, "Algeria," 17–18.

7. Mardoukh, "*Dirāsa*," 66.

8. Fazekas, *La Villa Abd-el-Tif et ses peintres*, 59–60; *Guide du Musée National des Beaux Arts d'Alger*, 5–9.

9. Mardoukh, "*Dirāsa*," 66.

CHAPTER 6

1. Ben Romdhane, "Art et artistes coloniaux," in *La Peinture Européenne en Tunisie sous le protectorat*, 21–23.

2. Louati, "Tunisia," in Ali, *Contemporary Art from the Islamic World*, 261–62; Louati, "La Vie artistique à Tunis avant l'independance," in *La Peinture Européenne en Tunisie*, 9–13, 15–20, 31, 33, 44, 49, 51, 54, 69, 74; Ben Romdhane, "Art et artistes coloniaux," 21–24.

3. Louati, "Tunisia," 262.

4. Ibid., 263–64.

5. Louati, *L'Abstraction dans la Peinture Tunisienne* (unpaginated), fifth page from title page; Louati, "Tunisia," 264–65.

CHAPTER 7

1. Sijelmassi, "L'Art contemporain au Maroc," 14–16.

2. Ibid., 17, 19, 235; Jullian, *The Orientalists*, 117–22; Barbour, *Morocco*, 152–53.

3. Sijelmassi, "L'Art contemporain au Maroc," 19–21.

4. T. Maraini, "Morocco," in Ali, *Contemporary Art from the Islamic World*, 213; *Encyclopaedia Britannica*, Micropaedia 6, 15th ed., 409; Sijelmassi, "L'Art contemporain au Maroc," 21–22, 262.

5. Sijelmassi, "L'Art contemporain au Maroc," 23, 116.

6. Ibid., 23–25.

CHAPTER 8

1. Pope and Ackerman, *A Survey of Persian Art* 16:245–49; Diba, "Iran," 150.

2. Emami, "Post-Qajar Painting," 2:641; Diba, "Iran," 150.

3. Emami, "Post-Qajar Painting," 2:641.

4. Ibid., 2:645.

5. Ibid., 2:641; Yarshater, "Contemporary Persian Painting," 2:363.

6. Emami, "Post-Qajar Painting," 2:641–42; Diba, "Iran," 155.

7. Emami, "Post-Qajar Painting," 2:642; Diba, "Iran," 154.

8. Ibid.

CHAPTER 9

1. Bahnassi, "Taṭawūr al-fan al-sūrī khilāl miʾat ʿām," 11–15, 18; M. Hammad, "Nashʾat al-fann al-tashkīlī al-muʿāṣir fī'l qutr al-ʿarabī al-sūrī," manuscript; T. al-Sharif, "Syria," in Ali, *Contemporary Art from the Islamic World*, 253–54.

2. Hitti, *History of the Arabs*, 752; Bahnassi, *Rūwwād al-fann al-ḥadīth fī 'l-bilāad al-'arabīyah*, 56; Bahnassi, "Taṭawūr al-fan al-sūrī," 16; al-Sharif, "Syria," in *Contemporary Art from the Islamic World*, 255.

3. Bahnassi, *Rūwwād*, 56–57; Bahnassi, *Al-fann al-ḥadīth*, 52–53; al-Sharif, "Syria," 255.

4. Bahnassi, "Taṭawūr al-fan al-sūrī," 17; al-Sharif, "Syria," 255; Bahnassi, *Rūwwād*, 56–57; M. Hammad, "Tajārib shakhṣīya fī 'l-fann al-tashkīlī," manuscript.

5. al-Sharif, "Syria," 255.

6. Ibid., 257, 259; Bahnassi, "Taṭawūr al-fan al-sūrī," 22–24; Afif Bahnassi, interviewed by author, Damascus, Sept. 17, 1992.

CHAPTER 11

1. S. Zaru, "Palestine," in Ali, *Contemporary Art from the Islamic World*, 236; Shammout, *Al-fann al-tashkīlī fī filisṭīn*, 31–35, 39.

2. Shammout, *Al-fann*, 60, 62.

3. Makhoul, *Contemporary Palestinian Art*, 35–42; Shammout, *Al-fann*, 78.

4. Shammout, *Al-fann*, 78.

5. Ibid., 82–83.

6. Ibid., 84–86.

CHAPTER 12

1. Muhammad Abdulla, interviewed by author, London, May 26, 1992; Hassan, "Khartoum Connection: The Sudanese Story," 110–11.

2. Osman Waqialla, interviewed by author, London, May 26, 1992, personal correspondence with Waqialla, Oct. 24, 1992.

3. Diab, "Sudan," 6–7, 224; Hassan, "Khartoum Connection: The Sudanese Story," 117–18, 244.

CHAPTER 13

1. Hitti, *History of the Arabs*, 739–41; Bacharach, *A Near East Studies Handbook 570–1974*, 23.

2. Salman, *Al-tashkīl al-mu'āṣir fī duwal majlis al-ta'āwūn al-khalījī*, 24–25; Taqi, "Contemporary School in Kuwait" (unpaginated), twentieth from title page.

3. *Al-marsam al-ḥur*, 11–16; Salman, *Al-tashkīl*, 98–99.

4. Salman, *Al-tashkīl*, 67–69.

5. Grant, "Saudi Art: A Fledgling Due to Take off," 28–31.

6. Salman, *Al-tashkīl*, 49–50.

7. Kay, "Fine Arts in the UAE," 78–80.

8. Bahnassi, *Rūwwād*, 170.

9. Williams, "A British Artist's Impressions of UAE," 81–82.

CHAPTER 14

1. Hussein, "Egypt," 34.

2. Al Said, *Jawad Salīm al-fannān w'al-ākharūn*, 121, 216; Jabra, *Celebration of Life*, 173–74; Mudaffar, "Iraq," 160–62.

3. Osman Waqialla, interviewed by author, London, May 26, 1992; Hassan, "Khartoum Connection: The Sudanese Story," 315.

4. Diba, "Iran," 152.

5. Sijelmassi, *L'Art contemporain au Maroc*, 24; *Seven Stories About Modern Art in Africa*, 245–46.

CHAPTER 15

1. Madiha Omar, interviewed by author, Amman, Oct. 21, 1992.

2. Lahoud, *Contemporary Art in Lebanon*, 257.

3. Zenderoudi, "An Artist for the Wider World," 41; Dagher, *Al-ḥurūfīya al-'arabīya fann wa hawīyah*, 27–29.

CHAPTER 16

1. Ahmad Moustafa, interviewed by author, London, June 11, 1991.

2. Lane, *Arabic English Lexicon* 2:2452.

3. Jabra, *Celebration of Life*, 172; Shaker Hassan Al Said, interviewed by author, Amman, Nov. 27, 1991.

4. Porter, "A Lifetime of Painting," 27, 30–33.

5. Khalid Khreis, interviewed by author, Amman, April 9, 1992.

6. Rafa al-Nasiri, interviewed by author, Amman, Nov. 7, 1991.

CONCLUSION

1. Allan, introduction, *Ali Omar Ermes: Art and Ideas*, 10.

BIBLIOGRAPHY

ENGLISH

Ali, W., ed. *Contemporary Art from the Islamic World*. London: Scorpion Publishing, 1989.

Allan, J. *Ali Omar Ermes: Art and Ideas*. Exhibition catalog. London: Saffron Books / Eastern Art Report, 1992.

Asher, M. "The Art of the Print in Turkey." In *A History of Turkish Painting*. Seattle: University of Washington Press, 1988.

Ataöv, T. *Turkish Painting*. Bucharest: Meridine Publishing House, 1979.

Bacharach, J. *A Near East Studies Handbook 570–1974*. Seattle: University of Washington Press, 1974.

Barbour, N. *Morocco*. London: Thames and Hudson, 1965.

Bisharat, L. "Turkey." In *Contemporary Art from the Islamic World*, ed. W. Ali. London: Scorpion Publishing, 1989.

Carswell, J. "The Lebanese View." In *Lebanon—The Artist's View: 200 Years of Lebanese Art*. Exhibition catalog. London: British Lebanese Association, 1989.

Çizgen, E. *Photography in the Ottoman Empire 1839–1919*. Istanbul: Haşet Kitabevi, 1987.

Contemporary Art in Kuwait. Kuwait: Kuwait International Investment, 1983.

Diab, R. "Sudan." In *Contemporary Art from the Islamic World*, ed. W. Ali. London: Scorpion Publishing, 1989.

Diba, K. "Iran." In *Contemporary Art from the Islamic World*, ed. W. Ali. London: Scorpion Publishing, 1989.

Emami, K. "Post-Qajar Painting." In *Encyclopaedia Iranica*, ed. E. Yarshater. London: Encyclopaedia Iranica, 1987.

Erbil, D. "Development of Turkish Sculpture." In *The Transformation of Turkish Culture*, ed. G. Renda and C. M. Kortepeter. Princeton, N.J.: Kingston Press, 1986.

Erol, T. "Painting in Turkey in the 19th and Early 20th Century." In *A History of Turkish Painting*. Seattle: University of Washington Press, 1988.

Ettinghausen, R., and E. Yarshater, eds. *Highlights of Persian Art*. Vol. 2. Boulder, Colo.: Westview Press, 1979.

The Fourth Dimension of Arabic Calligraphy. Exhibition catalog of Osman Waqialla. London: Islamic Cultural Center, 1987.

Grant, J. "Saudi Art: A Fledgling Due to Take Off." *Art and the Islamic World* 4, no. 1 (1986).

Hassan, S. "Khartoum Connection: The Sudanese Story." In *Seven Stories About Modern Art in Africa*. Exhibition catalog. Paris and New York: Flammarion, 1995.

A History of Turkish Painting. Seattle: University of Washington Press, 1988.

Hitti, P. *History of the Arabs*. London: Macmillan, 1980.

Hourani, A. *A History of the Arab People*. London: Faber and Faber, 1991.

Hussein, M. T. "Egypt." In *Contemporary Art from the Islamic World*, ed. W. Ali. London: Scorpion Publishing, 1989.

Jabra, J. I. *A Celebration of Life*. Baghdad: Dar Al-Ma'mun, 1988.

———. *Grassroots of Iraqi Art*. Jersey, U.K.: Wasit Graphic and Publishing, 1980.

Jullian, P. *The Orientalists*. Oxford: Phaidon Press, 1977.

Karnouk, L. *Modern Egyptian Art—The Emergence of a National Style*. Cairo: American University in Cairo Press, 1988.

Kay, S. "Fine Arts in the UAE." *Art and the Islamic World* 3, no. 4 (1986).

Lahoud, E. *Contemporary Art in Lebanon*. Beirut: Dar El-Machreq, 1974.

Lane, E. W. *Arabic English Lexicon*. Vol. 2. Cambridge: Islamic Texts Society, 1984.

Lebanon—The Artist's View: 200 Years of Lebanese Art. Exhibition catalog. London: British Lebanese Association, 1989.

Levey, M. *The World of Ottoman Art*. London: Thames and Hudson, 1976.

Louati, A. "Tunisia." In *Contemporary Art from the Islamic World*, ed. W. Ali. London: Scorpion Publishing, 1989.

Makhoul, B. *Contemporary Palestinian Art: An Analysis of Cultural and Political Influences*. Doctoral diss., Manchester Metropolitan University, 1995.

Mansel, P. *Sultans in Splendour: The Last Years of the Ottoman World*. London: André Deutsch, 1988.

Maraini, T. "Morocco." In *Contemporary Art from the Islamic World*, ed. W. Ali. London: Scorpion Publishing, 1989.

Mediene, B. "Algeria." In *Contemporary Art from the Islamic World*, ed. W. Ali. London: Scorpion Publishing, 1989.

Mudaffar, M. "Iraq." In *Contemporary Art from the Islamic World*, ed. W. Ali. London: Scorpion Publishing, 1989.

Phaidon Dictionary of 20th-Century Art. Oxford: Phaidon Press, 1977.

Pope, A. U., and P. Ackerman. *A Survey of Persian Art*. Vol. 14. Tokyo, Japan: Sopa, Ashiya, 1981.

Porter, V. "A Lifetime of Painting." In J. Allan, *Ali Omar Ermes: Art and Ideas*. Exhibition catalog. London: Saffron Books/Eastern Art Report, 1992.

Renda, G. "Modern Trends in Turkish Painting." In *The Transformation of Turkish Culture*, ed. G. Renda and C.M. Kortepeter. Princeton, N.J.: Kingston Press, 1986.

———. "Traditional Turkish Painting and the Beginning of Western Trends." In *A History of Turkish Painting*. Seattle: University of Washington Press, 1988.

Renda, G., and C. M. Kortepeter, eds. *The Transformation of Turkish Culture*. Princeton, N.J.: Kingston Press, 1986.

al-Sharif, T. "Syria." In *Contemporary Art from the Islamic World*, ed. W. Ali. London: Scorpion Publishing, 1989.

Sözen, M. *The Evolution of Turkish Art and Architecture*. Istanbul: Haset Kitabevi, n.d.

Taqi, A. "The Contemporary School and Development of Fine Arts in Kuwait." In *Contemporary Art in Kuwait*. Kuwait: Kuwait International Investment, 1983.

Williams, C. "A British Artist's Impressions of UAE." *Art and the Islamic World* 3, no. 4 (1986).

Yarshater, E. "Contemporary Persian Painting." In *Highlights of Persian Art*, ed. E. Ettinghausen and E. Yarshater. Boulder, Colo.: Westview Press, 1979.

———, ed. *Encyclopaedia Iranica*. London: Encyclopaedia Iranica, 1987.

Zaru, S. "Palestine." In *Contemporary Art from the Islamic World*, ed. W. Ali. London: Scorpion Publishing, 1989.

Zenderoudi, Hosseyn. "An Artist for the Wider World." Interview. *Eastern Art Report* 3, no. 4 (1991–92).

FRENCH

Ben Romdhane, N. "Art et artistes coloniaux." In *La Peinture Européenne en Tunisie sous le protectorat* (European painting in Tunisia under the [French] protectorate). Exhibition catalog. Tunis: Center d'Art Vivant de la Ville de Tunis, 1989.

Fazekas, S. *La Villa Abd-El-Tif et ses peintres (1907–1962)* (Villa Abd-El-Tif and its painters). Mémoire de Maitrise, Paris: Université Panthéon-Sorbonne, n.d.

Guide du Musée National des Beaux Arts d'Alger (Guide to the National Museum of Fine Arts in Algiers). Algiers: Ministére de l'Education Nationale, 1970.

Louati, A. *L'Abstraction dans la peinture Tunisienne* (Abstraction in modern Tunisian painting). Exhibition catalog. Tunis: Center d'Art Vivant de la Ville de Tunis, 1986.

———. "La vie artistique à Tunis avant l'independance." In *La Peinture Européenne en Tunisie sous le protectorat* (European painting in Tunisia under the [French] protectorate). Exhibition catalog. Tunis: Center d'Art Vivant de la Ville de Tunis, 1989.

Musées d'Algerie II: L'Art Algerien Populaire et Contemporain (The museums of Algeria: Popular and contemporary Algerian art). Madrid: Collection Art et Culture, 1973.

La Peinture Européenne en Tunisie sous le Protectorat (European painting in Tunisia under the [French] protectorate). Exhibition catalog. Tunis: Center d'Art Vivant de la Ville de Tunis, 1989.

Salim, N. *L'Art contemporain en Iraq* (Contemporary art in Iraq). Lausanne: Sartec, 1977.

Sijelmassi, M. *L'Art contemporain au Maroc* (Contemporary art in Morocco). Paris: ACR, Édition, 1989.

ARABIC

Al Said, S. H. *Fuṣūl min tārīkh al-ḥaraka al-tashkīlīyah fiʾl-ʿIrāq—jusuʿawwal* (Chapters from the history of the art movement in Iraq [Part 1]). Baghdad: Ministry of Culture and Information, 1983.

———. *Jawād Salīm al-fannān waʾl-ākharūn* (Jawad Salim, the artist and the others). Baghdad: Ministry of Culture and Information, 1991.

Bahnassi, A. *Rūwwād al-fann al-ḥadīth fiʾl-bilād al-ʿarabīyah* (Pioneers of modern art in the Arab world). Beirut: Dar al-Raʾid al-Arabi, 1985.

———. *Al-fann al-ḥadīth fiʾl-bilād al-ʿarabīyah* (Modern art in the Arab world). Tunis: UNESCO/Dar al-Janub liʾl-Nashr, 1980.

———. "Taṭawūr al-fann al-sūrī khilāl miʾat ʿĀm" (Development of Syrian art in one hundred years). *Al-ḥawlīyāt al-atharīyah al-ʿarabīyah al-sūrīyah* (HAAS) (The annual Arab Syrian archeological and historical review) 23, nos. 1 and 2 (1973). Damascus: General Directorate of Museums and Antiquities, 1973.

Dagher, S. *Al-ḥurūfīya al-ʿarabīya fann wa hawīya* (Arab letterism, art and identity). Beirut: Sharikat Al-Matbuʿāt liʾl-Tawzīʿ waʾl-Nashr, 1990.

Hammad, M. "*Tajārib shakhṣīya fiʾl-fann al-tashkīlī*" (Personal experiences in plastic art). Manuscript.

Iskandar, I., K. Mallakh, and S. Sharouni. *Thamānūna sana min al-fann* (Eighty years of art). Cairo: Al-haïʾa al-masrīya al-ʿāmma liʾl-kitāb, 1991.

Mardoukh, I. "Dirāsa ʿan wāqiʿ al-fann al-tashkīlī al-jazāʾirī" (A study of Algerian plastic arts). *Al-tashkīl al-ʿarabī*, no. 4 (1978).

Al-marsam al-ḥur (The free atelier). Kuwait: Ministry of Information, 1986.

Salman, A. *Al-tashkīl al-muʿāṣir fī duwal majlis al-taʿāwūn al-khalījī* (Modern art in the countries of the Gulf Cooperation Council). Kuwait: Gulf Cooperation Council, 1984.

Sayegh, S. "Thamānīnāt al-fann al-lubnānī waʾl-asʾila al-ṣaʿba" (The difficult questions on Lebanese art during the 1980s). *Finoon Arabiah* 1, no. 1 (1981).

Shammout, I. *Al-fann al-tashkīlī fī filisṭīn* (Modern art in Palestine). Kuwait: Ismail Shammout, 1989.

INTERVIEWS AND CORRESPONDENCE BY AUTHOR

Muhammad Ahmad Abdulla (Sudanese ceramicist), interview, London, May 26, 1992.

Shaker Hassan Al Said (Iraqi painter and art historian), interview, Amman, Nov. 27, 1991.

Afif Bahnassi (Syrian art historian), interview, Damascus, Sept. 17, 1992.

Jabra Ibrahim Jabra (Iraqi painter, art historian, and critic), interview, Amman, July 21, 1992.

Khaled Khreis (Jordanian painter), interview, Amman, April 9, 1992.

Ahmad Moustafa (Egyptian painter), interview, London, June 11, 1991.

Rafa al-Nasiri (Iraqi painter), interview, Amman, Nov. 7, 1991.

Madiha Omar (Iraqi painter), interview, Amman, Oct. 21, 1992.

Osman Waqialla (Sudanese calligrapher and painter), interview, London, May 26, 1992, and personal correspondence, Oct. 24, 1992.

INDEX